AN INDEX OF ICONS
IN ENGLISH EMBLEM BOOKS
1500·1700

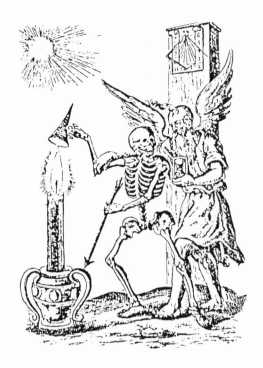

AN INDEX OF ICONS
IN ENGLISH EMBLEM BOOKS
1500·1700

by Huston Diehl

UNIVERSITY OF OKLAHOMA PRESS : NORMAN AND LONDON

Library of Congress Cataloging-in-Publication Data

Diehl, Huston, 1948–
 An index of icons in English emblem books,
1500–1700.

 Bibliography: p. 253
 1. Emblem books, English—Indexes. 2. Emblems—
England—Indexes. 3. Symbolism in art—Themes, motifs
—Indexes. 4. Epigrams, English—Indexes. 5. Mottoes—
Indexes. I. Title.
Z1021.3.D53 1986 016.7 85–40950
ISBN 0–8061–1989–6 (alk. paper)

This publication has been supported by the National Endowment for the Humanities, a federal agency which supports
the study of such fields as history, philosophy, literature, and languages.

The paper in this book meets the guidelines for permanence and durability of the Committee on Production Guidelines
for Book Longevity of the Council on Library Resources, Inc.

Contents

Illustrations

Acknowledgments

I compiled the major portion of this index while I held a National Endowment for the Humanities Faculty Fellowship in Residence at the University of Chicago. David Bevington provided guidance and encouragement throughout my year in Chicago; for his advice, direction, and generosity, and for his continued support, I owe him much thanks. My fellow NEH seminar members made my work less tedious with their good will and high spirits. They also helped me understand a number of puzzling images by referring me to classical, biblical, medieval, and Renaissance sources. My interest in the emblem genre began in graduate seminars taught by Karla Langedijk and Dale B. J. Randall at Duke University. I was fortunate to have access to the fine collections of English and Continental emblem books in the libraries of Duke University and the University of Chicago and at the Newberry Library. The University of Oklahoma funded the work of revising and preparing the manuscript for publication with grants from the College of Arts and Sciences and the Research Council, and the National Endowment for the Humanities provided a generous grant to the University of Oklahoma Press to defray the cost of publication.

I am grateful to all the people who have read, critiqued, edited, and responded to this index while it was in progress. Roland Mushat Frye offered invaluable suggestions for revisions of the manuscript as well as much-appreciated support and encouragement. His commitment to this project greatly facilitated its publication. Ernest Gilman also gave a thorough and careful reading and made many useful comments. Carol Coe applied her considerable intelligence and energy to the task of transforming thousands of handwritten index cards into a readable manuscript. Darla Chaddick assisted me in verifying each entry. The index is more accurate and more usable because of the efforts of all these people.

I completed this book the year my father, Gilbert Herman Diehl, died and my daughter, Susannah Simons Lewis, was born. I owe them more than I can say: my father, for encouraging me to ask questions and seek answers; Susannah, for reminding me to trust in the immediate moment. This book is for them.

HUSTON DIEHL

Iowa City, Iowa

Key to Abbreviations

H.A.	H. A. [Henry Hawkins], *The Devout Hart, or Royal Throne of the Pacified Salomon* (Rouen, 1634)
Arwaker	Edmund Arwaker, *Pia Desideria; or, Divine addresses* (3 books in 1; London, 1686)
Astry	Sir James Astry, *The Royal Politician* (London, 1700)
Ayres	Philip Ayres, *Emblemata Amatoria; or, Cupids Address to the Ladies* (London, 1683)
R. B.	R. B. [Robert or Richard Burton, pseudonym of Nathaniel Crouch], *Delights for the Ingenious: Emblems, Divine and Moral, Ancient and Modern* (London, 1684)
Bunyan	J. B. [John Bunyan], *A Book for Boys and Girls, or Country Rhymes for Children* (London, 1686)
Combe	Thomas Combe, *The Theater of Fine Devices* (London, 1614)
Farlie	Robert Farlie, *Lychnocausia* (London, 1638)
Godyere	H. G. [Sir Henry Godyere], *The Mirrour of Majesty; or, The Badge of Honour* (London, 1618)
Hall	J. H. [John Hall], *Emblems with Elegant Figures* (London, 1658)
Harvey	Christopher Harvey, *Schola cordis or the heart of it selfe* (London, 1647)
Hawkins	H. A. [Henry Hawkins], *Parthenia Sacra, or, the Mysterious and delicious Garden of the Sacred Parthenes* (Paris, 1633)
Jenner	Thomas Jenner, *The Soules Solace, or thirtie and one spirituall emblems* (London, 1626)
E. M.	E. M. [Edward Manning], *Ashrea: or, The Grove of Beatitudes* (London, 1665)
Montenay	Georgette de Montenay, *A Book of Arms, or remembrances* (Frankfort, 1619)
Peacham	Henry Peacham, *Minerva Britanna, or a garden of heroical Devises* (London, 1612)
Quarles, Emb.	Francis Quarles, *Emblemes* (London, 1635)
Quarles, Hier.	Francis Quarles, *Hieroglyphikes of the life of Man* (London, 1638)
P. S.	P. S., *The Heroicall Devices of M. Claudius Paradin* (London, 1591)
Thynne	Francis Thynne, "Emblemes and Epigrames" (MS, ca. 1600)
Van der Noodt	Jan van der Noodt, *A Theatre wherein be represented the miseries that follow the voluptuous worldlings* (London, 1569)
Van Veen	Otto van Veen, *Amorum Emblemata* (Antwerp, 1608)
Whitney	Geoffrey Whitney, *A Choice of Emblemes* (Leyden, 1586)
Willet	Andrew Willet, *Sacrorum emblematum centuria una* (Cambridge, n.d.)
Wither	George Wither, *A collection of emblemes, ancient and modern* (London, 1635)

Continental Sources of English Emblem Books

Alciati, Andrea. *Emblemata*. Antwerp, 1581.
 See Geoffrey Whitney, *A Choice of Emblemes* (Leyden, 1586).
Aneau, Barthelemy. *Picta Poesis*. Lugduni, 1552.
 See Geoffrey Whitney, *A Choice of Emblemes* (Leyden, 1586).
Faerno, Gabriello. *Fabulae Centum*. Rome, 1564.
 See Geoffrey Whitney, *A Choice of Emblemes* (Leyden, 1586).
Haefton, Benedict van. *Schola Cordis*. Antwerp, 1629.
 See Christopher Harvey, *Schola cordis or the heart of it selfe*
 (London, 1647).
Hugo, Herman. *Pia Desideria Emblematis*. Antwerp, 1624.
 See Edmund Arwaker, *Pia Desideria; or Divine addresses*
 (London, 1686).
 Francis Quarles, *Emblemes* (London, 1635).
Junius, Hadrianus. *Emblemata*. Antwerp, 1565.
 See Geoffrey Whitney, *A Choice of Emblemes* (Leyden, 1586).
La Perrière, Guillaume de. *Le Theatre des bons engins*. Paris, 1539.
 See Thomas Combe, *The Theater of Fine Devices* (London, 1614).
Montenay, Georgette de. *Emblemes*. Lyons, 1571.
 See Geoffrey Whitney, *A Choice of Emblemes* (Leyden, 1586).
Paradin, Claude. *Devises Heroiques*. Lyons, 1551.
 See P. S., *The Heroicall Devises of M. Claudius Paradin.*
 London, 1591;
 Geoffrey Whitney, A Choice of Emblemes (Leyden, 1586).
Ripa, Cesare. *Iconologia*. Rome, 1603.
 See Henry Peacham, *Minerva Britanna* (London, 1612).
Rollenhagen, Gabriel. *Nucleus emblematum selectissimorum*. Utrecht, 1611? and 1613.
 See George Wither, *A Collection of Emblemes* (London, 1634).
Saavedra Fajardo, Diego de. *Idea de un Principe politico Christiano.*
 Milan, 1642.
 See Sir James Astry, *The Royal Politician* (London, 1700).
Sambucus, Joannes. *Emblemata*. Antwerp, 1581.
 See Geoffrey Whitney, *A Choice of Emblemes* (Leyden, 1586).
Simeoni, Gabriele. *Le Imprese heroiche et morali*. Lyons, 1559.
 See P. S., *The Heroicall Devises of M. Claudius Paradin*
 (London, 1591).
Typus Mundi. Antwerp, 1627.
 See Francis Quarles. *Emblemes* (London, 1635).

AN INDEX OF ICONS
IN ENGLISH EMBLEM BOOKS
1500·1700

Introduction

One of the most popular and widely read forms of literature in the sixteenth and seventeenth centuries was the emblem book. In the sixteenth century alone 140 editions of Andrea Alciati, the first emblem writer, appeared—far more than editions of Rabelais. Eighty-five years after Alciati's first book of emblems was published in 1531, 700 different editions of emblems had come into print. In England the vogue for emblems was so strong, Gabriel Harvey protested, that the students at Cambridge neglected Aristotle and the classics for emblem writers like Claude Paradin, whose French emblem book was translated into English in 1592.[1] From its origin in 1531 to its decline at the end of the seventeenth century, the emblem book had a wide and deep influence on European culture. Writers and artists used it as a source book for motifs, images, themes, and stories. Rhetoricians and theoreticians defined the emblem's generic form and discussed the nature of emblematic tropes. Protestant preachers used images from the Bible and their own sermons as the bases for emblem books they wrote, and Jesuit priests created scores of emblem books which they encouraged Catholic believers to use as aids in meditation. Few corners of European culture were untouched by the emblem.

An emblem book is a collection, or anthology, of individual emblems. Each emblem in a typical emblem book combines an enigmatic motto, either in Latin or in the vernacular; a symbolic picture or icon; and an epigram or verse commentary. The motto and picture pose a riddle or enigma which the epigram solves or explains. Ideally the three parts of an emblem are interdependent. Together motto, icon, and epigram reveal the emblem's meaning, a meaning that was initially concealed by the enigmatic nature of the motto and icon. Separated, however, each part is inadequate to express the larger significance of the emblem.

Not every emblem conforms to this standard tripartite structure. Certainly among the English emblem books the form varies widely. In Francis Quarles's *Emblemes*, for instance, each emblem includes two mottoes—one usually in Latin, the other in English—a picture, an extended verse commentary, quotations from church fathers, and a short epigram. The emblems of Sir James Astry are in prose, those of Jan Van der Noodt con-

tain no mottoes, and the "naked" emblems of Andrew Willet, Francis Thynne, and John Bunyan include no pictures, although they do refer to imagined visual images. Emblematic subject matter, too, differs widely among the various emblem books. Some, like Geoffrey Whitney's *A Choice of Emblemes* and Henry Peacham's *Minerva Britanna*, gather miscellaneous emblems dealing with a range of topics, including mythology, history, fables, proverbs, personifications, heraldry, beast and plant lore, and hieroglyphics. Other books have a more narrow focus, developing a single theme: emblems of love in Otto Van Veen's *Emblems of Love*, of light in Robert Farlie's *Lychnocausia* and Francis Quarles's *Hieroglyphicks of the Life of Man*, of the heart in Christopher Harvey's *Schola cordis or the heart of it selfe*. Quite a few English emblem writers deal primarily with sacred themes. Among these Georgette de Montenay, Andrew Willet, and Thomas Jenner are explicitly anti-Catholic and antipapist; Francis Quarles and Edmund Arwaker apply Protestant interpretations to sacred texts; and Henry Hawkins gives Catholic interpretations of traditional religious images. Emblem books also vary in length. Edward Manning's *Ashrea* contains only eight emblems; P. S.'s translation of Claude Paradin's *Heroicall Devises* includes more than two hundred.

Regardless of the variations in form and content, all these emblems interpret classical, biblical, and medieval images according to the values and beliefs of their own age. They thus reveal some of the ways Renaissance men and women understood and used the myths and images they inherited from the past. Emblem books can be seen as compendia of the culturally significant images which were known to literate persons who lived in the sixteenth and seventeenth centuries. They are therefore valuable resources for scholars in the humanistic disciplines, especially literature, art history, theology, and history.

Although many of the English emblem books have Continental sources, and some are actual translations of European emblem books (see Continental Sources of English Emblem Books above), their authors tend to adapt these sources to English politics, religion, and culture. English emblem books often apply traditional images to native conflicts, customs, events, and individuals, and they frequently alter the original interpretation of an image to suit their own English purposes. Peacham, for example, dedicates many of his emblems to specific Englishmen and women, applying general images to their particular circumstances. George Wither, for another, makes a point of distancing his emblems from their source, Gabriel Rollenhagen's *Nucleus emblematum se-*

[1]Robert J. Clements, *Picta Poesis: Literary and Humanistic Theory in Renaissance Emblem Books* (Rome: Edigioni di storia e letteratura, 1960), pp. 127, 33, 220; Elbert N. S. Thompson, *Literary Bypaths of the Renaissance* (New Haven, Conn.: Yale University Press, 1924), p. 63.

lectissimorum. Even though he uses the plates from Rollenhagen's book, he often ignores visual elements in the pictures, as well as Rollenhagen's explanations, choosing instead to create his own interpretations even when they are less appropriate to the picture he features. In addition, some English emblem writers like Andrew Willet and Thomas Jenner create highly original and individualistic emblem books quite apart from the Continental iconographic tradition. The English emblem books thus provide insight into English iconographic traditions which are often ignored by scholars who focus on Continental traditions. They also preserve standard icons which were prevalent on the Continent as well as in England.

Since the pioneering work of Mario Praz, whose *Studies in Seventeenth-Century Imagery* includes a comprehensive bibliography of existing Renaissance and Baroque emblem books, and Rosemary Freeman, whose *English Emblem Books* examines the genre in England, many scholars have studied the Renaissance emblem; its form; its theoretical underpinnings; its images, motifs, and themes; and its relation to literature and art.[2] In recent years scholars like Barbara Lewalski, Elizabeth Eisenstein, and Frances Yates have also considered the emblem in the context of its culture, relating the genre to such cultural phenomena as Protestant theology, the

printing press, and the art of memory.[3] These studies find in the popular genre of the emblem manifestations of the larger culture. Despite this critical interest in the emblem book there has been until now no comprehensive index of the English emblem books. I have prepared such an index in the hope that this tool, together with the now widely available editions of English emblem books, will allow scholars in the humanistic disciplines access to these compendia of English Renaissance and Baroque images.

This index makes available for the first time an alphabetical compilation of every icon in every English emblem book (including the polyglot editions of Continental books with English texts) printed in the sixteenth and seventeenth centuries. It indexes the twenty-four extant English emblem books of this period and one manuscript which is available in a modern edition through the Early English Text Society. It thus complements the monumental German reference book by Arthur Henkel and Albrecht Schöne, *Emblemata: Handbuch Sinnbildkunst des XVI. und XVII. Jahrhunderts* (Stuttgart: J. B. Metzler, 1967), and its *Supplement der Erstaugabe* (Stuttgart: J. B. Metzler, 1976). This German book indexes selected emblems from forty-three Continental emblem books but only one English emblem book (Geoffrey Whitney's *A Choice of Emblemes*). *An Index of Icons in English Emblem Books*, however, is comprehensive to England for the years 1500 to 1700.

Each of the entries in this index begins with a call word or phrase, in small-capital letters, which identifies a particular emblematic image. Beneath the call word or phrase appear specific references to every English emblem book (identified by author and page) where that icon can be found. Each reference is accompanied by a description of the cited emblem's three main parts: the motto is quoted in full; the picture, or icon, is described; and the epigram which interprets the enigmatic motto and the symbolic picture is paraphrased or described. The emblem which appears on page 179 of Henry Peacham's *Minerva Britanna*, for example, is listed in the index as follows:

MATTOCK AND PURSE
Peacham, p. 179.

 Motto: "Negatur utrumque."
 Icon: A purse hangs over a mattock.
 Epigram: The speaker worries about his financial future, knowing that he can neither do physical labor nor beg.

[2] Mario Praz, *Studies in Seventeenth-Century Imagery* (London: Warburg Institute, 1947); and Rosemary Freeman, *English Emblem Books* (London: Chatto & Windus, 1948). See, for example, Clements, *Picta Poesis*; Rosalie Colie, *The Resources of Kind* (Berkeley: University of California Press, 1973); Peter M. Daly, *Literature in the Light of the Emblem* (Toronto: University of Toronto Press, 1979); Ernest B. Gilman, "Word and Image in Quarles' *Emblemes*," *Critical Inquiry* 6 (Spring, 1980): 385–410; D. J. Gordon, *The Renaissance Imagination*, ed. Stephen Orgel (Berkeley: University of California Press, 1975); William S. Heckscher, "Renaissance Emblems," *Princeton University Library Chronicle* 15 (1954): 58–68; William S. Heckscher and Cameron F. Bunker, "Review of *Emblemata: Handbuch zur Sinnbildkunst des XVI. und XVII. Jahrhunderts* by Arthur Henkel and Albrecht Schöne," *Renaissance Quarterly* 23 (1970): 59–80; Elizabeth K. Hill, "What Is an Emblem?" *Journal of Aesthetics and Art Criticism* 29 (1970): 261–65; Karl Josef Holtgen, *Francis Quarles, 1592–1644* (Tubingen: Max Niemeyer, 1978); J. Paul Hunter, *The Reluctant Pilgrim* (Baltimore, Md.: Johns Hopkins Press, 1966); Wolfgang Lottes, "Henry Hawkins and *Partheneia Sacra*," *Review of English Studies*, n.s. 26 (1975): 144–53; Hessel Miedema, "The Term *Emblema* in Alciati," *JWCI* 31 (1968): 234–50; Daniel Russell, "The Term 'Embleme' in Sixteenth-Century France," *Neophilologus* 59 (1975): 336–51; Henri Stegemeier, "Review of *Emblemata* by Henkel and Schöne," *Journal of English and Germanic Philology* 67 (1968): 656–72; Frances A. Yates, "The Emblematic Conceit in Giordano Bruno's *De Gli Eroici Furori* and in the Elizabethan Sonnet Sequences," *JWCI* 6 (1943): 101–21. These works provide only a small sample of the scholarship on emblematic literature. For a more comprehensive bibliography see Arthur Henkel and Albrecht Schöne, *Emblemata: Handbuch zur Sinnbildkunst des XVI. und XVII. Jahrhunderts* (Stuttgart: J. B. Metzler, 1967); and its *Supplement der Erstaugabe* (Stuttgart: J. B. Metzler, 1976).

[3] Barbara Kiefer Lewalski, *Protestant Poetics and the Seventeenth-Century Religious Lyric* (Princeton, N.J.: Princeton University Press, 1979); Elizabeth L. Eisenstein, *The Printing Press as an Agent of Change* (Cambridge: Cambridge University Press, 1979); and Frances A. Yates, *The Art of Memory* (Chicago: University of Chicago Press, 1966).

If a particular emblem does not conform to this conventional tripartite structure, the reference to it indicates what part is missing or irregular (e.g., "Icon: None"). When more than one reference appears under a call word, the references are arranged alphabetically according to the last name of the author of the emblem book in which the image appears. The only exception to this is the emblem book by R. B.; since this book reprints complete emblems from George Wither's *A Collection of Emblemes* without any changes or additions, references to his emblems are cited within the references to the appropriate Wither emblem immediately following the citation to Wither.

In addition to cataloguing the primary image of each emblem, the index gives cross references for all secondary images. For instance, Peacham features a personified figure of melancholy on page 126 of *Minerva Britanna*. In the index this image is listed and described under the call word "MELANCHOLY," and each of the secondary attributes which Peacham assigns to this personification—a moneybag, an owl, a book, a cube, and the gesture of silence—is given an entry which refers the reader back to the call word "MELANCHOLY," where the full entry is given, and also cites the author (Peacham) and the page number (p. 126) where the image can be found. When an emblem features two or more images, giving equal emphasis to each image, each is listed in the call word, in alphabetical order (e.g., "MATTOCK AND PURSE" or "BRIDLE, CUPID, MEASURE"). Cross references are then given for the images listed after the initial one (e.g., "PURSE, *See also*: MATTOCK AND PURSE, Peacham, p. 179"). If an icon includes minor pictorial details which are not interpreted or given symbolic significance in the epigram, these details do not appear in the index.

This book indexes the *images* of emblem books, not the ideas symbolized by these images. If an image of a woman is identified as Hope, for example, it appears under the call word "HOPE." If, however, an image of an anchor is interpreted as a sign of hope, it is indexed under the call word "ANCHOR," not "HOPE." Although an index of the ideas represented by the emblematic images would be useful, it is beyond the scope of this work.

In identifying an image, I have tried to remain faithful to the Renaissance texts. If the epigram of a particular emblem calls an image of a woman "matron," I list it as such, not as "mother," "wife," or "woman." Sometimes this fidelity to the texts creates inconsistencies. An identical image of a reptile may be called "snake" by one author and "serpent" by another. Likewise, an image which we today would identify with a single word may be called a number of different names, many of them obsolete today. The image of a barrel, for instance, appears in the index as "BARREL," "HOGSHEAD," and "TUN." I hope that these inconsistencies and multiple terms are offset by the historical accuracy of the terminology.

There are, of course, significant Renaissance distinctions between words we now use synonymously. This fact provides further justification for the method I have employed. To enable the reader to locate examples of an image classified under a number of different call words, I have included within the index proper cross references to: (1) synonyms for images that appear in the emblem books (e.g., for "BABE," "BABY, CHILD, INFANT"; for "MATRON," "LADY, MOTHER, OLD WOMAN, WIFE"); (2) twentieth-century synonyms for Renaissance terms (e.g., for "BARREL," "HOGSHEAD, TUN"; for "CUTTLE-FISH," "OCTOPUS, POLIPUS"); (3) variations in spelling (e.g., "AETHIOPIAN" and "ETHIOPIAN"); (4) alternative names for Greek and Roman mythological figures (e.g., "MINERVA" and "PALLAS,"; "JOVE" and "JUPITER"); and (5) generic categories for specific images (e.g., for "*Coin*", "GOLD, MONEY, RICHES, SHILLING, SILVER GROAT"). In addition, I have on occasion quoted directly from an epigram that I am summarizing to give the reader the flavor of the original and to preserve particularly interesting examples of Renaissance slang, expressions, or technical terminology.

The synopses and descriptions of the emblem's epigrams are necessarily concise and at times even reductive. Generally speaking, the more complex or better written the epigram, the less satisfactory is such a short summary. With a talented writer like Francis Quarles, in particular, a brief description of his verse cannot do justice to the rich, associative language, the logical turns of thought, and the wit and tone of his poems. It is my hope that these brief summaries will, however, enable the reader to comprehend the basic significance of an emblem's central images. Beyond that I urge the reader to go to the original poems and examine the nuances of language and the complexities of thought.

The Illustrations section gives a brief description of the pictorial material in each emblem book included in this index. These descriptions address such details as the number and type of illustrations in each emblem book; the artist or artists, if known; the form of each emblem, including the various pictorial and verbal parts and the relation of the picture to the words; and the general content, including the primary subject matter of each book, the most common type of images, and the thematic unity, if any. This section also reproduces one representative picture from each of the illustrated English emblem books.

Following the Illustrations is a Bibliography of Sixteenth- and Seventeenth-Century English Emblem Books. Included in the citation for each emblem book are (1) the author, title, place, and date of publication of the first known edition; (2) the *Short-Title Catalogue* number and the University Microfilms carton number of this edition; (3) any known variant spellings, names, dates, etc.; (4) a bibliographic citation of any Continental emblem book that was a direct source for the

English book; and (5) all modern editions of the book.

Erwin Panofsky and E. M. Gombrich, among others, have developed widely accepted methods for reading and interpreting visual images which have culturally determined, symbolic meaning. In their analyses of works of Renaissance art these scholars frequently trace a particular image in art and literature as it moves through time, showing how it develops, accrues, and changes meaning. These innovators in the study of visual images use emblems from the Renaissance emblem books, among other texts, to explicate the images of visual art. Through such historical research they recover and describe the multiple meanings of a given image. They then interpret the image according to its particular context. Although art historians developed this methodology, it is now used by scholars in other humanistic disciplines.

Scholars using iconological methods can find in this index sixteenth- and seventeenth-century interpretations of many visual images which appear in Renaissance and Baroque art. They can use the index to document the existence or popularity of a culturally significant image. They can also study the changes and variations in meaning of a particular image and discover the ways certain images are used in both sacred and secular contexts. In addition they can use the index to establish the ways in which context determines the meaning of a given image.

This index has other uses as well. Students of literature can turn to it to see whether a given poetic image carried conventional meaning in the Renaissance. They can use it to discover the traditional attributes of a personification or the conventional interpretations of a mythological story. They may want to check the frequency of a particular image to determine whether it was widely known in sixteenth- and seventeenth-century England. Students of theology can use the index to study the emblem writers' tendency to transform scriptural passages into symbolic pictures, to employ typology, and to depict Reformation and Counter-Reformation controversies through pictures. They can also use the index to discover how certain Roman Catholic and medieval images were reinterpreted in England according to Protestant doctrine. Students of rhetoric can examine the index to see the variety of tropes emblem writers used to interpret a particular image, and students of culture can find in the index evidence of particular habits of mind or common social attitudes. Whatever approaches its readers use, I hope that this index makes the English emblem books more accessible to them.

The Index

A

AARON
See:

ROD OF AARON
P. S., p. 142.

ABRAHAM
See:

MELCHIZEDEK
Willet, no. 63.

Abundance
See: BOUNTY.

ACHILLES
See:

TOMB OF ACHILLES
Whitney, p. 193.

ACTEON
Whitney, p. 15.
Motto: "Voluptas aerumnosa."
Icon: Acteon is devoured by hounds as Diana watches.
Epigram: Those who pursue their passion become "brutish beasts."

ACTEON AND DIANA
Peacham, p. 175.
Motto: "Laboris effecta."
Icon: Diana observes Acteon being pursued by hunters.
Epigram: Diana escaped being wounded by love's darts through labor.

ADAM
Montenay, p. 290.
Motto: "Ubi es."
Icon: Adam hides behind a tree.
Epigram: When Adam sinned, he hid from God behind a tree, but God sees everything.
Whitney, p. 229.
Motto: "Dominus vivit & videt."
Icon: Adam hides from God behind a fig tree; the sun shines on him.
Epigram: There is no way to hide from God.

ADAMANT AND NORTH STAR
Van Veen, p. 39.
Motto: "The North-starre of love."
Icon: Cupid looks to lady while compass points to the North Star.
Epigram: The power of love is like the adamant; it attracts the lover's mind and is irreversible.

ADAM SOWS EARTH
Quarles, *Emb.*, p. 8.
Motto: "Sic malum cicuit unicum in omne malum"
Icon: Adam sows seeds, reaps monsters; fire, earth, air, water threaten him.
Epigram: Adam's lust brought forth sin and death.

ADDER
See:

FOWLER
Whitney, p. 78.
See also: DRAGON, SERPENT, SNAKE, VIPER.

ADONIS
Peacham, p. 169.
Motto: "Haud conveniunt."
Icon: A boar kills Adonis.
Epigram: The death of Adonis makes Venus hostile toward hunting; her hostility illustrates love's opposition to virtue and preference for idleness.

AENEAS AND ANCHISES
Whitney, p. 163.
Motto: "Pietas filiorum in parentes."
Icon: Aeneas bears Anchises from the burning city of Troy.
Epigram: As Aeneas saved his father from the destruction of Troy by carrying him on his back, so sons should revere and care for their parents.

AENEAS AND NERO
Thynne, no. 1.
Motto: "Pietie and Impietie."
Icon: None.
Epigram: Aeneas, who saved his father and son from the burning Troy, exemplifies piety; Nero, who killed his mother, exemplifies impiety.

AESCULAPIUS
Whitney, p. 212.
Motto: "Medici Icon."
Icon: A bearded man crowned with laurel holds a scepter and a knotted staff and sits surrounded by a dragon, a cock, and a dog.
Epigram: This is a portrait of Aesculapius the physician. The beard signifies long experience;

the laurel, fame; the scepter, authority among the sick; the knotted staff, difficult skill; the dragon, renewal; the cock, care; the dog, faithfulness; and the act of sitting, a constant mind.

AETHIOPIAN
Willet, no. 100.
 Motto: "Peccati fibrae."
 Icon: None.
 Epigram: As the Aethiopian will not change his skin, so he who delights in sin will not alter his ways.

See also:
 BATH
 Thynne, no. 43.
 MOSES AND WIFE
 Bunyan, no. 32.
 WASHING THE AETHIOPIAN
 Whitney, p. 57.

AGAMEMNON
Whitney, p. 45.
 Motto: "Furor and rabies."
 Icon: Agamemnon holds a sword and shield with an image of a lion on it.
 Epigram: The shield of a king expresses the monarch's chief desires and thoughts: Agamemnon carries a shield with a lion on it to express his boldness.

AGED MAN
Wither, p. 87.
R. B., no. 23.
 Motto: "To learning, I a love should have, Although one foot were in the grave."
 Icon: A man with one foot in the grave reads a book; the sun sets, the moon rises, and a skull, shovel, and pickax lie beside the grave.
 Epigram: As long as man lives, he can continue to learn.
See also: OLD MAN.

AGED MAN AND BABY
Whitney, p. 167.
 Motto: "Cum tempore mutamur."
 Icon: An aged man on crutches stands beside a baby in a cradle.
 Epigram: No one can escape the mutability of time.

AGED MAN AND YOUTH
Combe, no. 12.
 Motto: "Nothing can temper young men's rage, Till they be tamed with old age."
 Icon: An old man sits beside a fire, while a young man, with a fire at his head, draws a sword.

 Epigram: Whereas the aged man is cold, doubtful, wary, the young man is hot, sure, careless.
Whitney, p. 50.
 Motto: "Quaere adolescens, utere senex."
 Icon: A youth works in the fields while an aged man sits at a well-laden table inside.
 Epigram: While you are young, work hard; when you are old, let the young work, and enjoy what you have earned.

Ahasuenis
See: ASSUERUS.

AIR
See:
 ADAM SOWS EARTH
 Quarles, *Emb.*, p. 8.

AJAX
See:
 PROWESS
 Whitney, p. 30.

AJAX AND HECTOR
Whitney, p. 37.
 Motto: "Inimicorum dona, infausta."
 Icon: Ajax gives Hector a girdle; Hector gives Ajax a sword.
 Epigram: Beware the gifts of enemies. Ajax killed Hector with the sword Hector gave him and used the girdle he had given Hector to drag him through the field.

ALEXANDER
See:
 GORDIAN KNOT AND ALEXANDER
 P. S., p. 272.

ALMOND TREE
Peacham, p. 159.
 Motto: "Praecocia non diuturna."
 Icon: An almond tree in blossom.
 Epigram: The almond tree, early in spring, brings forth blossoms which quickly wither but bears fruit late. Likewise, some children blossom early, but their promise goes unfulfilled; others are plodders but eventually are productive.

ALMSGIVING
Whitney, p. 190.
 Motto: "Bis dat qui cito dat."
 Icon: A gentleman gives alms to a beggar.
 Epigram: When someone is in need, do not defer giving alms.

ALMSGIVING AND TRUMPET
Montenay, p. 390.
 Motto: "Ne tibiis canatur."

Icon: While a man blows a trumpet, he gives alms to a beggar.

Epigram: When one helps someone in distress, he should not call attention to himself.

Whitney, p. 224.

Motto: "Noli tuba canere Eleemosynam."

Icon: While a man blows a trumpet, he gives alms to a beggar.

Epigram: When a man makes his acts of charity public, he is motivated more by desire for recognition than by the spirit of giving.

ALTAR

See:

DEATH'S HEAD, HANDSHAKE, HEART

Wither, p. 99.

GOLDEN FLEECE

Astry, no. 39.

LAMB

Peacham, p. 130.

PRIAM

Peacham, p. 65 (misnumbered 95).

RIVER

Willet, no. 20.

WASHING HANDS

Wither, p. 41.

R. B., no. 33

ALTAR AND FLAME

Wither, p. 15.

Motto: "I pine, that others may not perish, And waste my Selfe, their Life to cherish."

Icon: Flames consume wood on an altar.

Epigram: As the flames consume the fuel on the altar, so thriftless children consume their parents' treasure, the commonwealth consumes the good statesman, and studies consume the scholar.

ALTAR AND HEART

Wither, p. 77.

Motto: "The Sacrifice, God loveth best, Are Broken-hearts, for Sin, opprest."

Icon: A heart burns on an altar.

Epigram: God despises insincere sacrifices; instead he looks for a humbled, troubled, contrite heart.

ALTAR AND LION

Peacham, p. 20.

Motto: "His servire."

Icon: A lion sleeps beside an altar on which a gauntlet holds a sword with a wreath.

Epigram: This emblem is dedicated to Henry Howard, earl of Northhampton; the lion, representing Northhampton, guards an altar, symbolizing piety, on which symbols of virtue are placed.

ALTAR AND SWORD

Godyere, no. 8 (misnumbered 12).

Motto: "Et Deo et patriae."

Icon: A gauntlet holds a sword on a burning altar.

Epigram: If you draw the sword of vengeance, let it be for the country and God; otherwise, you will lose all.

ALTAR, BALL, EAGLE, SNAKE

Wither, p. 101.

Motto: "He needs not feare, what spight can doe, Whom Vertue friends, and fortune, too."

Icon: An eagle stands on a winged ball on top of an altar, flanked by two snakes.

Epigram: The altar represents religion; the winged ball, the fickleness of "Outward-blessings"; the eagle, the contemplative man; the snakes, envy; together, these figures teach that the man who joins virtue and wealth will be secure from envy.

ALTAR, BALL, SPADE

Wither, p. 239.

Motto: "A Fortune is ordain'd for thee, According as they Labours bee."

Icon: A spade stands on a winged ball on top of an altar.

Epigram: The spade signifies labor; the winged ball, inconstant, worldly things; the altar, firmer things; together, they teach man to devote his work to serious rather than vain things.

ALTAR, BOOK, CUP, HELMET, MONEY

P. S., p. 371.

Motto: "Expetandae opes ut dignis largiamur."

Icon: A hand pours money from a cup onto a helmet and a book which lie on an altar.

Epigram: The altar represents worthiness; the helmet and book, arms and letters; the money, riches; the cup, liberality; together, these images signify that man should desire riches in order to give them to the worthy.

AMALTHEA

See:

PEACE

Thynne, no. 32.

Amor

See: CUPID.

ANCHISES

See:

AENEAS AND ANCHISES

Whitney, p. 163.

ANCHOR
Arwaker, bk. 2, no. 13.
 Motto: "But it is good for me to hold me fast by
 God, to put my trust in the Lord God."
 Icon: Divine Love carries a human figure who
 holds an anchor.
 Epigram: Man should forsake all others, and cling
 to God, who is his security.
Quarles, *Emb.*, p. 232.
 Motto: "It is good for me to draw neare to the
 Lord; I have put my trust in the Lord
 God."
 Icon: Divine Love carries a man on his back and
 bears an anchor on his shoulder; in the
 background are a storm at sea, a ship-
 wreck, and a siren.
 Epigram: Trust not the things of the world, for your
 hope is in God, who will save you.
P. S., p. 135.
 Motto: "Tutum te littore sistam."
 Icon: An anchor.
 Epigram: Christ is man's anchor, a safe refuge for
 man.
See also:
 FOUNTAIN
 Hall, p. 88.
 HEART AND SMOKE
 Wither, p. 39.
 HUSBANDMAN
 Wither, p. 106.
 R. B., no. 32.

ANCHOR AND DOLPHIN
P. S., p. 326.
 Motto: "Festina lente."
 Icon: An anchor and a dolphin.
 Epigram: The anchor and dolphin teach man to
 make haste slowly.
Wither, p. 72.
 Motto: "If Safely, thou desire to goe,
 Bee nor too swift, nor overflow."
 Icon: A dolphin intertwines an anchor.
 Epigram: The dolphin signifies speediness, the an-
 chor "grave-deliberation" or "staydnesse";
 united, they teach us how to proceed.

ANCHOR AND SHIP
Astry, no. 63.
 Motto: "Consule utrique."
 Icon: A ship is moored between two anchors,
 one at the helm, the other at the stern.
 Epigram: This anchored ship represents the prudent
 counsel, "duly weighed from the begin-
 ning to the end."

ANCHOR AND SPADE
Wither, p. 150.
R. B., no. 22.

 Motto: "Our Dayes, untill our Life hath end,
 In Labours, and in Hopes, wee spend."
 Icon: A woman holds an anchor and a spade.
 Epigram: The spade represents man's original sin
 and punishment of labor; the anchor,
 hope.

ANCHOR, BOOK, FRIAR
Wither, p. 73.
R. B., no. 43.
 Motto: "They that in Hope, and Silence, live,
 The best Contentment, may atchive."
 Icon: A friar holds an anchor and a book.
 Epigram: The friar's habit represents solitude and
 "retiredness"; the closed book, silence;
 anchor, hope; together, they represent
 contentment.

ANELLUS'S WIFE AND MILLER
Whitney, p. 80.
 Motto: "Praepostera fides."
 Icon: A woman embraces a man beside a mill.
 Epigram: Anellus believed that he was being cheated
 by the miller, so he sent his wife to view
 the grinding. She, however, cuckolded
 him. Anellus is an example of a fool too
 reckless and liberal with both his grain
 and his wife.

ANGEL
Peacham, p. 18.
 Motto: "E corpore pulchro Gratior."
 Icon: The bust of an angel.
 Epigram: Dedicated to Prince Charles, this device
 compares the prince's physical beauty to an
 angel and asks him to imitate the inner
 virtues of an angel.
Willet, no. 5.
 Motto: "Angelorum ministerium."
 Icon: None.
 Epigram: The physical characteristics of the angel
 express his power: three pairs of wings,
 four faces (man, lion, eagle, ox, repre-
 senting reason, strength, flight, movement
 on ground), hands of men (to do our
 work), and feet of a calf.
See also:
 CASTLE, CHRIST, HERETIC
 Godyere, no. 29.
 CHURCH
 Willet, no. 37.
 FALL
 Quarles, *Emb.*, p. 116.
 HEAVEN
 Hawkins, no. 8, p. 89.
 HORSEMAN, SEVEN-HEADED BEAST, SWORD
 Van der Noodt, no. 19.

SCREEN AND TAPER
Quarles, *Hier.*, no. 5.
TRUMPET
Hall, p. 108.
See also: CHERUB, DIVINE LOVE.

ANGEL AND HOUSE
Hawkins, no. 15, p. 172.
Motto: "Fiat lux."
Icon: An angel knocks at the door of a house.
Epigram: At the Annunciation the angel asks Mary to house Christ in her womb.

ANGEL, TRUMPET, WIND
Montenay, p. 426.
Motto: "Venite."
Icon: Four winds blow while an angel blows a trumpet.
Epigram: When the four winds appear and the angel sounds the trumpet, the Last Judgment will be at hand.

Angler
See: FISHERMAN.

ANIMAL
See:
CIRCE
Whitney, p. 82.
FEAR
Whitney, p. 52.
TABLET
Whitney, p. 100.
See also: APE, ASS, BEAR, BEAST, BEAVER, BOAR, BULL, CAMEL, CAT, COLT, CONY, DOG, ELEPHANT, FOX, GOAT, GREYHOUND, HARE, HART, HEDGEHOG, HIND, HOG, HORSE, HOUND, LAMB, LEOPARD, LION, MOLE, MONKEY, MOUSE, OX, PANTHER, PORCUPINE, RAM, RAT, RHINOCEROS, SHEEP, SMALL CREATURE, SOW, SPANIEL, SQUIRREL, STAG, WHELP, WOLF.

ANNUNCIATION
See:
ANGEL AND HOUSE
Hawkins, no. 15, p. 172.
CHAIN OF GOLD
P. S., p. 43.

ANT
See:
DILIGENCE AND IDLENESS
Combe, no. 100.
IDLENESS AND LABOR
Whitney, p. 175.
See also: PISMIRE.

ANT AND GRASSHOPPER
Whitney, p. 159.
Motto: "Dum aetatis ver agitur: consule brumae."
Icon: A grasshopper and ants in a winter landscape.
Epigram: When the grasshopper asks ants to feed him during the cold winter months, they refuse, pointing out that during the summer they worked hard storing food for the winter while he sang and danced.

ANT, CONY, GRASSHOPPER, SPIDER
Willet, no. 97.
Motto: "Bestiarum prudentia."
Icon: None.
Epigram: Though the ant, cony, spider, and grasshopper are small, they have some strength; man should learn from them.

ANTEBAT
Combe, no. 26.
Motto: "It is not good in peace or warre, To presse thine enemie too farre."
Icon: Soldiers with blindfolds over their eyes attack their enemy.
Epigram: The "antebats," who "with hooded eyes" turned on their enemies, teach men to beware of desperate men who do not fear death and will turn on fleeing soldiers.

ANTEROS, CUPID, PALM
Van Veen, p. 11.
Motto: "Contending encreaseth love."
Icon: Cupid and Anteros contend for the palm.
Epigram: When Cupid and Anteros contend for the palm, he who loves best wins the victory.

ANTICHRIST
See:
DRAGON WITH TEN HORNS
Willet, no. 22.
SEVEN-HEADED BEAST
Van der Noodt, no. 17.
WHORE OF BABYLON
Godyere, no. 21.
Montenay, p. 302.
Van der Noodt, no. 18.
See also: HORSEMAN, SWORD, WHORE OF BABYLON.

Anvil
See: STITH

ANVIL AND ARROW
Montenay, p. 86.
Motto: "Operam perdere."
Icon: A man shoots arrows at an anvil; the arrows break and fall.
Epigram: As the anvil repels and breaks the arrows shot at it, so God defends his Word and Church from his enemies.

ANVIL AND BLADE
Combe, no. 31.

Motto: "Men should beware and take great heed,
To hazard friends without great need."

Icon: A man strikes a blade against an anvil, breaking the blade.

Epigram: If a man strikes the anvil too forcefully with his blade, he risks breaking it; so a man who presses his friends too hard risks losing them.

ANVIL AND HAMMER
Wither, p. 17.
Motto: "Till God hath wrought us to his Will The Hammer we shall suffer still."

Icon: A hammer strikes an object on an anvil.

Epigram: Afflictions improve and refine man; therefore, the author asks that he may lie between God's anvil and hammer.

ANVIL AND KNIFE
P. S., p. 68.
Motto: "Non quam diu, sed quam bene."

Icon: A knife cuts an anvil.

Epigram: The "Philosophicall knife" was made so perfectly and carefully that it could cut an anvil; so, what matters is not how long something takes to accomplish, but how well it is accomplished.

ANVIL AND SWORD
Whitney, p. 192.
Motto: "Importunitas evitanda."

Icon: A man strikes his sword against an anvil and breaks it.

Epigram: The man who tries his sword against an anvil to prove the blade's strength hazards much; so too the man who tries his friends rather than loving and caring for them.

ANVIL, DIAMOND, SLEDGE
Wither, p. 171.
Motto: "True Vertue, firme, will always bide, By whatsoever suffrings tride."

Icon: A hand holding a sledge hammers a diamond on an anvil.

Epigram: Like the diamond which endures hammering, the virtuous man endures affliction, suffering, and trial.

ANVIL, HAMMER, HEART
Harvey, no. 8.
Motto: "Cordis Durities."

Icon: A devil holds a heart on an anvil while Divine Love hammers it.

Epigram: Man's heart is hard, and like an anvil is unmoved by the wrath of God.

APE
Combe, no. 47.

Motto: "The child procures his parents ruth, That is not chastis'd in his youth."

Icon: An ape embraces its baby.

Epigram: Like the ape which embraces its child so hard that it kills it, the parent who indulges his child harms him.

P. S., p. 282.
Motto: "Caecus amor prolis."

Icon: An ape hugs its child.

Epigram: Like the ape which loves its child so much that it hugs it to death, many parents hurt their children with excessive kindness.

Whitney, p. 145.
Motto: "In curiosos."

Icon: An ape sits beside a workman's tools; its foot is caught in stocks.

Epigram: The ape who tried to use the workman's tools and had its foot crushed teaches that no one should presume to use another's art.

Whitney, p. 188.
Motto: "Caecus amor prolis."

Icon: An ape hugs its child.

Epigram: As the ape hugs its baby so hard that it kills it, so parents who spoil their children harm them with foolish love.

Whitney, p. 190.
Motto: "Stultorum quanto status sublimior, tanto manifestior turpitudo."

Icon: Men watch an ape climbing high in a tree; another ape, crouching low at the base of a tree, goes unnoticed.

Epigram: If the fool is promoted, his folly becomes apparent and brings shame to those who supported him; when he is kept in low estate, his folly goes unnoticed.

See also:
GRAPEVINE
Peacham, p. 157.
See also: MONKEY.

APE AND ASS
Combe, no. 42.
Motto: "Simplicitie is of small price And Ev'n reputed for a vice."

Icon: Apes surround an ass.

Epigram: In court the simple man is like an ass among apes, overlooked by the proud.

APE AND DOG
Whitney, p. 58.
Motto: "Non dolo, sed vi."

Icon: An ape thrusts a dog's paws into a fire.

Epigram: Just as the ape who wanted chestnuts roasting in the fire thrust the dog into the fire to get the chestnuts for it, so kings, heartless in their ambition, force subjects to

undergo trial so that their desires are gratified.

APE AND FOX
Thynne, no. 62.
 Motto: "Prodigalitie."
 Icon: None.
 Epigram: Better to be profligate, like the fox, which has a bushy tail, than to be in want, like the ape, which has no tail to cover its hinder parts.
Whitney, p. 142.
 Motto: "In copia minor error."
 Icon: A fox looks at an ape in a tree.
 Epigram: A warning against mocking: the ape mocked the fox for its tail, but the fox derided the ape for having no tail to hide its "shameless partes."

APE AND MISER
Whitney, p. 169.
 Motto: "Male parta male dilabuntur."
 Icon: An ape sits at a window and throws out gold coins.
 Epigram: The story of a miser whose ape got loose, raided his hoard, and threw gold out to the people of the street illustrates the futility of hoarding money and the ultimate punishment of the miser.

APE AND TOY
Peacham, p. 168.
 Motto: "Vanae merces. In Naupalum."
 Icon: An ape plays with toys.
 Epigram: A satire on the "rich Naupalus" who acts as though his new-gotten wealth is as important as Jason's golden fleece.

APE AND USURER
P. S., p. 367.
 Motto: "Male parta, male dilabuntur."
 Icon: An ape throws money from a window.
 Epigram: The ape of a usurer threw its master's money out the window; this illustrates that "things evil got, are as evill spent."

APE, ASS, MOLE
Whitney, p. 93.
 Motto: "Infortunia nostra, alienis collata, leviora."
 Icon: An ass, an ape, and a mole converse.
 Epigram: The ass complained that it had no horns, the ape that it had no tail, the mole that it had no eyes; this teaches us to be content with our lot.

Aphrodite
See: VENUS.

APODES AND WANDERER
Whitney, p. 89.
 Motto: "Vita irrequieta."
 Icon: A footless bird flies over a village as a man, carrying a basket, walks past the village.
 Epigram: The apodes is a footless creature which flies about without rest; it is like the homeless wanderer who passes towns but has no place to go.

APOLLO
See:
 MIDAS
 Whitney, p. 218.
See also: PHOEBUS.

APOLLO AND BACCHUS
Whitney, p. 146.
 Motto: "In inventam."
 Icon: Apollo with his harp and Bacchus with grapes stand on a pedestal.
 Epigram: These two sons of love offer men health and happiness.

APOLLO AND HARP
Wither, p. 234.
 Motto: "Apollo shoots not ev'ry day, But, sometime on his Harpe doth play."
 Icon: Apollo plays a harp; his bow and arrow are laid aside.
 Epigram: There is a time for play as well as for work.

APOLLO, JOVE, MINERVA
Godyere, no. 26.
 Motto: Jovis Apollinis et Minervae.
 Icon: Jove, Apollo, and Minerva stand in an amphitheater.
 Epigram: Jove represents providence; Minerva, wit; Apollo, contentment.

APOSTLE
See:
 CASTLE, CHRIST, HERETIC
 Godyere, no. 29.

APPARITION
See:
 FEAR OF APPARITIONS
 Bunyan, no. 65.

APPLE
Thynne, no. 24.
 Motto: "Internall vertues are best."
 Icon: None.
 Epigram: Although the apple has an attractive exterior, its value—its fruit—is beneath the skin; likewise man's appearance is less important than the inward mind.

See also:
RACE
Ayers, no. 39.

APPLE AND FLOWER
Arwaker, bk. 3, no. 2.
 Motto: "Stay me with flagons, comfort me with apples, for I am sick with love."
 Icon: A sickly, reclining figure is attended by a woman who gives her flowers and apples.
 Epigram: Nature's beauties cannot cure the man sick of love of God.
Quarles, *Emb.*, p. 248.
 Motto: "Stay me with Flowers; Comfort me with Apples, for I am sick of love."
 Icon: Maids bring flowers and apples to a reclining person.
 Epigram: The soul, sick with love for God, desires flowers (faith) and fruit (good works).

APPLE OF HESPERIDES
P. S., p. 67.
 Motto: "Ab insomni non custodita Dracone."
 Icon: The golden apples of Hesperides.
 Epigram: The apple of Hesperides which the dragon watched over and Hercules stole signifies that virtues and exploits are to be found everywhere.

See also:
HERCULES
Peacham, p. 36.

APPLE TREE
Bunyan, no. 26.
 Motto: "Upon the promising Fruitfulness of a Tree."
 Icon: None.
 Epigram: The apple tree is an emblem of those whom God plants: its blasted blossoms are motions unto good chilled by affection; its blasted apples are good purposes which bear no fruit; its worm-ridden apples are good attempts ruined by bad thoughts; its wind-blown apples are good works spoiled by trial.
E. M., no. 5.
 Motto: "Dum detrahis, erigis, auges."
 Icon: An apple tree (which is drawn as a banana tree).
 Epigram: The apple tree, which has leaves used as mattresses and quilts, represents the merciful man, who gives to the needy.

ARCH
See:
TRIUMPHAL ARCH
Van der Noodt, no. 9.

ARCHER
Jenner, no. 14.
 Motto: "The way to please God in all our actions."
 Icon: An archer aims at his target.
 Epigram: As the archer aims at his target with one eye, so the man who will serve God must shut his eye to riches, praise, and worldly honor.
Wither, p. 25.
 Motto: "Oft Shooting, doth nor Archers make; But, hitting right the Marke they take."
 Icon: An archer aims at a target.
 Epigram: We care not how many arrows the archer shoots but how closely he hits the mark; likewise God is concerned not with how many times we say our devotions but with how well meant they are.

ARCHIMEDES
Whitney, p. 208.
 Motto: "Tunc tua res agitur, paries cum proximus ardet."
 Icon: Archimedes plays chess while his home burns.
 Epigram: Do not hesitate to act when danger threatens; it is madness to play games when a house is on fire.

Ardor
See: ZEAL.

Ares
See: MARS.

ARGO
Peacham, p. 54.
 Motto: "In actione consistit."
 Icon: The ship *Argo* at sea.
 Epigram: Just as the *Argo* risked great danger to win the golden fleece, so man should endure pain, avoid sloth, and act.

ARGUS AND CUPID
Van Veen, p. 239.
 Motto: "Love exceeds in subtiltie."
 Icon: Cupid plays on a pipe, puts Argus to sleep.
 Epigram: Although Argus has a hundred eyes, Cupid can deceive him.

ARION
Wither, p. 10.
R. B., no. 39.
 Motto: "An Innocent no Danger feares, How great soever it appeares."
 Icon: Arion stands on a dolphin and plays a viola.
 Epigram: The story of Arion playing music and

being saved by a dolphin illustrates that innocence fears no danger.

ARION AND DOLPHIN
Whitney, p. 144.
 Motto: "Homo homini lupus."
 Icon: Arion is thrown overboard; a dolphin watches, then saves him.
 Epigram: Arion was mistreated by the seaman but saved by a dolphin; this illustrates how man is the worst enemy of man.

ARK
See:
 NOAH'S ARK
 Willet, no. 18.
 SIEVE
 Quarles, Emb., p. 88.

ARK OF THE COVENANT
Willet, no. 48.
 Motto: "Ne discedas a statione."
 Icon: None.
 Epigram: The biblical story of the king bringing home the ark, the Levites preparing a way, and Uzzah being punished for touching it teaches that we should do our work cheerfully and not do what God has forbidden.

See also:
 LEVITES
 Willet, no. 60.

ARK OF THE COVENANT AND DAGON
Willet, no. 61.
 Motto: "Religio misturam non patitur."
 Icon: None.
 Epigram: The ark stands beside a maimed statue of Dagon: pagan rites cannot coexist with true religion.

ARM
See:
 WORLD IN ARMS
 Quarles, Emb., p. 68.

ARMED HAND AND SWORD
P. S., p. 333.
 Motto: "Without deceit or guile."
 Icon: An armed hand bears a sword.
 Epigram: This device signifies the high constable who is trusty and faithful to the king.

ARMILLARY SPHERE
See:
 COIN
 Quarles, Emb., p. 80.
 HEAVEN
 Hawkins, no. 8, p. 89.

INNOCENCE AND LEARNING
Hall, p. 28.
 SHIP
 Hawkins, no. 21, p. 253.
 WORLD

ARMOR
Ayres, no. 32.
 Motto: "Ther's no Defence against love."
 Icon: Cupid shoots arrows at armor.
 Epigram: No armor can protect man from wounds of love.
Willet, no. 56.
 Motto: "In Ostentatores."
 Icon: None.
 Epigram: As David had no need of Saul's armor, so virtue needs no protection; the hypocrite, however, hides behind false show.

See also:
 PALLAS
 Thynne, no. 51.

ARMOR AND CUPID
Van Veen, p. 23.
 Motto: "Nothing resisteth love."
 Icon: Cupid shoots darts at armor.
 Epigram: Iron and steel cannot shield man from the force of love.

ARMS
See:
 KING WITH SIX ARMS
 Wither, p. 179.
 R. B., no. 15.

ARMS FOLDED
See:
 PHLEGM
 Peacham, p. 129.
 SLOTHFUL MAN
 Willet, no. 65.

ARMS OUTSTRETCHED
See also:
 LEARNING
 Peacham, p. 26.

ARMY
See also:
 HORSEMAN, SEVEN-HEADED BEAST, SWORD
 Van der Noodt, no. 19.
 SERPENT
 Whitney, p. 189.

ARROW
Arwaker, bk. 1, frontispiece.
 Motto: "Lord thou knowest all my desire, and my groaning is not hid from thee."

Icon: A man sits with a bow in his lap; an arrow pierces his breast; beside him is a mask; above, three arrows point to two ears and an eye in the sky.

Epigram: Man confides his secret love, desire, and grief only to God.

Astry, no. 60.

Motto: "O subir o baiar."

Icon: An arrow points upward.

Epigram: As an arrow shot from a bow either rises or falls, so a government either increases in grandeur or diminishes.

Ayres, no. 8.

Motto: "Be quick & sure."

Icon: Cupid holds an arrow to his breast.

Epigram: The lover should be active and receive what Cupid sends.

Ayres, no. 19.

Motto: The Heart, Loves Butt.

Icon: Cupid shoots an arrow at a man's breast.

Epigram: Love wounds.

See also:

ANVIL AND ARROW
Montenay, p. 86.

ARMOR
Ayres, no. 32.

BOY AND TYRANT
Montenay, p. 134.

BUCKLER AND WORLD
Montenay, p. 362.

CUPID
Wither, p. 227.
R. B., no. 34.

CUPID AND TORCH
Van Veen, p. 191.

DEATH AND TIME
Quarles, *Hier.*, no. 6

HEART AND SMOKE
Wither, p. 39.

HEART PIERCED BY ARROW
Ayres, no. 15.

HIND
Peacham, p. 4.

LUNA
Godyere, no. 32.

SHEAF OF ARROWS
Wither, p. 177.

SHIELD
Peacham, p. 166.

SUN AND WIND
Van Veen, p. 125.

See also: DART, SHAFT, SPEAR.

ARROW AND BIRD
P. S., p. 41.

Motto: "Dederitne viam casusue, Deusue."

Icon: Three birds are pierced by an arrow.

Epigram: An emblem of the dukes of Lorraine, the arrow piercing three birds represents authority and princely dignity.

ARROW AND BOW
See:

PROCRIS
Whitney, p. 211.

ARROW AND ECHENEIS
Whitney, p. 188.

Motto: "Maturandum."

Icon: An echeneis (the remora, or sucking fish) winds around an arrow.

Epigram: The slow-moving echeneis entwining the swift-moving arrow warns us to haste no more than reason allows.

ARROW AND EYE
Van Veen, p. 151.

Motto: "Lookes are loves arrowes."

Icon: Arrows from a lady's eyes pierce the heart of a man.

Epigram: Each glance of the beloved is like an arrow wounding the lover.

ARROW AND HART
Wither, p. 214.

Motto: "When woe is in our selves begun, Then, whither from it, can wee run?"

Icon: An arrow pierces the side of a hart.

Epigram: Like the hart which, pierced by an arrow, futilely tries to flee its pain, man cannot escape sin, which is part of his human condition.

ARROW AND HEART
H. A., p. 214.

Motto: "Jesus wounds and pierced the hart with shafts of love."

Icon: Jesus shoots arrows into a heart.

Epigram: The wounds Jesus makes cleanse the heart of sin.

Hall, p. 52.

Motto: "I will pierce heaven with my mind, and be present with thee in my desires."

Icon: Divine Love shoots and pierces a winged heart on fire with an arrow as a heart flies heavenward.

Epigram: Man, inflamed with the love of God, mounts to heaven.

ARROW AND MARBLE
Whitney, p. 138.

Motto: "Calumniam contra calumniatorem virtus repellit."

Icon: An arrow breaks against a marble block.

Epigram: Just as an arrow cannot pierce marble but

instead rebounds to the person who shoots it, so slander does not harm the virtuous but reflects on the slanderer.

ARROW AND SEA
Whitney, p. 72.
 Motto: "Virtus unita, valet."
 Icon: Calm water is siphoned from the sea, and arrows tied together lie on a bank.
 Epigram: Both the sea and the bundle of arrows are emblems of concord: united, they are mighty; separated, they have no force.

ARROW AND SERPENT
P. S., p. 240.
 Motto: "Vis nescia vinci."
 Icon: A serpent intertwines arrows.
 Epigram: As arrows joined together cannot by force be broken, so countries in league together are invincible.

ARROW AND SNAKE
Wither, p. 220.
 Motto: "Invincibilitie is there, Where Order, Strength, and Union are."
 Icon: A snake intertwines six interwoven arrows.
 Epigram: The snake and "well-order'd" arrows express the strength resulting from prudence combined with discipline.

ARROW AND STAR
P. S., p. 108.
 Motto: "Vias tuas domine demonstra mihi."
 Icon: A star is encircled by arrows.
 Epigram: The star encircled by arrows represents the need for God's direction.

ARROW AND STONE
P. S., p. 203.
 Motto: "Infringit solido."
 Icon: An arrow shot into a stone rebounds.
 Epigram: An arrow shot into a stone rebounds to hurt the man that shot it; likewise, the man who slanders the godly hurts himself.

ARROW AND TREE
Peacham, p. 16.
 Motto: "Unita valebunt."
 Icon: A sheaf of arrows is tied to the trunk of a tree.
 Epigram: Dedicated to Philip of Spain, this device symbolizes Fernando's victory over the Moors.

ARROW, BOW, TAPER
Quarles, *Hier.*, no. 11.
 Motto: "Iam ruit in Venerem."
 Icon: A taper in an urn with the roman numeral 30 in the top of five segments; on one side,

a goat; below, a bow and arrows and a dead tree entwined by a grapevine.
 Epigram: In the third decade of life man, halfway between birth and death, is given to love, desire, pleasure.

ARROW, DEATH, PRAYING MAN
P. S., p. 364.
 Motto: "Improbus a nullo flectitur obsequio."
 Icon: Death holds an arrow at the breast of a praying man.
 Epigram: The image of Death slaying a praying man signifies the wicked men who show no compassion to men who petition them.

ARROW, DICTANUS, HART
P. S., p. 354.
 Motto: "Esto tienne su remedio, y non yo."
 Icon: A hart, pierced by an arrow, eats the herb dictanus.
 Epigram: Although the hart can cure its wound with dictanus, the heart wounded by love is incurable.

ARROW, HAIR, OLIVE TREE
Willet, no. 4.
 Motto: "Generosa soboles."
 Icon: None.
 Epigram: Dedicated to the children of Rutland and Bedford, this poem cites three "marks" of the family: the arrow, the locks of hair, and the olive tree.

Artemis
See: CYNTHIA, DIANA, LUNA.

Artist
See: PAINTER.

ARTS
See:
 MARS AND MERCURY
 Godyere, no. 14 (misnumbered 13).

Ascending
See: RISING.

ASS
Combe, no. 95.
 Motto: "When thou for ayd to God dost pray, To helpe thyselfe thou must assay."
 Icon: An ass carrying a load lies on the ground, while his owner spreads his arms in dismay.
 Epigram: When your ass falls into the mire, pray to God for help, but also try to help yourself.
Whitney, p. 8.
 Motto: "Non tibi, sed Religioni."
 Icon: An ass bears a statue of Isis through the streets; people kneel to worship it.
 Epigram: Let pastors of the church beware of being

like the ass which bore the statue of Isis through the streets of Egypt; it grew arrogant and foolish because it thought that people bowed to it, not to the statue.

Whitney, p. 18.

Motto: "In avaros."

Icon: An ass, loaded with food and goods, eats a thistle.

Epigram: This ass is like the miser; it is so enthralled with its treasures that it refuses to use them; instead it feeds on the unsatisfying thistle.

See also:

APE AND ASS
Combe, no. 42.

APE, ASS, MOLE
Whitney, p. 93.

JAWBONE OF ASS AND WATER
P. S., p. 234.

SAGE
Whitney, p. 130.

ASS AND CUPID
Combe, no. 62.

Motto: "Where Cupid list to play the knave,
He makes the Asse to brag & brae."

Icon: An ass dances while Cupid plays a lute.

Epigram: Love has the power to make the clown a courtier.

ASS AND DOG
Combe, no. 46.

Motto: "The learned live but poore and bare,
When fooles be rich and better fare."

Icon: Man gives an ass a bone, a dog hay.

Epigram: The disorder created when the dog is given hay and the ass a bone resembles the disorder of today, when fools are rich and the wise poor.

ASS AND OCNUS
Whitney, p. 48.

Motto: "Labor irritus."

Icon: Ocnus makes a rope out of rushes and grass; an ass eats the rope.

Epigram: As the ass ruins what Ocnus worked so hard to make, so a wicked, wasteful wife spends what her husband toils to make.

ASS AND PILLOW
Combe, no. 13.

Motto: "Unhappie be some that be wise,
And fooles sometime to honor rise."

Icon: An ass stands on pillows.

Epigram: Like the pampered asses in Thessaly, fools sometimes fare better than wise men.

ASS AND STAG
Quarles, *Emb*., p. 52.

Motto: "Da mihi froena timor; Da mihi calcar amor."

Icon: A man rides a plodding ass up a steep hill toward heaven, behind a snail; another man rides a stag, beating it with a scourge, toward the world.

Epigram: Man is dull and sluggish in his devotion to God but swift and desirous in his pursuit of worldly pleasure.

ASS, CUPID, WING
Van Veen, p. 115.

Motto: "Love altreth nature."

Icon: Cupid puts wings on an ass.

Epigram: Love has the power to change nature, making the dull witty and the slow quick.

ASS, FOX, LION
Whitney, p. 154.

Motto: "Aliena pericula, cautiones nostrae."

Icon: A lion, an ass, and a fox stand beside the carcasses of their prey.

Epigram: After the lion attacked the ass for dividing equally the spoils of the hunt among the lion, fox, and ass, the fox gave all the best meat to the lion, demonstrating the value of learning from others' misfortunes.

ASSUERUS AND ESTHER
Quarles, *Emb*., p. 204.

Motto: "If I have found favour in thy sight, let my life be given me at my petition."

Icon: King Assuerus, in the image of Divine Love, reaches toward a kneeling Esther, who holds a paper.

Epigram: God is like King Assuerus; the regenerate soul is like the weeping Esther, whom Assuerus wed.

ASTRAEA
See:

DEVIL
Quarles, *Emb*., p. 60.

ASTRONOMER
See:

STAR
Wither, p. 251.

ASTRONOMER AND PLOWMAN
Whitney, p. 9.

Motto: "Experientia docet."

Icon: A plowman with a harrow faces an astronomer; a prince on a horse observes them.

Epigram: A prince found the weather predictions of a plowman more accurate than those of a learned astronomer; he commanded them to exchange instruments and announced that experience was superior to learning.

ASTRONOMER AND WELL
Whitney, p. 157.
 Motto: "In eos, qui, proximioribus spretis, re-
 motiora sequuntur."
 Icon: An astronomer gazes on stars and falls into
 a well.
 Epigram: An art that foretells future perils but can-
 not see near dangers is foolish.

ATALANTA
See:
 RACE
 Ayres, no. 39.

Athena
See: MINERVA, PALLAS.

ATTILIUS
Whitney, p. 114.
 Motto: "Regulus Attilius: Hosti etiam servanda
 fides."
 Icon: Attilius, a prisoner, his hands and feet
 bound, lies beside a barrel spiked with
 nails.
 Epigram: Attilius, taken prisoner, refused to be ran-
 somed because so many enemy prisoners
 would be set free in exchange for his re-
 lease; his terrible suffering in captivity did
 not subdue him, and he serves as an ex-
 ample of a man who loved his country
 better than himself.

AVARICE
See:
 NET
 Peacham, p. 197.
See also: COVETOUSNESS AND ENVY.

AVARICE AND CUPID
Van Veen, p. 205.
 Motto: "Love causeth liberalitie."
 Icon: Cupid pulls a purse from Avarice.
 Epigram: Love makes even the greedy liberal.

AWL AND EAR
P. S., p. 164.
 Motto: "Servuitus libera."
 Icon: An awl bores an ear.
 Epigram: After a period of bondage, a servant
 could, according to Mosaic law, choose ei-
 ther liberty or "free-will service," and, if
 he chose the latter, his master bored his ear
 with an awl; every Christian man should
 choose "free-will service" to God, volun-
 tarily vowing obedience.

AX
Willet, no. 26.
 Motto: "Deo minanti obviam eundum."
 Icon: None.

 Epigram: As the ax is not used on the tree except
 when wood is to be hewed, so God does not
 threaten except when he sits in judgment.
See also:
 BIRTH OF PALLAS
 Peacham, p. 188.
 CHAIN AND POLEAX
 P. S., p. 71.
 CHOPPING OAK
 Wither, p. 29.
 R. B., no. 40.

AX AND OAK
Ayres, no. 35.
 Motto: "Persevere."
 Icon: Cupid raises an ax to chop a tree.
 Epigram: Just as the oak will yield to the repeated
 blows of an axe, so a hardhearted woman
 will yield to the lover who perseveres.

AX AND WOODSMAN
Whitney, p. 228.
 Motto: "Soli Deo gloria."
 Icon: A woodsman cuts down a tree with an ax.
 Epigram: Just as the ax is impotent without the
 woodsman, so man can do nothing without
 God.

AX, CUPID, TREE
Van Veen, p. 211.
 Motto: "By continuance."
 Icon: Cupid chops a tree with an ax.
 Epigram: Many strokes of the ax fell the great tree;
 likewise, the lover's continual pursuit gains
 the mistress.

B

BABE
See:
 BEARDED MAN AND POT
 Van der Noodt, no. 12.
See also: BABY, CHILD, INFANT.

BABY
See:
 AGED MAN AND BABY
 Whitney, p. 167.
See also: BABE, CHILD, INFANT.

BABYLON
See:
 TOWER OF BABYLON
 Montenay, p. 122.

BACCHUS
Peacham, p. 96.
 Motto: "Vini, vis."

Icon: Naked Bacchus, lying beside grapes and a wine cup, holds a caduceus.

Epigram: When wine intoxicates the fool, he thinks he is wise and believes he is eloquent.

Peacham, p. 191.
Motto: "Vini natura."
Icon: Bacchus sits on a barrel of wine, holds a cup and grapes, and has wings on his head; beside him Pegasus leaps.
Epigram: Wings and Pegasus befit Bacchus because he invigorates.

Whitney, p. 187.
Motto: "In statuam Bacchi."
Icon: Bacchus—naked, vine leaves in hair—plays a pipe and beats a drum; a wine cup and grapevines surround him.
Epigram: Wine transforms a man into a beast.

See also:
APOLLO AND BACCHUS
Whitney, p. 146.
CROCODILE AND DOG
Whitney, p. 225.
CUPID AND VENUS
Peacham, p. 174.
NET
Combe, no. 2.

BACCHUS AND LION SKIN
Combe, no. 48.
Motto: "Disguised things may seeme most strange,
 But nature seeld is seene to change."
Icon: Bacchus with a flagon and a bowl wears a lion skin and holds the club of Hercules.
Epigram: Just as Bacchus cannot disguise himself by wearing Hercules' lion skin, so a fool cannot pose successfully as a wise man.

BACCHUS AND PEGASUS
Thynne, no. 15.
Motto: "Wine."
Icon: None.
Epigram: Bacchus has wings on his head and is accompanied by Pegasus, because wine raises up dull minds and lends force.

Bag
See: SACK.

BAGPIPE
P. S., p. 224.
Motto: "Attendite vobis."
Icon: Bagpipe.
Epigram: To establish and preserve the Christian religion, ministers must diligently preach the Word of God.

BAKER
Willet, no. 10.
Motto: "Principis incuria."
Icon: None.
Epigram: When the baker sleeps, the pastries are ruined; so it is when a prince fails to look after his country.

BALANCE
Astry, no. 81.
Motto: "Quid valeant vires."
Icon: A shield and a sword are weighed on a balance.
Epigram: Because the forces of all powers are limited, the prince should weigh what his sword is able to strike and his shield to defend.

Combe, no. 10.
Motto: "Use justice still with due regard,
 Respect no person nor reward."
Icon: A man weighs objects with a balance.
Epigram: Justice must be free from bribes, favoritism.

Combe, no. 14.
Motto: "In friends this difference sole is hyde,
 True friends stand fast, the faine slide."
Icon: A woman holds a balance.
Epigram: The lightest feather outweighs false faith, but a true friend is constant.

Montenay, p. 306.
Motto: "Ex fide victurus est."
Icon: A man stands with one foot in the scale of an even balance and the other foot in the scale of a balance tipped toward him.
Epigram: Belief in God and Christ will gain man victory over death.

Peacham, p. 44.
Motto: "Quae pondere major."
Icon: A pen and a bay wreath outweigh a cannon on a balance.
Epigram: Although military might is important, learning outweighs might.

P. S., p. 343 (misnumbered 243).
Motto: "Statere ardo non transiliendus."
Icon: A man holds a balance which breaks.
Epigram: Men of evil conscience are like a pair of balances, which, when overloaded, break.

See also:
JUDGE AND JUSTICE
Arwaker, bk. 1, no. 10.
Quarles, *Emb.*, p. 160.
LION
Godyere, no. 2.
SAGE
Whitney, p. 130.

SIEVE
Quarles, *Emb.*, p. 88.
See also: SCALE.

BALANCE AND BUBBLE
Quarles, *Emb.*, p. 16.
Motto: "Quis levior? cui plus ponderis addit amor."
Icon: Divine Love holds a balance; Cupid loads one side with weights, but the other side, into which a human figure blows a bubble, is heavier.
Epigram: The whole world is lighter and more trivial than a bubble.

BALANCE, HEART, LAW
Harvey, no. 20.
Motto: "Cordis Ponderatio."
Icon: Divine Love holds a balance on which law outweighs a heart.
Epigram: If brought to trial, the human heart would not be equal to the law.

BALD
See:
FORTUNE
Wither, p. 174.
OCCASION
Combe, no. 63.
R. B., no. 41.
Whitney, p. 181.
Wither, p. 184.

BALL
P. S., p. 295.
Motto: "Concussus surgo."
Icon: A ball.
Epigram: The ball signifies the man who, when shaken, rises.
Wither, p. 16.
Motto: "When to suppresse us, Men intend, They make us higher to ascend."
Icon: Men toss balls in the air.
Epigram: Man is like a ball, tossed to and fro by the world; when we are thrown down, we rebound higher.
See also:
ALTAR, BALL, EAGLE, SNAKE
Wither, p. 101.
ALTAR, BALL, SPADE
Wither, p. 239.
ETERNITY
Peacham, p. 141.
FOOTBALL
Peacham, p. 81.
FORTUNE
Thynne, no. 7.

Wither, p. 174.
FORTUNE AND MERCURY
Thynne, no. 5.
WOMAN
Wither, p. 7.
R. B., no. 16.
See also: GLOBE, SPHERE.

BALL AND WOMAN
Wither, p. 231.
Motto: "No Emblem, can at full declare, How fickle, minds-unconstant are."
Icon: A woman stands on a winged ball and holds feathers.
Epigram: The woman signifies the inconstant mind, given to giddiness and fickleness; the winged ball signifies vain, temporal things; the feather, the mind that wavers.

BALL, GRIFFIN, STONE
Wither, p. 139.
Motto: "Good Fortune will with him abide, That hath true Vertue, for his guide."
Icon: A griffin stands on a stone, above a winged ball.
Epigram: The griffin signifies virtue; the stone, the solidity of virtue; the winged ball, good fortune which accompanies the virtuous man.

BALL, KEY, TURF, SHILLING
P. S., p. 307.
Motto: "Num status telluris honor."
Icon: Shillings surround a key to which a ball and a piece of turf are tied.
Epigram: Signs of good luck, these things were given to magistrates: the turf to keep down the price of food, the key to preserve liberty, and the ball to represent authority.

BALL, LAUREL, SNAKE, SWORD
Wither, p. 109.
Motto: "Though Fortune, hath a powerfull Name Yet, Vertue overcomes the same."
Icon: A winged ball is encircled by a snake and topped by a laurel and a sword.
Epigram: Prudence, represented by the snake, makes conquest, represented by the laurel and the sword, over fortune, represented by the winged ball.

BALM
See:
SWINE
Combe, no. 17.

BALSAM
Willet, no. 77.

Motto: "De Balsamo."
Icon: None.
Epigram: As precious balsam cures the body, so
 God's word comforts the heart.

BANANA TREE
See:
 APPLE TREE
 E. M., no. 5.

BAND OVER MOUTH
See:
 MELANCHOLY
 Peacham, p. 126.

Banner
See: ENSIGN, FLAG.

BANQUET
See:
 GLORY
 Whitney, p. 42.

BAR AND ICE
Jenner, no. 5.
 Motto: "The course to keepe a continuall *soft
 heart*."
 Icon: A man uses a bar to break up ice.
 Epigram: As men continually break up the ice with
 heavy bars so that their animals can have
 water, so the good Christian should con-
 tinually soften his heart with prayers and
 meditations.

BARE FEET
Willet, no. 42.
 Motto: "Non visitur Deus sine mentis lumine."
 Icon: None.
 Epigram: As Moses cast off his shoes when he came
 to the holy place to hear God, so man
 should prepare his mind for prayer.

BARREL
Wither, p. 246.
 Motto: "The Tongue, which every secret speakes,
 Is like a Barrell full of leakes."
 Icon: A barrel, full of holes, leaks liquid.
 Epigram: The leaking barrel signifies the man who
 utters everything he knows, the tattler.
See also:
 CANDLE
 Ayres, no. 11.
 CODRUS, DIOGENES, KING
 Whitney, p. 198.
 HANDSHAKE
 Peacham, p. 135.
 HOGSHEAD
 P. S., p. 186.
See also: HOGSHEAD, TUN.

BARREL, FIRE, HOLE
Van Veen, p. 145.
 Motto: "Love will appear."
 Icon: Cupid hides a burning torch under a
 barrel; its light shines through a hole.
 Epigram: The fire of love cannot be hidden.

BARREN TREE
Bunyan, no. 33.
 Motto: "Upon the barren fig-tree in God's Vine-
 yard."
 Icon: None.
 Epigram: The barren fig tree, which bears no fruit
 despite cultivation, is like the man who
 fails to glorify God with good works de-
 spite God's concern; both face destruction.

BASIN
See:
 MARBLE
 Whitney, p. 136.

BASKET
See:
 BRANCH
 Astry, no. 54.

BATH
Thynne, no. 43.
 Motto: "Art cannot take awaye the vice of nature."
 Icon: None.
 Epigram: As the bath can never make the Negro
 white or the harlot pure, so art cannot
 change nature.

BAUBLE
See:
 FOOL AND HEART
 Harvey, no. 4.

See also: TOY.

BAUBLE AND FOOL
Arwaker, bk. 1, no. 2.
 Motto: "O, God, thou knowest my simplicity, and
 my faults are not hid from thee."
 Icon: A fool plays with baubles while Divine
 Love covers his eyes and points to heaven.
 Epigram: Because of Original Sin man is prone to
 folly.
Quarles, *Emb.*, p. 132.
 Motto: "O Lord, thou knowest my Foolishnesse,
 and my Sins are not hid from thee."
 Icon: A fool with baubles looks at Divine Love,
 who covers his eyes and points to heaven.
 Epigram: Man is like the fool with his baubles;
 he rejects heaven for trifles like honor,
 pleasure.

BAY
See:

FIXED HEAD
Wither, p. 145.
See also: LAUREL.

BAY LEAVES AND SWORD
Peacham, p. 43.
Motto: "Proemio et poena."
Icon: Bay leaves entwine a sword.
Epigram: Bay leaves represent reward for learning and renown; a sword of justice represents punishment for base and cowardly acts.

BAY TREE, LYRE, TAPER
Quarles, *Hier.*, no. 12.
Motto: "Ut Sol ardore virili."
Icon: A taper in an urn with a roman numeral 40 in the top of four segments; on one side, a swine; below, two bay trees and a lyre.
Epigram: In the fourth decade of life a man is in his prime; he will either create great art or realize that he is incapable of such creation; indulgence will threaten his accomplishments.

BAY WREATH
See:

BALANCE
Peacham, p. 44.

BAY WREATH, OLIVE BRANCH, SWORD
Wither, p. 241.
Motto: "For whatsoever, Man doth strive,
 The Conquest, God alone, doth give."
Icon: Olive branches flank a sword beneath a bay wreath.
Epigram: When war has a peaceful end, the victory comes from God.

BEACON
See:

COCK
Peacham, p. 139.

BEACON AND MARINER
Jenner, no. 8.
Motto: "The use of the failings of God's Children."
Icon: A man in a ship steers clear of beacons.
Epigram: As the mariner knows to shun beacons marking hazards, so the Christian knows to avoid the failings and sins of God's children described in Scripture.

BEAR
Ayres, no. 5.
Motto: "By Little & Little."

Icon: A bear licks its young while Cupid watches.
Epigram: As the bear patiently shapes her young, so man may patiently woo his love.
Combe, no. 98.
Motto: "Who so to studie doth incline,
 The hardest wit it shall refine."
Icon: A bear licks its young into shape.
Epigram: As the mother bear molds her mishapen whelp into form, so study and discipline refine children's wit.
P. S., p. 96.
Motto: "Horrent conunota moveri."
Icon: A bear with smoke coming from its mouth.
Epigram: As the fierce bear should not be provoked, so the angry man should not be incensed.
Van Veen, p. 57.
Motto: "Love is wroght with tyme."
Icon: A bear licks its cub while Cupid watches.
Epigram: As the mother bear licks her cub into shape, so love is fashioned from an unformed thing.

See also:

BEAST
Willet, no. 30.

FRIEND
Peacham, p. 148.

SHEAF OF ARROWS
Wither, p. 177.

See also: CUB.

BEAR AND BEE
Wither, p. 23.
Motto: "By Paine, on Pleasures we doe seize;
 And, we by Suff'rance, purchase Ease."
Icon: Bees swarm around a bear climbing a tree toward their hive.
Epigram: Like the bear which, in its desire for honey, climbs among stinging bees and robs them, the sensual man, in his lust, takes great risks.

BEAR AND LION
Willet, no. 17.
Motto: "Fugientes afflictio sequitur."
Icon: None.
Epigram: As the old man who passes a lion and then meets a bear, so a man who misses one trouble and is unthankful will soon confront more troubles.

BEARD
See:

AESCULAPIUS
Whitney, p. 212.

BEARDED MAN AND POT
Van der Noodt, no. 12.
 Motto: None.
 Icon: An ugly, bearded man overturns a pot of water, holds an olive and a palm, and wears a laurel; beside him a wolf suckles babies.
 Epigram: The bearded man represents the Roman Catholic church, which governs ancient Rome, corrupting it. Under its tyranny peace and honor are destroyed.

BEAST
Willet, no. 30.
 Motto: "Quatuor monarchiae."
 Icon: None.
 Epigram: Four beasts represent four powerful nations: the lioness with wings, the Assyrians; the bear with three bones in its teeth, the Persians; the leopard with four wings, the Greeks; the beast with iron teeth and ten horns, the Italians.
See also: ANIMAL, SEVEN-HEADED BEAST.

BEAST AND DART
P. S., p. 218.
 Motto: "Aemula naturae."
 Icon: Two darts seem like horns on a beast's head.
 Epigram: Diligence and practice can enable man to match nature, as Domitianus demonstrated when he threw darts at a beast, making them appear like natural horns.

BEAST AND SWORD
P. S., p. 280.
 Motto: "Sic sopor irrepat."
 Icon: A beast crawls on a sword.
 Epigram: A king discovered gold when a small beast climbed out of his mouth while he slept and crossed a river on a servant's sword.

BEAST AND TRUMPET
Montenay, p. 110.
 Motto: "Cane."
 Icon: A king sits on a throne and beckons to a man with a beast's head who holds a trumpet.
 Epigram: If a king does not govern his country well, and his subjects do not excel in learning, then they are like this beast, which has a trumpet but cannot play.

BEATING
Whitney, p. 112.
 Motto: "Habet, & bellum suas leges."
 Icon: A group of children beat a bearded man with rods.

 Epigram: The traitorous schoolmaster from Faleria led his charges into the hostile Roman camp and turned them over to Camillus, who was laying seige to Faleria. Rather than taking the children captive, Camillus gave them whips and rods and had them drive the schoolmaster back to town because of his treachery. The townspeople were so moved that they yielded their town to Camillus.

BEAUTY
Peacham, p. 58.
 Motto: "Pulchritudo foeminea."
 Icon: A naked woman sits on a dragon, holds a glass and a dart, and wears a wreath of lilies.
 Epigram: The woman represents Beauty: her nakedness shows that she needs no art; her mirror, that man is moved to love by sight; her dart, the wounds she gives; the dragon, love's poison; the lilies, the frailty of her pride.

BEAUTY AND CUPID
Van Veen, p. 207.
 Motto: "Love had never foul mistris."
 Icon: Cupid walks with a beautiful woman.
 Epigram: Love thinks his mistress is beautiful.

BEAUTY WATER
See:
 HEART
 Arwaker, bk. 2, no. 6.

BEAVER
Whitney, p. 35.
 Motto: "Ære quandoque salutem redimendam."
 Icon: A beaver is pursued by a hunter and a hound; he tears off his testicles ("stoanes") with his teeth.
 Epigram: Just as the beaver sacrifices its testicles, the object of the hunter's pursuit, to save itself, so man should give up his riches to his foes to redeem his life: worldly treasure is unimportant.

BED
See:
 GLORY
 Whitney, p. 42.
 NAKED WOMAN
 Ayres, no. 20.
 PHYSICIAN
 Arwaker, bk. 1, no. 3.
 RISING AND SEEKING
 Arwaker, bk. 2, no. 11.
 Quarles, *Emb.*, p. 224.

BED AND CROSS
Arwaker, bk. 2, no. 10.
 Motto: "By night on my Bed, I sought him whom
 my Soul loveth, I sought him, but I found
 him not."
 Icon: A human figure holds a lamp, points to an
 empty bed; on the floor Divine Love lies
 on a cross.
 Epigram: Man seeks God in bed, but he should seek
 him on the Cross.
Quarles, *Emb.*, p. 220.
 Motto: "By night on my bed I sought him whom
 my soule loveth; I sought him, but I found
 him not."
 Icon: A human figure holds a lamp in the dark-
 ness and points to an empty bed; on the
 other side of the bed Divine Love lies on a
 cross.
 Epigram: Christ is found not in the bed of ease but
 suffering on the Cross.

BEE
Bunyan, no. 9.
 Motto: "Upon the Bee."
 Icon: None.
 Epigram: The bee, which stings those who would
 gather its honey, is an emblem of sin,
 whose sweetness causes death.
Hawkins, no. 7, p. 70.
 Motto: "Ope rosa et se dula."
 Icon: A bee is encircled by a wreath of flowers.
 Epigram: The bee is an architect of houses, the crea-
 tor of a commonwealth, and industrious,
 and it feeds on dew; the bee is thus likened
 to the Virgin.
Hawkins, no. 7, p. 78.
 Motto: None.
 Icon: A bee flies from a hive, and the wind
 blows.
 Epigram: The Virgin is compared to the industrious
 bee; her womb, the hive; Christ, the dew.
Peacham, p. 50.
 Motto: "Vos vobis."
 Icon: Bees, wasps, butterflies hover over a
 flowering plant.
 Epigram: Just as the deserving bee is beaten from
 the flower by the wasp and the butterfly, so
 deserving men are sometimes beaten by
 envy or their inferiors.
Willet, no. 84.
 Motto: Res crescunt concordia.
 Icon: None.
 Epigram: As bees work in harmony together, so
 should man.
See also:
 BEAR AND BEE

Wither, p. 23.
FLOWER
Whitney, p. 51.
TOMB OF NERO
Peacham, p. 144.

BEE AND CUPID
Ayres, no. 16.
 Motto: "Cupid himself stung."
 Icon: Cupid, crying beside Venus, points to a
 scene of himself with bees and beehives.
 Epigram: The bee sting is a trifle compared to the
 sting of love.
Whitney, p. 147.
 Motto: "Fel in melle."
 Icon: Cupid flies away from bee hives, bees pur-
 sue him.
 Epigram: Cupid was attracted to the sweet honey but
 discovered the bees' stings as well as their
 honey; likewise, men are attracted to
 beauty but often find that beauty is
 poisonous.
Whitney, p. 148.
 Motto: "Fere simile ex Theocrito."
 Icon: Cupid turns from the hollow of a tree
 where bees swarm and holds up his hand
 to Venus.
 Epigram: Cupid desired honey, put his hand into a
 hive, and was stung; he cried to his
 mother, Venus, who replied, "Think how
 much more you hurt others with your
 arrows."

BEE AND DUST
Astry, no. 73.
 Motto: "Compressa quiescunt."
 Icon: A hand throws dust on a swarm of bees.
 Epigram: When bees mutiny, man throws dust on
 them to separate and pacify them; like-
 wise, the most effective way to put down
 sedition is division.

BEE AND HELMET
Whitney, p. 138.
 Motto: "Ex bello pax."
 Icon: Bees use a helmet as a hive.
 Epigram: Just as the bees make honey in the soldier's
 helmet, so sweet peace comes after war.
Wither, p. 90.
 Motto: The Bees, will in an Helmet breed;
 And, Peace, doth after Warre, succeed.
 Icon: Bees swarm around a helmet and weapons
 of war.
 Epigram: The helmet signifies war; the bees, peace;
 together they suggest that peace abides in
 republics which support the military.

BEE AND HIVE
Astry, no. 62.
Motto: "Nulli patet."
Icon: Bees swarm around a hive.
Epigram: As a bee conceals the art by which it makes
 combs, so the prince should know the im-
 portance of silence and secrecy in govern-
 ment.
Whitney, p. 200.
Motto: "Patria cuique chara."
Icon: Bees fly to a hive.
Epigram: The community of bees represents the
 ideal commonwealth. This idea is ex-
 tended by being applied to the estate of a
 particular individual.
Wither, p. 250.
Motto: "Wee, bring the Hony to the Hive;
 But, others, by our labours thrive."
Icon: Bees fly around a hive.
Epigram: Like bees which are robbed of the honey
 they labor to produce, many men are de-
 prived of the fruits of their labors.

BEE AND LION
Astry, no. 99.
Motto: "Merces belli."
Icon: Bees swarm about the mouth of a dead
 lion.
Epigram: As bees make honeycomb in the mouth of a
 dead lion, so the sweetness of peace comes
 from the bitterness of war.

BEE AND OLIVE
Thynne, no. 63.
Motto: "To mr. Thomas Valence."
Icon: None.
Epigram: The bees represent health and quiet mind;
 the olive, peace and long life.

BEE AND PLOW
Astry, no. 42.
Motto: "Omne tulit punctum."
Icon: Two bees pull a plow.
Epigram: The honey-making bees pulling the plow
 illustrate the necessity of mingling plea-
 sure and profit.

BEE AND SWORD
Combe, no. 21.
Motto: "An hypocrite is noted still,
 By speaking faire and doing ill."
Icon: Bees swarm around a man with a drawn
 sword.
Epigram: The hypocrite is like a man who puts
 honey on his sword; when he is exposed,
 however, he suffers the stings of bees.

BEE AND TORTOISE
Combe, no. 28.

Motto: "Fortunes blasts cannot prevaile,
 To overthrow dame Vertues saile."
Icon: Bees swarm around a tortoise.
Epigram: As his shell protects the tortoise from the
 bees' stings, so wisdom can protect a man
 from fortune.

BEECH, CORN, OAK
Thynne, no. 56.
Motto: "The olde Testament."
Icon: None.
Epigram: In earlier times the oak and beech pro-
 vided sustenance for men, but now corn, a
 superior food, has replaced this food; like-
 wise Moses' law formerly sustained men,
 but now Christ, "the perfect meate," has
 superseded it.

BEEHIVE, CROCODILE, SAFFRON
Peacham, p. 154.
Motto: "Inani impetu."
Icon: A crocodile crawls toward a beehive sur-
 rounded by saffron plants.
Epigram: As saffron protects honey in a beehive
 from a crocodile, so divine grace protects
 our hopes from the devil.

Beetle. *See*: SCARABEE.

BEETLE AND ROSE
P. S., p. 274.
Motto: "Turpibus exitium."
Icon: A beetle in the middle of a rose.
Epigram: Like the beetle which is nourished in dung
 and dies in the rose, some youths delight
 in carnal pleasures but shun virtue.

BEGGAR
Bunyan, no. 39.
Motto: "Upon the Beggar."
Icon: None.
Epigram: The beggar who pleads for alms until he
 receives them is like the man who cease-
 lessly prays to God for mercy until he re-
 ceives it; imitate the beggar.

See also:
 FLY
 Peacham, p. 155.
 SPOUSE OF CHRIST
 Bunyan, no. 58.
See also: POOR.

BELL
Astry, no. 11.
Motto: "Ex pulsu noscitur."
Icon: A bell in a tower.
Epigram: The bell is an emblem of a prince, for it
 hangs in the most eminent place of the city
 and regulates citizens' actions, and, if it is
 flawed, its sound (speech) reveals the flaw.

Bunyan, no. 29.
 Motto: "Upon a Ring of Bells."
 Icon: None.
 Epigram: Bells are like the powers of the soul, their clappers like the passions of the mind, the ropes which ring the bell like promises.
Montenay, p. 202.
 Motto: "Multi sunt vocati."
 Icon: A man rings a bell in a chapel.
 Epigram: The bell calls everyone to hear God's word; it is time the wicked heed it.

See also:
 FALCON
 Astry, no. 10.

BELLEROPHON
Thynne, no. 28.
 Motto: "Counsell and vertue subdue deceipfull Persons."
 Icon: None.
 Epigram: As Bellerophon mounted Pegasus and valiantly slew Chimera, so the individual being addressed achieves fame through courageous acts.
Thynne, no. 53.
 Motto: "Not to climbe over highe."
 Icon: None.
 Epigram: The fall of Bellerophon warns men not to aspire too high.

BELLONA
See:
 PEACE
 Thynne, no. 32.

BELLOWS
See:
 CUPID AND STILL
 Combe, no. 79.
 LEVITY
 Peacham, p. 149.
 TRUTH
 Whitney, p. 4.

BELLOWS AND FIRE
Montenay, p. 398.
 Motto: "Patere."
 Icon: A man on fire holds a fiery club and threatens another, who blows bellows at him.
 Epigram: When a wrathful man turns on you in fury, use bounty, not violence, in defense.

BELLOWS AND WINDMILL
Combe, no. 85.
 Motto: "Who Labours that to bring to passe, That cannot be, is but an asse."
 Icon: A man tries to move a windmill with a bellows.

 Epigram: Wise men do not attempt impossible things.

BELLOWS, HEART, TREASURE
Harvey, no. 5.
 Motto: "Cordis Vanitas."
 Icon: The devil holds a bellows to a heart, while worldly treasures (crown, scepter, pearls) blow out the top of the heart.
 Epigram: Ambition puffs up the heart, makes men dote on trifles, and causes men's damnation.

BELLOWS, SUN, TORCH
Quarles, *Emb.*, p. 64.
 Motto: "Sic lumine lumen ademptum."
 Icon: A fool points a bellows at the sun, while Cupid trims a torch placed on the world.
 Epigram: The rebellious fool tries to blow out heaven's fire and vainly trusts in his own light.

Belt
See: GIRDLE.

BERRY AND CUPID
Van Veen, p. 173.
 Motto: "Brown beries are sweet of taste."
 Icon: Cupid shoots at a human figure picking berries.
 Epigram: Love does not always choose the fairest white but is also delighted by the lovely brown.

BIRCH SWITCH
See:
 REPENTANCE
 Peacham, p. 46.

BIRD
Bunyan, no. 43.
 Motto: "Of Fowls flying in the Air."
 Icon: None.
 Epigram: The birds of all sizes and varieties which fly in the sky represent men who shall possess heaven.
Whitney, p. 54.
 Motto: "In quatuor anni tempora."
 Icon: Birds surround a tree.
 Epigram: The birds indicate seasonal changes, suggest to man the movement of time; the swallow suggests the spring; the cuckoo, the summer; the vine finch, the harvest; the chaffinch, the winter.
Whitney, p. 55.
 Motto: "Parvam culinam, duobus ganeonibus non sufficere."
 Icon: One bird drives another out of a tree.
 Epigram: Two redbreasts cannot live in the same grove without fighting continuously; this

shows that "there is no gaine" in small things.

Whitney, p. 180.
Motto: "Verbum emissum non est revocabile."
Icon: A bird flies from a man's outstretched arms.
Epigram: Just as a bird cannot be controlled once it is released, so words, once spoken, cannot be returned.

See also:

ARROW AND BIRD
P. S., p. 41.
FIG TREE
Whitney, p. 53.
HANNO
Whitney, p. 84 (misnumbered p. 76).
HYOSCYAMUS
Peacham, p. 51.
OWL
Wither, p. 63.
RUIN, TAPER, TREE TRUNK
Quarles, *Hier.*, no. 15.
SAGE
Whitney, p. 130.

See also: CHAFFINCH, CHICK, COCK, CRANE, CROW, CUCKOO, DOVE, DUCK, EAGLE, FALCON, FENNY BITTERN FINCH (CHAFFINCH), FINCH (VINE FINCH), FOWL, GOOSE, GOSHAWK, GOSLING, HALCYON, HAWK, HEN, KITE, LARK, MAVIS, NIGHTINGALE, OSTRICH, OWL, PARROT, PARTRIDGE, PEACOCK, PELICAN, PHOENIX, QUAIL, RAVEN, REDBREAST, RINGDOVE, STORK, SWALLOW, SWAN, THRUSH.

BIRD AND CAGE
Combe, no. 38.
Motto: "Patience brings the minde to rest, And helps all troubles to digest."
Icon: A bird in a cage.
Epigram: Although the bird is imprisoned in a cage, it continues to sing; so men should be patient in adversity, suppress their sorrow.

BIRD AND CHILD
Bunyan, no. 31.
Motto: "Of the Child with the Bird at the Bush."
Icon: None.
Epigram: The bird which sits amid thorns represents the sinner; the child who takes pity on him and wishes to protect him is Christ; the food, sunshine, and song the bird prefers are the vain, empty pleasures of the world.

BIRD AND CLOUD
Godyere, no. 27.
Motto: "Et tenebrae factae sunt."
Icon: A dark cloud hangs over a bird with its head down.

Epigram: The noble mind will "vanquish deaths darkest ill."

BIRD AND CROWN
Peacham, p. 124.
Motto: "Huic ne credere [illegible]."
Icon: A bird builds a nest in a crown on the top of a rosebush.
Epigram: As the weak bird finds shelter in the crown, so another finds protection and patronage from the king.

BIRD AND FIRE
Van der Noodt, no. 14.
Motto: None.
Icon: A bird flies to heaven from the flames of a fire.
Epigram: A white bird emerged from the fire when it was pure and beautiful and flew to heaven; now the fire is corrupt.

BIRD AND KEEPER
Combe, no. 90.
Motto: "A worde once spoken though in vaine, It cannot be recald againe."
Icon: A keeper releases a bird.
Epigram: As the keeper cannot catch the bird again once he has released it, so man cannot recall his words.

BIRD AND LION
Peacham, p. 91.
Motto: "Innocentia muninem tutissimum."
Icon: A lion, lying on its back, is attacked by birds of prey.
Epigram: As birds attack a beast they normally fear when it is wounded, so one's enemy attacks when one is vulnerable.

BIRD, CAGE, HAWK
Wither, p. 96.
Motto: "My Fortune, I had rather beare; Then come, where great perills are."
Icon: A hawk flies over a small bird in a cage.
Epigram: The caged bird is more content with its confinement when it sees the hawk outside; so man should learn to bear his fortune, knowing that he could suffer much worse fortune.

Birder
See: FOWLER.

BIRDER AND PIPE
Combe, no. 54.
Motto: "The Prince that would beware of harme, Must stop his eares to flatterers charme."
Icon: A birder blows on a pipe, luring birds into his net.
Epigram: Like the birder who lures his prey by play-

ing a pipe, the flatterer covers his defeat with sweet words.

BIRTH OF PALLAS
Peacham, p. 188.
Motto: "Omnis a Deo Sapientia."
Icon: Jove, with his thunderbolt and eagle, gives birth to Pallas from his forehead while Mulciber, holding an ax, and a midwife assist.
Epigram: Pallas represents heavenly wisdom, sent from God.
Thynne, no. 38.
Motto: "Dull witts."
Icon: None.
Epigram: At the birth of Pallas, Vulcan assisted by opening Jove's head with an ax; similarly, dull wits have wisdom drawn from them.
See also:
PALLAS
Thynne, no. 51.

BIT
See:
BLINDNESS AND CUPID
Van Veen, p. 61.

BLACK
See:
CUPID AND LILY
Van Veen, p. 123.

Blackberry
See: BRAMBLE.

BLADE
See:
ANVIL AND BLADE
Combe, no. 31.

BLEEDING
See:
CHRIST ON CROSS
E. M., frontispiece.
See also: BLOOD, BOXING GLASS.

BLIND
See:
CUPID AND FORTUNE
Van Veen, p. 157.
FORTUNE
Wither, p. 174.

BLIND AND LAME
Van Veen, p. 15.
Motto: "As one hand washeth the other."
Icon: The blind man carries the lame man.
Epigram: Love is kind; the lover supplies the defects of his beloved.
Whitney, p. 65.
Motto: "Mutuum Auxilium."

Icon: A blind man carries a lame man, who guides him.
Epigram: Just as the blind man and the lame man help each other, so the poor and rich should live in mutual friendship and dependence.

BLINDFOLD
Ayres, no. 10.
Motto: "Blind Love."
Icon: Blindfolded Cupid gropes toward ladies.
Epigram: Love is likened to the game of "Blind mans buffe."
See also:
ANTEBAT
Combe, no. 26.
CAGE AND HEART
Hall, p. 44.
CUPID AND GRAFTED TREE
Combe, no. 81.
CUPID AND SIEVE
Combe, no. 77.
CUPID AND STILL
Combe, no. 79.
FORTUNE
Combe, nos. 20, 29.
JUDGE AND JUSTICE
Arwaker, bk. 1, no. 10.
Quarles, *Emb.*, p. 160.
WIFE
Combe, no. 93.

Blindfold
See: HOODWINK.

BLINDFOLD AND HORSE
P. S., p. 176.
Motto: "Premitur, non opprimitur."
Icon: A blindfolded horse.
Epigram: When men contested the ownership of a beast, the judge proclaimed that whoever the horse chose after a blindfold was removed was the owner.

BLINDFOLD AND SHACKLE
Hall, p. 20 (misnumbered p. 6).
Motto: "How long! How long! why is not this hour the period of my filthiness."
Icon: Cupid blindfolds a man, whose feet are in shackles.
Epigram: When the weight of sin lies heavily on the soul, its sighs and groans to God initiate the healing process.

BLIND MAN AND CANDLE
Farlie, no. 22.
Motto: "Lux mea tibi tenebrae."
Icon: A blind man with a staff stands beside a candle.
Epigram: As a blind man cannot see the light of a

candle, so man cannot see the light of Christ until his eyes are opened.

BLIND MAN AND GLASS
Bunyan, no. 48.
 Motto: "Upon a Looking Glass."
 Icon: None.
 Epigram: The glass which reflects the beauty and defects of the man who looks into it represents the Word; the blind man who cannot see the glass or its reflection represents the man who fails to comprehend the Word.

BLIND WOMAN AND PHYSICIAN
Whitney, p. 156.
 Motto: "Dolor è medicina."
 Icon: A blind woman sits in a chair while a man steals her possessions.
 Epigram: A false physician promised to cure a blind woman, then busied himself stealing all her possessions. She regained her sight, but when he demanded his fee for curing her, she refused, arguing that, since she saw none of her household goods, she must still be blind.

BLINDNESS
See:
 SIN
 Peacham, p. 146.

BLINDNESS AND CUPID
Van Veen, p. 61.
 Motto: "Love blyndeth."
 Icon: Blind Cupid turns from a bit, a shield, and Mercury's caduceus.
 Epigram: Love, led by fancy, is blind and does not see the wisest way.

BLOOD
Peacham, p. 99.
 Motto: "Atheôn exitus."
 Icon: Blood spurts from a hand.
 Epigram: The atheist Julian defied God, but when he lay wounded and dying, he cried out that Christ overcame him and "cast his blood into the Aire."
See also:
 BOUNTY
 Godyere, no. 31.
 FOUNTAIN AND HEART
 Harvey, no. 17.
 HEART AND WASHING
 Montenay, p. 354.
 PELICAN
 Whitney, p. 87.
 Wither, p. 154.
 R. B., no. 7.

PHOENIX
Van der Noodt, no. 5.
RAVEN, TREE, WOLF
Montenay, p. 58.
ROSE
Hawkins, no. 2, p. 25.
See also: BLEEDING.

BLOOD AND HEART
H. A., p. 95.
 Motto: "Jesus purgeth the hart with expiatory bloud."
 Icon: Jesus sprinkles drops of blood on a heart.
 Epigram: Christ's blood cleans the heart.

BLOOD, FOUNTAIN, HEART
H. A., p. 83.
 Motto: "Jesus the living fountaine in the hart."
 Icon: Jesus stands inside a heart; blood from his wounds flows into a fountain.
 Epigram: The blood of Christ cleanses the heart of man.

Bloodletting
See: BOXING GLASS.

BLOODY ROBE
See:
 HORSEMAN, SEVEN-HEADED BEAST, SWORD
 Van der Noodt, no. 19.

BLOWING
Whitney, p. 160.
 Motto: "Bilingues cavendi."
 Icon: A man blows on his food while a satyr watches.
 Epigram: When the host blew on his hands to warm them, then blew on his food to cool it, the satyr rejected him as two-faced: shun the "double tonged."

BOAR
Whitney, p. 153.
 Motto: "In pace de bello."
 Icon: A boar sharpens its tusk while a fox watches.
 Epigram: As the boar prepares its tusks for battle in times of peace, so countries should prepare their forces for war during peacetime.
See also:
 ADONIS
 Peacham, p. 169.
 VULTURE
 Whitney, p. 119.
See also: HOG, PIG, SWINE.

BOAR AND MAN
Wither, p. 110.

Motto: "A Life, with good-repute, Ile have,
 Or, winne an honourable Grave."
Icon: A man fights a boar.
Epigram: As the man fights the savage boar, prefer-
 ring to die honorably than to live in cow-
 ardice, so men should courageously battle
 vice.

BOARD AND SPLINTER
Montenay, p. 102.
Motto: "Ejice primum trabem."
Icon: A man attempting to take a splinter out of
 another's eye is struck on the head by a
 board.
Epigram: The man who corrects another, claiming
 to know the right way to heaven, is himself
 in danger and should help himself, not
 meddle with others.

BOAT
Wither, p. 221.
Motto: "When thou art shipwrackt in Estate,
 Submit with patience, unto Fate."
Icon: A boat drifts on a rough sea.
Epigram: The boat adrift on a sea with no anchor,
 oar, or guide signifies the man who trusts
 fate.
See also: SHIP.

BODY AND HOUSE
Bunyan, no. 12.
Motto: "Upon over-much niceness."
Icon: None.
Epigram: Some men are overconcerned about the ap-
 pearances of their body and house but ig-
 nore what matters, the inside.

BOILING
See:
 BROTH AND FIRE
 Whitney, p. 216.
 BROTH AND FLAME
 Montenay, p. 198.

Bond
See: CHAIN, SHACKLE, STOCK(S).

BONE
P. S., p. 317.
Motto: "In hunc intuens."
Icon: A hand holds the bones of a dead man.
Epigram: The bones of a dead man were carried
 about at Egyptian banquets to remind men
 of their mortality.
Willet, no. 3.
Motto: "Post funus spes una superstes."
Icon: None.
Epigram: As the prophet envisioned bones in the

valley receiving flesh and life, so the dead
shall be resurrected.
Wither, p. 8.
Motto: "This Ragge of Death, which thou shalt
 see,
 Consider it; and Pious bee."
Icon: A hand holds the bones of a dead man.
Epigram: Consider these bones, think on your own
 death, and put trust in the spirit rather
 than the flesh.
See also:
 ASS AND DOG
 Combe, no. 46.
 DOG
 Whitney, p. 39.
See also: DEATH, SKELETON.

BONE AND DOG
Ayres, no. 25.
Motto: "Envy accompanyes Love."
Icon: Dogs fight over a bone as Cupid watches.
Epigram: Two men will fight over a woman in the
 same way that dogs fight over a bone.

BOOK
Montenay, p. 378.
Motto: "Scientia inflat."
Icon: A man holds an open book and stands be-
 side two children looking at a fire.
Epigram: The man who excels in learning should
 employ his talent for the public good.
Peacham, p. 40.
Motto: "Salomonis prudentia."
Icon: Above an open book are crossed branches
 of cedar and hyssop, a heart, and an eye.
Epigram: These images symbolize the wisdom of
 Solomon: the book is the means of wis-
 dom; the branches of cedar and hyssop
 represent "all that ever grew"; the eye,
 sound judgment; and the heart, that rulers
 must not trust others.
Peacham, p. 140.
Motto: "Vindicta Divina."
Icon: A winged book flies above the burning city
 of Sodom.
Epigram: The winged book represents God's anger
 and the quick punishment of profaners."
Whitney, p. 166.
Motto: "Veritas invicta."
Icon: Wings lift a book with the word of God
 into the blazing light of the heavens while
 Satan tries to drag the book into the dark-
 ness of hell with a chain.
Epigram: Though Satan strives to hide truth, the
 Lord gives his word light, and men find
 salvation in his Book.

Willet, no. 24.
 Motto: "Sapientia humana stultitia coram Deo."
 Icon: None.
 Epigram: An open book cannot be read by an uneducated man; a closed book cannot be read by a learned man. When God's word is despised, it benefits neither the untaught nor the wise.

See also:
 AGED MAN
 Wither, p. 87.
 R. B., no. 23.
 ALTAR, BOOK, CUP, HELMET, MONEY
 P. S., p. 371.
 ANCHOR, BOOK, FRIAR
 Wither, p. 73.
 R. B., no. 43.
 BOY
 Bunyan, no. 71.
 CHILD AT WATCH
 Wither, p. 94.
 COLOSSUS OF RHODES
 Peacham, p. 161.
 DEATH AND SCHOLAR
 Wither, p. 1.
 R. B., no. 3.
 DIOMEDES AND ULYSSES
 Whitney, p. 47.
 FAITH
 Peacham, p. 7.
 FAME
 Wither, p. 146.
 R. B., no. 37.
 HOURGLASS
 Hall, p. 104.
 INNOCENCE AND LEARNING
 Hall, p. 28.
 KING
 Wither, p. 31.
 R. B., no. 35.
 LAWBOOK AND SWORD
 Wither, p. 163.
 R. B., no. 31.
 LEARNING
 Peacham, p. 26.
 MELANCHOLY
 Peacham, p. 126.
 OATH
 Ayres, no. 38.
 SCHOLAR AND SOLDIER
 Godyere, no. 30.
 SCIENCE
 Godyere, no. 19.
 SIEVE
 Quarles, *Emb.*, p. 88.

 TIME AND WISDOM
 Godyere, no. 28.
 TRUTH
 Peacham, p. 134.
 VICE AND VIRTUE
 Wither, p. 22.
 R. B., no. 2.

BOOK AND EWER
Peacham, p. 10.
 Motto: "Prius ablue sordes."
 Icon: A basin and ewer stand on a book.
 Epigram: Wash hands before turning to the heavenly book, cast away unclean thoughts, and pray to God.

BOOK AND OWL
Wither, p. 79.
 Motto: "By Studie, and by Watchfulnesse,
 The Jemme of Knowledge, we possesse."
 Icon: An owl stands on an open book.
 Epigram: The owl signifies watchfulness; the open book, fruitful studies; together, they teach the way to wisdom.

BOOK AND RUIN
Whitney, p. 131.
 Motto: "Scripta manent."
 Icon: A building lies in ruins; books lie on a table.
 Epigram: Writing lasts when all other monuments decay in time.

BOOK AND SATAN
Montenay, p. 318.
 Motto: "Et usque ad nubes veritas tua."
 Icon: A book, crowned with a wreath, flies on wings in front of the sun, while a hand in the clouds holds a wing; below, Satan pulls a chain attached to the book.
 Epigram: Man should read the Bible with humility and not with pride or vanity, which is satanic.

BOOK AND SCHOLAR
Whitney, p. 171.
 Motto: "Usus libri, non lectio prudentes facit."
 Icon: One scholar in a study reads a book while another observes him.
 Epigram: Study is useless unless the knowledge gained from it is practiced; wisdom comes from experience.

BOOK AND SWORD
Wither, p. 32.
 Motto: "A Princes most ennobling Parts,
 Are Skill in Armes, and Love to Arts."
 Icon: A king holds a book and a sword.

Epigram: The ideal king masters both skill in arms and knowledge of liberal arts.

BOOK, CANDLE, HOURGLASS
Whitney, p. 172.
Motto: "Studiis invigilandum."
Icon: A candle, an open book, and an hourglass are set on a table.
Epigram: Remember how time passes, and use your time well.

BOOK, CANDLE, SUN
Montenay, p. 174.
Motto: "Res omnes caecis sunt tene brae."
Icon: A man holds a candle and an open book; the sun shines.
Epigram: The wicked man may want to teach others, but he, like the candle when the sun shines brightly, is useless when man has God's word.

BOOK, CUPID, DISTAFF, HERCULES
Van Veen, p. 83.
Motto: "Love is the schoolmaster of artes."
Icon: Cupid holds a book and instructs Hercules to spin.
Epigram: Love teaches the lover all the arts.

BOOK, FIRE, WORLD
Montenay, p. 238.
Motto: "Si jam accensus."
Icon: A hand holds a book to flames which consume the world.
Epigram: Nothing in the world can endure; only Christ's Gospel is permanent.

BOOK, HEART, SMOKE, WING
Wither, p. 91.
Motto: "The Heart of him, that is upright, In Heavenly-knowledge, takes delight."
Icon: A smoking and winged heart sits on an open book.
Epigram: The book represents wisdom; the winged heart, desire for knowledge; the smoke, those perturbations within man until he understands heavenly wisdom.

BOOK, LION, SWORD
Godyere, no. 25.
Motto: "Pace a glieletti e guerra a gliempi e rei."
Icon: A winged lion holds a sword beside an open book.
Epigram: Virtuous books are as powerful as the sternest lion and give peace and contentment.

BOOK, SERPENT, SWORD
Peacham, p. 2.
Motto: "Initium Sapientiae."

Icon: A serpent winds around a sword which stands on a book.
Epigram: Worldly wisdom must be grounded on God's word.

BOOK, SWORD, WORLD
P. S., p. 336.
Motto: "Ex utroque Caesar."
Icon: A man holding a book and a sword stands on the world.
Epigram: Weapons and good letters made Caesar ruler over all the world.

Boreas
See: WIND.

BOREAS AND CANDLE
Farlie, no. 37.
Motto: "Altero extinguor, altero accendor."
Icon: Two faces of Boreas blow on a candle.
Epigram: Boreas both kindles and extinguishes the candle; so, too, Fortune throws down and raises, and God casts down and advances.

BOREAS AND LANTERN
Farlie, no. 53.
Motto: "Fata viam inveniunt."
Icon: Boreas blows through a chink in a lamp.
Epigram: As the wind finds the chink in the lamp and extinguishes the flame, so death finds our weaknesses.
Farlie, no. 52.
Motto: "Hac tantum patui."
Icon: Boreas blows a lamp.
Epigram: As one chink makes the lamp vulnerable to the wind, so one sin can overthrow the soul.

Bottle
See: FLAGON, FLASK.

Bough
See: BRANCH.

BOUGH, DART, SEPULCHRE
P. S., p. 59.
Motto: "Sola vivit in illo."
Icon: A dart entwined with boughs on top of a sepulcher.
Epigram: This device expresses the idea of the resurrection of the dead.

BOUNDER STONE
See:
TERMINUS
Wither, p. 161.

BOUNTY
Godyere, no. 31.
Motto: "Meritum sibi munus."

Icon: The female figure of Bounty holds a wreath
 and a palm; blood flows from her heart
 into the mouth of a kneeling figure.

Epigram: Bounty imparts comfort to worth and re-
 wards true desert.

BOW
Combe, no. 25.
 Motto: "No toile can last without his rest,
 In every thing the meane is best."
 Icon: A man draws a bow.
 Epigram: As the bow that is drawn with too much
 strength is weakened, so man who labors
 in excess is hurt.
Peacham, p. 202.
 Motto: "Nil viribus impar."
 Icon: A hand holds a bow.
 Epigram: Before you attempt important tasks, try
 your strength and consider your end.
P. S., p. 356.
 Motto: "Ingenium superat vires."
 Icon: A bow.
 Epigram: The bow signifies that policy is greater
 than strength.
Whitney, p. 168.
 Motto: "Ingenium superat vires."
 Icon: An archery bow with a mechanical device
 to wind the string.
 Epigram: Man's wisdom surpasses his strength:
 though man could not, with his physical
 strength, bend the bow, he could, with his
 wit, make a mechanical device that could.

See also:
 ARROW
 Arwaker, bk. 1, frontispiece.
 Ayres, no. 19.
 ARROW, BOW, TAPER
 Quarles, *Hier.*, no. 11.
 BOY AND TYRANT
 Montenay, p. 134.
 CENTAUR
 Wither, p. 103.
 R. B., no. 42.
 CUPID
 Wither, p. 227.
 R. B., no. 34.
 CUPID AND SEA
 Van Veen, p. 93.
 HEART AND SMOKE
 Wither, p. 39.
 LUNA
 Godyere, no. 32.
See also: FIDDLESTICK.

BOWL
See:
 BACCHUS AND LION SKIN

Combe, no. 48.
See also: CUP.

BOWLING
Quarles, *Emb.*, p. 40.
 Motto: "Utriusque crepundia Merces."
 Icon: Cupid and Mammon bowl, Satan points
 the way, and Fortune, on a wheel with a
 sail, holds a fool's cap as a prize.
 Epigram: Lust and Riches contend in the world for
 the fool's cap which Fortune bestows; Satan
 encourages them.

BOW OF SHIP
See:
 DOG AND BOW OF SHIP
 P. S., p. 252.

BOXING GLASS
P. S., p. 233.
 Motto: "De mal me paists."
 Icon: A "boxing glass" sucks up blood.
 Epigram: Like the physician's boxing glass, which
 sucks up corrupt blood, the wicked mind
 seeks evil.

BOY
Bunyan, no. 71.
 Motto: "Upon the Boy dull as his Book."
 Icon: None.
 Epigram: Like the boy who excels in play but is a
 blockhead at his books, some men excel in
 vice but are dunces in the way of paradise.
See also: CHILD, YOUTH.

BOY AND BUTTERFLY
Bunyan, no. 21.
 Motto: "Of the Boy and Butter Fly."
 Icon: None.
 Epigram: The boy who chases the butterfly is like
 those who are concerned solely with the
 world, which is fading and transient.

BOY AND HOBBYHORSE
Bunyan, no. 67.
 Motto: "Upon the Boy on his hobby-horse."
 Icon: None.
 Epigram: Like the boy on his hobbyhorse who swag-
 gers and prides himself on his riding, the
 conceited man holds himself above men
 who are more godly, honest, and wise.

BOY AND PLUM
Bunyan, no. 47.
 Motto: "Upon the Boy and his Paper of Plumbs."
 Icon: None.
 Epigram: The boy who gleefully eats a paperful of
 plums and then has nothing left but paper
 is like the man who values worldly things

and finds that he is left with nothing valuable.

BOY AND TYRANT
Montenay, p. 134.
 Motto: "A malo castigaberis."
 Icon: A man threatens a small boy with a bow, but an arrow sticks in his own forehead.
 Epigram: The tyrant commits acts of cruelty against the innocent but in the end is made to feel the wound himself.

BOY, WATCH, WATCHMAKER
Bunyan, no. 46.
 Motto: "The Boy and Watch-maker."
 Icon: None.
 Epigram: The boy who has a watch but needs to learn how to care for it represents the convert; the watch represents Grace within his heart; the watchmaker who counsels him on how to care for the watch, Christ; his counsel, his Word.

Bramble
See: BRIAR.

BRAMBLE AND FLOWER
Montenay, p. 186.
 Motto: "Sic amica mea inter."
 Icon: Brambled bushes grow up around a flower, obscuring it.
 Epigram: Like the bramble which obscures the flower, so the wicked of the world obscure God's word with lies.

BRANCH
Astry, no. 54.
 Motto: "A se pendet."
 Icon: A hand cuts off a branch of a tree with a sickle and encircles it with a basket of earth.
 Epigram: The gardener cuts off a branch of a tree and roots it so that it becomes independent of the tree. Man's love of liberty makes this a dangerous practice for princes; if a province is given some independence, it will not want to obey.
Wither, p. 217.
 Motto: "When Hopes, quite frustrate were become,
 The Wither'd-branch did freshly bloome."
 Icon: A hand holds a withered branch from which a new twig springs.
 Epigram: As the new twig grows from the withered branch, so man should have hope that life may be renewed, resurrected.
See also:
 EAGLE AND SUN

Godyere, no. 4.
 LOADSTAR
 Peacham, p. 145.
See also: BOUGH.

BRASIDAS
See:
 SHIELD
 Whitney, p. 141.

BRASS POT AND EARTHEN POT
Whitney, p. 164.
 Motto: "Aliquid mali propter vicinum malum."
 Icon: A brass pot and an earthen pot float side by side in a river.
 Epigram: Just as the brass pot has the capacity to shatter the earthen pot if the two collide, so mighty men can destroy the helpless poor; better, then, that "like to like."

BRASS SERPENT
Willet, no. 51.
 Motto: "Scandala removenda sunt."
 Icon: None.
 Epigram: When the people made the brass serpent into a god, Moses destroyed it; this teaches that what causes offence must be removed.

BRAZEN SERPENT AND CROSS
P. S., p. 7.
 Motto: "Secum feret omnia martis."
 Icon: A serpent entwines a cross.
 Epigram: The brazen serpent erected by Moses prefigures the salvation and redemption of Christ.

BREAD
See:
 ABRAHAM
 Willet, no. 63.

BREAD AND CROSS
P. S., p. 11.
 Motto: "Pignora cara sui."
 Icon: Bread on a cross.
 Epigram: The cross and the bread are remembrances of Christ and his redemption. The cross is man's meat, or sustenance.

BREAD AND DOG
Wither, p. 255.
 Motto: "Why should I feare the want of Bread? If God so please, I shall bee fed."
 Icon: A hand offers bread to a dog.
 Epigram: As God feeds the dog in its need, so he will provide for man.

BREAST
See:
 CUPID AND HOPE
 Van Veen, p. 59.

BREAST AND FOOL
Quarles, *Emb.*, p. 48.
 Motto: "Inopem me copia fecit."
 Icon: A cornucopia appears above breasts which
 a fat fool sucks greedily, and a thin fool
 milks into a sieve.
 Epigram: It is folly to give the flesh more than it
 needs or less than it needs; the mean is
 virtue.

BREATH
Bunyan, no. 55.
 Motto: "Upon a Stinking Breath."
 Icon: None.
 Epigram: Men with foul stomachs or ulcerous lungs
 breathe in wholesome air but give off a
 stinking breath; likewise, men with de-
 lusive or foolish notions breathe in the
 wholesome Scripture but breathe out pesti-
 lent and putrified air.

BRIAR
See:
 PHILOMEL
 Peacham, p. 74.

BRIAR AND LILY
Whitney, p. 221.
 Motto: "Aculei irriti."
 Icon: A lily grows among briars.
 Epigram: As the lily blooms even when it is enclosed
 by briars, so the good remain virtuous even
 when surrounded by the wicked.

BRIDLE
Astry, no. 21.
 Motto: "Regit et corrigit."
 Icon: A bridle hangs from the sky.
 Epigram: The bridle represents the law which guides
 and curbs the mob.
Willet, no. 33.
 Motto: "Linguae custodia."
 Icon: None.
 Epigram: The bridle symbolizes God's control of
 men's tongues.
See also:
 CUPID AND BRIDLE
 Van Veen, p. 89.
 GOLDEN MEAN
 Wither, p. 169.
 R. B., no. 11.
 LAMB AND LION
 Montenay, p. 142.
 NEMESIS
 Whitney, p. 19.
 Whitney, p. 139.
 TEMPERANCE
 Peacham, p. 93.

BRIDLE AND LION
Peacham, p. 32.
 Motto: "Dies et ingenium."
 Icon: A hand controls the reins of a bridled lion.
 Epigram: Experience tames even the fiercest natures.

BRIDLE, CUPID, MEASURE
Van Veen, p. 31.
 Motto: "Love is not to bee measured."
 Icon: Cupid stands on a measure and a bridle.
 Epigram: Love cannot be measured or bridled.

BRITAIN
Peacham, p. 108.
 Motto: "Quem timuisti, timet."
 Icon: The female figure of Britain, her hair
 disheveled, holds a scepter and pushes
 away a ship with her foot.
 Epigram: This icon depicts Britain's suffering dur-
 ing the Roman occupation.

BROKEN PILLAR
See:
 PILLAR
 Montenay, 70.

BROOM
See:
 CANDLE AND MATRON
 Farlie, no. 16.

BROOM AND HEART
H. A., p. 71.
 Motto: "Jesus sweeps the dust of sinnes from the
 hart."
 Icon: Jesus sweeps a heart with a broom.
 Epigram: Jesus cleanses the heart.

BROOM STALK
P. S., p. 204.
 Motto: "Sans autre guide."
 Icon: Broom stalks in a stone.
 Epigram: Broom stalks are stuck in stones by trav-
 elers to direct the way. This signifies that
 virtue is the only guide to eternal happi-
 ness.

BROTH AND FIRE
Whitney, p. 216.
 Motto: "Qui se exaltat, humiliabitur."
 Icon: Broth in a pot boils over into the fire.
 Epigram: As broth boils over into the fire, so the
 proud fall.

BROTH AND FLAME
Montenay, p. 198.
 Motto: "Qui se exaltat humiliabitur."
 Icon: The broth in a pot over a flame boils over.
 Epigram: As the broth boils over and extinguishes
 the flame, so humble men, who are instru-
 ments of God, will shame prodigal men.

BROTHER

Montenay, p. 310.

Motto: "Sol ne occidat super iram vestram."

Icon: A man embraces his brother; each holds an olive branch, the sun shines, and swords lie at their feet.

Epigram: Man should not strive with his brother but live in peace and love; God blesses those who live in love.

BRUTUS

Whitney, p. 70.

Motto: "Fortuna virtutem superans."

Icon: Brutus falls on his sword, committing suicide.

Epigram: Fortune may subdue even the most valiant.

BRYSUS

Peacham, p. 151.

Motto: "Somniorum Dea."

Icon: Brysus holds a bowl upside down; all sorts of riches fall from it.

Epigram: Brysus, the goddess of dreams, promises plenty but gives nothing; men who believe in her are victims of their fancy.

BUBBLE

Whitney, p. 55.

Motto: "Cuncta complecti velle, stultum."

Icon: Little boys chase bubbles.

Epigram: As the boys vainly try to catch bubbles, so men who pursue all arts end up not comprehending any of them sufficiently.

See also:

GLOBE OF HEAVENS
BALANCE AND BUBBLE
Quarles, *Emb.*, p. 16.
GLOBE OF HEAVENS
Hall, p. 84.
VANITY
Arwaker, bk. 2, no. 5.
Quarles, *Emb.*, p. 200.

BUBBLE AND SMOKE

Quarles, *Emb.*, p. 76.

Motto: "Quam grave servitium est, quod levis esca parit."

Icon: Cupid sits on a bubble to which he is chained, holds a smoking candle, and smokes a pipe; Divine Love, holding a lantern, observes.

Epigram: Riches and honors are no more than smoke or bubbles, empty and fading.

BUBBLE AND TOY

Hall, p. 4.

Motto: "Toyes of toyes, and vanities of vanities did withhold mee."

Icon: A winged figure blows bubbles while a woman standing at a table laden with toys and musical instruments gives a scepter to a child.

Epigram: Worldly things are vain trifles which men, like children, foolishly dote upon.

BUCEPHALUS

Combe, no. 91.

Motto: "None waxe more proud we lightly see, Then beggars raised to high degree."

Icon: A horse in armor throws a rider.

Epigram: When the horse Bucephalus had rich armor on its back, only Alexander could control him; so base and lowly men are proud and disdainful when they gain honor.

Buck

See: DEER, HART, HIND, ROE, STAG.

BUCK AND LION

Combe, no. 39.

Motto: "To be a soldier good indeed, Must of a Captain good proceed."

Icon: A lion leads a herd of bucks against an army of lions led by a buck.

Epigram: Bucks led by a lion are stronger than lions led by a buck, for a valiant leader causes cowards to fight, while a cowardly leader undercuts his soldiers' might.

BUCKET

See:

TAPER
Quarles, *Hier.*, no. 1.

BUCKET AND WELL

Jenner, no. 23.

Motto: "The opposition of sinne and grace."

Icon: A woman draws a bucket from a well.

Epigram: As one bucket in a well goes down when the other is drawn up, so is the relationship between grace and sin: the two cannot stand together in one heart.

BUCKLER AND WORLD

Montenay, p. 362.

Motto: "Resistite fortes."

Icon: An armed man protects himself with a buckler (round shield) from arrows shot from inside the world; Satan blows a trumpet.

Epigram: Satan, World, Death, and Hell conspire to overthrow man, but he protects himself with faith.

BULL

Astry, no. 80.

Motto: "In arena et ante arenam."

Icon: A bull butts a tree.

Epigram: As the bull practices defending himself

before he engages his rival, so wise princes ought to polish their designs and develop their ideas before executing them.

See also:
 FEAR
 Whitney, p. 52.
See also: OX.

Bundle
See: FARDEL, SHEAF.

BUNDLE OF RODS
See:
 CHAIN AND POLEAX
 P. S., p. 71.

Burden
See: FARDEL.

BUSH
See:
 SIGN
 Jenner, no. 28.

BUTTERFLY
See:
 BEE
 Peacham, p. 41.
 BOY AND BUTTERFLY
 Bunyan, no. 21.
See also: MOTH.

BUTTERFLY AND CRAB
P. S., p. 324.
 Motto: "Festina lente."
 Icon: A crab holds a butterfly.
 Epigram: Together, the crab and butterfly signify the importance of the mean in all actions of a prince.
Whitney, p. 121.
 Motto: "Festina lente."
 Icon: A crab holds a butterfly.
 Epigram: The paradoxical concept of *festina lente* ("hurry slowly") is applied to judges, who must balance justice and mercy.

BUTTERFLY AND FLAME
P. S., p. 340.
 Motto: "Cosi vivo piacer canduce a morte."
 Icon: A butterfly flies into the flame of a candle.
 Epigram: Like the butterfly which is attracted to the flame and burns, the man who acts without deliberation destroys himself.

BUTTERFLY AND SPIDER
Wither, p. 18.
 Motto: "From thence, where Nets and Snares are layd,
 Make-hast; lest els you be betray'd."
 Icon: A butterfly flies above a spider and a web.

Epigram: The spider with its web represents, among other things, men who seek to enrich themselves by ruining others; the butterfly those gallants vulnerable to being ensnared.

C

CADUCEUS
Ayres, no. 27.
 Motto: "The power of Eloquence in Love."
 Icon: Cupid holds a caduceus.
 Epigram: Eloquence has the power to sway a lady.
See also:
 BACCHUS
 Peacham, p. 96.
 BLINDNESS AND CUPID
 Van Veen, p. 61.
 CUPID AND MERCURY
 Van Veen, p. 80.
 FELICITY
 Peacham, p. 25.
 LION
 Godyere, no. 2.
 MARS AND MERCURY
 Godyere, no. 14 (misnumbered 13).
 OWL
 Wither, p. 9.
 VICE AND VIRTUE
 Wither, p. 22.
 R. B., no. 2.

CADUCEUS AND CORNUCOPIA
Wither, p. 88.
 Motto: "Good-fortune, will by those abide,
 In whom, True-vertue doth reside."
 Icon: Two cornucopias intertwine a winged caduceus.
 Epigram: The caduceus represents art and wisdom; the cornucopias, plenty; combined, they express the truth that eternal blessing abounds where there are internal graces.

CAGE
Arwaker, bk. 3, no. 10.
 Motto: "Bring my Soul out of prison, that I may praise thy name."
 Icon: Divine Love unlocks a cage which imprisons a man.
 Epigram: Man asks God to free him from his earthly prison, his body.
Quarles, *Emb.*, p. 280.
 Motto: "Bring my soule out of Prison that I may praise thy Name."
 Icon: Divine Love unlocks a cage which imprisons a man.

Epigram: Man's soul is like a bird; his flesh, the cage; the sacraments, sustenance; birth and death, the keys that lock and unlock the soul.

See also:

BIRD AND CAGE
Combe, no. 38.
BIRD, CAGE, HAWK
Wither, p. 96.
NIGHTINGALE IN CAGE
Whitney, p. 101.

CAGE AND HEART
Hall, p. 44.
Motto: "Love, when it come's doth captivate all the other affections, and draw them unto it self."
Icon: A cage on a tale encloses hearts; Divine Love holds up a circular chain to a blindfolded man; above, a serpent biting its tail, palm branches, beams of light.
Epigram: Love of God captivates all other affections, drawing all unto itself; God is love.

Calumny
See: SLANDER.

CAMEL
Combe, no. 69.
Motto: "He that himself is void of wit, In a wise man despiseth it."
Icon: A camel paws water.
Epigram: As the camel will not drink until it has defiled the water with its foot, so rude people debase eloquence.

Peacham, p. 125.
Motto: "Mihi gravato Deus."
Icon: A kneeling camel, loaded with riches, is surrounded by men.
Epigram: Dedicated to Thomas Ridgewaie, this emblem likens the gentleman to a camel which carries the burden but does not enjoy the riches.

CAMP
See:

PEAR TREE
Peacham, p. 136.

CANDELABRA
Farlie, no. 4.
Motto: "Quam numerosa Lux."
Icon: A candelabra with seven burning candles.
Epigram: Many candles resemble the light of the sun; at Doomsday saints shall mount the sky to join Christ, like many suns, and darkness shall be dispelled forever.

CANDLE
Astry, no. 58.

Motto: "In perdida de su luz."
Icon: Two unlit candles are held to the flame of another candle.
Epigram: As the flaming candle bestows its light on the other candles without losing any of its own brilliance, so the prince may bestow honor on those who deserve it without detriment to his own.

Ayres, no. 11.
Motto: "Love will out."
Icon: Cupid holds a barrel over a candle, but the light shines from a hole.
Epigram: Love cannot be hidden.

Bunyan, no. 12.
Motto: "Meditations upon the Candle."
Icon: None.
Epigram: Man is like a candle; as a candle receives its light from what it is not, so man receives grace from God; man's sinful state resembles an unlighted candle; man's death, a wick's end.

Bunyan, no. 42.
Motto: "Upon the Sight of a Pound of Candles falling to the Ground."
Icon: None.
Epigram: The candles which fall and are scattered about represent God's elect in their lapst state; the single candle which is lighted so that others can be found and picked up represents Christ.

Farlie, no. 1.
Motto: "Sursum."
Icon: A candle burns.
Epigram: As the light of a candle seeks its source, the soul of man seeks God.

Farlie, no. 2.
Motto: "Quo animula."
Icon: A candle burns out.
Epigram: When man dies, the soul returns "home" to its Maker.

Farlie, no. 6.
Motto: "Non sub Modio."
Icon: A candle burns.
Epigram: Priests, who are entrusted with the word of light, should not hide that light but show it to the world.

Farlie, no. 7.
Motto: "Par vis componere magna."
Icon: A candle shines on the earth; the sun, moon, and stars shine in the heavens.
Epigram: God's light surpasses the light of the sun, moon, stars, man.

Farlie, no. 10.
Motto: "Vita Mihi Mors."
Icon: A candle burns.
Epigram: As the candle's flame causes both its life

and its death, so that which gives us breath likewise spends our breath.

Farlie, no. 11.
 Motto: "Mihi noceo, aliis prosum."
 Icon: A candle burns while boys play; an arm holds another candle out a window.
 Epigram: As the candle sacrifices itself to give light to others, so Christ died so that men could live.

Farlie, no. 14.
 Motto: "Fessa tibi nunc Lampada trado."
 Icon: As a candle burns out, a man uses it to light another.
 Epigram: That man is happy who, at his death, leaves something that endures after him.

Farlie, no. 18.
 Motto: "Video & Taceo."
 Icon: A candle burns.
 Epigram: The candle, burning in the darkness, hears and sees the secrets of the night; man should, like the candle, say nothing about these secrets.

Farlie, no. 23.
 Motto: "Tenebrae mihi famam."
 Icon: A candle burns.
 Epigram: As a candle seems brighter when the stars are veiled in clouds, so virtue is more glorious when compared to vice.

Farlie, no. 28.
 Motto: "Memet Nutrio."
 Icon: A candle burns.
 Epigram: Like the candle which nourishes itself, the happy man is content with his own state, not taking from others.

Farlie, no. 30.
 Motto: "Mors mihi Lucrum."
 Icon: A candle with no flame.
 Epigram: As the candle lasts longer when the light is put out, so man gains eternal life by death.

Farlie, no. 31.
 Motto: "Sur sum Peto, deorsum trahor."
 Icon: A candle burns.
 Epigram: Like the candle, which reaches heavenward but sinks downward as it burns, man desires heaven but is bound by the body to Earth.

Farlie, no. 33.
 Motto: "Proprio sumptu."
 Icon: A candle burns.
 Epigram: Like the candle which contains its own sustenance and never begs, the wise man is content with what he has, refuses a patron's dole.

Farlie, no. 41.
 Motto: "Data Lux suspiria tollit."
 Icon: A candle nearly burned out.

 Epigram: When the candle shone brightly, it was valued, but when it diminished, it was neglected; likewise, when fortune favors man, he is admired, but when fortune frowns on him, he is scorned.

Farlie, no. 45.
 Motto: "Praestat morari."
 Icon: A woman replaces an old candle with a new one.
 Epigram: When one candle is almost burned out, another replaces it, extinguishing the first; so sons too often cause their fathers early deaths.

Farlie, no. 46.
 Motto: "Signum est Luxisse."
 Icon: An unlit candle.
 Epigram: The smoky snuff of the candle shows that it once shone; likewise, virtue and vice leave some tokens behind which remind us of them.

Farlie, no. 56.
 Motto: "In imo minimum & pessimum."
 Icon: A candle burns out.
 Epigram: Like the candle which burns brightly at first and then shines less, so man flourishes when he is young and then sorrows and decays.

Farlie, no. 58.
 Motto: "Vale."
 Icon: A candle burns out.
 Epigram: At death the body, like the snuff, turns to ashes; the soul, like the flame, rises to heaven.

Montenay, p. 246.
 Motto: "Quod nutrit me consummat."
 Icon: A man holds a candle upside down.
 Epigram: Like the candle which, when held upside down, is put out by the very wax which nourished it, so wicked men will be destroyed by their own wickedness.

Peacham, p. 66.
 Motto: "Allah vere. i. Deus dabit."
 Icon: One candle burns among three unlighted candles.
 Epigram: When an ambitious Moslem tyrant threatened the Christian state, God defeated him.

Wither, p. 76.
 Motto: "A Candle that affords no light, What profits it, by Day, or Night?"
 Icon: An unlit candle stands on a table.
 Epigram: Many men resemble the unlit candle: they do not use their talents or realize their potential.

Wither, p. 165.
 Motto: "My Substance, and my Light, are spent, In seeking other mens content."

Icon: A candle burns.
Epigram: As the candle consumes itself to give others light, so some men freely sacrifice themselves to help others.

See also:
BLINDMAN AND CANDLE
Farlie, no. 22.
BOOK, CANDLE, HOURGLASS
Whitney, p. 172.
BOOK, CANDLE, SUN
Montenay, p. 174.
BOREAS AND CANDLE
Farlie, no. 37.
BUBBLE AND SMOKE
Quarles, *Emb.*, p. 76.
CHRIST AND GRAVEYARD
Montenay, p. 258.
EYE AND CANDLE
Farlie, no. 20.
HOURGLASS
Hall, p. 104.
LIGHT
Montenay, p. 234.
OWL
Wither, p. 253.
SKULL AND WHEAT
Wither, p. 21.
See also: TAPER.

CANDLE AND CHILD
Jenner, no. 15.
Motto: "The cause why wicked men, die either suddenly, sullenly, or desperately."
Icon: Children fight while a candle burns.
Epigram: Children often waste the light their parents leave them at night and have to find their way to bed in the dark; so, too, many men waste the light of life their God gives them and find themselves desperately facing death.

CANDLE AND CUPID
Van Veen, p. 137.
Motto: "Lost loves speedie recoverie."
Icon: Cupid blows on flame of candle.
Epigram: Just as the candle which is blown out may be blown in again, so love which is lost may be recovered.

CANDLE AND DARKNESS
Quarles, *Emb.*, p. 56.
Motto: "Phosphere redde diem."
Icon: A human figure sits in the dark beside a candle.
Epigram: Man prays for God to bring the light of heaven and to bring him out of ignorance.

CANDLE AND FIRE
Farlie, no. 26.

Motto: "Consumar si non cito."
Icon: A hand lights a melting candle at a fire.
Epigram: If the candle is not lit at the fire quickly, the fire consumes it; so men of small means are at the mercy of their patrons.

CANDLE AND FLY
Bunyan, no. 22.
Motto: "Of the Fly and the Candle."
Icon: None.
Epigram: The fly which tries to fight the flame of the candle and burns trying to extinguish it is like the man who opposes the Gospel's light and is destroyed by the Gospel.
Farlie, no. 25.
Motto: "Nocitura peto."
Icon: A fly flies into the flame of a candle.
Epigram: As the fly is lured into the flame by its light and is burned, so fools are undone by attraction to glory.
Wither, p. 40.
Motto: "Those Fooles whom Beauties Flame doth blinde,
 Feele Death, where Life they thought to finde."
Icon: A fly flies into the flame of a candle.
Epigram: As the flame of the candle attracts and destroys the fly, so the beauty of women attracts and destroys lustful men.

CANDLE AND HAND
Farlie, no. 21.
Motto: "Cito consumar necesse est."
Icon: A hand holds a candle which burns on both ends.
Epigram: As the hand that holds the candle which burns on both ends risks being burned, so a friend who tries to prevent ruin of a profligate husband and wife risks malice from both of them.
Peacham, p. 3.
Motto: "Cui cedet."
Icon: Two hands grip a burning candle from one direction; a third hand holds it from the opposite side.
Epigram: The burning candle is divine truth; the two hands represent ambition and greed, which seek to extinguish the light; the third hand is God's, which defends the truth.

CANDLE AND KNIFE
Farlie, no. 29.
Motto: "Non memet Extinguo."
Icon: A man kills himself with a knife as a candle burns.
Epigram: The man who commits suicide violates nature.

CANDLE AND MATCH

Farlie, no. 43.

> Motto: "Sic Vos non Vobis."
>
> Icon: A man lights a candle with a match; on the table are a tinderbox, flint, and steel.
>
> Epigram: The candle, match, steel, flint, and tinderbox all serve man; so everything on earth is for man's use.

CANDLE AND MATRON

Farlie, no. 16.

> Motto: "Perdita Invenio."
>
> Icon: A matron sweeps the floor with a broom as a candle burns.
>
> Epigram: As the matron uses the light of a candle to find the groat she has lost, so man should light "cleanthes lamp" and find "the lost treasure of our mind."

CANDLE AND MORNING STAR

Farlie, no. 17.

> Motto: "Phosphore redde diem."
>
> Icon: A candle burns out as the morning star rises.
>
> Epigram: When the candle that has shined throughout the night begins to go out, the morning star rises to give light; so, too, when God's holy servants on earth die, they call on Christ to come.

CANDLE AND MOTH

Van Veen, p. 103.

> Motto: "For one pleasure a thowsand paynes."
>
> Icon: Moths fly around the flame of a candle.
>
> Epigram: The lover is like the moth which delights in the light of the candle but is burned if he flies into the flame.

CANDLE AND RAT

Farlie, no. 13.

> Motto: "Sic perire miserum est."
>
> Icon: Rats climb, gnaw on a candle.
>
> Epigram: As the rats consume the candle before it has completely burned, so some youths have met untimely deaths.

Farlie, no. 19.

> Motto: "Lucentem metuistis."
>
> Icon: Rats climb on a candle.
>
> Epigram: While the candle burned, no one injured it, but when its light was snuffed out, it was devoured by rats; so glory is a defense from envy which, when vanished, makes man vulnerable.

CANDLE AND RUST

Farlie, no. 12.

> Motto: "Aut splendore aut situ consumor."
>
> Icon: A candle burns beside rust.
>
> Epigram: It is better to give light to others than to rest in sloth, better to die by light than by rust.

CANDLE AND SMOKE

Farlie, no. 36.

> Motto: "Dum spiro spero."
>
> Icon: A candle burns out, smokes.
>
> Epigram: Until the candle is completely extinguished, it has hope; so, too, man has hope until he dies.

CANDLE AND SUN

Farlie, no. 3.

> Motto: "Hinc mihi sordes."
>
> Icon: A candle burns beneath the sun.
>
> Epigram: When the soul is "plung'd into the body darke," it forgets that it was once pure, a child of the sun.

Farlie, no. 9.

> Motto: "Parce, alias fruere."
>
> Icon: A man snuffs out the light of a candle as the sun rises.
>
> Epigram: If the candle is put out when the sun rises, it will last and give light when there is no day; so man should husband well his estate.

Farlie, no. 34.

> Motto: "Lucenti non invideo."
>
> Icon: The sun shines on two candles, one with a flame, one without.
>
> Epigram: Glory inspires envy, but a greater glory like the sun takes the envy from a lesser glory like the candle.

Montenay, p. 402.

> Motto: "Quid vero agis."
>
> Icon: A man holds a candle while the sun shines.
>
> Epigram: As the candle is useless in broad sunlight, so superstition is powerless in the light of God.

CANDLE AND TABLE

Wither, p. 181.

> Motto: "A Vertue hidden, or not us'd, Is either Sloth, or Grace abus'd."
>
> Icon: A candle burns on the floor beside a table.
>
> Epigram: Men who hide their gifts or fail to realize their potential are like lighted candles beneath a table, useless.

CANDLE AND TAPER

Farlie, no. 39.

> Motto: "Exitus Probat."
>
> Icon: A candle and a taper burn out.
>
> Epigram: While they burned, the taper and the candle both shone, but after they were put out, one gave off an odious smell, the

other a sweet smell; likewise, wicked and honest men seem the same in life but are differentiated in death.

CANDLE AND TORCH

Farlie, no. 50.

Motto: "Si tu foris, Ego domi."

Icon: A man holds a torch, and a candle sits on a table.

Epigram: The husband is like the torch which ventures into the night; the wife, like the candle which stays inside keeping the house lighted.

CANDLE AND WIND

Farlie, no. 24.

Motto: "Magis consumor minus luceo."

Icon: A wind blows on the flame of a candle.

Epigram: When the wind blows in anger on a candle, the candle shines less but is consumed faster; it is impossible to push things bounded by nature beyond their limits.

CANDLE AND WORLD

Montenay, p. 226.

Motto: "Non ex te."

Icon: A man turns from the world and kneels beside a burning candle.

Epigram: If man is rich or wise or eloquent in this world, he should attribute his glory to God.

CANDLE, HOURGLASS, SKULL

Wither, p. 184.

Motto: "This Day, my Houre-glasse, forth is runne,
Thy Torch, to Morrow, may bee done."

Icon: A child rests his arm on a skull and sits beside a burning candle on the top of an hourglass.

Epigram: All men are mortal and may die tomorrow.

CANDLE, PROPHET, SEAL

Willet, no. 35.

Motto: "Ministri officium."

Icon: None.

Epigram: As the seal leaves a print on the paper, so the pastor must inform the mind; as the candle lights the house, so he must shine; as the Prophet healed the "pottage," so he must give alms.

CANDLESTICK, LAMP, OIL, OLIVE TREE, PIPE

Willet, no. 8.

Motto: "Ecclesia veritatis columna."

Icon: None.

Epigram: The candlestick represents the church; the seven burning lamps, God's grace; the pipes which run oil, the minister; the oil, the spirit; the olive tree, Christ.

CANNON

See:

BALANCE

Peacham, p. 44.

CANNON AND QUADRANT

Astry, no. 4.

Motto: "Non solum armis."

Icon: A hand loads a cannon with a "quadrant."

Epigram: Law and learning are as important to the state as arms, and peace should be equally as well governed as war.

CANVAS

Astry, no. 2.

Motto: "Ad Omnia."

Icon: A hand holds pencils and colors beside a blank canvas.

Epigram: The relationship between nature and art.

Cap

See: HAT.

CAP OF LIBERTY, CUPID, YOKE

Van Veen, p. 73.

Motto: "For freedom servitude."

Icon: Cupid stands on a cap of liberty holding a yoke.

Epigram: Love leads the lover to "willing bondage."

CAP ON SPEAR

P. S., p. 228.

Motto: "Captive liberte."

Icon: A cap on a spear.

Epigram: The cap on a spear was used as a sign of liberty but actually represents licentious liberty to sin, which is in fact servitude.

CAPRICORN

P. S., p. 35.

Motto: "Imperium sine fine dedi."

Icon: The image of capricorn.

Epigram: Augustus Caesar, born under Capricorn, attributed his power and fortune to Capricorn.

CAPTAIN

Willet, no. 13 (misnumbered 14).

Motto: "Index equus."

Icon: None.

Epigram: As the captain will encourage his soldiers, so the judge must help the poor and give each what is due.

Captive

See: PRISONER.

CAPTIVE AND KING

Bunyan, no. 50.

Motto: "Of the Love of Christ."

Icon: None.

Epigram: Like the king who dies so that captive slaves may live, Christ died so that man may live; Christ makes captives kings.

Carcass
See: CARRION.

CARD
See:

SIEVE
Quarles, *Emb.*, p. 88.

CARPENTER
Jenner, no. 9.

Motto: "Reconciliation to God."

Icon: A carpenter works at a bench with tools.

Epigram: Christ is like a carpenter, joining man to God.

Wither, p. 148.
R. B., no. 19.

Motto: "When each man keepes unto his Trade, Then, all things better will be made."

Icon: A carpenter holds the tools of his trade.

Epigram: We should be like the carpenter, staying with the trade we know best and not meddling in others' affairs.

Carriage
See: CHARIOT.

CARRION AND RAVEN
Montenay, p. 206.

Motto: "Speculum fidele."

Icon: Ravens feed on carrion.

Epigram: As the ravens feed on the dead carrion, so our souls feed on the spiritual food of the Sacrament.

CARRYING MAN
See:

ANCHOR
Arwaker, bk. 2, no. 13.
Quarles, *Emb.*, p. 231.

CASPIAN SEA
Peacham, p. 27.

Motto: "Sine refluxu."

Icon: A rocky shore surrounds a body of water.

Epigram: Just as the Caspian Sea is still and unchanging, so should man be constant.

CASTLE AND WATER
Astry, no. 83.

Motto: "Me combateny deffiender."

Icon: A castle in the middle of waters.

Epigram: Because no castle is impregnable unless situated in the midst of waters, the safety of a state depends on the exercise of arms.

CASTLE, CHRIST, HERETIC
Godyere, no. 29.

Motto: "Bis interimitur qui suis armis perit."

Icon: Christ holding a cross stands at the top of a castle guarded by angels and apostles; Catholic heretics outside the castle are consumed by fire.

Epigram: Catholic heretics who attempt to undermine "the Castle of Christs-truth" destroy themselves.

CASTOR AND POLLUX
P. S., p. 211.

Motto: "Prosper uterque mari."

Icon: Two "fires" of Castor and Pollux.

Epigram: When two fires called Castor and Pollux appear together, they are a sign of good luck, but if either appears alone, it is a sign of bad luck; so, too, if love between a husband and wife flourishes, there is domestic bliss, but if either one is froward, there will be ruin.

CAT
P. S., p. 74.

Motto: "Arbitrii mihi jura mei."

Icon: A cat.

Epigram: The cat represents liberty.

See also:

MELANCHOLY
Peacham, p. 126.

CAT AND COCK
Peacham, p. 118.

Motto: "Innocentiam iniuriis maximè obnoxiam esse."

Icon: A cat holds a cock in its mouth.

Epigram: The cat accuses the cock of unnatural acts: incest and crowing while others sleep.

CAT AND MOUSE
Whitney, p. 222.

Motto: "Impunitas ferociae parens."

Icon: Two cats lie in cages while mice dance around them.

Epigram: Just as mice rejoice when cats are caged, so wicked men rejoice when worthy men are persecuted.

Wither, p. 215.
R. B., no. 28.

Motto: "When Magistrates confined are, They revell, who were kept in feare."

Icon: Mice play around a cat in a cage.

Epigram: The cat represents the tyrant; the mice, men he kept in fear; when the tyrant is confined, those he persecuted will rejoice.

CAT, FOX, HOUND
Peacham, p. 138.

Motto: "Dolis minime fidendum."

Icon: A hound attacks a fox as a cat hides in a tree.

Epigram: The fox was killed by the hounds even though it had cultivated many devious "shifts"; the cat, however, escaped the hounds with her one honest "shift."

CATHOLIC CLERIC

See:

SHIP

Godyere, no. 22.

CAVE

See:

TRUTH

Whitney, p. 4.

USURER

Thynne, no. 20.

CAVE AND THUNDERBOLT

Arwaker, bk. 1, no. 12.

Motto: "Oh! that thou would'st hide me in the Grave! that thou would'st keep me secret, until thy wrath be past!"

Icon: A man hides in a cave from Divine Love with thunderbolts.

Epigram: Man's fear of God's wrath causes him to try vainly to hide himself from God.

Quarles, *Emb.*, p. 168.

Motto: "O that thou wouldst protect me in the grave and hide me untill thy furie be past."

Icon: A man hides in a cave as Divine Love pursues him with thunderbolts.

Epigram: Man cannot hide from God's vengeance but is safe with a clean conscience.

CEDAR AND OAK

Willet, no. 80.

Motto: "Animi constantia."

Icon: None.

Epigram: The cedar and the oak, which can withstand the buffeting of winds, represent constancy.

CEDAR BRANCH

See:

BOOK

Peacham, p. 40.

CENTAUR

Wither, p. 103.

R. B., no. 42.

Motto: "When great Attempts are undergone, Joyne Strength and Wisdome, both in one."

Icon: A centaur holds a snake and a bow.

Epigram: Join wisdom (the upper part of the cen-taur, the snake) with strength (the lower part of the centaur, the bow).

CERBERUS AND HERCULES

Thynne, no. 26.

Motto: "Philosophie."

Icon: None.

Epigram: Three-headed Cerberus represents philosophy (divine, human, and natural); Hercules, conquering Cerberus in his last labor, represents the valiant mind conquering philosophy through painful toil.

CERES

See:

CUPID AND VENUS

Peacham, p. 174.

CHAFF

Willet, no. 95.

Motto: "Regis authoritas."

Icon: None.

Epigram: As the wind sifts chaff from corn, so the king rids the country of vice.

See also:

SIEVE

P. S., p. 184.

Whitney, p. 68.

CHAFFINCH

See:

BIRD

Whitney, p. 54.

CHAIN

Godyere, no. 5.

Motto: "Morir piu tosto che mancar di fede."

Icon: A chain encircles a chain, connected by hands; pales project from an inner chain; in the center is a heart with a winged head inside.

Epigram: The chain represents religion; the hands, concord; the "spiny pale," conflict; the heart, the Church; the wings and head, the Holy Ghost.

See also:

BOOK AND SATAN

Montenay, p. 318.

BUBBLE AND SMOKE

Quarles, *Emb.*, p. 76.

CAGE AND HEART

Hall, p. 44.

CROWN

Peacham, p. 1.

EARTH AND KING

Quarles, *Emb.*, p. 276.

HEART

Hall, p. 32.

WIFE
Combe, no. 93.
See also: SHACKLE.

CHAIN AND HAND
P. S., p. 141.
 Motto: "Nec fas est, nec posse reor."
 Icon: Hands are freed from chains.
 Epigram: The true slave is not he whose hands are chained but rather he who is entangled in sin.

CHAIN AND LION
Peacham, p. 82.
 Motto: "Arbiter ipse mei."
 Icon: A lion holds a chain which binds him.
 Epigram: As the lion who slips out of the collar and chain which binds him is more courageous in his freedom, so the righteous man, freed from hell's bondage, is happy.

CHAIN AND POLEAX
P. S., p. 72.
 Motto: "Hoc Latio restare canunt."
 Icon: Two poleaxes, decorated with garlands and bundles of rods, are chained together.
 Epigram: The traditional image of the triumphs of Rome—the poleaxes adorned with garlands and rods—are chained to signify the bondage and ruin of Italy today.

CHAIN OF COCKLES
P. S., p. 25.
 Motto: "Immensi tremor Oceani."
 Icon: A gold chain of cockleshells tied with a double knot with the image of Saint Michael on a pendant.
 Epigram: The gold chain is a sign of virtue, concord, and friendship; the gold signifies magnanimity; the cockles, equality; the knots, covenant of friendship; the image of Saint Michael, victory over the devil.

CHAIN OF GOLD
P. S., p. 43.
 Motto: "Fortitudo eius Rhodum tenuit."
 Icon: A golden chain.
 Epigram: The chain is a symbol of the Knights of Rhodes; it has on it four letters and an image of the Annunciation which signify the greatness of Amatus, the first knight.

CHAIN, GLOBE, WING
Arwaker, bk. 3, no. 9.
 Motto: "I am in a straight between two, having a desire to be dissolved and to be with Christ."
 Icon: A winged figure reaches to heaven but is chained to a globe.

 Epigram: Man's desire to be united with God is hindered by his earthly existence.

CHAIR AND CUPID
Van Veen, p. 95.
 Motto: "Love hath no rest."
 Icon: Cupid walks past empty chairs.
 Epigram: Love cannot rest in any seat, for he continually tries to please his mistress.

CHALKSTONE
Bunyan, no. 54.
 Motto: "Upon the Chalk-Stone."
 Icon: None.
 Epigram: Like the chalkstone, which is white, warm, and soft and leaves a white impression on those it touches, the child of God is white in life, warm in affection, and easily wrought upon and leaves an impression of godliness on those with whom he deals.

CHAMELEON AND CUPID
Ayres, no. 24.
 Motto: "Compliance in Love."
 Icon: Cupid holds a chameleon.
 Epigram: The lover is tuned by his beloved and, like the chameleon, takes on whatever color she gives.
Van Veen, p. 63.
 Motto: "As love will."
 Icon: Cupid holds a chameleon.
 Epigram: Love is like the chameleon, changing according to the will of the beloved.

CHAMELEON AND DOLPHIN
P. S., p. 243.
 Motto: "Mature."
 Icon: A chameleon and a dolphin.
 Epigram: The importance of "slow celerity" in one's actions.

CHAOS
Whitney, p. 122.
 Motto: "Sine justitia, confusio."
 Icon: A confused, disordered world in which the wind, sea, and heavenly bodies exist independently of each other.
 Epigram: A survey of biblical history and classical myth presents the idea that without justice chaos reigns.

CHAPMAN
Jenner, no. 18.
 Motto: "The Reprobates utmost bounds."
 Icon: A chapman considers his merchandise.
 Epigram: Like the chapman who looks for wares at the cheapest prices and ends up buying nothing, so the youth decides that God's

kingdom must be had at too dear a price and thus loses heaven.

CHARIOT
See:

DIANA
Hawkins, no. 10, p. 111.

DILIGENCE AND IDLENESS
Combe, no. 100.

CHARIOT AND FIRE
P. S., p. 70.
Motto: "Qua Proceres abiere pii."
Icon: A fiery chariot.
Epigram: As Elias was carried through the air in a fiery chariot, so true worshipers ascend to heaven in fervent meditation.

CHARIOT AND SCYTHE
Astry, no. 64.
Motto: "Resolver i executar."
Icon: A chariot with scythes on its wheels is pulled by a team of horses.
Epigram: The chariot represents speedy execution, for it moves and executes at the same time.

CHARIOT, DEVIL, WORLD
Quarles, *Emb.*, p. 44.
Motto: "Mundus in exitium ruit."
Icon: A goat and a pig pull the world in a chariot driven by the devil; Divine Love tries to pull back the world.
Epigram: The devil holds the world captive, drives it to hell.

Charity, Charitable act
See: ALMSGIVING.

Cherry tree (cornelian)
See: CORNEL TREE.

CHERUB
See:

CHURCH
Willet, no. 37.
See also: ANGEL, DIVINE LOVE.

Chesbole
See: POPPY.

CHESBOLE AND STAFF
P. S., p. 182.
Motto: "Aequari pavet alta minor."
Icon: A staff cuts off "chesboles," or poppies.
Epigram: On a walk with his son, Tarquin cut off the heads of chesboles with his staff to indicate his intention of punishing the nobles to subdue them.

CHESS GAME
Combe, no. 27.

Motto: "When death doth call us at the doore,
 What ods betwixt the Prince and poore?"
Icon: Men play at chess.
Epigram: In the chess game the king controls all the other men until the mate is given; so in life the distinctions between high and low become meaningless in death.

See also:

ARCHIMEDES
Whitney, p. 208.

CHICK
See:

HEN AND KITE
Montenay, p. 366.

CHICK AND EGG
Bunyan, no. 3.
Motto: "Meditations upon an Egg."
Icon: None.
Epigram: The shell of an egg is like the flesh of man; the chick is the soul which is freed when the flesh falls off; the sinful flesh is like the rotten egg.

Chicken
See: CHICK, COCK, HEN.

CHILD
Bunyan, no. 66.
Motto: "Upon the Disobedient Child."
Icon: None.
Epigram: Because of Original Sin children rebel and disobey even when they are loved and cared for.

See also:

BIRD AND CHILD
Bunyan, no. 31.
CANDLE AND CHILD
Jenner, no. 15.
CANDLE, HOURGLASS, SKULL
Wither, p. 184.
FRUIT TREE
Whitney, p. 173.
See also: BABE, BABY, BOY, INFANT.

CHILD AND FATHER
Jenner, no. 25.
Motto: "The right carriage of a Christian in his calling."
Icon: A child brings chips to his father.
Epigram: The relationship between the child and his parent is like the relationship between man and God; the child is concerned with pleasing his father by bringing him chips, not with the chips themselves; so man should care about doing God's will, not about wealth.

CHILD AND FOOL
Whitney, p. 81.
 Motto: "Fatuis levia commitito."
 Icon: A child on his cockhorse, a fool in motley
 and coxcomb with baubles, and a man.
 Epigram: Just as a young child is pleased with his toy
 and a fool prefers his toys to jewels, so vain
 men seek honors they do not deserve; the
 prudent prince gives them their due, no
 more.

CHILD AND MOTHER
Montenay, p. 266.
 Motto: "Non est fastidiosa."
 Icon: A mother holds children on her lap, and
 others gather around her.
 Epigram: Like the good parent who loves and cares
 for her children, God will help us when
 we need him.

CHILD AND WALKER
Arwaker, bk. 2, no. 3.
 Motto: "O hold thou up my goings in thy paths,
 that my footsteps slip not."
 Icon: A child in a walker moves toward Divine
 Love.
 Epigram: Man is a child, his steps slow; God lends
 him a helping hand.
Quarles, *Emb.*, p. 192.
 Motto: "Stay my stepps in thy Pathes that my feet
 do not slide."
 Icon: A child in a walker reaches toward Divine
 Love.
 Epigram: Man is a child, his steps slow; God lends
 him a helping hand.

CHILD AT WATCH
Wither, p. 94.
 Motto: "Death's one long-Sleepe; and, Life's no
 more,
 But one short-Watch, an houre before."
 Icon: A child with his head on his arm sits be-
 side a table with an open book, a lighted
 candle, and an hourglass.
 Epigram: Man's life is no more than a short watch;
 man should not waste his time but prepare
 himself for the Lord's summons.

CHILD, MOTHER, WOLF
Whitney, p. 162.
 Motto: "In eos qui multa promittunt, & nihil
 praestant."
 Icon: A mother scolds her child while a wolf
 prowls outside the house.
 Epigram: The wolf, overhearing the mother threaten
 to throw her child to wolves, is disap-
 pointed when the mother assures the child
 he will not be the wolf's prey; the wolf

complains of people who promise much
but give nothing.

CHILD, SKULL, SNAKE BITING TAIL
Wither, p. 45.
R. B., no. 1.
 Motto: "As soone, as wee to bee, begunne;
 We did beginne, to be Undone."
 Icon: A child sits beside a skull within a snake
 biting its tail.
 Epigram: An emblem of mortality, this icon presents
 a child and skull to signify that "from our
 very Birth, our Dying springs" and a
 snake biting its tail to represent the "Revo-
 lution of all Earthly things."

CHILDBIRTH
Willet, no. 40.
 Motto: "Humana conditio."
 Icon: None.
 Epigram: As the child is born through great travail
 and labor, man's entire life is full of strife.

CHIPS
See:
 CHILD AND FATHER
 Jenner, no. 25.

CHOICE BETWEEN CUPID AND LAW
See:
 CUPID AND LAW
 Arwaker, bk. 2, no. 1.
 Quarles, *Emb.*, p. 184.

CHOICE OF HERCULES
See:
 HERCULES
 Whitney, p. 40.
 VIRTUE AND VICE
 Wither, p. 22.
 R. B., no. 2.

CHOKING
See:
 THIEF
 Whitney, p. 41.

CHOLER
Peacham, p. 128.
 Motto: "Cholera."
 Icon: A man holds a sword; behind him lie a
 lion and a shield with a flame on it.
 Epigram: Choler holds a sword in wrath, is young
 and passionate, and is, like the lion, ruth-
 less and brave.

CHOPPING OAK
Wither, p. 29.
R. B., no. 40.
 Motto: "By many Strokes, that Worke is done,
 Which cannot be perform'd at One."

Icon: A man chops an oak with an axe.
Epigram: What cannot be accomplished with one attempt can be done with many.

CHRIST
See:

CASTLE, CHRIST, HERETIC
Godyere, no. 29.
CHURCH
Willet, no. 37.
RAINBOW
Hawkins, no. 9, p. 100.
SHIP
Hawkins, no. 21, p. 253.

CHRIST AND GRAVEYARD
Montenay, p. 258.
Motto: "Surge, Illucescet tibi Christus."
Icon: Christ stands in a graveyard among skulls, bones, a corpse, and a pick and shovel and lights a candle.
Epigram: Christ pitied man and came into this world to drive away Satan, death, and hell.

CHRISTIAN
See:

MARTYR
Whitney, p. 224.

CHRIST ON CROSS
E. M., frontispiece.
Motto: "And it shall bee for a sign unto thee upon thine hand,
and for a memoriall betwene thine eyes."
Icon: Christ on the Cross.
Epigram: This book develops analogies between parts of Christ's body and the Beautitudes: (1) nakedness and the poor in spirit, (2) bowed head and the meek, (3) weeping and those who mourn, (4) mouth and those who thirst, (5) bleeding and the merciful, (6) wounded side and the pure of heart, (7) hands and the peacemakers, and (8) feet and the persecuted.

CHURCH
Willet, no. 37.
Motto: "Rectè precanti praeste adest Christus."
Icon: None.
Epigram: Cherubs, angels, and Christ are present in the house of prayer; therefore, man "ought to pray with fear."
See also: TEMPLE.

CHURCH AND STORK
Astry, no. 25.
Motto: "Hic tutior."
Icon: A stork in a nest on the steeple of a church.
Epigram: As the stork builds its nest on the church steeple for security, so the Prince founds his Kingdom on the Church to make it strong and lasting.

CHURN AND CUPID
Van Veen, p. 119.
Motto: "Moving maketh uniting."
Icon: Cupid churns milk.
Epigram: As milk which is "moved" solidifies, so lovers' minds are unified after resistance.

CIRCE
Whitney, p. 82.
Motto: "Homines voluptatibus transformantur."
Icon: Circe waves a wand at animals.
Epigram: Ulysses' men whom Circe transformed into beasts preferred to serve her rather than to return to their former shape; they are like men who give in to passion and desire rather than serve God.

CIRCLE
See:

COMPASS
Wither, p. 143.
CROWN, HANDSHAKE, HEART
Wither, p. 237.
ETERNITY
Peacham, p. 141.

CIRCUMCISION AND HEART
Harvey, no. 13.
Motto: "Cordis Circumcisio."
Icon: A human figure holds a heart, dangling with worldly things, and reaches for a knife offered by Divine Love.
Epigram: Christ cures the soul by killing sin; to follow him, men must circumcise their hearts, cutting out pride, wealth, ambition.

CITY AND CORD
P. S., p. 187.
Motto: "Virtutis Fortuna comes."
Icon: Cities are encompassed in a net of cords.
Epigram: When painters portrayed Fortune giving Timotheus of Athens cities encompassed in cords, Timotheus took offense, believing that they attributed his happiness to Fortune rather than to virtue.

CITY GATE
See:

PILGRIM
Arwaker, bk. 2, no. 7.

CITY OF GOD
Van der Noodt, no. 20.
Motto: None.
Icon: John kneels, looks at the holy city of God

which an angel shows him. It is square, with gates of pearl, golden houses, and a stream.

Epigram: The City of God is eternal and perfect.

CITY WATCH
See:
EMBRACE
Arwaker, bk. 2, no. 12.
Quarles, *Emb.*, p. 228.

Clay
See: EARTHEN.

CLAY, DUST, POTTER
Arwaker, bk. 1, no. 5.
Motto: "Remember, I beseech thee, that thou hast made me as the clay, and wilt thou bring me into dust again?"
Icon: Divine Love shapes clay on a potter's wheel, while a human figure blows on dust.
Epigram: God created man from clay; man is thus fragile, mortal.

Quarles, *Emb.*, p. 140.
Motto: "Remember I beseech thee, that thou hast made me as the clay, & wilt thou bring me into dust againe!"
Icon: Divine Love shapes clay on a potter's wheel, while a human figure blows on dust.
Epigram: Man comes from earth and must to earth return; God is the eternal Potter who creates man.

Cleaning
See: WASHING.

Clergy
See: CATHOLIC CLERIC, NUN, PREACHER, PRELATE, PRIEST.

CLOAK
Jenner, no. 20.
Motto: "The second false putting on of Christ."
Icon: A man hangs a cloak in a corner, while another examines cloth.
Epigram: A hypocrite wears religion like a cloak in public but takes it off at home.

CLOCK
Astry, no. 57.
Motto: "Uni reddatur."
Icon: A clock.
Epigram: As the wheels of a clock perform their office silently and well, giving the hand its motion, so counselors should be in mutual correspondence with their Prince, helping him but not usurping his authority.

Combe, no. 71.
Motto: "There is no thing can be more deere, Than Time, if we could keepe it heere."

Icon: A woman holds a clock on a sieve.
Epigram: Once past, time will not return; therefore, man should take time while he may.

See also:
HOURGLASS
Hall, p. 104.
See also: SUNDIAL.

CLOCK, WING, YOUTH
Combe, no. 68.
Motto: "When youth is in his flowring prime, He cares not how he passe his time."
Icon: A youth pulls the weights of a winged clock.
Epigram: Youth wastes time, hastens his own dying day.

CLOTH
See:
MAGNIFYING GLASS
Peacham, p. 56.
PURPLE
Astry, no. 16.
SHEARS
Astry, no. 14.

CLOTHES
Bunyan, no. 16.
Motto: "Upon Apparel."
Icon: None.
Epigram: Although God gave man clothes to hide his nakedness, man uses them to expose his pride.

Clothing
See: CAP, CLOAK, CLOTHES, COAT, GARMENT, GIRDLE, HAT, ROBE, SCARF, SHIRT, VEIL.

CLOUD
Bunyan, no. 15.
Motto: "Upon the Suns Reflection upon the Clouds in a fair morning."
Icon: None.
Epigram: Clouds laced with the gold of the sun are like the prayers of saints, returned with manifold blessings.

Willet, no. 26.
Motto: "Nesciat sinistra, quid faciat dextra."
Icon: None.
Epigram: As the cloud drops rain on everything, without discrimination, so the poor give freely.

See also:
BIRD AND CLOUD
Godyere, no. 27.
MOUNTAIN
Peacham, p. 163.

CLOUD, LADY, SERPENT
Van der Noodt, no. 6.

Motto: None.
Icon: A beautiful lady walks on flowers and herbs. In a second image of the same woman she is in clouds, and a serpent bites her heels.
Epigram: On earth nothing endures but suffering.

CLOUDS AND SUN
Bunyan, no. 11.
Motto: "Upon a Low'ring Morning."
Icon: None.
Epigram: The sun in the clouds creates red streams; then the clouds pour forth rain; likewise, the Gospel light creates in us a sense of both grace and sin.

CLOVE TREE
E. M., no. 4.
Motto: "Sic Amor attrahat ardens."
Icon: A clove tree.
Epigram: The clove tree, which draws all the moisture and nutriments to itself, represents the man who hungers and thirsts after righteousness.

CLUB
See:
BACCHUS AND LION SKIN
Combe, no. 48.
CUPID AND HERCULES
Van Veen, p. 33.
HERCULES
Peacham, p. 36.
Whitney, p. 16.
Whitney, p. 40.
LION SKIN
Astry, no. 97.

CLUB AND DOG
Astry, no. 9.
Motto: "Sibimet invidia vindex."
Icon: Two dogs bite a club.
Epigram: Envy opposes the glory of Hercules, but in doing so, destroys itself.

CLUB AND OLIVE BRANCH
P. S., p. 150.
Motto: "Utrum lubet."
Icon: An olive branch entwines a club.
Epigram: The club entwined with the olive branch signifies the choice of either war or peace.

COAL AND SUN
Peacham, p. 29.
Motto: "Sol alter, veritas."
Icon: Coals burn in a grate as the sun shines.
Epigram: As the sun outshines the glowing coals which seemed bright in the darkness, so truth outshines and exposes traitorous plots that burned in secret.

COAT
See:
STORM AND TRAVELER
Jenner, no. 21.

COAT OF ARMS, CUPID, PALM
Van Veen, p. 65.
Motto: "Love excelleth all."
Icon: Cupid tramps on a coat of arms, holds a palm.
Epigram: Love recognizes no differences of birth or wealth.

COBWEB
P. S., p. 154.
Motto: "Lex exlex."
Icon: A cobweb.
Epigram: The law is like a cobweb: it oppresses little flies but never touches great ones.

COCK
Ayres, no. 12.
Motto: "Life for love."
Icon: Two cocks face, threaten one another as Cupid watches.
Epigram: Rival lovers are likened to cocks which will fight to the death.
Peacham, p. 139.
Motto: "Vigil utrinque."
Icon: A cock on top of a beacon.
Epigram: God's ministers should be like this cock, ever watchful.
Wither, p. 71.
Motto: "To brawle for Gaine, the Cocke doth sleight;
But for his Females, he will fight."
Icon: Two cocks face one another, with hens and other birds in the background.
Epigram: Beware of men who, like the cocks, will fight with fury and rage over a female, however base.
See also:
AESCULAPIUS
Whitney, p. 212.
CAT AND COCK
Peacham, p. 118.
GANYMEDE
Peacham, p. 48.
SLEEP
Quarles, Emb., p. 28.

COCK AND JEWEL
Thynne, no. 19.
Motto: "Diligence obtayneth Riches."
Icon: None.
Epigram: The hungry cock steadfastly sought for food in the dunghill and found a precious jewel; this illustrates how the gods relieve needy souls who labor diligently.

COCK AND LION
Whitney, p. 120.
Motto: "Vigilantia, & custodia."
Icon: A cock perches on the roof of a Roman temple; a lion sits by the door.
Epigram: The cock which wakes men from sleep represents the pastoral duty of waking the world from the sleep of sin; the lion which guards the gates represents the pastoral duty of defending Christian people from their enemies.

COCK AND TRUMPET
P. S., p. 267.
Motto: "Pacis & armorum vigiles."
Icon: A cock stands on a trumpet.
Epigram: The trumpet is the watch of war, the cock of peace.

COCKLE
See also:
CHAIN OF COCKLES
P. S., p. 25.

COCKLE FISH
P. S., p. 193.
Motto: "Cocumque ferar."
Icon: A cockle fish.
Epigram: Like the cockle fish, which is always ready to hurt its enemy, wicked men continually oppress others.

CODRUS, DIOGENES, KING
Whitney, p. 198.
Motto: "Animus, non res."
Icon: Diogenes sits in his barrel, Codrus sits at a low stool, and a king with a crown and scepter stands beside them.
Epigram: Diogenes, who gave up all his goods and lived in a barrel, and Codrus, who ate modestly at a stool, were richer than kings, for they were content.

Coffer
See: ARK OF THE COVENANT.

COFFIN
See:
LANTERN
Quarles, *Hier.*, no. 8.

COIN
Quarles, *Emb.*, p. 80.
Motto: "Non omne, quod hic micat, aurum est."
Icon: Divine Love stands beside a table spread with coins and an armillary sphere and points to heaven.
Epigram: The world is false and deceitful; it entices man with vain treasures.

See also:
GANYMEDE
Peacham, p. 48.
See also: GOLD, MONEY, RICHES, SHILLING, SILVER GROAT.

COIN AND TOUCHSTONE
Wither, p. 233.
Motto: "All is not Gold, which makes a show; But, what the Touchstone findeth so."
Icon: A hand holds a coin to a touchstone.
Epigram: The touchstone distinguishes true gold from false appearances; so, too, trial proves many apparent friends false.

COLASMUS
Whitney, p. 158.
Motto: "Post fata: uxor morosa, etiam discors."
Icon: People gather by a stream.
Epigram: When Colasmus's wife drowned in a flood, he looked for her body upstream rather than down, explaining that his wife always fought against reason; he was advised that such a wife was better lost than found.

COLOR
See:
CANVAS
Astry, no. 2.
DYEING CLOTH
Whitney, p. 134.

Coloring
See: DYEING.

COLOSSUS OF RHODES
Peacham, p. 161.
Motto: "Ulterius durabit."
Icon: The Colossus of Rhodes straddles the entrance of a harbor, holding a book and a lamp.
Epigram: Monuments decay in time, but good literature is invulnerable to time.

COLT
Astry, no. 38.
Motto: "Con halago i con rigor."
Icon: A hands holds a whip in front of a colt and strokes the colt.
Epigram: As the horse courser breaks his colt, using the same hand to stroke and threaten it, so the Prince must tame his subjects.

Column
See: PILLAR, SPIRE.

COLUMNAE ROSTRATAE
See:
PILLAR AND SHIP
Astry, no. 30.

COMET
P. S., p. 209.
 Mottò: "Candor illaesus."
 Icon: A comet.
 Epigram: As a comet portends either good fortune or great hurt, so the government of a new prince shall experience either success or destruction.

COMET AND SWORD
P. S., p. 143.
 Motto: "Ventura desuper urbi."
 Icon: A sword hangs in front of a comet.
 Epigram: The comet in the shape of a sword foreshadowed the destruction of Jerusalem after the Passion of Christ; it is a sign of God's justice.

Commerce
See: TRADE.

COMPASS
Astry, no. 56.
 Motto: "Qui a secretis ab omnibus."
 Icon: A hand holds a compass to paper.
 Epigram: The prince's secretary is like the compass; he not only writes but measures the resolves and sets a fit time for their execution.

Peacham, p. 72.
 Motto: "Te aspicit unam."
 Icon: A compass with a needle pointing north lies beside a drawing compass; stars shine.
 Epigram: The writer assures "Sidenia" that, although he admires many who shine from afar, she is his "Arctick," that which he most desires.

Peacham, p. 184.
 Motto: "In Requie, Labor."
 Icon: A compass inscribes two circles.
 Epigram: There is danger in excess, and value in contemplation.

Wither, p. 143.
 Motto: "Good Hopes, we best accomplish may, By lab'ring in a constant-Way."
 Icon: A compass inscribes a circle.
 Epigram: As the foot of the compass is fixed firmly in one place when the circle is drawn, so we should be constant when we labor to accomplish something.

See also:
 ADAMANT AND NORTH STAR
 Van Veen, p. 39.
 NEEDLE OF COMPASS
 Quarles, *Emb.*, p. 258.
 SCIENCE
 Godyere, no. 19.

CONQUEROR AND KNEELING FOE
Arwaker, bk. 1, no. 6.
 Motto: "I have sinned, what shall I do unto thee, O thou Preserver of Men? why hast thou set me as a Mark against thee?"
 Icon: Divine Love in armor holds two swords while a human figure kneels in front of him.
 Epigram: Man's sins merit the vengeance of God, but man nevertheless asks God for mercy.

Quarles, *Emb.*, p. 144.
 Motto: "What shall I do unto thee, O thou preserver of men; why hast thou set mee as a marke against thee."
 Icon: Divine Love in armor holds two swords while a human figure kneels in front of him.
 Epigram: The speaker confesses his sins, bemoans his sinfulness, yields to God, and asks his mercy.

CONY
See:
 ANT, CONY, GRASSHOPPER, SPIDER
 Willet, no. 97.
See also: HARE, RABBIT.

COOPER
Ayres, no. 31.
 Motto: "'Tis yeilding gaines the Lover victory."
 Icon: Cupid as a cooper bends the rod into a hoop.
 Epigram: The lover must be like the rod, pliant, ready to bend to the woman's humor.

CORAL
Astry, no. 3.
 Motto: "Robur et decus."
 Icon: Coral in a sea.
 Epigram: Unlike the fragile rose, coral is made stronger by the force of waves and wind; thus it is better to educate with discipline and harshness than with tenderness and luxury.

CORD
See:
 CITY AND CORD
 P. S., p. 187.
 DRAWING AND RUNNING
 Arwaker, bk. 2, p. 8.
 GLOBE
 Godyere, no. 9.
See also: ROPE, THREAD.

CORD AND HEART
Harvey, no. 42.
 Motto: "Vinculum Cordis ex Funibus Christi."

Icon: Divine Love holds a cord which binds a
 heart.
Epigram: God binds man's heart with the cord of
 love.

CORD AND SWINE
Jenner, no. 7.
 Motto: "A Caveat against raigning Sinne."
 Icon: A man with a scourge holds a hog by a
 cord, drives it.
 Epigram: As the swine is driven to slaughter with a
 small cord, so the soul of man is deprived
 of heaven by one sin.

CORN
P. S., p. 305.
 Motto: "Mihi pondera luxus."
 Icon: A sheaf of corn with broken stalks.
 Epigram: As corn sometimes overwhelms itself, its
 ears breaking off, so too much pleasure is
 hurtful.
See also:
 BEECH, CORN, OAK
 Thynne, no. 56.
 EAR OF CORN
 Thynne, no. 22.

CORN AND RAIN
Astry, no. 41.
 Motto: "Ne quid nimis."
 Icon: Rain beats down on cornfields.
 Epigram: Excess of rain harms, rather than helps the
 corn; so, too, excessive rewards harm a
 man.

CORNEL TREE
E. M., no. 1.
 Motto: "Tam nudus natus homo."
 Icon: The cornel tree.
 Epigram: Like the cornel tree (cherry tree), which
 begins to bloom in February, before any
 leaves appear, man is born naked and
 should therefore be poor in spirit.

CORNUCOPIA
See:
 BREAST AND FOOL
 Quarles, Emb., p. 48.
 CADUCEUS AND CORNUCOPIA
 Wither, p. 88.
 CUPID AND OCCASION
 Van Veen, p. 175.
 DILIGENCE AND IDLENESS
 Combe, no. 100.
 FELICITY
 Peacham, p. 25.
 IDLENESS AND LABOR
 Whitney, p. 175.
 LION

Godyere, no. 2.
 OWL
 Wither, p. 9.

CORNUCOPIA AND HANDSHAKE
Wither, p. 166.
 Motto: "The safest Riches, hee shall gaine,
 Who always Faithfull doth remaine."
 Icon: A handshake in front of a cornucopia.
 Epigram: The cornucopia signifies wealth; the hand-
 shake, faith; together, they teach that the
 faithful will have true plenty.

CORNUCOPIA AND WHEEL
Wither, p. 248.
 Motto: "The gaining of a rich Estate,
 Seemes, many times, restrain'd by Fate."
 Icon: Cornucopias are fastened to a wheel.
 Epigram: Fate controls the gaining and losing of
 wealth.

CORNUCOPIA, STONE, WHEEL
P. S., p. 205.
 Motto: "Fata obstant."
 Icon: A stone on a chain weighs down a wheel on
 top of which lie two cornucopias.
 Epigram: Attaining riches is difficult and is impeded
 by poverty.

Coronet
See: CROWN.

CORONET AND SWORD
Wither, p. 245.
 Motto: "Protect mee, if I worthy bee;
 If I demerit, punish mee."
 Icon: A coronet on a sword.
 Epigram: The good will be rewarded with the coro-
 net; the evil will be punished with the
 sword.

CORPSE
See:
 CHRIST AND GRAVEYARD
 Montenay, p. 258.
 CROW
 Combe, no. 45.
 LOUSE
 Combe, no. 94.
See also: DEAD.

COSMOS
See:
 MAN AND UNIVERSE
 Peacham, p. 190.
See also: UNIVERSE, WORLD.

COUNTRY
Arwaker, bk. 2, no. 7.
 Motto: "Come my Beloved, let us go forth into
 the Fields, let us lodge in the Villages."

Icon: A human figure and Divine Love, carrying walking sticks, walk into the country.

Epigram: The speaker yearns to leave the city for the pastoral solitude of the country, where love thrives.

Quarles, *Emb.*, p. 208.

Motto: "Come my beloved, let us goe forth into the fields, let us remaine in the villages."

Icon: A human figure and Divine Love, carrying walking sticks, walk into the country.

Epigram: This emblem reminds the reader of the pleasures of the country and the value of contemplation.

See also: LANDSCAPE.

COURT OF HEAVEN
See:

HEAVEN
Arwaker, bk. 3, no. 14.
Quarles, *Emb.*, p. 296.

COURT OF LAW
See:

JUDGE AND JUSTICE
Arwaker, bk. 1, no. 10.
Quarles, *Emb.*, p. 160.

Covering
See: HIDING.

COVERING EYES
See:

VANITY
Arwaker, bk. 2, no. 5.

COVERING FACE
See:

ECLIPSE
Arwaker, bk. 1, no. 7.
Quarles, *Emb.*, p. 148.

COVETOUSNESS AND ENVY
Whitney, p. 95.

Motto: "De invido & Avaro, jocosum.

Icon: A man with a purse and a money chest faces another man and points to three eyes on the ground.

Epigram: The fable of two men granted a boon by the gods: the first to ask would get his wish, and the other would get the same gift, doubled. The covetous man refused to go first so that he could get twice the gift; the envious man asked to lose one eye, knowing the covetous man would then be blinded.

See also: AVARICE.

Cow
See: OX.

Coxcomb
See: FOOL, FOOL'S CAP.

CRAB
See also:

BUTTERFLY AND CRAB
P. S., p. 324.
Whitney, p. 121.
INCONSTANCY
Peacham, p. 147.

CRAB AND WORLD
Wither, p. 219.

Motto: "The motion of the World, this day, Is mov'd the quite contrarie way."

Icon: The world on the back of a crab.

Epigram: The world, like the crab, moves backward.

CRADLE
See:

HERCULES
Astry, no. 1.
INFANT AND HANDMAID
Quarles, *Emb.*, p. 216.
INFANT AND SISTER
Arwaker, bk. 2, no. 9.
PLANT AND TAPER
Quarles, *Hier.*, no. 9.

CRANE AND OX
Willet, no. 82.

Motto: "Animalium industria."

Icon: None.

Epigram: As the crane knows its time and the ox knows the way to its master's house, so man should know and fear God.

CRANE AND STONE
Thynne, no. 50.

Motto: "Our betters or enemies not to be provoked with wordes."

Icon: None.

Epigram: As cranes put stones in their mouths to stop their voices and conceal their flight, so men should be silent and thus protect themselves from their enemies.

CRAYFISH AND PEN
Peacham, p. 57.

Motto: "Scripta non temere edenda."

Icon: A crayfish holds a pen.

Epigram: What one writes remains after his death; therefore write with care, using advice and judgment to perfect the work.

CRESCENT MOON
Wither, p. 111.

Motto: "Shee shall increase in glory, still, Untill her light, the world, doth fill."

Icon: A crown above three intertwined crescent moons.

Epigram: Three moons in one represent the three-fold estate of the Church: (1) the Church of living men, (2) the Church of spirits dead, and (3) the Church triumphant, when all parts are united.

CRIPPLE
Ayres, no. 23.
Motto: "Sooner wounded than cured."
Icon: Cupid as a cripple looks at a lady.
Epigram: The lover prefers to be wounded by the sight of his beloved.

Van Veen, p. 165.
Motto: "Slow in departing."
Icon: Cupid as a cripple stands outside a door and watches a lady within.
Epigram: Love comes in haste but is slow to depart.
See also: LAME.

CROCODILE
Van Veen, p. 217.
Motto: "The unkynd lover killeth with laghing countenance."
Icon: A crocodile sheds tears as it kills a man.
Epigram: The crocodile weeps when it kills a man; the unkind lover laughs when she destroys a man.

Whitney, p. 3.
Motto: "Providentia."
Icon: A crocodile on the bank of a river.
Epigram: Just as the crocodile knows how far the Nile will overflow its banks and lays her eggs accordingly, so man should foresee the results of his actions.

Wither, p. 112.
Motto: "True Vertue is a Coat of Maile, 'Gainst which, no Weapons can prevaile."
Icon: A crocodile.
Epigram: Like the crocodile, who possesses a natural armor, man should be armed with patience, innocence, and fortitude.
See also:
BEEHIVE, CROCODILE, SAFFRON
Peacham, p. 154.

CROCODILE AND DOG
Whitney, p. 125.
Motto: "Sobriè potandum."
Icon: A dog laps water near the bank of a river where a crocodile lies; in the background Bacchus drinks from a cup.
Epigram: Just as the thirsty dog comes to the river to drink, sees the dangerous crocodile, and thus drinks cautiously near the bank, so men should realize the danger of wine and drink temperately.

CROCODILE AND PALM TREE
P. S., p. 81.
Motto: "Colligavit nemo."
Icon: A crocodile is chained to and hangs from a palm tree.
Epigram: The crocodile represents Egypt; the palm tree, Augustus Caesar's victory over Egypt, hitherto unconquered.

Crook
See: STAFF.

CROSS
P. S., p. 4.
Motto: "Manet insontem gravis exitus."
Icon: A cross.
Epigram: The godly suffer great affliction in this life.
See also:
BED AND CROSS
Arwaker, bk. 2, no. 10.
Quarles, *Emb.*, p. 220.
BRAZEN SERPENT AND CROSS
P. S., p. 7.
BREAD AND CROSS
P. S., p. 11.
CASTLE, CHRIST, HERETIC
Godyere, no. 25.
CHRIST ON CROSS
E. M., frontispiece.
CROWN, CROSS, SERPENT
Wither, p. 47.
FAITH
Peacham, p. 7.
Wither, p. 81.
FLAG OF CROSS
Astry, no. 26.
HOURGLASS AND SKULL
Wither, p. 152.
R. B., no. 24.
PIETY
Godyere, no. 12.
RAINBOW
Hawkins, no. 9, p. 100.

CROSS AND CUP
P. S., p. 253.
Motto: "Antidoti salubris amaror."
Icon: A cross in a cup.
Epigram: Our salvation consists in the imitation of the misery of the Passion; through Christ man may change the bitterness of the Cross to the cup of salvation.

CROSS AND HAND
Wither, p. 75.
Motto: "Their Friendship firme will ever bide, Whose hands unto the Crosse are tide."

Icon: Two hands are tied with a rope to a cross.
Epigram: True and faithful friendships form not in vanity or mirth but in affliction.

CROSS AND HEART
H. A., p. 148.
Motto: "Jesus brings in the crosse into the hart, and easily imprints it in the lover."
Icon: Jesus carries a cross and enters a heart.
Epigram: The devout man carries the image of Christ's suffering in his heart.

CROSS, CROWN, RING OF MARGARITES
P. S., p. 323.
Motto: "Quis dicere laudes?"
Icon: A ring of margarites, or pearls, encircles a cross on which the letters *EL* are inscribed; above the ring is a cross.
Epigram: This is the device of the duke of Savoy; *EL* refers to the duke's name, Emanuell, and to the meaning of that name, God; the ring of margarites refers to Margaret, the duchess of Savoy; the cross signifies God's love and favor; the crown, princely wisdom.

CROSS, LAUREL BOUGH, ROSE
P. S., p. 259.
Motto: "Victrix casta fides."
Icon: Laurel boughs intersect behind a cross above which is a rose.
Epigram: The cross, laurel, and rose signify the integrity of the faith between Laura and Petrarch and "the subdued affections of this wicked world."

CROW
Astry, no. 47.
Motto: "Et juvisse nocet."
Icon: A crow is pinned to the ground; other crows come to assist it and are caught.
Epigram: Princes must avoid being trapped through their compassion for others, as crows are caught.

Combe, no. 45.
Motto: "Beware of fained, flattering showes, For none are worse then friendly foes."
Icon: A flock of crows feed on a corpse.
Epigram: Flatterers are worse than crows; crows feed on the dead, flatterers on the live and unsuspecting.

CROW AND POT
Wither, p. 64.
Motto: "When wee by Hunger, Wisdome gaine, Our Guts, are wiser then our Braine."
Icon: A crow drops pebbles into a pot, and water overflows.
Epigram: When the crow needs water, it drops pebbles into a narrow-mouthed pot to make the water rise; likewise, poverty and hunger produce the best inventions.

CROWN
Astry, no. 100.
Motto: "Qui legitime certaverii."
Icon: A crown.
Epigram: The crown of immortality will be awarded to the good prince.

Peacham, p. 1.
Motto: "Nisi desuper."
Icon: A crown hangs from a chain over sea and land.
Epigram: James rules England by God's will.

Quarles, *Emb.*, p. 304.
Motto: "Fidesque Coronat ad aras."
Icon: A human figure is crowned by angels.
Epigram: God gives us faith, and faith gives us the crown of life.

P. S., p. 309.
Motto: "Me pompae provexit apex."
Icon: A crown.
Epigram: Different kinds of crowns, used to honor Romans, are discussed.

See also:

BIRD AND CROWN
Peacham, p. 124.
CRESCENT MOON
Wither, p. 111.
CROSS, CROWN, RING OF MARGARITES
P. S., p. 323.
DOG, HARE, SCEPTER
Combe, no. 92:
DRAGON WITH TEN HORNS
Willet, no. 22.
EAGLE
Astry, no. 22.
EAGLE AND SUN
Godyere, no. 4.
FAITH
Wither, p. 81.
FIRE
Wither, p. 98.
R. B., no. 50.
GLORY
Peacham, p. 21.
HARP
Astry, no. 61.
HEART, LAUREL, PALM
H. A., p. 235.
HORSEMAN, SEVEN-HEADED BEAST, SWORD
Van der Noodt, no. 19.
JOVE
Thynne, no. 34.
JUPITER
Combe, no. 57.
LEOPARD

Peacham, p. 97.
LION
Peacham, p. 107.
MARTYR
Whitney, p. 224.
NAKED MAN
Wither, p. 12.
R. B., no. 4.
OWL
Wither, p. 9.
PORCUPINE
P. S., p. 17.
PORTCULLIS
Peacham, p. 31.
REWARD
Peacham, p. 121.
SALAMANDER
P. S., p. 17.
SEVEN-HEADED BEAST
Van der Noodt, no. 17.
SKULL
Astry, p. 384.
STAR
P. S., p. 19.
TOMB
Astry, no. 101.
TREE
Astry, no. 70.
WHORE OF BABYLON
Godyere, no. 21.

See also: CORONET, DIADEM, GARLAND, INDIAN DIADEM,
LAUREL CROWN, PAPAL CROWN, WREATH.

CROWN AND CUPID
Peacham, p. 195.
 Motto: "Nec in una sede morantur."
 Icon: Cupid, with a bow and arrows, holds a
 crown to his head.
 Epigram: Neither power nor money can rule Cupid.

CROWN AND DEAD
Thynne, no. 9.
 Motto: "Immortallitie of the Sowle."
 Icon: None.
 Epigram: Pagans once crowned their dead in cele-
 bration of the dead's escape from sorrow
 and pain; likewise, Christians should re-
 joice, not sorrow, at a loved one's death.

CROWN AND GATE OF THORNS
Quarles, *Emb.*, p. 104.
 Motto: "Erras: Hâc itur ad illam."
 Icon: Cupid and Divine Love stand at a gaming
 table;
 Cupid aims his ball at a crown while
 Divine Love aims his ball at a thorny gate.
 Epigram: The path to hell is short and easy, but the
 path to heaven is narrow and difficult.

CROWN AND HART
P. S., p. 298 (misnumbered 398).
 Motto: "Hoc Caesar me donavit."
 Icon: A winged hart with a crown.
 Epigram: This image preserves the memory of
 Caesar.

CROWN AND HAT
Peacham, p. 171.
 Motto: "Sanctitas simulata."
 Icon: A hat covers a crown.
 Epigram: An attack on the Puritans, this emblem ac-
 cuses the Puritans of pride in presuming
 to overlook the king.

CROWN AND HAWTHORNE
Peacham, p. 90.
 Motto: "Tyranni morbus suspicio."
 Icon: A crown in a hawthorne tree with the let-
 ters *H* and *E* on either side.
 Epigram: Richmond devised this emblem for his
 shield after overthrowing Richard to ex-
 press the care and guilt that accompanies
 his crown.

CROWN AND HEART
Montenay, p. 150.
 Motto: "Dominus Custodiat Introctum Tuum."
 Icon: A hand holds a crowned heart.
 Epigram: God rules and keeps the hearts of kings.

CROWN AND LION
Peacham, p. 11.
 Motto: "Sic pacem habemus."
 Icon: Two lions hold a crown.
 Epigram: The two lions, representing England and
 Scotland, hold up the crown of Britain and
 thus symbolize the concord which came to
 Britain when England and Scotland made
 peace.
P. S., p. 337.
 Motto: "Solatur conscientia & finis."
 Icon: A crowned lion.
 Epigram: A good conscience comforts a man.

CROWN AND MITER
Godyere, no. 1.
 Motto: "Rex et Sacerdos Dei."
 Icon: A crown and miter.
 Epigram: This emblem discusses the importance of
 the king and the priest to a commonwealth
 and the relation of human and divine law.

CROWN AND MOON
P. S., p. 21.
 Motto: "Donec totum impleat orbem."
 Icon: A crown above three intertwined crescent
 moons.
 Epigram: The moon represents the Church, which is

always subject to alteration; the crown represents the one God under whom all Christians are gathered.

CROWN AND PILLAR
Astry, no. 31.
Motto: "Existimatione nixa."
Icon: A crown on top of a pillar.
Epigram: The empire is like a pillar, which is preserved by its own authority.

CROWN AND SCEPTER
Wither, p. 78 (misnumbered p. 66).
Motto: "A King, that prudently Commands, Becomes the glory of his Lands."
Icon: A crowned scepter.
Epigram: The scepter represents kingly power; the crown, glory; joined, the crowned scepter signifies the king who is an honor to his land.

CROWN AND SERPENT
Peacham, p. 137.
Motto: "Regum Majestatem non imminuendam."
Icon: Serpents wind around monuments and guard the crown within.
Epigram: The serpents represent the protection of the monarch.
P. S., p. 246.
Motto: "In se contexta recurrit."
Icon: A crown made up of fruits of the earth and a serpent biting its tail.
Epigram: The serpent signifies the year; the crown, the bounty which God bestows on the year.

CROWN AND SHIP
P. S., p. 316.
Motto: "Classis monumenta subactae."
Icon: A crown made in the form of a ship's prow.
Epigram: The crown of a ship is presented to the men who first charge the enemy's navy.

CROWN AND SKULL
P. S., p. 319.
Motto: "Victoria limes."
Icon: A crowned skull.
Epigram: The dead are crowned to signify that they have overcome the sorrows and labors of life.

CROWN AND STAR
Peacham, p. 160.
Motto: "Ira Principum: Quocunque ferar."
Icon: A crown on top of a star.
Epigram: The might of the king strikes down rebels.

CROWN AND THORN
Astry, no. 20.
Motto: "Bonum fallax."
Icon: A crown with thorns within.

Epigram: Kingship brings not just pleasure but also care and danger.

CROWN AND VALLEY
P. S., p. 315.
Motto: "Hoc valli insigne recepti."
Icon: A crown in form of a valley.
Epigram: A crown in the form of a valley was given to the man who took a valley from enemies.

CROWN AND WALL
P. S., p. 314.
Motto: "Excidii turribus honos."
Icon: A crown of gold made in the shape of a wall.
Epigram: A crown in the shape of a wall was presented to the man who first scaled the enemy's wall.

CROWN AND WHEEL
Peacham, p. 76.
Motto: "Status humanus."
Icon: A wheel with four crowns placed at right angles to each other.
Epigram: As the wheel turns, the crown that is on top changes position with the crown on the bottom; even so, Fortune continually changes the conditions of men.

CROWN, CROSS, SERPENT
Wither, p. 47.
Motto: "When we above the Crosse can rise, A Crowne, for us, prepared lies."
Icon: A crown hangs above a serpent, entwined on a cross.
Epigram: The cross signifies suffering; the serpent, he who embraces the cross; the crown, the victory over suffering.

CROWN, FIRE, SWORD
Montenay, p. 298.
Motto: "Per Multas Afflictiones."
Icon: Three men are threatened with swords and fire; a hand from heaven holds a crown above them.
Epigram: The man who is persecuted for his love of God receives a heavenly crown.

CROWN, FOWL, SCEPTER
Wither, p. 67.
Motto: "That Kingdome will establish'd bee, Wherein the People well agree."
Icon: Birds surround a crowned scepter.
Epigram: The crowned specter surrounded by various kinds of fowl signifies the glory of a kingdom in which subjects of all degrees support the sovereignty of the state.

CROWN, HALTER, PURSE
Peacham, p. 153.

Motto: "Sors."
Icon: A figure holds a rope in one hand, a crown and purse in the other.
Epigram: The capriciousness of Fortune is illustrated by the story of a despairing person about to kill himself with a halter who finds a hidden treasure; he discards the halter in his joy, but the owner of the treasure, when he discovers his loss, takes up the halter and kills himself.

CROWN, HAND, HEART
Wither, p. 180.
Motto: "The Hearts of Kings are in God's Hands; And, as He lists, He Them commands."
Icon: A hand holds a heart above which hangs a crown.
Epigram: King's hearts are directed by God's hand.

CROWN, HANDSHAKE, HEART
Wither, p. 237.
Motto: "That's Friendship, and true-love, indeed, Which firme abides, in time of need."
Icon: A crown above a flaming heart supported by a handshake within a circle.
Epigram: When friends are constant in affliction, their affection is proved true.

CROWN, LILY, SWORD
P. S., p. 277.
Motto: "Consilio firmata Dei."
Icon: Lilies flank a sword with a crown on the blade.
Epigram: The crowned sword between two lilies signifies the protection of the kingdom of France.

CROWN OF GRASS
P. S., p. 311.
Motto: "Merces sublimis honorum."
Icon: A crown of grass.
Epigram: Soldiers gave the leader of the army a triumphal crown of grass after he had subdued the enemy.

CROWN OF OAK
P. S., p. 313.
Motto: "Servati gratia Civis."
Icon: An oak crown.
Epigram: A crown of oak honored the man who delivered the city from danger.

CROWN OF STARS AND WHEAT
P. S., p. 199.
Motto: "Haec conscia numinis aetas."
Icon: A crown of stars about the sun.
Epigram: The crown of stars and wheat around the sun appeared as a sign of Christ's birth.

CROWN OF THORNS AND HEART
Harvey, no. 45.
Motto: "Sepimentum Cordis Corona Spinea."
Icon: Divine Love places a crown of thorns around a heart.
Epigram: Hearts which are hedged with Christ's crown of thorns will flourish.

CROWN, PALM TREE, SWORD
P. S., p. 255.
Motto: "Cessit victoria victis."
Icon: A palm tree with many crowns grows from a sword.
Epigram: The blood of the martyrs is turned into a crowned palm tree, an eternal reward of victory.

CROWN, SEA HORSE, STORK
Wither, p. 155.
Motto: "Bee Just; for, neither Sea nor Land, Shall hide thee from the Royall-hand."
Icon: A stork sits on a crown high above a sea-horse and eats a serpent.
Epigram: The seahorse signifies ingratitude and wickedness; the crown, the love and protection of princes for their pious subjects; the serpent, that which is offensive.

CROWN, SHIELD, SWORD
P. S., p. 334.
Motto: "Perimit & tuetur."
Icon: A sword pierces a shield with a crown above.
Epigram: This device signifies the Duke of Guise, who punishes the wicked and saves the godly.

CROWN, SNAKE, STAR
P. S., p. 329.
Motto: "Fato prudentia major."
Icon: A star enclosed by a snake biting its tail, with a crown above.
Epigram: Wisdom is of greater force than destiny alone.

Crucifix
See: CROSS.

CRUCIFIXION
See:
 PELICAN
 Wither, p. 154.
 R. B., no. 7.
 SHADOW
 Arwaker, bk. 2, no. 14.

CUB
See:
 BEAR

Ayres, no. 5.
Combe, no. 98.
Van Veen, p. 56.
See also: BEAR, LION.

CUBE
Wither, p. 228.
 Motto: "On whether side soe're I am,
 I, still, appear to bee the same."
 Icon: A cube.
 Epigram: The cube signifies the virtuous man who, regardless of external forces, remains firm and unchanging.
See also:
 MELANCHOLY
 Peacham, p. 126.

CUCKOO
Bunyan, no. 20.
 Motto: "Of the Cuckow."
 Icon: None.
 Epigram: The cuckoo, which can only suck others' eggs and sing a noisy song, is like the formalist (one who observes the ceremonies and rules of religion but does not have inner faith).
Thynne, no. 58.
 Motto: "Ingratitude."
 Icon: None.
 Epigram: The cuckoo is an image of ingratitude: the adult cuckoo leaves its eggs in another bird's nest, but after the bird rears the young cuckoos, they kill her.
See also:
 BIRD
 Whitney, p. 54.

CUDGEL
Jenner, no. 24.
 Motto: "The Bridle of the *wicked*."
 Icon: A man holds a cudgel over a dog who looks at sheep.
 Epigram: Like the dog who wants to prey on the sheep but fears the cudgel, the wicked desire to sin but fear God's judgment.

Cultivating
See: TENDING, WATERING.

CUP
Montenay, p. 374.
 Motto: "Sufficit."
 Icon: Hands in clouds hold a small cup and a large cup.
 Epigram: God distributes his blessings as he will, and we should be thankful for much or little.

See also:
 ALTAR, BOOK, CUP, HELMET, MONEY
 P. S., p. 371.
 BACCHUS
 Peacham, p. 96.
 Peacham, p. 191.
 Whitney, p. 187.
 CROSS AND CUP
 P. S., p. 253.
 DRAGON WITH TEN HORNS
 Willet, no. 22.
 FAITH
 Wither, p. 81.
 PIETY
 Godyere, no. 12.
 TEMPERANCE
 Peacham, p. 93.
 WHORE OF BABYLON
 Godyere, no. 21.
 Montenay, p. 302.
 Van der Noodt, no. 18.
See also: BOWL.

CUP AND FLOWER
P. S., p. 119.
 Motto: "Quid non mortalia pectora cogis?"
 Icon: Flowers float in a cup.
 Epigram: Cleopatra dropped poisonous flowers into Antony's cup but then stopped him from drinking; the cup with poisonous flowers thus signifies the audacity of a shameless woman.

CUP AND FORTUNE
Van Veen, p. 13.
 Motto: "Lyke fortune to both."
 Icon: Fortune fills a cup held by two Cupids.
 Epigram: Fortune gives the same fate to both lovers.

CUPID
Thynne, no. 40.
 Motto: "Noe impuritie in heaven."
 Icon: None.
 Epigram: To preserve the purity of heaven, Jove exiled the troublemaking Cupid; likewise, God cast Lucifer from heaven.
Whitney, p. 63.
 Motto: "Potentissimus affectus, amor."
 Icon: Winged Cupid whips lions which draw him in a chariot.
 Epigram: If Cupid can awe the mighty lions like this, then imagine his power over "feeble man."
Whitney, p. 182.
 Motto: "Potentia amoris."
 Icon: Cupid holds a fish and a bouquet of flowers.

Epigram: Love has power over both the sea and the
 land.
Wither, p. 227.
R. B., no. 34.
 Motto: "Be wary, whosoe're thou be,
 For, from Loves arrowes, none are free."
 Icon: Cupid with a bow and arrow.
Epigram: No one is safe from Cupid's arrows.
See also:

ADAMANT AND NORTH STAR
Van Veen, p. 39.
ANTEROS, CUPID, PALM
Van Veen, p. 11.
ARGUS AND CUPID
Van Veen, p. 239.
ARMOR
Ayres, no. 32.
ARMOR AND CUPID
Van Veen, p. 23.
ARROW
Ayres, nos. 8, 19.
ASS AND CUPID
Combe, no. 62.
ASS, CUPID, WING
Van Veen, p. 115.
AVARICE AND CUPID
Van Veen, p. 205.
AX AND OAK
Ayres, no. 35.
AX, CUPID, TREE
Van Veen, p. 211.
BALANCE AND BUBBLE
Quarles, *Emb.*, p. 16.
BEAR
Ayres, no. 5.
BEAUTY AND CUPID
Van Veen, p. 207.
BEE AND CUPID
Ayres, no. 16.
Whitney, pp. 147, 148.
BELLOWS, SUN, TORCH
Quarles, *Emb.*, p. 64.
BERRY AND CUPID
Van Veen, p. 173.
BLINDFOLD
Ayres, no. 10.
BLINDNESS AND CUPID
Van Veen, p. 61.
BONE AND DOG
Ayres, no. 25.
BOOK, CUPID, DISTAFF, HERCULES
Van Veen, p. 83.
BOWLING
Quarles, *Emb.*, p. 40.
BRIDLE, CUPID, MEASURE
Van Veen, p. 31.

BUBBLE AND SMOKE
Quarles, *Emb.*, p. 76.
CADUCEUS
Ayres, no. 27.
CANDLE
Ayres, no. 11.
CANDLE AND CUPID
Van Veen, p. 137.
CAP OF LIBERTY, CUPID, YOKE
Van Veen, p. 73.
CHAIR AND CUPID
Van Veen, p. 95.
CHAMELEON AND CUPID
Ayres, no. 24.
Van Veen, p. 63.
CHOICE BETWEEN CUPID AND DIVINE LOVE
Arwaker, bk. 2, no. 1.
CHURN AND CUPID
Van Veen, p. 119.
COAT OF ARMS, CUPID, PALM
Van Veen, p. 65.
COCK
Ayres, no. 12.
COOPER
Ayres, no. 31.
CRIPPLE
Ayres, no. 23.
CROWN AND CUPID
Peacham, p. 195.
CROWN AND GATE OF THORNS
Quarles, *Emb.*, p. 104.
DARKNESS
Van Veen, p. 113.
DART AND DEVIL
Quarles, *Emb.*, p. 112.
DICTAMON AND HEART
Van Veen, p. 155.
ENTREATING
Ayres, no. 41.
FALL
Quarles, *Emb.*, p. 116.
FIGHT
Ayres, no. 13.
FIRE AND POT
Van Veen, p. 97.
FIRE AND WIND
Ayres, no. 42.
FISHING
Ayres, no. 9.
FORTUNE, TIME, WORLD
Quarles, *Emb.*, p. 36.
GLASS
Quarles, *Emb.*, p. 84.
HAND AND WING
Van Veen, p. 111.
HARE AND TORTOISE

Van Veen, p. 99.
HEART
Ayres, no. 8.
Quarles, *Emb.*, p. 120.
HEART PIERCED BY ARROW
Ayres, no. 15.
HELIOTROPE
Ayres, no. 14.
HERCULES
Whitney, p. 40.
HUNT
Ayres, no. 26.
Ayres, no. 30.
Ayres, no. 43.
Van Veen, p. 241.
MARTYR
Ayres, no. 22.
NET
Ayres, no. 3.
OAK
Ayres, no. 21.
OAK AND WIND
Van Veen, p. 117.
OATH MAKING
Ayres, no. 38.
ONE
Ayres, no. 34.
OVEN
Ayres, no. 44.
RABBIT
Ayres, no. 4.
ROSE
Ayres, no. 17.
SAGE
Whitney, p. 135.
SEED
Ayres, no. 1.
SHIP AND SEA
Van Veen, p. 109.
SIEVE
Quarles, *Emb.*, p. 88.
SPHERE OF UNIVERSE
Ayres, no. 33.
SUN AND WIND
Van Veen, p. 125.
TORCH
Ayres, no. 2.
TRADE
Ayres, no. 40.
TREAD UPON
Ayres, no. 28.
WASHING HAND
Wither, p. 162.
WASP AND WORLD
Quarles, *Emb.*, p. 12.
WORLD

Quarles, *Emb.*, pp. 24, 100.
WORLD IN ARMS
Quarles, *Emb.*, p. 68.
YOKE
Ayres, no. 6.

CUPID AND BRIDLE
Van Veen, p. 89.
 Motto: "Love parforce."
 Icon: Cupid bridles a man.
 Epigram: Cupid bridles and tames the unwilling.

CUPID AND DART
Van Veen, p. 9.
 Motto: "A wished warre."
 Icon: Cupids shoot darts at each other.
 Epigram: Lovers willingly receive the wounds given by their beloved.

CUPID AND DEAD
Van Veen, p. 247.
 Motto: "Triall made to late."
 Icon: A woman weeps beside a dead man holding a standard of love.
 Epigram: Proof of love is made too late in death.

CUPID AND DEATH
Peacham, p. 172.
 Motto: "De Morte, et Cupidine."
 Icon: In the foreground Death and Cupid sleep; in the background Death shoots young lovers, and Cupid shoots aged persons.
 Epigram: The story of Cupid and Death mixing up their arrows illustrates the danger of violating natural order.

Thynne, no. 4.
 Motto: "Death and Cupid."
 Icon: None.
 Epigram: When Death and Cupid accidentally exchanged weapons, the aged fell in love, and the young died; this demonstrates the importance of "kind" and "nature."

Whitney, p. 132.
 Motto: "De morte, & amore: Jocosum."
 Icon: Death and Cupid in the sky shoot arrows at people below: an old man with a woman and a young man dead.
 Epigram: When Death and Cupid accidentally exchanged weapons, the aged fell in love, and the young died. Chance causes untimely death and wanton age.

CUPID AND DIANA
Thynne, no. 6.
 Motto: "Labour quencheth Lecherie."
 Icon: None.
 Epigram: Diana is invulnerable to Cupid's arrows because she is active, avoids sloth and indolence.

CUPID AND DOOR
Van Veen, p. 105.
Motto: "Love is resisted at first or never."
Icon: A man stands at a door, resists Cupid.
Epigram: Whoever shuns love must shut Cupid out-
doors, for once he enters, he cannot be
thrown out.

CUPID AND ENVY
Quarles, *Emb.*, p. 20.
Motto: "His vertitue orbis."
Icon: Envy with serpent hair holds a scourge of
serpents while Cupid beats the world with
a scourge.
Epigram: Lust and envy scourge the world.

CUPID AND FORTUNE
Van Veen, p. 157.
Motto: "Blynd fortune blyndeth love."
Icon: Blind Fortune holds Cupid on her ball and
ties a blindfold over his eyes.
Epigram: Sometimes blind Fortune blinds love.
Van Veen, p. 225.
Motto: "By force made more forceible."
Icon: Fortune restrains Cupid.
Epigram: When fortune thwarts love's will, love
seeks to gain his desire by force.

CUPID AND FOX
Van Veen, p. 235.
Motto: "The old fox is oft beguyled."
Icon: Cupid shoots and ensnares foxes.
Epigram: Love ensnares even crafty old men.

CUPID AND GLASS
Van Veen, p. 7.
Motto: "Cleer and pure."
Icon: Cupid holds a glass.
Epigram: As the glass shows the face, so the deed re-
veals the lover.
Van Veen, p. 127.
Motto: "Out of sight out of mynde."
Icon: Cupid looks at reflection in the glass.
Epigram: The glass reflects the face when one looks
at it, but not when one is gone; likewise,
absence causes the lover to forsake love.

CUPID AND GRAFTED TREE
Combe, no. 81.
Motto: "In all his stockes blind love doth set
The grasses of griefe, our hearts to fret."
Icon: Blind Cupid grafts trees.
Epigram: Cupid is a gardener, sowing love and graft-
ing anguish and grief onto existing plants.
Van Veen, p. 5.
Motto: "Two united."
Icon: Cupid grafts a tree.
Epigram: As the graft becomes one with the tree, so
lovers are joined in one root.

CUPID AND HANDSHAKE
Van Veen, p. 179.
Motto: "Proffred service past the date,
Is wished when it is to late."
Icon: Wounded cupid holds a basket containing
clasped hands and offers it to another cupid
who refuses it.
Epigram: If love's offered service is repeatedly re-
jected, it cannot be acquired later.

CUPID AND HARE
Van Veen, p. 187.
Motto: "The greater love, the greater feare."
Icon: Cupids embrace; hares gather at their feet.
Epigram: The greater the love, the greater the fear
of loss.

CUPID AND HEART
Van Veen, p. 47.
Motto: "Demonstration more effectuall then
speech."
Icon: Cupid stands before a lady, holding a
paper on which a heart is inscribed.
Epigram: Love is shown more in deeds than in words.

CUPID AND HERCULES
Van Veen, p. 33.
Motto: "Love is the cause of virtue."
Icon: Cupid wounds Hercules, who stands with
a club over conquered Hydra.
Epigram: Love inspires most worthy deeds.
Van Veen, p. 53.
Motto: "Virtue the good of love."
Icon: Hercules leads Cupid.
Epigram: Virtue leads love and gives it courage to
perform duty.

CUPID AND HOPE
Van Veen, p. 59.
Motto: "Hope feedeth."
Icon: Cupid sucks from the breast of Hope.
Epigram: Hope is the nurse of love.

CUPID AND HUNT
Van Veen, p. 131.
Motto: "The chasing goeth before the taking."
Icon: Cupid with dogs pursues a deer.
Epigram: As the deer must be pursued before it is
caught, so the lady.

CUPID AND INN
Van Veen, p. 197.
Motto: "Love gives cold entretaynment."
Icon: Cupid invites a man into an inn.
Epigram: The man who lodges where love is the host
is unwise for he will find only bane.

CUPID AND LAW
Arwaker, bk. 2, no. 1.
Motto: "My soul breaketh out for the very fer-

vent desire that it hath always unto thy Judgments."

Icon: A man turns away from Cupid, who is holding a beehive, and reaches out to the Mosaic law, held by Divine Love.

Epigram: Man is torn between heaven's appeal to obey and earth's appeal to be free, but at last chooses God.

Quarles, *Emb.*, p. 184.

Motto: "My soule hath coveted to desire thy judgements."

Icon: A human figure faces Divine Love, who holds law; earthly Cupid stands behind the figure with his hand on his shoulder.

Epigram: Man is torn between the law of God and the law of sin, between good and bad.

CUPID AND LETTER
Van Veen, p. 133.

Motto: "Loves joy is revyved by letters."

Icon: Cupid reads a letter.

Epigram: When lovers are separated, love letters bring them joy.

CUPID AND LILY
Van Veen, p. 123.

Motto: "Absence killeth."

Icon: Cupid, with an arrow in his breast, points to black lilies.

Epigram: When the lover is absent from his love, the lilies seem black, and nothing delights him.

CUPID AND LOOKING GLASS
Van Veen, p. 183.

Motto: "Fortune is loves looking-glas."

Icon: Cupid holds up a glass to a lady's face.

Epigram: As the glass represents the face, so fortune reveals love's success.

CUPID AND LOVER
Van Veen, p. 29.

Motto: "To late to fly."

Icon: Cupid chases a fleeing lover with a dart in his breast.

Epigram: Once love strikes, the lover cannot run from love.

CUPID AND LUTE
Wither, p. 82.

Motto: "Love, a Musician is profest,
 And, of all Musicke, is the best."

Icon: Cupid holds a lute.

Epigram: Love is a musician and makes every lover musical.

CUPID AND MARS
Van Veen, p. 209.

Motto: "Love pacifyeth the wrathful."

Icon: Cupid takes a sword from Mars.

Epigram: Love tames the wrathful.

CUPID AND MERCURY
Van Veen, p. 81.

Motto: "Love is author of eloquence."

Icon: Mercury, with an arrow in his chest, hands caduceus to Cupid.

Epigram: Love inspires the lover to eloquence.

CUPID AND NUMBER 1
Van Veen, p. 3.

Motto: "Only one."

Icon: Cupid puts his foot on a tablet full of numbers, holds up a tablet inscribed with the number *1* and a wreath.

Epigram: The lover ought to love only one.

CUPID AND OATH
Van Veen, p. 141.

Motto: "Love excused from perjurie."

Icon: Cupid, with his hand on a book, makes an oath while Jove and Venus watch.

Epigram: Venus excuses the lover if he makes an oath which proves untrue.

CUPID AND OCCASION
Van Veen, p. 175.

Motto: "Love useth manie meanes."

Icon: Cupid seizes a forelock of Occasion, who holds a cornucopia; ivy entwines a tree in the background.

Epigram: As the ivy finds a tree to support it, so the lover takes hold of an occasion for his advantage.

CUPID AND PEACOCK
Van Veen, p. 195.

Motto: "Love hateth pryde."

Icon: Cupid steps on a peacock's tail.

Epigram: Love hates pride and disdain.

CUPID AND PIKE
Van Veen, p. 199.

Motto: "Loves endurance."

Icon: Soldiers threaten Cupid with pikes.

Epigram: Love overcomes danger.

CUPID AND PILLAR
Van Veen, p. 201.

Motto: "No labor wearisome."

Icon: Cupid holds a pillar on his shoulder.

Epigram: Labor is not painful to love.

CUPID AND PILLARS OF HERCULES
Peacham, p. 73.

Motto: Major Hercule.

Icon: Blindfolded, naked Cupid holds the pillars of Hercules.

Epigram: Although Cupid seems like a small child, he has the strength to conquer great heroes.

CUPID AND PLUMMET
Van Veen, p. 77.
Motto: "Not swarving from right."
Icon: Cupid stands beside a plummet—a leaden ball, attached to a line, hanging above a board.
Epigram: As the plummet hangs directly down, so the lover must not sway from his beloved.

CUPID AND PORTRAIT
Van Veen, p. 193.
Motto: "Contentment is conceat."
Icon: Cupid stares at a portrait of his lady.
Epigram: The lover imagines that he sees his beloved when she is absent.

CUPID AND SCOURGE
Van Veen, p. 69.
Motto: "The mouth is the discoverer of the mynd."
Icon: One Cupid holds a scourge, another lays his hand where the scourge hit him.
Epigram: Where the smart is felt, the hand is laid, and what the heart contains, the mouth discovers.

CUPID AND SEA
Van Veen, p. 93.
Motto: "Love fyndeth meanes."
Icon: Cupid uses his quiver as a boat, his bow as an oar, his wings as a sail, in order to cross the sea.
Epigram: Love will do anything to come to his beloved.

CUPID AND SERPENT BITING TAIL
Van Veen, p. 1.
Motto: "Love is everlasting."
Icon: Cupid sits within a circle made by a serpent biting its tail.
Epigram: Time cannot ruin love.

CUPID AND SHAFT
Van Veen, p. 215.
Motto: "Without ceasing."
Icon: Cupid shoots many shafts into a lover's heart.
Epigram: Cupid causes sorrow and pain, which the lover endures.

CUPID AND SIEVE
Combe, no. 77.
Motto: "All those that love do fancie most, But lose their labour and their cost."
Icon: Blindfolded Cupid holds a sieve through which a man pours water.
Epigram: Love is like a sieve: the more one pours into it, the more he loses.

CUPID AND SLEEP
Van Veen, p. 149.
Motto: "Love night and day attendant."
Icon: Cupid sits on the bed of a sleeping man.
Epigram: Love attends the lover continuously, appearing to him in his dreams while he sleeps.

CUPID AND SNARE
Van Veen, p. 87.
Motto: "Good earnest hapneth in sporte."
Icon: Cupid catches another cupid in a snare.
Epigram: Love catches the lover, making him a prisoner.

CUPID AND STILL
Combe, no. 79.
Motto: "A thousand dangers dayly grow, Of foolish Love, as lovers Know."
Icon: Blindfolded Cupid fans the fire of a still with bellows; a heart is in the flames.
Epigram: Love is dangerous: it fans the fires of repentance and causes tears.

CUPID AND TERMINUS
Van Veen, p. 19.
Motto: "Nothing hindreth love."
Icon: Cupid puts a foot on a leaning statue of Terminus.
Epigram: Force may not remove love, to which all must give place.

CUPID AND TIME
Van Veen, p. 237.
Motto: "Loves harte is ever young."
Icon: Time clips Cupid's wings.
Epigram: Only time can curtail love, but age is not hostile to love.

CUPID AND TINDERBOX
Van Veen, p. 159.
Motto: "Loves labor spent in vayn."
Icon: Cupids try to start a fire with a tinderbox.
Epigram: If the spark does not enkindle the tinder, there is no fire; likewise, if love does not enkindle love, it dies.

CUPID AND TORCH
Van Veen, p. 191.
Motto: "Love killed by his owne nouriture."
Icon: Cupid holds a torch upside down. An arrow pierces his breast.
Epigram: As the torch, turned upside down, is killed by its own wax, so the lover's desire.

CUPID AND TORTOISE
Van Veen, p. 91.
Motto: "The slow lover speeds not."
Icon: Cupid beats a tortoise with his bow.
Epigram: Cupid hates slothfulness.

CUPID AND TORTURE

Van Veen, p. 185.

Motto: "Love in enduring death."

Icon: Cupid is bound to a stake, burned.

Epigram: Love is constant, even in the face of torture and death.

CUPID AND TREASURE

Van Veen, p. 129.

Motto: "Love bought and sold."

Icon: One Cupid offers treasure to another cupid.

Epigram: Love is sometimes sold for treasure.

CUPID AND VENUS

Peacham, p. 174.

Motto: "Sine Cerere et Baccho."

Icon: Cupid and Venus warm themselves by a fire; in the background Bacchus and Ceres flee.

Epigram: Where temperance and sobriety rule, lust and pleasure are frozen.

Thynne, no. 3.

Motto: "Temperance abateth fleshlie Delightes."

Icon: None.

Epigram: "Soberness," like cold, freezes lust and abates the pleasures of the flesh.

CUPID AND VIZARD

Van Veen, p. 221.

Motto: "Dissimulation is loves wisdome."

Icon: Cupid holds a vizard to his face.

Epigram: Love dissembles to protect itself from malice.

CUPID AND WORLD

Montenay, p. 210.

Motto: "Sublato amore omnia ruunt."

Icon: Cupid holds the world on a string.

Epigram: Love and faith bring the world to unity and tranquillity.

CUPID, DEAFNESS, FAME

Van Veen, p. 67.

Motto: "Love often deaf."

Icon: Fame blows a trumpet; Cupid covers his ears.

Epigram: Love refuses to hear rumors and ill opinions about his beloved.

CUPID DEFORMED

Quarles, *Emb.*, p. 96.

Motto: "Venturum exhorresco diem."

Icon: The sun with a face and hand shines onto Cupid, who rises out of the world, his head resembling the devil's, deformed and ugly.

Epigram: God will take vengeance on the lustful, who are deformed by their sin, at Judgment Day.

CUPID, DOG, HARE

Van Veen, p. 25.

Motto: "Hee that catcheth at much takes hold of little."

Icon: Cupid and dogs chase two hares.

Epigram: As the man who chases two hares loses both, so the man who embraces two loves loses both.

CUPID, DRINKING, EATING

Van Veen, p. 85.

Motto: "Occasion causeth theft."

Icon: Cupid eats from a table and drinks from a fountain.

Epigram: As the hungry cannot refrain from eating and the thirsty from drinking, so the lover cannot abstain from enjoying his love.

CUPID, EARTH, HEAVEN

Van Veen, p. 35.

Motto: "All depends upon love."

Icon: Cupid shoots darts at earth and heavens.

Epigram: Without love the universe would be chaos.

Van Veen, p. 37.

Motto: "More strong than Atlas."

Icon: Cupid holds heaven and earth on his shoulders.

Epigram: Cupid's power is greater than Atlas's, for love upholds heaven and earth.

CUPID, ENVY, FORTUNE

Van Veen, p. 107.

Motto: "Fortune aydeth the audatious."

Icon: Fortune and Cupid fight Envy.

Epigram: Fortune helps the lover who valiantly fights envy.

CUPID, ENVY, SHADOW

Van Veen, p. 51.

Motto: "Envy is loves shadow."

Icon: Cupid stands in the sun, his shadow resembling envy, with serpents in his hair and around his hands.

Epigram: Envy is the shadow of love; the more love appears, the more envy is seen.

CUPID, ENVY, WAR

Van Veen, p. 49.

Motto: "No love without warre."

Icon: Cupid, wearing a helmet and holding a standard, stands beside soldiers in a camp; figures of envy stand in the opposing camp.

Epigram: Love wages war against envy.

CUPID, FOOL, NET

Quarles, *Emb.*, p. 72.

Motto: "Non amat iste; sed hamat amor."

Icon: Cupid in a boat casts a net and catches a fool while Divine Love watches.

Epigram: By appealing to the physical senses, Cupid ensnares foolish men with sweet lures.

CUPID, FURNACE, TEAR
Van Veen, p. 189.
Motto: "Loves teares are his testimonies."
Icon: Cupid weeps beside a furnace.
Epigram: The lover's heart is like the furnace, kindled by desire, blown by sighs, producing tears.

CUPID, GOOSE, PEACH, SILENCE
Van Veen, p. 71.
Motto: "Loves secresie is in silence."
Icon: Cupid, holding a peach branch, stands beside a goose and makes a gesture of silence.
Epigram: The peach and goose signify silence which the lover must adhere to.

CUPID, HARE, LADY
Van Veen, p. 41.
Motto: "Beginnings are dificill."
Icon: Cupid approaches a lady, but a hare pulls him back.
Epigram: When the lover begins his suit, he is torn between hope and fear.

CUPID, HARE, PALM
Van Veen, p. 101.
Motto: "Love hath no feare."
Icon: Cupid stands with a foot on a hare, holds a palm.
Epigram: Love conquers fear.

CUPID, JOVE, LADY
Van Veen, p. 181.
Motto: "Love endures no compagnion."
Icon: Cupid drives Jove away from a lady.
Epigram: Love allows no one to share his beloved.

CUPID, MASK, RING
Van Veen, p. 55.
Motto: "Love requyres sinceritie."
Icon: Cupid steps on a mask, holds a ring.
Epigram: Love does not dissemble or disguise himself.

CUPID, PHOEBUS, PYTHON
Van Veen, p. 21.
Motto: "Love subdueth all."
Icon: Cupid wounds Phoebus, who stands by a slain python.
Epigram: Cupid conquers even the greatest.

CUPID, PHYSIC, SICKNESS
Van Veen, p. 121.
Motto: "Love refuseth help."
Icon: Cupid lies sick in bed but refuses medicines.

Epigram: The lover refuses to cure his grief by renouncing love.

CUPID, PHYSICIAN, SICKNESS
Van Veen, p. 169.
Motto: "Love is loves phisition."
Icon: Cupid as a physician attends a sick and wounded lover.
Epigram: Love, which causes the lover's wounds, is the best cure.

CUPID, SEA, SHELL
Van Veen, p. 203.
Motto: "Loves infinite paynes."
Icon: Cupid tortures a lover, who sits by the sea with the beach strewn with shells.
Epigram: The griefs of love outnumber the billows of the sea and the shells of the shore.

CUPID, TOY, VENUS
Quarles, *Emb.*, p. 92.
Motto: "Haec animant pueros cymbala; at illa viros."
Icon: Venus holds crying Cupid on her lap, amusing him with a toy while Divine Love points to heaven, where angels make music.
Epigram: Earthly things are trifles; man should trust instead in the higher joys of heaven.

CUPID WATERING GARDEN
Van Veen, p. 79.
Motto: "Love growes by favour."
Icon: Cupid waters a garden.
Epigram: As the garden flourishes when it is watered, so love grows when it is nourished by favors.

CUP OF GOLD
P. S., p. 90.
Motto: "Inter eclipses exorior."
Icon: A golden cup.
Epigram: The golden cup signifies the prince's glory, which shines among the stars.

CUP OF POISON
See:
 GANYMEDE
 Peacham, p. 48.

Cupping glass
See: BOXING GLASS.

CURTAIN
Quarles, *Emb.*, p. 288.
Motto: "When shall I come and appear before the Lord."
Icon: A human figure stands in front of a drawn curtain behind which stands Divine Love.

Epigram: Man longs to see God, to have the curtain of flesh removed.

Cushion
See: PILLOW.

CUSHION, HAMMER, STONE
Jenner, no. 4.
 Motto: "The meanes to get a soft heart."
 Icon: A hammer hits a stone which lies on a cushion.
 Epigram: When a hard stone is placed on a cushion, it can easily be shattered; so the love of God will soften the stony heart.

CUTTLEFISH
Whitney, p. 97.
 Motto: "Dum potes, vive."
 Icon: A cuttlefish escapes from a fisherman.
 Epigram: As the cuttlefish is able to escape the fisherman by muddying the water, so man should use all his means to save his life.
See also: OCTUPUS, POLIPUS.

CYNTHIA
Wither, p. 24.
R. B., no. 47.
 Motto: "Who by good Meanes, good things would gaine,
 Shall never seeke, nor aske in vaine."
 Icon: Cynthia on a hunt.
 Epigram: Cynthia, who never hunts in vain, represents minds who pursue their goals with constancy.
See also: DIANA, LUNA.

CYPRESS TREE
Combe, no. 65.
 Motto: "The fairest shape of th'outward part,
 Shewes not the vertues of the heart."
 Icon: A cypress tree.
 Epigram: Just as the cypress tree appears beautiful but bears no wholesome fruit, so outward beauty and titles tell nothing of the inner man.
Peacham, p. 167.
 Motto: "Nitor in adversum."
 Icon: A cypress tree stands with a weighty object in its branches.
 Epigram: As the cypress tree grows higher, the greater the weight oppressing it, so constancy defies fortune.
Whitney, p. 205.
 Motto: "Pulchritudo sine fructu."
 Icon: A cypress tree.
 Epigram: As the cypress tree is handsome and sweet-smelling but yields no fruit, so are those men who fawn and promise much but are barren of deeds.

D

Daedalus
See DEDALUS AND ICARUS

DAGON
See:
 ARK OF THE COVENANT
 Willet, no. 61.

DAMASK ROSE
Thynne, no. 27.
 Motto: "Societie."
 Icon: None.
 Epigram: As the damask rose has both a beautiful color and a delightful fragrance, so human society has both love and faith.

DANAE
Ayres, no. 36.
 Motto: "Gold the Picklock."
 Icon: A statue of a naked woman with a fish on her shoulder stands in a garden where Cupids toss objects.
 Epigram: Gold is more powerful than thunder or lightning, as Danae discovered.

DARK
See:
 HEART AND MONSTER
 H. A., p. 58.

DARKNESS
Van Veen, p. 113.
 Motto: "Love lyketh darknes."
 Icon: Cupid kisses a lady in darkness.
 Epigram: Love prefers darkness and secrecy.
See also:
 CANDLE AND DARKNESS
 Quarles, *Emb.*, p. 56.
 NIGHT AND SUN
 Astry, no. 12.
 RUIN, TAPER, TREE TRUNK
 Quarles, *Hier.*, no. 15.
See also: NIGHT.

DARKNESS AND HAND
Hall, p. 36.
 Motto: "Who took me by the hand, and brought me out of that darkness wherewith I was in love?"
 Icon: Divine Love takes a human figure by the hand and pulls him out of darkness.
 Epigram: God teaches man joy and brings him out of the darkness of sin.

DARKNESS AND HEART
Harvey, no. 3.
 Motto: "Cordis Tenebrae."

Icon: A human figure at the mouth of a cave faces darkness which surrounds his heart.

Epigram: Unless the light of truth guides one, his heart will be lost to the darkness of hell.

DARKNESS AND LAMP
Quarles, *Emb.*, p. 128.
 Motto: "My soule hath desired thee in the night."
 Icon: Divine Love, surrounded by darkness, holds a lamp and points heavenward.
 Epigram: Darkness surrounds man's soul, but heaven provides light.

DART
Arwaker, bk. 3, no. 1.
 Motto: "I charge you, O Daughters of Jerusalem, if you find my Beloved, that you tell him that I am sick of Love."
 Icon: A reclining figure with a flaming dart at her breast gestures to the daughters of Jerusalem.
 Epigram: The soul is overwhelmed by its love for God.

Quarles, *Emb.*, p. 244.
 Motto: "I charge you, o yee Daughters of Jerusalem if yee finde my beloved that you tell him that I am sicke of love."
 Icon: A reclining woman with a flaming dart in her breast gestures to the daughters of Jerusalem.
 Epigram: The soul is overwhelmed by its love for God.

P. S., p. 335.
 Motto: "Consequitur quodcumque petit."
 Icon: A dart is entwined with a ribbon and inscribed with a motto.
 Epigram: The owner of the device will obtain whatever she desires.

See also:
 ARMOR AND CUPID
 Van Veen, p. 23.
 BEAST AND DART
 P. S., p. 218.
 BEAUTY
 Peacham, p. 58.
 BOUGH, DART, SEPULCHRE
 P. S., p. 59.
 CUPID AND DART
 Van Veen, p. 9.
 CUPID AND LOVER
 Van Veen, p. 29.
 CUPID AND UNIVERSE
 Van Veen, p. 35.
 DEATH
 Bunyan, no. 56.
 FLAME AND HEART
 Hall, p. 72.

HANDSHAKE AND HEART
Godyere, no. 15 (misnumbered 12).
HEART
Hall, p. 32.

DART AND DEVIL
Quarles, *Emb.*, p. 112.
 Motto: "Post vulnera Daemon."
 Icon: Divine Love shoots a dart at Cupid, who sits on the world while the Devil holds a dart to his head.
 Epigram: The Devil conquers the foolish man who cannot give up the pleasures of the world and therefore cannot be pierced by the dart of repentance.

DART AND RING
P. S., p. 284.
 Motto: "Supplicio laus tuta semel."
 Icon: A dart passes through a ring.
 Epigram: An Indian, renowned for his ability to throw a dart through a ring, refused to perform his trick for Alexander, for he preferred to die rather than risk the shame of missing.

DART AND SHIELD
P. S., p. 158.
 Motto: "Parce Imperator."
 Icon: Many darts pierce a shield.
 Epigram: This shield represents the virtue of Secua, who fought valiantly even after his shield had been pierced by 120 darts.

DART AND WOUND
Hall, p. 12.
 Motto: "So I was sick and in torture, turning me up and down in my bonds."
 Icon: Divine Love ministers to a human figure, lying sick, wounded by a dart; in the background Cupid with an arrow and the sun.
 Epigram: God alone can heal our wounds, which he himself creates in our obdurate hearts.

DAUGHTER OF JERUSALEM
See:
 DART
 Arwaker, bk. 3, no. 1.
 Quarles, *Emb.*, p. 244.

DAWN
Bunyan, no. 5.
 Motto: "Meditations upon Peep of day."
 Icon: None.
 Epigram: Perceiving the state of grace is like perceiving the dawn; just as man cannot distinguish night from day, he cannot know if he is cursed or blessed.
See also: SUNRISE.

DAY
See:

> SORROW AND TIME
> Arwaker, bk. 1, no. 15.
> Quarles, *Emb.*, p. 180.

DEAD
See:

> CROWN AND DEAD
> Thynne, no. 9.
> CUPID AND DEAD
> Van Veen, p. 247.
> CUPID, DEAFNESS, FAME
> Van Veen, p. 67.

See also: CORPSE.

DEAD BOUND TO QUICK
Whitney, p. 99.
Motto: "Impar conjugium."
Icon: A king directs men as they bind a living person to a dead man.
Epigram: The torture of binding a living person to a dead man, devised and used by the tyrant Mezentius (Mezetius), represents the cruelties of enforced or parent-arranged marriages.

DEATH
Bunyan, no. 56.
Motto: "Upon Death."
Icon: None.
Epigram: Death has a dart which is poison to men who do not partake of God's glory, for its sting is sin, and its strength is the law; but Christ washes the sin from worthy men and saves the chosen from Death.

See also:

> ARROW, DEATH, PRAYING MAN
> P. S., p. 364.
> BONE
> P. S., p. 317.
> Wither, p. 8.
> CUPID AND DEATH
> Thynne, no. 4.
> Whitney, p. 132.
> GLASS
> Arwaker, bk. 1, no. 14.
> Quarles, *Emb.*, p. 176.
> SLEEP
> Quarles, *Emb.*, p. 28.
> SNARE
> Arwaker, bk. 1, no. 9.

DEATH AND KING
Montenay, p. 106.
Motto: "Si Dominus voluerit."
Icon: Death, blowing a trumpet and holding a sword, stands beside the world and threatens a king on horseback.
Epigram: Kings should remember their own mortality and help the poor.

DEATH AND SCHOLAR
Wither, p. 1.
R. B., no. 3.
Motto: "By Knowledge onely, Life wee gaine, All other things to Death pertaine."
Icon: Death, in the image of a skeleton, holds a scepter and treasures while a scholar holds a book and an armillary sphere.
Epigram: Worldly power and riches lead to death, but knowledge leads to virtue.

DEATH AND TIME
Quarles, *Hier*, no. 6.
Motto: "Tempus erit."
Icon: Death with an arrow holds a candlesnuffer above a burning taper while Time, with wings and an hourglass, stays Death's arms; on a post is a sundial.
Epigram: A debate between Death and Time establishes Time as superior.

DEATH AND WORLD
Montenay, p. 386.
Motto: "Desiderans dissolvi."
Icon: Death leads a man out of the world.
Epigram: The godly man receives death with joy; the wicked, with despair.

DEATH AND YOKE
Montenay, p. 46.
Motto: "Rectum judicium."
Icon: Death captures a man with a sling, while a hand from heaven holds a yoke.
Epigram: Because death spares no one, men should patiently bear the yoke of God.

DEATH, FRUIT, TREE, TAPER
Quarles, *Hier*, no. 14.
Motto: "Invidiosa Senectus."
Icon: A taper with the roman numeral *60* in the top of two segments stands in an urn; on one side is a coiled serpent, and beside it death, a skeleton, shakes leaves from a tree.
Epigram: In the sixth decade of life man is like the tree in autumn, losing its leaves and fruit; he prepares for death.

Death's-head
See: SKULL.

DEATH'S-HEAD, HANDSHAKE, HEART
Wither, p. 99.
Motto: "Death, is unable to divide Their Hearts, whose Hands True-love hath tyde."

Icon: Hands clasp over a burning heart on an altar, beneath a death's-head.

Epigram: Marriage unites a couple until death.

DEATH'S-HEAD, MATTOCK, SCEPTER
P. S., p. 373 (misnumbered 273).

Motto: "Mors sceptra ligonibus aeguans."

Icon: A death's-head appears above a mattock and a scepter.

Epigram: Death makes equal the king's scepter and the poor man's mattock.

DECEIT
Peacham, p. 47.

Motto: "Dolus."

Icon: Deceit folds his hands in prayer and gazes devoutly to heaven; his lower body is serpentlike; a panther stands behind him.

Epigram: Deceit seems to be devout but in fact is sinful; like the panther he tricks others by pretending to be something he is not.

See also: FRAUD.

DECOY
See:

FOWLER AND LARK
Bunyan, no. 23.

DECREE
See also:

TEARING DECREE
P. S., p. 127.

DEDALUS AND ICARUS
Van Veen, p. 43.

Motto: "Fly in the middest."

Icon: Cupid watches the flight of Dedalus and the fall of Icarus.

Epigram: In love one should take the middle course.

DEER
Willet, no. 2.

Motto: "Ad patriae suae non exignum columen columnam hanc mittunt Musarum alumni."

Icon: None.

Epigram: Dedicated to a particular man, this poem compares that man to a deer: (1) as the deer chews cud, the man thinks of God's law; (2) as the deer leaps, the man joys in heaven; (3) as the deer runs swiftly, the man shuns evil; and (4) as the deer seeks water, the man seeks faith.

See also:

CUPID AND HUNT
Van Veen, p. 131.

See also: BUCK, HART, HIND, ROE, STAG.

DEFORMED CUPID
See:

CUPID DEFORMED
Quarles, *Emb.*, p. 96.

Demeter
See: CERES.

DEMOCRITUS AND HERACLITUS
Whitney, p. 14.

Motto: "In vitam humanam."

Icon: Democritus laughs and Heraclitus weeps.

Epigram: The wickedness of the world moved Democritus to laugh, Heraclitus to weep.

DEVIL
Quarles, *Emb.*, p. 60.

Motto: "Debilitata fides: Terras Astraea reliquit."

Icon: The Devil sits on top of the world, observes Fraud (two-faced) beating Astraea and Sense clipping Faith's wings.

Epigram: The Devil has usurped God's throne, and hell has broken loose on earth; the speaker asks for God's help.

See also:

BELLOWS, HEART, TREASURE
Harvey, no. 5.
CHARIOT, DEVIL, WORLD
Quarles, *Emb.*, p. 44.
DART AND DEVIL
Quarles, *Emb.*, p. 112.
DRINK, FOOD, HEART
Harvey, no. 6.
FALL
Quarles, *Emb.*, p. 116.
HEART AND NET
H. A., p. 30.

See also: SATAN.

DEVIL, HEART, SLEEP
Harvey, no. 2.

Motto: "Ablatio Cordis."

Icon: A human figure, with his head on a pillow, sleeps while two devils take hold of his heart, which rests in his hand.

Epigram: Sloth and lust endanger the heart, making it vulnerable to the Devil and eternal damnation.

DEVIL'S MESSENGER
See:

POURING AND WORLD
Montenay, p. 118.

DEW
Hawkins, no. 6, p. 59.

Motto: "Rore madens rore liquescens."

Icon: Dew falls from heaven.

Epigram: Dewdrops are like precious pearls, the tears of nature; the dew is likened to Christ, who entered Mary's womb like a drop of dew.

Hawkins, no. 6, p. 67.
Motto: "Benedicta inter muliers."
Icon: Dew falls from heaven onto the barren Earth.
Epigram: The dew is likened to Christ, a pure vapor entering the Virgin's womb.

See also:
GOLDEN FLEECE
Astry, no. 39.
LEARNING
Peacham, p. 26.

DEW AND OINTMENT
Willet, no. 68.
Motto: "Charitas non quaerit quae sua sunt."
Icon: None.
Epigram: Peace is likened to the healing ointment and the fruitful dew.

DIADEM
P. S., p. 101.
Motto: "Ecquis emat tanti sese dimittere?"
Icon: Hands hold a diadem.
Epigram: If a man realized what troubles, miseries, and dangers the crown brings, he would refuse it.

See also: CROWN.

DIAMOND
See:
ANVIL, DIAMOND, SLEDGE
Wither, p. 171.
RING AND SWINE
Wither, p. 224.
See also: JEWEL.

DIANA
Hawkins, no. 10, p. 111.
Motto: "Quo te cunque sequor."
Icon: Diana, with a half-moon on her head, sits in a chariot drawn by horses, holds a scepter, and draws Neptune with a string.
Epigram: As the moon controls the ebb of the ocean, the writer asks the Virgin Mary—the chaste Diana—to draw him to virtue, away from vice.

See also:
ACTEON
Whitney, p. 15.
ACTEON AND DIANA
Peacham, p. 175.
CUPID AND DIANA
Thynne, no. 6.
See also: CYNTHIA, LUNA.

DICE
Whitney, p. 176.
Motto: "Semper praesto esse infortunia."
Icon: Three women play at dice.
Epigram: While women play frivolously at dice, throwing to see who will be the first to die, the one who this game of chance declared would live the longest suddenly dies. The moral: trust not in chance but in God.

See also:
DRINKING
Whitney, p. 17.

DICTAMON AND HART
Van Veen, p. 155.
Motto: "No help for the lover."
Icon: A wounded hart eats the herb dictamon, while a wounded Cupid watches.
Epigram: The wounded hart cures himself with dictamon, but the wounded lover can find no cure for his grief.

DICTANUS
See:
ARROW, DICTANUS, HART
P. S., p. 354.

DIGGING
See:
HEART AND WORLD
Montenay, p. 338.
PIT AND SPRING
Montenay, p. 334.

DILIGENCE AND IDLENESS
Combe, no. 100.
Motto: "The hand that idlenesse detests,
Doth hoord the money in the chests."
Icon: Diligence sits in a chariot, drawn by ants, holds a cornucopia and beats Idleness with a scourge.
Epigram: This picture of Idleness and Diligence teaches that, unless we labor like the ant, we will live in woe and want.

DIOGENES
See:
CODRUS, DIOGENES, KING
Whitney, p. 198.
LANTERN
Farlie, no. 5.

DIOMEDES AND ULYSSES
Whitney, p. 47.
Motto: "Marte and arte."
Icon: An armed soldier (Diomedes) and a robed man with a book (Ulysses) face each other.
Epigram: The ideal captain must join these two men

and balance the ideas they represent: action and wisdom, courage and counsel, prowess and wit.

Disease
See: SICKNESS.

Disguise
See: DISSIMULATION, MASK.

DISGUISE AND STAFF
P. S., p. 341.
 Motto: "Amico ficto nulla fit injuria."
 Icon: A man hits a person in disguise with a staff.
 Epigram: A man who feigns friendship is like a person in disguise; when he is injured, he throws off his disguise, saying, "No wrong to a feigned friend."

DISMEMBERMENT
Willet, no. 55.
 Motto: "Par pari."
 Icon: None.
 Epigram: The king of Bezek was punished in the same manner he had tortured others, by cutting off his hand and foot; so God often punishes according to the crime.

DISSIMULATION
See:
 NET
 Peacham, p. 197.
See also: DISGUISE.

DISTAFF
See:
 BOOK, CUPID, DISTAFF, HERCULES
 Van Veen, p. 83.
 HERCULES
 Peacham, p. 95.
 SARDANAPALUS
 Thynne, no. 10.

Distillery
See: STILL.

DIVIDED
See:
 HEART DIVIDED
 Harvey, no. 9.

DIVIDING
See:
 TREE
 Astry, no. 70.

DIVINE LAW AND WORLD
Whitney, p. 223.
 Motto: "Nemo potest duobus dominis servire."

 Icon: A man carries the world on his shoulder and drags the divine law on his foot.
 Epigram: The man who places worldly above heavenly things starves his soul.

DIVINE LOVE
See:
 ANCHOR
 Arwaker, bk. 2, no. 13.
 Quarles, *Emb.*, p. 232.
 ANVIL, HAMMER, HEART
 Harvey, no. 8.
 ARROW AND HEART
 Hall, p. 52.
 ASSUERUS AND ESTHER
 Quarles, *Emb.*, p. 204.
 BALANCE AND BUBBLE
 Quarles, *Emb.*, p. 16.
 BALANCE, HEART, LAW
 Harvey, no. 20.
 BAUBLE AND FOOL
 Arwaker, bk. 1, no. 2.
 Quarles, *Emb.*, p. 132.
 BED AND CROSS
 Arwaker, bk. 2, no. 10.
 Quarles, *Emb.*, p. 220.
 BUBBLE AND SMOKE
 Quarles, *Emb.*, p. 76.
 CAGE
 Arwaker, bk. 3, no. 10.
 Quarles, *Emb.*, p. 280.
 CAGE AND HEART
 Hall, p. 44.
 CAVE AND THUNDERBOLT
 Arwaker, bk. 1, no. 12.
 Quarles, *Emb.*, p. 168.
 CHARIOT, DEVIL, WORLD
 Quarles, *Emb.*, p. 44.
 CHILD AND WALKER
 Arwaker, bk. 2, no. 3.
 Quarles, p. 192.
 CIRCUMCISION AND HEART
 Harvey, no. 13.
 CLAY, DUST, POTTER
 Arwaker, bk. 1, no. 5.
 Quarles, *Emb.*, p. 140.
 COIN
 Quarles, *Emb.*, p. 80.
 CONQUEROR AND KNEELING FOE
 Arwaker, bk. 1, no. 6.
 Quarles, *Emb.*, p. 144.
 CORD AND HEART
 Harvey, no. 42.
 COUNTRY
 Arwaker, bk. 2, no. 7.
 Quarles, *Emb.*, p. 208.

CROWN AND GATE OF THORNS
Quarles, *Emb.*, p. 104.
CROWN OF THORNS AND HEART
Harvey, no. 45.
CUPID AND LAW
Arwaker, bk. 2, no. 1.
Quarles, *Emb.*, p. 184.
CUPID, FOOL, NET
Quarles, *Emb.*, p. 72.
CUPID, TOY, VENUS
Quarles, *Emb.*, p. 92.
CURTAIN
Quarles, *Emb.*, p. 288.
DARKNESS AND HAND
Hall, p. 36.
DARKNESS AND LAMP
Quarles, *Emb.*, p. 128.
DART AND DEVIL
Quarles, *Emb.*, p. 112.
DART AND WOUND
Hall, p. 12.
DOVE AND HEART
Harvey, no. 34.
DRAWING AND RUNNING
Arwaker, bk. 2, no. 8.
Quarles, *Emb.*, p. 212.
EARTH AND HEAVEN
Arwaker, bk. 3, no. 6.
Quarles, *Emb.*, p. 264.
ECLIPSE
Arwaker, bk. 1, no. 7.
Quarles, *Emb.*, p. 148.
EMBRACE
Arwaker, bk. 2, no. 12.
Quarles, *Emb.*, p. 228.
ENLARGING HEART
Harvey, no. 35.
FALL
Quarles, *Emb.*, p. 116.
FIRE AND HEART
Harvey, no. 36.
FLAME AND HEART
Hall, p. 72.
FLAMING SWORD, GARDEN, HEART
Harvey, no. 31.
FOUNTAIN
Hall, p. 56.
FOUNTAIN AND HART
Arwaker, bk. 3, no. 11.
Quarles, *Emb.*, p. 284.
FURNACE AND HEART
Harvey, no. 18.
GIVING HEART
Harvey, nos. 18, 24.
GLASS

Quarles, *Emb.*, p. 84.
HAMMER, HEART, NAIL
Harvey, no. 46.
HEART
Arwaker, bk. 2, no. 6.
Hall, p. 32.
Quarles, *Emb.*, p. 120.
HEART AND LAW
Harvey, no. 26.
HEART AND LEVEL
Harvey, no. 23.
HEART AND PILLAR
Harvey, no. 43.
HEART AND PLUMMET
Harvey, no. 22.
HEART AND REST
Harvey, no. 40.
HEART AND SCOURGE
Harvey, no. 40.
HEART AND SEED
Harvey, no. 28.
HEART AND SHAFT
Harvey, no. 28.
HEART AND TEAR
Harvey, no. 33.
HEART AND WANDERER
Harvey, no. 11.
HEART AND WINE
Hall, p. 40.
HEART AND WINEPRESS
Harvey, no. 47.
HEART AND WING
Harvey, no. 38.
HEART DIVIDED
Harvey, no. 9.
HEART, LIGHT, SUNDIAL
Harvey, no. 25.
HEART OF ICE AND SIN
Harvey, no. 16.
HELIOTROPE AND LOADSTONE
Arwaker, bk. 3, no. 3.
HUNGER
Hall, p. 16.
ICE
Hall, p. 16.
INFANT AND HANDMAID
Quarles, *Emb.*, p. 216.
INFANT AND SISTER
Arwaker, bk. 2, no. 9.
JUDGE AND JUSTICE
Arwaker, bk. 1, no. 10.
Quarles, *Emb.*, p. 160.
LABYRINTH AND PILGRIM
Arwaker, bk. 2, no. 2.
Quarles, *Emb.*, p. 188.

LANTERN
Arwaker, bk. 1, no. 1.
LIGHTNING AND ROD
Arwaker, bk. 2, no. 4.
Quarles, *Emb.*, p. 196.
LILY AND WREATH
Arwaker, bk. 3, no. 3.
Quarles, *Emb.*, p. 252.
LUTE
Arwaker, bk. 2, no. 15.
MELTING
Arwaker, bk. 3, no. 15.
Quarles, *Emb.*, p. 260.
MILL WHEEL AND SCOURGE
Arwaker, bk. 1, no. 4.
Quarles, *Emb.*, p. 136 (note: second of two pages numbered 136).
NEEDLE OF COMPASS
Quarles, *Emb.*, p. 258.
PHYSICIAN AND PATIENT
Arwaker, bk. 1, no. 3.
Quarles, *Emb.*, p. 136 (note: first of two pages numbered 136).
RISING AND SEEKING
Arwaker, bk. 2, no. 11.
Quarles, *Emb.*, p. 224.
ROE
Arwaker, bk. 3, no. 15.
Quarles, *Emb.*, p. 300.
SEA AND SHIPWRECK
Arwaker, bk. 1, no. 11.
Quarles, *Emb.*, p. 164.
SHADOW
Arwaker, bk. 2, no. 14.
Quarles, *Emb.*, p. 236.
SHIP
Hall, no. 48.
SIEVE
Quarles, *Emb.*, p. 88.
SLEEP
Quarles, *Emb.*, p. 28.
SNARE
Hall, p. 68.
SUNDIAL
Arwaker, bk. 1, no. 13.
Quarles, *Emb.*, p. 172.
TORTURE
Hall, p. 8.
TYING HEART
Harvey, no. 39.
VANITY
Arwaker, bk. 2, no. 5.
Quarles, *Emb.*, p. 200.
VEIL
Arwaker, bk. 3, no. 12.

WASP AND WORLD
Quarles, *Emb.*, p. 12.
WATERING HEART
Harvey, no. 29.
WHEEL, WIND, WORLD
Quarles, *Emb.*, p. 108.
WING
Arwaker, bk. 3, no. 12.
Quarles, *Emb.*, p. 292.
WORLD
Quarles, *Emb.*, p. 100.
WORLD IN ARMS
Quarles, *Emb.*, p. 68.
WREATH
Quarles, *Emb.*, p. 252.

DOCK
Whitney, p. 98.
 Motto: "Virescit vulnere virtus."
 Icon: A man treads on a plant known as dock.
 Epigram: As the docks continue to grow even though they are trodden daily, so virtue thrives.
See also: RUMICE.

Doctor
See: PHYSICIAN, SURGEON.

DOCTRINA
See:
 LEARNING
 Peacham, p. 26.

Doctrine
See: LEARNING.

DODONIAN [DODONAEAN] TREE
Van der Noodt, no. 10.
 Motto: None.
 Icon: Men fell the Dodonian tree which grows on the river.
 Epigram: The Dodonian tree symbolizes Rome, its ancient glory, its destruction by the barbarians, and its reappearance as a Roman Catholic state.

DOG
Thynne, no. 25.
 Motto: "Threates of the inferior to be contemned."
 Icon: None.
 Epigram: When the small dog threatens larger dogs with a loud voice, they ignore it; so strong and wise men scorn the anger of the weak.
Whitney, p. 39.
 Motto: "Mediocribus utere partis."
 Icon: A dog with a bone in its mouth looks at its reflection in a stream.
 Epigram: When the greedy dog sees its reflection, it is discontent and drops its bone; likewise,

when a man of low estate is discontent with his lot and tries to advance, he loses everything.

Whitney, p. 140.
Motto: "Feriunt summos fulmina montes."
Icon: A large dog, yoked to a wagon, works while smaller dogs run beside him.
Epigram: Just as the large, working dog is vulnerable to the biting and barking of the smaller dogs, so the monarch, in his powerful position, is vulnerable.

Willet, no. 93 (misnumbered 39).
Motto: "Cavete à canibus."
Icon: None.
Epigram: Unlike the dog, which barks at everything, a man should learn to discriminate between the good and the bad.

See also:
AESCULAPIUS
Whitney, p. 212.
APE AND DOG
Whitney, p. 58.
ASS AND DOG
Combe, no. 46.
BONE AND DOG
Ayres, no. 25.
BREAD AND DOG
Wither, p. 255.
CLUB AND DOG
Astry, no. 9.
CUDGEL
Jenner, no. 24.
CUPID, DOG, HARE
Van Veen, p. 25.
See also: HOUND, SPANIEL, WHELP.

DOG AND BOW OF SHIP
P. S., p. 252.
Motto: "Infestis tutamen aquis."
Icon: A dog leans forward on the bow of a ship.
Epigram: A dog on the bow of a ship signifies vigilance.

DOG AND HIND
Van der Noodt, no. 1.
Motto: None.
Icon: Dogs pursue a hind.
Epigram: Death vanquishes beauty.

DOG AND LION
Whitney, p. 44.
Motto: "Desiderium spe vacuum."
Icon: A lion devours its prey while a dog looks on.
Epigram: As the dog hopes to share the lion's prey, so greedy men hope to acquire another man's fortune.

Willet, no. 69.
Motto: "Dum spiro spero."
Icon: None.
Epigram: As a living dog is better than a dead lion, so, too, a poor man who still enjoys life is better than a dead nobleman.

DOG AND MOON
Whitney, p. 213.
Motto: "Inanis impetus."
Icon: A dog barks at the moon.
Epigram: The dog which sees its shadow by the light of the moon and barks because it thinks another dog is present is like those fools who vainly attack learned men who outshine others.

DOG AND STONE
Thynne, no. 31.
Motto: "Revenge."
Icon: None.
Epigram: When a dog bites the stone thrown at it, it only hurts itself; so a man only furthers his own grief by rashly taking revenge on the instruments of his hurt rather than the agents.

Whitney, p. 56.
Motto: "Alius peccat, alius plectitur."
Icon: A boy throws a stone at a dog, which attacks the stone.
Epigram: Just as a dog angrily attacks a stone rather than the boy who throws it, so men fight with the innocent and avoid those who have inflamed them.

DOG, HARE, SCEPTER
Combe, no. 92 (misnumbered 90).
Motto: "Love and feare are chiefest things, That stablish Scepters unto kings."
Icon: A dog and a hare hold a crown over a specter.
Epigram: Subjects should serve their kings like the dog and the hare, with love and fear.

DOG IN MANGER
Whitney, p. 184.
Motto: "Nec sibi, nec alteri."
Icon: A dog in a manger snarls at an ox.
Epigram: As the dog keeps the ox from his food through spite, so the envious man.

DOLPHIN
Combe, no. 96.
Motto: "A wanton woman and a light Will not be tam'd by art nor night."
Icon: A man holds a dolphin by the tail.
Epigram: It is easier to restrain a dolphin than to control the will of a wanton woman.

Peacham, p. 86.
 Motto: "In salo sine sale."
 Icon: A dolphin swims in the sea.
 Epigram: As the dolphin lives in the sea but remains untainted by the salt, so the particular lady addressed here lives in danger but keeps her honor.

Whitney, p. 90.
 Motto: "In eum qui truculentia suorum perierit."
 Icon: A dolphin lies on the shore.
 Epigram: As the sea sometimes throws the mighty dolphin onto the shore, so countries sometimes exile great men, despite their accomplishments.

See also:
 ANCHOR AND DOLPHIN
 P. S., p. 326.
 Wither, p. 72.
 ARION
 Wither, p. 10.
 R. B., no. 39.
 ARION AND DOLPHIN
 Whitney, p. 144.
 CHAMELEON AND DOLPHIN
 P. S., p. 243.

DOLPHIN AND TELEMACHUS
Thynne, no. 64.
 Motto: "Strangers more freindlie to us then our own kinde and kindred."
 Icon: None.
 Epigram: As the dolphins saved Telemachus from drowning, so strangers may do us more good than our own kindred.

DOLPHIN, GLOBE, RING
P. S., p. 327.
 Motto: "Pacatum ipsa regam avitis vertutibus orbem."
 Icon: A dolphin bears a ring encircling a globe on its back; palm and olive branches decorate the moon.
 Epigram: This device signifies the progeny of King Dolphin.

Doomsday
See: LAST JUDGMENT, LAST THINGS.

DOOR
Whitney, p. 204.
 Motto: "Avaritia huius saeculi."
 Icon: Rich people enter on one side of a door, poor people on the other.
 Epigram: This emblem criticizes the discrepancy between the treatment of the rich and the poor and then complains about the poverty of poets.

See also:
 CUPID AND DOOR
 Van Veen, p. 105.
 JANUS
 Wither, p. 138.

DOOR, HEART, KNOCKING
H. A., p. 45.
 Motto: "Jesus knocks at the doore of the hart."
 Icon: Jesus knocks on a door hinged to a heart.
 Epigram: When Jesus comes to call, receive him.

DOVE
Hawkins, no. 18, p. 198.
 Motto: "In foraminibus Petrae."
 Icon: A dove.
 Epigram: "The dove is the true and perfect type of Love" and therefore a symbol of the Virgin.

See also:
 RINGDOVE
 Whitney, p. 29.
 ROSE
 Hawkins, no. 2, p. 25.
 SEA
 Hawkins, no. 20, p. 242.
See also: RING DOVE, TURTLEDOVE.

DOVE AND HEART
Harvey, no. 34.
 Motto: "Cordis Inhabitatio."
 Icon: Divine Love sends a dove into the human heart.
 Epigram: God sends forth the spirit of his Son into men's hearts.

DOVE AND SERPENT
Wither, p. 151.
 Motto: "Man's life, no Temper, more doth blesse, Then Simple-prudent-harmelessenesse."
 Icon: Two serpents intertwine a staff on which a dove sits.
 Epigram: The man who combines the prudence of a serpent with the innocence of a dove is blessed.

DOVE AND VIRGIN MARY
Hawkins, no. 18, p. 207.
 Motto: "Nigra sum sed formosa."
 Icon: A dove flies from a cloud to the Virgin Mary.
 Epigram: The Holy Ghost, like a dove, seeks the Virgin Mary, who, in her chastity and love, is like a dove.

DRAGON
Peacham, p. 30.
 Motto: "Rex medicus patria."

Icon: A dragon holds a scepter.

Epigram: The dragon represents the proper ruler; he should be ever watchful and purge corruption when he finds it.

P. S., p. 248.

Motto: "Pythone peremto."

Icon: A dragon functions as a martial ensign.

Epigram: The dragon signifies continual watchfulness.

See also:

AESCULAPIUS
Whitney, p. 212.

BEAUTY
Peacham, p. 58.

SEVEN-HEADED BEAST
Van der Noodt, no. 17.

See also: ADDER, SERPENT, SNAKE, VIPER.

DRAGON AND EAGLE

P. S., p. 258.

Motto: "Ut lapsu graviore ruant."

Icon: A dragon and an eagle fight.

Epigram: The perpetual enmity between the dragon and the eagle represents the contention between haughty men.

DRAGON WITH TEN HORNS

Willet, no. 22.

Motto: "Antichristi effigies."

Icon: None.

Epigram: The red dragon with ten horns, ridden by a whore in purple with a crown and a cup, symbolizes Antichrist, identified here as the pope.

DRAWING AND RUNNING

Arwaker, bk. 2, no. 8.

Motto: "Draw me, we will run after thee, (in the favour of thy Oyntments)."

Icon: Divine Love, carrying a torch which burns ointments, runs and draws a human figure with a cord.

Epigram: Love, like a cord, holds tightly and "draws affectionately."

Quarles, *Emb.*, p. 212.

Motto: "Draw me; we will run after thee because of the savour of thy good oyntments."

Icon: Divine Love, carrying a torch which burns ointments, runs and draws a human figure with a rope.

Epigram: Man in unable to run on his own and asks God to draw him with his power.

DREAM

Van Veen, p. 167.

Motto: "Dreames do produce joy."

Icon: A lover lies in bed, and his lady appears to him in a dream.

Epigram: The lover dreams that his beloved is present.

See also: BRYSUS.

DRESSING TABLE

See:

HEART
Arwaker, bk. 2, no. 6.

DRINK, FOOD, HEART

Harvey, no. 6.

Motto: "Cordis Aggravatio."

Icon: A heart lies on a banquet table, laden with dishes of food and a pitcher of wine while a devil offers a human figure wine.

Epigram: Excess of food and drink oppresses the heart, preventing it from rising to God.

DRINKING

Whitney, p. 17.

Motto: "Ludus, luctus, luxus."

Icon: Men drink, play games with dice, and fight.

Epigram: The emblem discusses the evils of drinking and gambling.

See also:

CUPID, DRINKING, EATING
Van Veen, p. 85.

FOUNTAIN
Hall, p. 56.

Driver

See: WAGONER.

DRUM

Whitney, p. 194.

Motto: "Vel post mortem formidolsi."

Icon: Two soldiers strike drums."

Epigram: Nature illustrates that enmity does not end with death, for the skins of the wolf and the sheep, if bound together, will jar and make no sound.

See also:

BACCHUS
Whitney, p. 187.

DRUM AND HORSE

Bunyan, no. 51.

Motto: "Of the Horse and Drum."

Icon: None.

Epigram: Like horses which startle and flee at the sound of drums, professors of the faith who cannot stand trial forsake Christ when they are threatened.

DUCK

See:

NET
Whitney, p. 27.

DUCK, FALCON, GOOSE
Whitney, p. 207.
 Motto: "Imparilitas."
 Icon: A falcon soars in the sky while ducks and geese hunt for food on the ground.
 Epigram: As the falcon flies far while the ducks and geese stay in one place near the house, so some men travel through the world while others are content to stay at home.

DUEL
Wither, p. 27.
R. B., no. 46.
 Motto: "Where Hellen is, there, will be Warre; For, Death and Lust, Companions are."
 Icon: Men duel while a woman watches.
 Epigram: Lust causes fighting and death.

DUNG
See:
 GRAPEVINE
 Peacham, p. 157.

DUST
See:
 BEE AND DUST
 Astry, no. 73.
 CLAY, DUST, POTTER
 Arwaker, bk. 1, no. 5.
 Quarles, *Emb.*, p. 140.
 MUSHROOM BALL AND SMOKE
 Wither, p. 85.

DYEING CLOTH
Whitney, p. 134.
 Motto: "In Colores."
 Icon: A man dyes cloth in a large vat.
 Epigram: Men desire new and different colors when old colors should be sufficient; the emblem lists the traditional symbolic significance of basic colors: black stands for religious; white, for pure conscience; green, for hope and youth; yellow, for covetousness and jealousy; red, for war and shame; blue for mariners; violet, for prophets; and gray and russet, for the poor.

E

EAGLE
Astry, no. 22.
 Motto: "Praesidia majestatis."
 Icon: A two-headed eagle holds a thunderbolt in one claw; above it is a crown.
 Epigram: Jove's royal eagles are an emblem of jus-

tice: they have sharpness of sight to inspect crimes, swiftness of wing for execution, and strength of talons so that they will not fail.
Van der Noodt, no. 11.
 Motto: None.
 Icon: An eagle flies towards the sun, falls burning to the earth, and rises "as a worme."
 Epigram: The eagle is presented as pride and presumption, "the soule that shunnes the cherefull light," probably the Roman church.

P. S., p. 250.
 Motto: "Caelo imperium jovis extulit ales."
 Icon: An eagle with lightning serves as a martial ensign.
 Epigram: An eagle was the chief ensign of the Romans because it was considered the king of birds and was associated with Jupiter.

Willet, no. 91.
 Motto: "De Aquila: Ubic ad aver jaceat eò congregautur aquilae."
 Icon: None.
 Epigram: As the eagle, the noblest of birds, seeks and finds its prey, so we ought to seek Christ.

Willet, no. 92.
 Motto: "Divina tutela."
 Icon: None.
 Epigram: As the eagle puts its young on its back, so God cares for us.

See also:
 ALTAR, BALL, EAGLE, SNAKE
 Wither, p. 101.
 ANGEL
 Willet, no. 5.
 BIRTH OF PALLAS
 Peacham, p. 188.
 DRAGON AND EAGLE
 P. S., p. 258.
 FORTUNE
 Wither, p. 6.
 R. B., no. 17.
 GANYMEDE
 Wither, p. 156.
 R. B., no. 44.
 JOVE
 Thynne, no. 34.
 JUPITER
 Combe, no. 57.
 OATH MAKING
 Ayres, no. 35.
 PROMETHEUS
 Peacham, p. 189.
 Whitney, p. 75.

SPREAD EAGLE
P. S., p. 212.
TERMINUS
Peacham, p. 193.
THRUSH
Thynne, no. 11.

EAGLE AND FLY
Combe, no. 32.
 Motto: "Great persons should not with their might,
 Oppresse the poorer, though they might."
 Icon: An eagle and flies.
 Epigram: As the eagle disdains to contend with flies, so great persons should avoid striving with their inferiors lest they risk dishonor.

EAGLE AND HART
P. S., p. 107.
 Motto: "Ardua deturbans vis animosa quatit."
 Icon: An eagle sits on the skull of a hart.
 Epigram: The eagle represents industry and diligence, for it defeats the hart by landing on its horns and filling its eyes with dust.

EAGLE AND PROMETHEUS
Thynne, no. 39.
 Motto: "The wretched not to be Doblie greived."
 Icon: None.
 Epigram: The eagle eats the heart of the wretched Prometheus, but, unlike the eagle, we should not vex the grieving man.

EAGLE AND SHAFT
Combe, no. 52.
 Motto: "With diligence we ought to wayt, To flie the snares of false deceit."
 Icon: An eagle with the shaft of an arrow in its breast.
 Epigram: Like the eagle which is killed by an arrow made with its own feathers, some men are the cause of their own ruin.

EAGLE AND SUN
Godyere, no. 4.
 Motto: "Post nubila phebus."
 Icon: An eagle holds a sword with a plumed crown and a crown with branches; the sun is shining.
 Epigram: The death of Prince Henry, son of James I and heir to the throne, is likened to an eclipse of the sun; Prince Charles's rise is likened to the sunshine after rain; the eagle holds emblems of peace and war, sent from heaven to Charles after Henry's death.

EAGLE AND WORLD
Peacham, p. 28.
 Motto: "His altiora."
 Icon: An eagle rises above a globe and a landscape.
 Epigram: The noble mind rises above worldly concerns.

EAGLE, SHEEP, WOLF
Godyere, no. 6.
 Motto: "Sub umbra alarum tuarum."
 Icon: A wolf chases a sheep, which takes refuge under an eagle's wing.
 Epigram: The lord chancellor is likened to an eagle which protects poor men from vicious men.

EAR
Montenay, p. 410.
 Motto: "Sed ex me."
 Icon: A hand points to an ear on a man's head.
 Epigram: Men often fill up their ears with worldly cares and fail to hear the word of God.

See also:
 ARROW
 Arwaker, bk. 1, frontispiece.
 AWL AND EAR
 P. S., p. 164.
 FAME
 Whitney, p. 196.
 FAME AND VIRTUE
 Peacham, p. 35.
 FLEEING, HEARING, SILENCE
 Whitney, p. 191.
 GARDEN AND NIGHTINGALE
 Hawkins, no. 13, p. 148.
 HEAD OF STATE
 Peacham, p. 22.
 LUTE
 Godyere, no. 18.
 SHAFT
 Quarles, *Emb.*, p. 124.

EAR AND HEART
Montenay, p. 414.
 Motto: "Frustra."
 Icon: A wind blows into the ear of a man, and a finger from heaven touches the heart.
 Epigram: Just as the wind cannot pierce one's body until it blows in the ear, so the word of God cannot enter his heart until God removes his sin.

EAR AND SHEAF OF WHEAT
P. S., p. 268.
 Motto: "De parvis grandis aceruus erit."
 Icon: Many ears of wheat surround a sheaf of wheat.
 Epigram: A sheaf of wheat is made up of many small

ears; so, too, great things come from small beginnings.

EAR OF AN ASS
See:
MIDAS
Whitney, p. 218.

EAR OF CORN
Thynne, no. 22.
Motto: "Vayne Ostentations."
Icon: None.
Epigram: The man of little learning who brags of his wit is like the empty ear of corn which grows above the rest of the corn but is without grain.

EAR OF GRAIN AND SHEAF
Wither, p. 50.
Motto: "Of Little-Gaines, let Care be had; For, of small Eares, great Mowes are made."
Icon: Single ears of grain stand beside a sheaf of grain.
Epigram: As many single ears of grain make a sheaf, so trifling things can, with care, be made significant.

EARTH
See:
ADAM SOWS EARTH
Quarles, *Emb.*, p. 8.
CUPID, EARTH, HEAVEN
Van Veen, p. 35.
CUPID, EARTH, HEAVEN
Van Veen, p. 37.
FOUNTAIN
Hawkins, no. 19, p. 219.
SUN
Astry, no. 86.
See also: GLOBE, GROUND, TURF, WORLD.

EARTH AND HEAVEN
Arwaker, bk. 3, no. 6.
Motto: "Whom have I in Heaven but Thee? and there is none upon Earth that I desire in comparison of Thee."
Icon: A human figure sits on the earth and points to the sphere of the heavens in which Divine Love resides.
Epigram: Nothing on earth matters to man as much as God in heaven.
Quarles, *Emb.*, p. 264.
Motto: "Whom have I in heaven but thee, & what desire I on earth in respect of thee."
Icon: A human figure sits on the earth and points to the sphere of the heavens on which Divine Love resides.

Epigram: Although man loves the earth, it means nothing to him without God.

EARTH AND MAN
Montenay, p. 218.
Motto: "Ex natura."
Icon: A man dissolves into the earth.
Epigram: Man should remember that he is but earth and dust.

EARTH AND WING
Quarles, *Emb.*, p. 276.
Motto: "I am in a streight betwixt two haveing a Desire to Depart & to be with Christ."
Icon: A human figure with wings flies toward heaven but is held back by the earth, which is chained to his leg.
Epigram: The soul longs to join God but is bound to the earth.

EARTH, FIRE, WIND
Willet, no. 36.
Motto: "Avarus."
Icon: None.
Epigram: The greedy man resembles the man who tries to catch the wind, work in fire, or dig in the earth: he trusts in the transitory and earthly.

Earthen
See CLAY.

EARTHEN POT
See:
BRASS POT AND EARTHEN POT
Whitney, p. 164.

Earthly love
See: CUPID.

EARTHQUAKE AND TEMPLE
Van der Noodt, no. 7.
Motto: None.
Icon: An ornate temple is destroyed by an earthquake.
Epigram: The great monuments of men are but vanity.
CUPID, DRINKING, EATING
Van Veen, p. 85.

EATING HEART
Combe, no. 8.
Motto: "It were a foolish senselesse part, With grief and care to eate thy heart."
Icon: A man eats his heart.
Epigram: Man should not waste his life in sorrow.
See also:
SIN
Peacham, p. 146.

TRUTH
Whitney, p. 4.

EATING VIPER
Peacham, p. 49.
Motto: Virtutem aut vitium sequi Genus.
Icon: A man eats a viper.
Epigram: The fabled family in Libya which lived on
 poisonous snakes is like the family of a
 traitor: the children suck the poison of
 their father's "infected mind" and are, in
 turn, infected.

See also:
ENVY
Whitney, p. 94.

ECHENEIS
See:
ARROW AND ECHENEIS
Whitney, p. 188.
See also: REMORA.

ECLIPSE
Arwaker, bk. 1, no. 7.
Motto: Wherefore hidest thou thy face, and hold-
 est me for thine enemy?
Icon: The moon eclipses the sun, and Divine
 Love hides his face from a human figure.
Epigram: When God turns away from sinful men in
 displeasure, the individual begs God not
 to desert him.

Astry, no. 77.
Motto: "Praesentia nocet."
Icon: The moon eclipses the sun, darkens the
 earth.
Epigram: Like the sun and the moon, princes and
 their ministers maintain a mutual corre-
 spondence, but when they confer person-
 ally, they create shadows of suspicion and
 jealousy.

Quarles, *Emb.*, p. 148.
Motto: Wherefore hidest thou thy face, and hold-
 est mee for thine enemy.
Icon: The moon eclipses the sun, and Divine
 Love hides his face from a human figure.
Epigram: When God turns away from sinful men in
 displeasure, the individual begs God not
 to desert him.

ECLIPSE OF MOON
Astry, no. 13.
Motto: "Censurae patet."
Icon: An eclipse of the moon.
Epigram: As the moon receives the sun's rays and
 reigns over night, so the prince receives
 the rays of divine justice and governs earth.
 When the moon is eclipsed, it is not il-

luminated by the sun; likewise, when the
prince is vicious, he is removed from the
light of divine justice.

EEL
Whitney, p. 77.
Motto: "Serò sapiunt Phryges."
Icon: A man catches an eel by wrapping it in fig
 leaves.
Epigram: The slippery eel which eluded fishermen
 so long was finally caught with fig leaves;
 so wicked men who long are able to hide
 their evil nature are eventually caught and
 punished.

See also:
FISHING FOR EEL
Combe, no. 44.

EEL AND HANDSHAKE
Combe, no. 88.
Motto: "No surety in a womans minde,
 Her fancie changeth with the winde."
Icon: A woman shakes hands with a man hold-
 ing an eel.
Epigram: A woman's constancy is no surer than the
 slippery, fleeting eel.

EEL AND SHIELD
Thynne, no. 48.
Motto: "Ensignes of the Clergye."
Icon: None.
Epigram: The slippery eel signifies that the clerk
 should control his tongue and refrain from
 uttering false words or secrets; the blue
 shield denotes the spiritual man; the
 "guelye arm" in midst of it, the clerk's
 modesty.

EGG
P. S., p. 202.
Motto: "Haud sidit inane."
Icon: One egg floats while another sinks to the
 bottom of a vessel of water.
Epigram: A fresh egg sinks, and a rotten one floats;
 so a wise man is humble and quiet, but a
 foolish man is ambitious and ostentatious.

See also:
CHICK AND EGG
Bunyan, no. 3.
HEN
Whitney, p. 64.

ELDER TREE
Peacham, p. 6.
Motto: "Humanae traditiones."
Icon: A tree, growing on a wall, breaks and
 falls.
Epigram: As this elder tree scorned the ground, as-

pired to grow on the wall, and consequently withered, so the proud and vainglorious.

ELEPHANT
Whitney, p. 150.
Motto: "Nusquam tuta fides."
Icon: An elephant leans on a tree as a man with an ax watches.
Epigram: Just as the elephant is killed when it falls asleep against a tree which the hunter has undermined, so no state is sure.
Willet, no. 89.
Motto: "De Elephante: Miràbilis Deus in operibus suis."
Icon: None.
Epigram: The elephant in his strength is a sign of God's might.
Wither, p. 183.
R. B., no. 48.
Motto: "Bee warie, whersoe're, thou be:
 For, from deceit, no place is free."
Icon: Men saw down a tree against which an elephant rests.
Epigram: As the elephant is killed by treachery, so the world is full of deceit.
See also:
 FEAR
 Whitney, p. 52.

ELEPHANT AND SERPENT
Whitney, p. 195.
Motto: "Victoria cruenta."
Icon: An elephant falls on and crushes a serpent.
Epigram: The serpent sucks the blood of the elephant and then is crushed when the huge beast falls on it; the best captains win the field with the least shedding of blood.

ELIAS [ELIJAH]
See:
 RAVEN
 Willet, no. 46.

ELM AND VINE
Van Veen, p. 245.
Motto: "Love after death."
Icon: A vine entwines an elm and Cupid holds his dying lover.
Epigram: As the vine embraces the old elm, so love endures after death.
Whitney, p. 62.
Motto: "Amicitia, etiam post mortem durans."
Icon: A flourishing vine intertwines a dead elm.
Epigram: Just as the grapevine supports the dead elm, so a good man helps his friend in old age and supports his friend's children after his death.

EMBRACE
Arwaker, bk. 2, no. 12.
Motto: "Saw you him whom my Soul loveth? It was but a little that I past from them, but I found him whom my Soul loveth: I held him, and wou'd not let him go."
Icon: A human figure embraces Divine Love. Another pleads with the city watch.
Epigram: Man is joyful upon finding God after a long search.
Quarles, Emb., p. 228.
Motto: "Saw yee him whom my Soule loveth? It was but a little that I passed from them, but I found Him whom my Soule loveth, I held Him and would not let him goe."
Icon: A human figure embraces Divine Love. Another pleads with the city watch.
Epigram: Man is joyful upon finding God after a long search.
Van Veen, p. 17.
Motto: "Union is loves wish."
Icon: Two Cupids embrace.
Epigram: The lover longs to be united with his beloved.
Whitney, p. 216.
Motto: "Sol non occidat super iracundiam vestram."
Icon: Two men, each holding a laurel branch, embrace; their swords lie on the ground; the sun sets.
Epigram: Cast away your swords, subdue your hostility, befriend your foe, and "Let not the sonne go downe upon your ire."
See also:
 BROTHER
 Montenay, p. 310.

ENEMY
See:
 SWORD AND WINE
 Montenay, p. 322.

England
See: BRITAIN.

ENLARGING HEART
Harvey, no. 35.
Motto: "Cordis Dilatatio."
Icon: Divine Love shows a man that his heart has been enlarged.
Epigram: When God enters man's heart, he enlarges it.

ENSIGN
Peacham, p. 203.
Motto: "Sic bellica virtus."
Icon: Three ensigns are folded up.
Epigram: Although valor is often forgotten in peace-

time, wisdom continues to value the courageous mind.

P. S., p. 289 (misnumbered 28).
 Motto: "Paix outragée se rend vengée."
 Icon: An ensign.
 Epigram: Persians foolishly rushed upon Caesar's ensign and were punished severely.

See also:
 SHIELD
 Peacham, p. 24.
 TREAD UPON
 Ayres, no. 28.
See also: FLAG, STANDARD, STANDARD-BEARER.

ENTREATING
Ayres, no. 41.
 Motto: "Love regards no entreatyes."
 Icon: Cupid pleads with another, who turns away.
 Epigram: Love does not yield to entreaties.

ENTREATING AND IGNORING
Van Veen, p. 163.
 Motto: "Love is pittilesse."
 Icon: One Cupid clasps his hands and entreats another Cupid, who turns away.
 Epigram: When angry, the lover is not moved by tears or pleas.

ENVIOUS
Whitney, p. 31.
 Motto: "Caecum odium."
 Icon: A man laughs and turns his back as another man's house burns.
 Epigram: The envious man enjoys the misfortunes of his neighbor.

See also:
 COVETOUS AND ENVIOUS
 Whitney, p. 95.

ENVY
Thynne, no. 35.
 Motto: "Envye."
 Icon: None.
 Epigram: Envy, who gnaws at her heart, wants so much to hurt her neighbors that she asks to lose one eye after Apollo promises to grant any request and double the favor for others.
Whitney, p. 94.
 Motto: "Invidiae descriptio."
 Icon: A woman with snakes in her hair eats vipers, tears out her heart, carries a staff, and is bleary-eyed.
 Epigram: Envy pines when others are happy, thrives on poisonous food, engenders venomous thoughts, works her own unrest, and refuses to see others' success.

See also:
 CUPID AND ENVY
 Quarles, *Emb.*, p. 20.
 CUPID, ENVY, FORTUNE
 Van Veen, p. 107.
 CUPID, ENVY, SHADOW
 Van Veen, p. 51.
 CUPID, ENVY, WAR
 Van Veen, p. 49.
 TRUTH
 Whitney, p. 4.

EPHAH
Willet, no. 21.
 Motto: "Impiis terminos transilire vetitum."
 Icon: None.
 Epigram: Zechariah's vision of two winged women carrying an ephah (bushel basket) containing wickedness illustrates how God controls sinners.

EPIDAURE [EPIDAURUS]
See:
 HERB
 Thynne, no. 14.

ERMINE
Hall, p. 92.
 Motto: "I was afraid least thou wouldest hear me, and deliver me instantly from the disease of lust, which I rather wished might be satisfied."
 Icon: Dogs chase an ermine.
 Epigram: The ermine prefers to die rather than soil her whiteness, but man prefers sin rather than purity.
Peacham, p. 75.
 Motto: "Cui candor morte redemptus."
 Icon: A hunter and hounds pursue a fleeing ermine.
 Epigram: Rather than defile its white skin, the ermine will choose to be caught by hunters, yet many men do not care how defiled their minds are.

Eros
See: CUPID.

ESAU
Willet, no. 75.
 Motto: "In profanos rerum coelestuim & iniquos aestimatores."
 Icon: None.
 Epigram: The story of Esau and his inheritance illustrates the man who trusts more in earthly things than in heaven.

ESAU AND JACOB
Willet, no. 44.

Motto: "Aemulatio puerilis."
Icon: None.
Epigram: As Jacob fought with his brother but be-
 came a holy man, so children may fight
 with their brothers and sisters and still be-
 come virtuous adults.

Eucharist
See: MASS.

ESTHER
See:

 ASSUERUS AND ESTHER
 Quarles, *Emb.*, p. 204.

ETERNITY
Peacham, p. 141.
 Motto: "Eternitas."
 Icon: A woman holds golden balls; her lower
 body is a circle of stars which encompasses
 her.
 Epigram: Eternity is young, has no beginning or
 end, is incorruptible, and is lighted by
 heaven.

Ethiopian
See: AETHIOPIAN, NEGRO.

EUPHEMEN
Thynne, no. 41.
 Motto: "Honor and rewarde nourisheth artes."
 Icon: None.
 Epigram: Euphemen nurturing the Muses with her
 milk represents honor and reward nour-
 ishing the arts.

EVE, HEART, SERPENT
Harvey, no. 1.
 Motto: "Contagio cordis."
 Icon: Eve, holding a serpent-infested heart,
 stands beside a tree which a serpent
 entwines.
 Epigram: The serpent tempts the soul which chooses
 evil even though it is aware of good and
 evil.

EVE, SERPENT, TREE
Quarles, *Emb.*, p. 4.
 Motto: "Totus mundus in maligno (mali ligno)
 positus est."
 Icon: Eve stands beside a tree which a serpent
 entwines.
 Epigram: The devil suggests but cannot compel;
 man is drawn to sin by his own lust.

EWER
See:

 BOOK AND EWER
 Peacham, p. 10.

MARBLE
Whitney, p. 136.
See also: PITCHER.

EYE
See:

 ARROW
 Arwaker, bk. 1, frontispiece.
 ARROW AND EYE
 Van Veen, p. 151.
 BOOK
 Peacham, p. 40.
 COVETOUS AND ENVIOUS
 Whitney, p. 95.
 ENVY
 Thynne, no. 35.
 Whitney, p. 94.
 FAME
 Peacham, p. 35.
 GARDEN AND NIGHTINGALE
 Hawkins, no. 13, p. 148.
 HEAD OF STATE
 Peacham, p. 22.
 HEART
 Quarles, *Emb.*, p. 120.
 IMAGE IN EYE
 Bunyan, no. 68.
 KING
 Wither, p. 31.
 R. B., no. 35.
 LEAF, TREE, WIND
 Hall, p. 64.
 SHAFT
 Quarles, *Emb.*, p. 124.
 TEAR
 Peacham, p. 142.
 VANITY
 Arwaker, bk. 2, no. 5.
 Quarles, *Emb.*, p. 200.
 VIOLET
 Hawkins, no. 4, p. 45.

EYE AND CANDLE
Farlie, no. 20.
 Motto: "Frustra me extinguis."
 Icon: A man blows out a candle while the eye of
 heaven shines.
 Epigram: The light of God shines all the time and
 cannot be put out.

EYE AND HAND
Astry, no. 51.
 Motto: "Fide et diffide."
 Icon: A hand with an eye on it reaches out to an-
 other hand.
 Epigram: Let the prince be well advised in the trea-

ties and alliances he makes, so that when he signs them he sees what he does.

EYE AND SCEPTER
Astry, no. 55.
Motto: "His praevide & provide."
Icon: A scepter is covered with eyes.
Epigram: The prince's ministers are like eyes, inspecting all things.

EYE, FIRE, HEART
Hall, p. 76.
Motto: "How shall we sing the Lords song in a strange land?"
Icon: Two naked cherubs hold a heart over a fire below the eye of God.
Epigram: Man's life in this world is full of sorrows, but man can conquer his grief with patience and love God.

EYE, HEART, SLEEP
Harvey, no. 32.
Motto: "Cordis Vigilia."
Icon: A sleeping human figure holds on his lap a heart with an eye.
Epigram: When the faithful man sleeps, his heart remains watchful and continues to seek God.

EYE, HEART, SUN
Wither, p. 43.
Motto: "The Minde should have a fixed Eye On Objects, that are plac'd on High."
Icon: An eye on a heart looks on the sun.
Epigram: The heart with an eye open to the sun signifies the mind which muses on celestial matters.

F

FACE AND GLASS
Combe, no. 53.
Motto: "The lives of Princes lewdly led, About the world are soonest spred."
Icon: A man looks at his face in a glass.
Epigram: As a blemish on the face is most conspicuous and hardest to hide, so is a fault in a prince more obvious and more dangerous than one in a lesser man.

FAITH
Jenner, no. 1.
Motto: "Justification by Faith."
Icon: A child (identified as Faith) approaches a man (Righteousness) who holds money-

bags (Christ) as another man (Sinner) is freed from prison.
Epigram: As the child seeks a reprieve for his imprisoned father from a friend who agrees to pay the debt, so faith turns to Christ, who pays with his blood so the winner can be freed.

Peacham, p. 7.
Motto: "Cuique et nemini."
Icon: The female figure of Faith holds an open book and leans on a cross.
Epigram: Faith rests on the Cross, puts her hope in heaven, and lives in love.

Wither, p. 81.
Motto: "They, after suffring, shall be crown'd, In whom, a Constant-faith, is found."
Icon: A woman stands on a squared stone, holds a cup and a cross, and wears a crown.
Epigram: Faith stands on a squared stone, the stable foundation of men's hopes; she holds a cross, signifying affliction, and a cup, signifying comfort; she wears a crown, signifying her glory and reward.

See also:
DEVIL
Quarles, *Emb.*, p. 60.

FALCON
Astry, no. 10.
Motto: "Fama nocet."
Icon: A falcon pecks at a bell attached to its claw.
Epigram: As the falcon tries to get rid of the bells attached to its feet because they hinder its freedom, so a man should beware of the fame his virtues bring him, for with fame comes envy.

Combe, no. 84.
Motto: "On others some presume to pray, And fall themselves into decay."
Icon: A falcon is tied to a tree.
Epigram: As the falcon, greedy for prey, finds itself tied to a tree, so men who lay wait on others often are the first to be harmed.

Peacham, p. 94.
Motto: "Servire nescit."
Icon: A falcon flies from a hand.
Epigram: As the falcon prefers freedom to the servitude of man, so the virtuous mind wishes to be free.

See also:
DUCK, FALCON, GOOSE
Whitney, p. 207.

FALCON AND GOSHAWK
P. S., p. 366.
Motto: "Sic majora cedunt."

Icon: A goshawk is carried with falcons.

Epigram: The goshawk among falcons signifies that true nobility consists not in riches or power but in excellency of mind.

FALL

Quarles, *Emb.*, p. 116.

Motto: "Post lapsum fortius asto."

Icon: Cupid and Divine Love wrestle, and Divine Love falls; the devil and an angel holding a palm and a bough watch the fight.

Epigram: The righteous man falls many times, but heaven protects him; the wicked man falls but has no power to rise again.

See also:

BELLEREPHON

Thynne, no. 53.

FAME

Whitney, p. 196.

Motto: "Pennae gloria perennis."

Icon: The winged figure of Fame, with ears inscribed on its body, blows a trumpet and carries a pen.

Epigram: After the Muses had abandoned England and the state of English poetry had declined, (Sir Philip) Sidney arrived, received the golden pen from Mercury, and achieved fame.

Wither, p. 146.

R. B., no. 37.

Motto: "By Studiousnesse, in Vertue's waies Men gaine an universall-praise."

Icon: The figure of Fame, with eyes on its wings, blows a trumpet, holds a book, stands on a globe placed on a square, and is encircled by a wreath.

Epigram: A personification of Fame, the square represents virtue; the globe, the world; the trumpet and book, Fame's glorification of man; the wreath, praise.

See also:

CUPID, DEAFNESS, FAME

Van Veen, p. 67.

QUINCTILIUS [QUINTILIAN?]

Whitney, p. 185.

FAME AND VIRTUE

Peacham, p. 35.

Motto: "Est hac almus honor."

Icon: Virtue, with a sun on her dress, gives a scroll to Fame, who blows a trumpet and wears a dress with eyes and ears on it.

Epigram: Virtue brings the good deeds of forgotten men to light, and Fame proclaims them to the world.

FAN OF FEATHERS

See:

VANITY

Arwaker, bk. 2, no. 5.

FARDEL

Combe, no. 70.

Motto: "Greedy gaping after gaine, Will make a man take any paine."

Icon: A man with a fardel on his back swims in a sea.

Epigram: To gain worldly goods, men will labor and endure peril.

Whitney, p. 179.

Motto: Auri sacra fames quid non?

Icon: A man with a large fardel strapped to his back swims in the sea.

Epigram: This shipwrecked traveler loved wealth so much that he risked his own life by tying a fardel of his goods on his back; so, too, men will endure great toil to attain wealth.

Farmer

See: HUSBANDMAN, PLOWMAN.

FATHER

See:

CHILD AND FATHER

Jenner, no. 25.

See also: MAN, OLD MAN.

FAUN, NYMPH, SPRING

Van der Noodt, no. 15.

Motto: None.

Icon: Fauns attack nymphs beside a spring.

Epigram: The spring represents faith and the church; the nymphs, the faithful; the fauns, the Roman Catholic church, which fouled the faith and drove away the faithful.

FAVOR

Peacham, p. 206.

Motto: "Aula."

Icon: A female figure of Favor holds a "Holy-water brush" and a knot of hooks and stands beside stocks and a spaniel.

Epigram: Favor is attractive; the "holy-water brush" represents her fair promises; the hooks and stocks, her bondage; the spaniel, her flattery.

FEAR

Whitney, p. 52.

Motto: "Fortissima minimus interdum cedunt."

Icon: A bull and an elephant shy from men holding cloths, a lion quakes at a cock, and a stag runs from a snake.

Epigram: As brave animals fear certain trivial things, so man should realize that even the simplest person can harm him.

FEAR OF APPARITION
Bunyan, no. 65.
Motto: "Upon our being afraid of the apparition of Evil spirits."
Icon: None.
Epigram: Some men fear apparitions more than they fear sinning; the just man who confronts the devil is safer than these men.

FEAR OF SMALL CREATURES
Bunyan, no. 64.
Motto: "Upon our being so afraid of small Creatures."
Icon: None.
Epigram: Man's fear of small creatures like rats, worms, and lice reflects the fall from paradise, where man was lord of all.

FEATHER
See:
BALL AND WOMAN
Wither, p. 231.
INDIAN DIADEM
Peacham, p. 199.
MUSE AND SIREN
Thynne, no. 57.
VANITY
Quarles, *Emb.*, p. 200.

FEET
See:
CHRIST ON CROSS
E. M., frontispiece.
ROSE
Hawkins, no. 1, p. 25.

FELICITY
Peacham, p. 25.
Motto: Fœlicitas publica.
Icon: A woman sits on a throne, holds a caduceus and a cornucopia, and wears a garland in her long hair.
Epigram: The woman represents felicity; the throne illustrates that she reigns like a queen in her contentment; the caduceus, that she possesses quiet and the muse's skill; the cornucopia, that she possesses plenty.

Female
See: DAUGHTER, HARLOT, LADY, MATRON, MOTHER, OLD WOMEN, WIFE, WOMAN.

FENNY BITTER[N]
Peacham, p. 63.
Motto: "In timidos et jactantes."

Icon: A heron (fenny bittern) stands in the reeds of a marsh.
Epigram: Just as this bird hides in the reeds and makes a sound as though it were far off, so the coward and the vainglorious.

Fetter
See: CHAIN, SHACKLE, STOCK(S)

FIDDLE
See:
MERMAID
Astry, no. 78.
WOMAN
Wither, p. 7.
R. B., no. 16.

FIDDLESTICK
See:
WOMAN
Wither, p. 7.
R. B., no. 16.

FIERY TONGUE
P. S., p. 13.
Motto: "Animis illabere nostris."
Icon: A dark cloud pours forth fiery tongues.
Epigram: The wicked spirit seems pleasant at first but is harmful, whereas the Holy Spirit terrifies but brings contentment, as when the Holy Ghost appeared to the Apostles like fiery tongues.

FIGHT
Ayres, no. 13.
Motto: "Cupid is a Warier."
Icon: Cupids fight each other.
Epigram: Love is likened to war.
See also:
DRINKING
Whitney, p. 17.
FIRE
Whitney, p. 7.
VICTORY
Wither, p. 254.
See also: STRIFE.

FIGHTING
Astry, no. 75.
Motto: "Bellum colligit qui discordia seminat."
Icon: Armed men spring from the ground and fight one another.
Epigram: As Medea sowed the dragon's teeth from which armed men sprang, so some princes sow discord and reap war.
See also: STRIFE.

FIG LEAF
See:

EEL
Whitney, p. 77.

FIG TREE
E. M., no. 2.
 Motto: "Sic juvat esse tenacem."
 Icon: A fig tree.
 Epigram: The fig tree represents the meek, who
 shall inherit the earth, because its branches
 bend downward and take root in the ground.
E. M., no. 6.
 Motto: "Nec cor nisi punctum.
 Icon: A fig tree drops tears."
 Epigram: The fig tree, which distills a kind of tear
 when it is wounded, represents the pure in
 heart.
Montenay, p. 418.
 Motto: "Discite."
 Icon: A fig tree.
 Epigram: When a man sees that the fig tree is green,
 he knows that summer has arrived; like-
 wise, when a man sees that Christ's Word
 and Sacrament are practiced, he knows that
 Christ is present.
Whitney, p. 53.
 Motto: "Luxuriosorum opes."
 Icon: Birds feed on a fig tree growing on a rock.
 Epigram: Just as the fig tree which is isolated is
 useless to man, feeding only birds, so fools
 waste their goodness, feeding only flat-
 terers.
See also:
 ADAM
 Whitney, p. 229.
 BARREN TREE
 Bunyan, no. 33.
 TENDING FIG TREE AND SHEEP
 Willet, no. 76.

FINCH (CHAF/FINCH)
See:
 BIRD
 Whitney, p. 54.

FINCH (VINE)
See:
 BIRD
 Whitney, p. 54.

FINGER
See:
 EAR AND HEART
 Montenay, p. 414.

FINGER AND NEEDLE
P. S., p. 125.
 Motto: "Heu cadit in quemquam tantum scelus."
 Icon: Needles are driven beneath fingernails.

 Epigram: Young virgins were tortured with needles
 driven beneath their fingernails, one of the
 cruelest forms of torture.

FINGER AND RING
Combe, no. 9.
 Motto: "There be some fools the cords do spin,
 wherein themselves be netted in."
 Icon: A man holds a ring to his finger.
 Epigram: The fool is like the man who strives to put
 a ring on a finger that is too big for it: his
 own folly binds him.

FINGER OVER MOUTH
See:
 FLEEING, HEARING, SILENCE
 Whitney, p. 191.
 SILENCE
 Whitney, p. 60.
 Willet, no. 31.
 WIFE
 Combe, no. 18.
 Whitney, p. 93.

FIRE
Astry, no. 15.
 Motto: "Dum luceam peream."
 Icon: Balls of fire in the sky.
 Epigram: As balls of fire in the sky imitate the splen-
 dor of stars, so princes should continually
 burn in the desire for fame.
Bunyan, no. 73.
 Motto: "Upon Fire."
 Icon: None.
 Epigram: Men who fall into fire burn in agony, yet
 men who are distant from it discuss its
 danger; likewise, men in the fires of hell
 suffer in torment, yet men on earth discuss
 hell as a fable.
Farlie, no. 54.
 Motto: "Herostrati fax."
 Icon: A hand holds a match to a fire.
 Epigram: Nothing is so harmless that it cannot hurt.
P. S., p. 175.
 Motto: "Vis est ardentior intus."
 Icon: A fire burns stock.
 Epigram: As the fire which burns within the dry
 stock is most dangerous, so secret treason
 of citizens brings a city great danger.
Whitney, p. 7.
 Motto: "Intestinae Simultates."
 Icon: A man sets fire to a house; outside, a woman
 with buckets climbs a ladder, and a man
 attacks another man.
 Epigram: Civil war is frightening.
Wither, p. 34.
 Motto: "When Two agree in their Desire,
 One Sparke will set them both on Fire."

Icon: A fire burns.
Epigram: A fire can be started by a spark produced when two sticks are rubbed together; similarly: (1) wrongs can stir up fire in gentle natures, (2) the opposition of two strong foes creates self-destruction, and (3) love is kindled in two hearts with "Like-Desires."

Wither, p. 98.
R. B., no. 50.

Motto: "Even as the Smoke doth passe away; So, shall all Worldly-pompe decay."
Icon: A fire burns behind objects of worldly power (e.g., a sword, crowns).
Epigram: All worldly pomp decays and disappears like smoke.

See also:

ADAM SOWS EARTH
Quarles, *Emb.*, p. 8.
AGE AND YOUTH
Combe, no. 12.
ALTAR AND HEART
Wither, p. 77.
ARCHIMEDES
Whitney, p. 208.
ARROW AND HEART
Hall, p. 52.
BARREL, FIRE, HOLE
Van Veen, p. 145.
BELLOWS AND FIRE
Montenay, p. 398.
BIRD AND FIRE
Van der Noodt, no. 14.
BOOK
Montenay, p. 378.
BOOK, FIRE, WORLD
Montenay, p. 238.
BROTH AND FIRE
Whitney, p. 216.
CANDLE AND FIRE
Farlie, no. 26.
CASTLE, CHRIST, HERETIC
Godyere, no. 29.
CHARIOT AND FIRE
P. S., p. 70.
CROWN, FIRE, SWORD
Montenay, p. 298.
CUPID AND STILL
Combe, no. 79.
CUPID AND VENUS
Peacham, p. 175.
Thynne, no. 3.
DEATH'S HEAD, HANDSHAKE, HEART
Wither, p. 99.
EARTH, FIRE, WIND
Willet, no. 36.

ENVIOUS
Whitney, p. 31.
EYE, FIRE, HEART
Hall, p. 76.
FIERY TONGUE
P. S., p. 13.
FLINT AND STEEL
Wither, p. 175.
GLASS
Arwaker, bk. 1, no. 14.
Astry, no. 76.
Quarles, *Emb.*, p. 176.
HEART
Hall, p. 32.
HEART AND PILLAR
Montenay, p. 62.
MARTYR
Whitney, p. 224.
MELTING
Arwaker, bk. 3, no. 5.
OAR
P. S., p. 116.
PHLEGM
Peacham, p. 129.
RAVEN, TREE, WOLF
Montenay, p. 58.
SALAMANDER
P. S., p. 17.
STIRRING FIRE
Combe, no. 7.
P. S., p. 342 (misnumbered 242).
TOWER OF BABYLON
Montenay, p. 122.
WHORE OF BABYLON
Montenay, p. 302.

See also: FIERY, FLAME.

FIRE AND FLAX
P. S., p. 148.
Motto: "Nil solidum."
Icon: A hand holds a reed on which flax burns.
Epigram: The burning flax represents earthly glory, which is transient and quickly passes away.

FIRE AND FLINT
P. S., p. 48.
Motto: "Ante ferit, quam flamma micet.
Icon: A flintstone strikes a fire."
Epigram: The flintstone which strikes a fire expresses the danger of war between kings.

FIRE AND GAME
Combe, no. 59.
Motto: "He that to thrift his mind would frame, Must not delight to follow game."
Icon: Men play at a game while a fire burns a house.

Epigram: Men should not play games when danger
 threatens.

FIRE AND GOLD
Van Veen, p. 45.
　　Motto: "Loves triall."
　　Icon: Cupids test gold in a fire.
　　Epigram: As gold is tested in the fire, so the lover is
 tried by fortune and distress.

FIRE AND GOLDSMITH
Montenay, p. 350.
　　Motto: "Sio demum purgabitur."
　　Icon: A goldsmith tends a fire which purifies
 metal, and a hand from heaven holds a
 ladle.
　　Epigram: Just as gold must be purified in a fire, so
 man must be purged of sin by Christ.

FIRE AND HEART
Harvey, no. 36.
　　Motto: "Cordis Inflammatio."
　　Icon: Divine Love sets a heart on fire.
　　Epigram: God inflames man's heart, making it burn
 with love.

FIRE AND LAUREL BOUGH
P. S., p. 52.
　　Motto: "Flammescit uterque."
　　Icon: Two laurel branches spark a fire.
　　Epigram: When two laurel branches are rubbed to-
 gether, long-lasting fire results; so, too,
 when mighty men meet, danger occurs.

FIRE AND POT
P. S., p. 54.
　　Motto: "Sara à chi tocca."
　　Icon: An earthen pot on a fire falls, pouring out
 its contents.
　　Epigram: The ire of a prince resembles the threat of
 a falling pot on a fire.
Van Veen, p. 97.
　　Motto: "Love inwardly consumeth."
　　Icon: A fire, which Cupid keeps hot, heats a
 closed pot.
　　Epigram: As the liquid in a pot over a fire is evapo-
 rated, so the lover's heart is wasted by the
 fire of his mistress's eyes.

FIRE AND SALAMANDER
Van Veen, p. 229.
　　Motto: "Love liveth by fyre."
　　Icon: A salamander lies in a fire.
　　Epigram: As the salamander lives, unhurt, in the
 fire, the lover thrives in the fire of love.
Wither, p. 30.
　　Motto: "Afflictions Fire consumeth Sinne;
 But, Vertue taketh Life therein."

Icon: A salamander, with a crown on its head,
 lies in a fire.
Epigram: As the salamander is unharmed by the fire,
 so heroic spirits are unharmed by afflic-
 tion, and faithful men's works are purified
 by trial.

FIRE AND STRAW
Van Veen, p. 219.
　　Motto: "Soon kindled soon consumed."
　　Icon: Cupid watches straw burn.
　　Epigram: Like straw which burns quickly, love
 which is enkindled quickly is soon con-
 sumed.

FIRE AND TONGS
Van Veen, p. 139.
　　Motto: "Love lacketh quietnes."
　　Icon: Cupid tries to hold a fire with tongs.
　　Epigram: Just as the fire cannot be held, so a lover's
 mind cannot be stayed.

FIRE AND TREE
Montenay, p. 278.
　　Motto: "Qua non facit bonos fructum."
　　Icon: A man saws down a tree and burns it in a
 fire.
　　Epigram: Like the tree which bears no fruit and so is
 cut down and burned, the man who pre-
 tends to be holy but is false will be cast
 into eternal fire.

FIRE AND WATER
P. S., p. 57.
　　Motto: "Humentia siccis."
　　Icon: Two buckets of water hang on a burning
 staff.
　　Epigram: Man's reason extinguishes man's passions.
Van Veen, p. 171.
　　Motto: Loves frye is unquencheable."
　　Icon: Cupid carries a burning torch in the rain.
　　Epigram: No coldness can slacken love's flame.

FIRE AND WIND
Ayres, no. 42.
　　Motto: "Augmented by favourable Blasts."
　　Icon: Cupid tends a fire blown by the wind.
　　Epigram: As the wind fans a fire, so a lady's breath
 kindles the desire of lovers.
Van Veen, p. 147.
　　Motto: "Favour encreaseth loves force."
　　Icon: Cupid builds a fire, which is fanned by the
 wind.
　　Epigram: As the wind increases the flames of a fire,
 so kind words increase love.

FIRE AND WOOD
Van Veen, p. 135.
　　Motto: "Love enkindleth love."

Icon: Cupid rubs two pieces of wood together and makes a fire.

Epigram: Like wood which is enkindled when rubbed together, the lover's eyes inflame desire when they meet.

FIRE, HAND, SWORD
P. S., p. 152.
Motto: "Agere & pati fortia."
Icon: A hand holding a sword is held in a fire.
Epigram: C. Mutius punished himself for killing the wrong man by thrusting his right hand in the fire.

Whitney, p. 111.
Motto: "Mutius Scaevola; Pietas in patriam."
Icon: A hand, grasping a sword, is held in the flames of a fire.
Epigram: The nobility and courage of Scaevola enabled him to withstand the pain of the fire to which he was condemned and caused him to be pardoned. This image, therefore, expresses the noble mind.

FIRE, MOUNTAIN, WIND
Wither, p. 97.
Motto: "The more contrary Windes doe blow, The greater Vertues praise will grow."
Icon: The wind blows on a fire at the top of a mountain.
Epigram: When the winds blow a fire on the mountaintop, the fire ascends higher; likewise, when the envious attack the virtuous, the virtuous shine more clearly.

FIREBRAND
P. S., p. 244.
Motto: "Lex publica Principis ignes."
Icon: A firebrand.
Epigram: Firebrands carried before princes in Rome signified that rulers ought to shine before all others in virtue.

See also:
POURING AND WORLD
Montenay, p. 118.
TRUTH
Whitney, p. 4.

FIREBRAND AND FOX
P. S., p. 181.
Motto: "Vindictae trabit exitium."
Icon: A fox with a firebrand on its tail.
Epigram: Like the foxes which Samson sent into the fields of the Philistines with firebrands on their tails, those who seek revenge are themselves destroyed.

FIREBRAND AND OX
P. S., p. 215.

Motto: "Terror & error."
Icon: A firebrand is tied to the head of an ox.
Epigram: A good captain will turn danger into virtue, as Hannibal did when he escaped a superior force by tying firebrands to the heads of oxen, making himself appear terrible to his foes.

FISH
Whitney, p. 52.
Motto: "Injuriis, infirmitas subjecta."
Icon: Birds of prey and large fish pursue small fish.
Epigram: Like the small fish, men in a "feeble state" are attacked from every side.

See also:
CUPID
Whitney, p. 182.
FISHERMAN
Willet, no. 25.
NET
Peacham, p. 71.
REPENTANCE
Peacham, p. 46.

FISH AND RING
P. S., p. 99.
Motto: "Invitum fortuna fovet."
Icon: A fish holds a ring in its mouth.
Epigram: Fortune so smiled on Policrates that when he threw a ring into the ocean it was later found in the belly of a fish; but fortune is fickle and later frowned on Policrates.

Fish and sea creatures: *See*: COCKLEFISH, CRAB, CRAYFISH, CUTTLEFISH, DOLPHIN, ECHENEIS, EEL, OYSTER, POLIPUS, PURPLEFISH, REMORA, SNAIL, WHALE.

FISH AND WATER
Bunyan, no. 7.
Motto: "Upon the Fish in the Water."
Icon: None.
Epigram: The water is to the fish what God is to holy men.

FISHERMAN
Whitney, p. 71.
Motto: "Fides non apparentium."
Icon: Two fishermen in a boat cast their nets into the water.
Epigram: Just as the fishermen must have hope and trust in things unseen, so the Christian should have faith and anchor on God's word.

Willet, no. 25.
Motto: "Bene agendo nunquam defessus."
Icon: None.
Epigram: The fishermen represent God's ministers;

the fishing place, the Church; the fish, men who are drawn into the Church.

See also:

CUTTLEFISH
Whitney, p. 97.

FISHERMAN AND SCORPION
Combe, no. 23.

Motto: "No man his minde should ever set,
To hope for that he cannot get."

Icon: A fisherman draws a scorpion into his net.

Epigram: As the fisherman boasts of his catch but finds a scorpion in his net, so the man who boasts of his strength and fails to recognize his weaknesses.

FISHING
Ayres, no. 9.

Motto: "Love a ticklish Game."

Icon: Cupids in a boat cast nets and fish.

Epigram: Virgins are like fish, and lovers must use bait, hook, and nets with skill.

Montenay, p. 170.

Motto: "Non sum in culpa."

Icon: A man fishes with a rod in a pond.

Epigram: Like the fisherman who unsuccessfully tries to catch a fish, the preacher sometimes cannot draw sin from a wicked man.

FISHING FOR EEL
Combe, no. 44.

Motto: "When warres and troubles most molest,
The wicked persons prosper best."

Icon: A fisherman standing in water catches an eel.

Epigram: As muddy and troubled waters are best for eel fishing, so a troubled and warring state is the best place for the wicked to prosper.

FIST CLENCHED
Peacham, p. 104.

Motto: "Ex Avaritia Bellum."

Icon: A clenched fist.

Epigram: The clenched fist is a symbol of the avaricious man who holds so tightly to his wealth that he will fight and kill to retain it.

FIXED HEAD
Wither, p. 145.

Motto: "True Knowledge is a constant Friend,
Whose Friendship, never shall have end."

Icon: A statue of a head crowned with bay leaves.

Epigram: Knowledge is constant, enduring, and abiding.

FLAG
See:

HERALDIC FLAG

Peacham, p. 101.

See also: ENSIGN, STANDARD.

FLAG OF THE CROSS
Astry, no. 26.

Motto: "In Hoc signo."

Icon: A hand holds a flag with a cross and the letters alpha and omega on it; below lie military gear.

Epigram: The only true valor is Christian valor, which is closely connected with humility, patience, and control of the passions. The alpha and omega letters are an emblem of God.

FLAGON
See:

BACCHUS AND LION SKIN
Combe, no. 48.

FLAIL AND WHEAT
Wither, p. 108.

Motto: "Affliction, doth to many adde
More value, then, before, they had."

Icon: A hand holds a flail and threshes wheat.

Epigram: Until the flail beats the wheat, separating the grain from the straw, the richness of the wheat does not appear; so, too, man's worth is enhanced by sorrow and affliction.

FLAME
Farlie, no. 42.

Motto: "Frustra me tegis."

Icon: A man hides a light under his coat, but the flame burns through.

Epigram: If a man hides a light under his coat, the flame will burn through; likewise, if a man conceals a hurt, it will eventually burst out.

See also:

ALTAR AND FLAME
Wither, p. 15.
BROTH AND FLAME
Montenay, p. 198.
BUTTERFLY AND FLAME
P. S., p. 340.
CHOLER
Peacham, p. 128.
CROWN, HANDSHAKE, HEART
Wither, p. 237.
GNAT AND FLAME
Whitney, p. 219.
HANDSHAKE AND HEART
Wither, p. 230.
HEART
H. A., p. 14.
HEART AND TORCH

Wither, p. 178.

HOURGLASS

Wither, p. 212.

MELTING

Arwaker, bk. 3, no. 5.

Quarles, *Emb.*, p. 260.

OVEN

Ayres, no. 44.

ROCK, SHIP, SEA

Peacham, p. 158.

TAPER

Quarles, *Hier.*, no. 2.

ZEAL

Peacham, p. 170.

See also: FIRE.

FLAME AND HEART

H. A., p. 226.

Motto: "The Hart enflamed with the love of Jesus shines al with light and flames."

Icon: A heart which encloses Jesus shines with flames.

Epigram: Jesus sets man's heart aflame with love.

Hall, p. 72.

Motto: "Oh love which doest ever burn and art never extinguish't, enlighten me with thy flames."

Icon: A human figure holds a flaming heart pierced with a dart and stands before Divine Love surrounded by flames.

Epigram: The speaker asks God to inflame his heart with love.

FLAME AND SWORD

P. S., p. 63.

Motto: "Autor ego audendi."

Icon: A flaming sword.

Epigram: The flaming sword represents the word of God.

FLAME AND TIME

Farlie, no. 57.

Motto: "Te lux mea fallit."

Icon: The winged figure of Time holds an hourglass and blows a trumpet; a flame separates from the wick and rises above a tomb toward the sun.

Epigram: At death the soul departs the body.

FLAME AND WAX

Whitney, p. 183.

Motto: "Qui me alit me extinguit."

Icon: Wax feeds a flame.

Epigram: Just as the wax both feeds and quenches the flame, so love.

FLAME AND WIND

Wither, p. 68.

Motto: "From that, by which I somewhat am, The Cause of my Destruction came."

Icon: A wind blows on the flame of a torch.

Epigram: The wind which feeds the fire, if excessive, also puts it out; likewise, excessive passion can destroy love.

FLAMING

See:

 DART

 Arwaker, bk. 3, no. 1.

 Quarles, *Emb.*, p. 244.

FLAMING SWORD, GARDEN, HEART

Harvey, no. 31.

Motto: "Cordis Custodia."

Icon: A human figure with a heart sits in an enclosed garden while Divine Love fends off the devil with a flaming sword.

Epigram: The godly heart should be compassed with care and guarded by the fear of God.

FLASK AND SWORD

Peacham, p. 83.

Motto: "Vulnerat ille medemur."

Icon: Flasks of oil and wine are tied to the blade of a sword.

Epigram: The sword symbolizes the law; the wine and oil, God's mercy.

FLASK, ROD, WOMAN, WORLD

Peacham, p. 119.

Motto: "Humanae miseriae."

Icon: A woman stands beside the world and holds a rod and a flask.

Epigram: These images represent human miseries: the rod, the discipline of childhood; the woman, man's love; the world, worldly cares; the flask, the disease of old age.

FLAX

See:

 FIRE AND FLAX

 P. S., p. 148.

FLEECE

See:

 GOLDEN FLEECE

 P. S., p. 50.

FLEEING

See:

 CUPID AND LOVER

 Van Veen, p. 29.

See also: RUNNING.

FLEEING, HEARING, SILENCE

Whitney, p. 191.

Motto: "Audi, tace, fuge."

Icon: A human figure points to large ears, another makes the gesture of silence, and a third flees from a coiled snake.
Epigram: Men should hear much, speak little, and flee from danger.

FLESH
See:
GLASS
Quarles, *Emb.*, p. 176.
HEART AND NET
H. A., p. 30.

FLINT
See:
CANDLE AND MATCH
Farlie, no. 43.
FIRE AND FLINT
P. S., p. 48.
HEART
Ayres, no. 7.

FLINT AND RAZOR
Combe, no. 33.
Motto: "Meddle not with thy over-match
 Lest thou thereby most hurt do catch."
Icon: A man tries to cut a flint rock with a razor.
Epigram: As the razor cannot harm the flint but only be hurt by it, so men who contend with men of more might can give no harm but only harm themselves.

FLINT AND STEEL
Wither, p. 175.
Motto: "Untill the Steele, the Flint shall smite,
 It will afford nor Heat, nor Light."
Icon: Steel strikes flint, creating sparks.
Epigram: Before flint sends forth sparks, it must be struck with steel; likewise, before our hearts shine with the light of grace, they must be smitten with affliction.

FLINT AND WATER
Bunyan, no. 6.
Motto: "Upon the Flint in the Water."
Icon: None.
Epigram: The flint which lies in the water but is unsoftened by it is like men who lie under God's words but remain unchanged by them.

FLINT, STEEL, TINDERBOX
Peacham, p. 103.
Motto: "Nostro elucescis damno."
Icon: Hands rub steel and flint together, and sparks fall into a tinderbox.
Epigram: Just as the steel and flint waste each other when they clash, and the tinderbox bene-

fits, so warring neighbors destroy themselves, and the "pettifoggers" benefit.

Flintstone
See FLINT.

FLOOD
See:
SEA
Whitney, p. 129.

FLOWER
Bunyan, no. 74.
Motto: "Of Beauty."
Icon: None.
Epigram: Beauty is like the flower which decays and fades.
Van Veen, p. 231.
Motto: "Ever the same."
Icon: Cupid holds fresh flowers in one hand, wilted flowers in the other.
Epigram: Unlike flowers which fade, true love is eternal.
Whitney, p. 51.
Motto: "Vitae, aut morti."
Icon: A flowering plant attracts both bees and spiders.
Epigram: Just as one flower contains opposites so that the spider sucks poison from it, and the bee, honey, so the Scripture contains opposites: a sword for the bad, a shield for the good.

See also:
APPLE AND FLOWER
Arwaker, bk. 3, no. 2.
Quarles, *Emb.*, p. 248.
BEE
Peacham, p. 41.
BRAMBLE AND FLOWER
Montenay, p. 186.
CUP AND FLOWER
P. S., p. 119.
CUPID
Whitney, p. 182.
GARDEN
Peacham, p. 183.
GARLAND
Peacham, p. 37.
GROUND AND SUN
Wither, p. 104.
HELIOTROPE
Hawkins, no. 5, p. 56.
HORSE AND TAPER
Quarles, *Hier.*, no. 10.
LORD, MONSTER, AND SNAKE
Hall, p. 1.

PICKING FLOWERS
Ayres, no. 18.
TOMB OF ACHILLES
Whitney, p. 193.
SAGES
Whitney, p. 130.
See also: CHESBOLE, DAMASK ROSE, HELIOTROPE, LILY,
POPPY, ROSE, THISTLE, VIOLET, WOODBINE.

FLOWER AND FRUIT
Godyere, no. 23.
Motto: "Unum et alterum divinum."
Icon: A plant which is half flower and half fruit.
Epigram: As fruits of different plants seem "divers in quality," so religion may *seem* to have schisms; the problem is not with nature or religion but with human reason.

FLOWER AND GLASS
Hall, p. 96.
Motto: In the morning it flourisheth and groweth up: in the evening it is cut down and withereth.
Icon: A woman stands beside a dressing table with a vase of flowers on it and looks in a looking glass.
Epigram: Beauty is transient; it fades like the flowers and disappears as quickly as one's reflection in a mirror.

FLOWER AND HEART
Harvey, no. 30.
Motto: "Cordis Flores."
Icon: Flowers grow out of a heart.
Epigram: God is a gardener, who plants faith in man's heart and reaps flowers of bliss.

FLOWER AND SUN
Wither, p. 140.
Motto: "When prosperous our Affaires doe growe; God's Grace it is, that makes them so."
Icon: The sun shines on a flower enclosed by a fence.
Epigram: As the flower grows and blossoms because of the sun, so man prospers through God's grace.
Wither, p. 159.
Motto: "Our outward Hopes will take effect, According to the King's aspect."
Icon: Flowers turn toward the sun.
Epigram: As the flowers turn toward the sun and are uplifted by it, so the nation thrives on the king.

FLY
Peacham, p. 155.
Motto: "Secundus deteriora dies."

Icon: Flies light on a poor beggar while another man brushes them away, and a king and his entourage watch.
Epigram: Just as brushing the satiated flies from a beggar only worsens his suffering by drawing hungry flies, so the death of a wealthy judge only brings a hungry one.
Thynne, no. 8.
Motto: "Bryberie."
Icon: None.
Epigram: Judges are like flies which feed on suffering men: older judges, like the flies glutted with blood, are already satisfied from many bribes, but younger judges, like hungry flies, are easily swayed by bribery.

See also:
CANDLE AND FLY
Bunyan, no. 22
Farlie, no. 25.
Wither, p. 40.
EAGLE AND FLY
Combe, no. 32.
SCREEN AND TAPER
Quarles, *Hier.*, no. 5.
SPIDER AND WEB
Combe, no. 49.
TOMB OF NERO
Peacham, p. 144.

FLY AND GLASS
P. S., p. 85.
Motto: "Labuntur nitidis scabrisque tenatius haerent."
Icon: Flies surround a glass.
Epigram: As flies fall from slippery places but rest easily on rough places, so man falls quickly from prosperity but stays in affliction.

FLY AND HORSE
Montenay, p. 126.
Motto: "Frustra curris."
Icon: Flies surround a horse.
Epigram: Like the horse which futilely attempts to rid itself of flies by running, the wicked cannot escape their conscience, which pricks them continually.

FLY AND MEAT
Bunyan, no. 60.
Motto: "Upon fly-blows."
Icon: None.
Epigram: Like the fly which makes good meat unfit for queasy stomachs, some men reproach good doctrine, making it seem unacceptable.

FLY AND MILK

Combe, no. 4.

Motto: "In pleasures vaine no time bestow,
Lest it procure your overthrow."

Icon: Flies drown in a milk pan, while a man swats other flies away.

Epigram: As the fly seeking to drink the sweet milk drowns in it, so the fool delights in pleasures which ruin him.

FLY AND PEACOCK FEATHER

P. S., p. 288.

Motto: "Tolle upluptatum stimulos."

Icon: A fan of peacock feathers beats away flies.

Epigram: As we beat away flies with peacock feathers, so we ought to purge ourselves of lust with watchfulness.

FLY ON TARGET

P. S., p. 102.

Motto: "Comminus quo minus."

Icon: The image of a fly appears on a target.

Epigram: The fly signifies the soldier's method of fighting; though it is small, it draws close and sets upon the enemy.

FODDER

See:

LAMB, LION, WOLF
Montenay, p. 222.

FOE

See:

CONQUEROR AND KNEELING FOE
Arwaker, bk. 1, no. 6.
Quarles, *Emb.*, p. 144.

FOOD

See:

BIRD AND CHILD
Bunyan, no. 31.
DRINK, FOOD, HEART
Harvey, no. 6.
HARPY
Peacham, p. 115.
RICH MAN
Montenay, p. 178.

See also: FODDER.

FOOL

Wither, p. 211.

Motto: "By seeming other than thou art,
Thou dost performe a foolish part."

Icon: A fool.

Epigram: Men who pretend to be what they are not are fools.

Wither, p. 225.
R. B., no. 13.

Motto: "The best good-turnes that Fooles can doe us,
Proove disadvantages unto us."

Icon: A fool puts goslings into a girdle.

Epigram: The fool, worried that the goslings will drown, puts them under his girdle, thereby killing them: fools do harm even when they intend to help.

See also:

BAUBLE AND FOOL
Arwaker, bk. 1, no. 2.
Quarles, *Emb.*, p. 132.
BELLOWS, SUN, TORCH
Quarles, *Emb.*, p. 64.
BREAST AND FOOL
Quarles, *Emb.*, p. 48.
CHILD AND FOOL
Whitney, p. 81.
CUPID, FOOL, NET
Quarles, *Emb.*, p. 72.

FOOL AND HEART

Harvey, no. 4.

Motto: "Cordis fuga."

Icon: A fool, surrounded by treasures, holds up a bauble but ignores a heart which is laid aside.

Epigram: The man who values material treasures is a fool playing with trifles; he has no heart.

FOOL IN TREE

Peacham, p. 112.

Motto: "In cos qui cum amicis fruantur, uti nesciant."

Icon: A fool saws off the branch of a tree he sits on.

Epigram: The fool who cuts off the branch supporting him is like the man who abuses the friends who support him.

FOOL'S CAP

See:

BOWLING
Quarles, *Emb.*, p. 40.

FOOT

See:

WIFE
Combe, no. 18.

FOOTBALL

Peacham, p. 81.

Motto: "Divitiae."

Icon: Boys play football.

Epigram: Wealth is like the ball in a game of football; it is tossed to and fro while men who seek after it are hurt.

FOREHEAD
P. S., p. 360.
 Motto: "Frons hominent praefert."
 Icon: A finger points to a man's forehead.
 Epigram: The forehead indicates each man's disposition.

FORELOCK
See:
 FORTUNE
 Wither, p. 174.
 OCCASION
 Combe, no. 63.
 Whitney, p. 181.
 Wither, p. 4.
 R. B., no. 41.

Forest
See: WOODS.

FORGE
See:
 MILL
 Astry, no. 84.

FORTUNE
Combe, no. 20.
 Motto: "They that follow fortunes guiding,
 Blindly fall with often sliding."
 Icon: Fortune, blindfolded, on a wheel, and with a sail, leads a blindfolded man onto a wheel.
 Epigram: The man who trusts in fortune is blind, with a blind guide; when he least expects it, he will fall.
Combe, no. 29.
 Motto: "We see it fall out now and then,
 The worser lucke the wiser men."
 Icon: Fortune—with a forelock, a blindfold, and wings—holds a hive and throws a net over a sleeping man.
 Epigram: Fortune scorns the good but provides for the idle and foolish.
Thynne, no. 7.
 Motto: "Fortune."
 Icon: None.
 Epigram: The inconstancy and instability of Fortune are expressed by the image of a woman, standing on a turning ball, her feet cut from her legs.
Thynne, no. 44.
 Motto: "Fortune."
 Icon: None.
 Epigram: Fortune is inconstant, turns her wheel, oppresses the noble and raises the clown.
Wither, p. 6.
R. B., no. 17.
 Motto: "Though Fortune prove true Vertues Foe, It cannot worke her Overthrowe."
 Icon: Fortune turns a man on a wheel, and Jove stands with his eagle.
 Epigram: Fortune is fickle; the man who neglects virtue for fortune is eventually destroyed by her; but the man who neglects fortune for virtue is exempt from the fear of change.
Wither, p. 174.
 Motto: "Uncertaine, Fortunes Favours, bee, And, as the Moone, so changeth Shee."
 Icon: Fortune, a naked woman, is blind, stands on a winged ball, holds a scarf, has a forelock and a bald head, and carries a moon.
 Epigram: Fortune has a pleasing appearance, blindly bestows her favors, rules over instable external things, gives mere toys as favors, shows both kindness and slippery tricks, and is ever changing.

See also:
 BOWLING
 Quarles, *Emb.*, p. 40.
 CUP AND FORTUNE
 Van Veen, p. 13.
 CUPID AND FORTUNE
 Van Veen, p. 157.
 Van Veen, p. 225.
 CUPID, ENVY, FORTUNE
 Van Veen, p. 107.

FORTUNE AND MERCURY
Thynne, no. 5.
 Motto: "Art, the antidote against fortune."
 Icon: None.
 Epigram: Mercury, sitting on a square, opposes Fortune, standing on a ball; art and wisdom are steadfast and prevail against inconstant fortune.

FORTUNE AND POVERTY
Peacham, p. 194.
 Motto: "Fortuna major."
 Icon: Poverty—a man in tattered clothes—binds Fortune, who lies on her wheel.
 Epigram: The valiant mind, though in poverty, is content and therefore is impervious to Fortune.

FORTUNE, TIME, WORLD
Quarles, *Emb.*, p. 36.
 Motto: "Faustra quis stabilem figat in orbe gradum."
 Icon: Fortune with her sail throws a man down, and Time with his sickle, hourglass, and wings steps on Cupid; together they turn the world.

Epigram: Fortune and time control the world, which is vain and transitory.

FOUNTAIN

Hall, p. 56.
 Motto: "Oh thou fountain of life, let my thirsting soul drink of Thee."
 Icon: Divine Love gives a human figure a drink beside a fountain.
 Epigram: The fountain of life quenches man's spiritual thirst.

Hall, p. 88.
 Motto: "Who against hope, believed in hope."
 Icon: A human figure holding a winged heart and anchor and a haloed figure stand beside a fountain.
 Epigram: Like the water of the fountain which comes out of the deep earth and flows upward, man's soul should scorn the earth and mount to heaven.

Hawkins, no. 19, p. 210.
 Motto: "Perennis et indeficiens."
 Icon: Fountain.
 Epigram: The Virgin Mary is like a fountain, an endless source of spiritual grace and perfection.

Hawkins, no. 19, p. 219.
 Motto: "Non pluerat Dominus Deus super terram sed Fons ascendebat e terra irrigans universam superficiem."
 Icon: A fountain waters the earth.
 Epigram: Because of Eve's sin, the earth was dry; then Mary, like a crystal spring, supplied the earth with grace.

See also:
 BLOOD, FOUNTAIN, HEART
 H. A., p. 83.
 REPENTANCE
 Peacham, p. 46.
See also: SPRING.

FOUNTAIN AND HAND

Astry, no. 72.
 Motto: "Vires alit."
 Icon: A hand stops the stream of a fountain.
 Epigram: When hands stop the flow of a fountain, the water pressure increases; so, too, virtue is strengthened by rest.

FOUNTAIN AND HART

Arwaker, bk. 3, no. 11.
 Motto: "Like as the Hart desireth the waterbrooks, so longeth my Soul after thee, O God."
 Icon: A human figure rides a hart toward a fountain in the shape of Divine Love.
 Epigram: As the hart seeks water, so the soul desires the purifying waters of God.

Quarles, *Emb.*, p. 284.
 Motto: "As the Hart panteth after the waterworks so panteth my soule after thee O Lord."
 Icon: A human figure rides a hart toward a fountain in the shape of Divine Love.
 Epigram: As the wounded hart flies to the waters, so the soul, wounded by Satan, flies to God.

FOUNTAIN AND HEART

Harvey, no. 17.
 Motto: "CORDIS MUNDATIO."
 Icon: A human figure washes a heart in blood which spouts from the side of a statue on a fountain.
 Epigram: The speaker wishes to wash his heart in his Savior's blood.

FOUNTAIN AND WATER

Arwaker, bk. 1, no. 8.
 Motto: "O that my Head were Waters, and mine Eyes a fountain of Tears, that I might weep day and night."
 Icon: A woman weeps beside a fountain as an angel pours water on her head.
 Epigram: The speaker desires to be like a fountain, weeping in repentance to expiate his guilt.

Quarles, *Emb.*, p. 152.
 Motto: "O that my Head were waters, and mine eyes a fountaine of teares."
 Icon: A woman weeps beside a fountain as an angel pours water on her head.
 Epigram: The way to heaven is through the tears of repentance.

FOWL

See:
 CROWN, FOWL, SCEPTER
 Wither, p. 67.
See also: BIRD.

FOWLER

Whitney, p. 78.
 Motto: "Noli altum sapere."
 Icon: A man with a bow and arrow aims at a flying bird; an adder bites his leg.
 Epigram: The fowler who aims at birds in the sky but is destroyed by the adder on the ground is analogous to the man who is proud but is destroyed by lowly things he despises or to the astronomer who studies the skies but is ignorant of dangers closer to hand.

FOWLER AND LARK

Bunyan, no. 23.
 Motto: "Upon the Lark and the Fowler."
 Icon: None.
 Epigram: The fowler is an emblem of the devil; his nets and whistles, evil; his glass, pleasure;

his decoy, the allure of sin; the lark, the saint who resists him.

FOWLER AND NET
Montenay, p. 370.
Motto: "Sic fraudibus scatent eorum domus."
Icon: A fowler entices birds into a net.
Epigram: Like the fowler who entices birds into his net with bait, wicked men allure others to iniquity with amity.

FOX
Peacham, p. 62.
Motto: "Quicquid delirant Reges."
Icon: A fox runs on ice while two men watch on the ground.
Epigram: Just as the Thracians used a fox to test the safety of the ice, so some men use weaker or poorer men to serve them.

Peacham, p. 70.
Motto: "In dilapidantes sibi credita aliena."
Icon: A fox with a basket on its back walks down a street.
Epigram: As the fox embezzled the alms he gathered in trust for the hounds, so some crafty men rob the beneficiaries of estates in whose trust they are placed.

Whitney, p. 22.
Motto: "Nullus dolus contra casum."
Icon: A fox stands on the ice of a river.
Epigram: A fox plays on ice, but when the sun melts and breaks up the ice, the fox is in danger. This shows that even subtle craft is powerless before chance.

See also:
APE AND FOX
Thynne, no. 62.
Whitney, p. 142.
ASS, FOX, LION
Whitney, p. 154.
BOAR
Whitney, p. 153.
CAT, FOX, HOUND
Peacham, p. 138.
CUPID AND FOX
Van Veen, p. 235.
FIREBRAND AND FOX
P. S., p. 181.

FOX AND GRAPE
Whitney, p. 98.
Motto: "Stultitia sua seipsum saginari."
Icon: A fox leaps at grapes hanging from an arbor.
Epigram: As the fox, unable to reach the grapes even after great effort, scorned them, so may you reject that which you have been unable to attain.

FOX AND LION
Whitney, p. 156.
Motto: "Dura usu molliora."
Icon: A lion and a fox meet.
Epigram: Just as the fox at first feared the lion but on further meetings overcame that fear, so we find that the most difficult arts, with trial, become plain and easy.

Whitney, p. 161.
Motto: "Ars deluditur arte."
Icon: A lion, its tongue hanging out, stands at the entrance of a den where a fox lives.
Epigram: When the lion came to the sickly fox and said that its tongue could heal the fox, the fox replied that, with the lion's teeth so near the tongue, he would decline the offer.

Whitney, p. 210.
Motto: "Fraus meretur fraudem."
Icon: A lion lies in its cave, and a fox stands outside.
Epigram: An aging lion caught its prey by luring them to its den, but the wily fox refused its invitation, noting that none who had visited the lion had returned.

FOX, KING, LION
Combe, no. 22.
Motto: "A Prince can have no better part,
Then foxes wit and lion heart."
Icon: A king holds a fox and a lion on a leash.
Epigram: The prince should be as courageous and strong as the lion, as witty and subtle as the fox.

FOX'S CLOTHING
Whitney, p. 124.
Motto: "Amicitia fucata vitanda."
Icon: A man in fox's clothing (the ears, fur, and tail of a fox) shakes hands with another man.
Epigram: Beware of men who conceal their malice behind smiles.

FRAUD
See:
DEVIL
Quarles, *Emb.*, p. 60.
ANCHOR, BOOK, FRIAR
Wither, p. 73.
R. B., no. 43.
See also: DECEIT.

FRIEND
Peacham, p. 148.
Motto: "In Amicos falsos."
Icon: A man hides in a tree while a bear menaces a man playing dead on the ground.

Epigram: The man in the tree illustrates the false friend who forsakes his friend in time of need.

FRIENDSHIP
Peacham, p. 181.
Motto: "Amicitiae effigies."
Icon: A statue stands with a "plaine" heart and the words "winter" and "summer" on its brow, the words "far" and "near" on its breast, and the words "life" and "death" on its skirt.
Epigram: True friendship is constant through fair and foul, whether far or near, in life and death.

Frivolity
See: LEVITY.

FROG
Bunyan, no. 36.
Motto: "Upon the Frog."
Icon: None.
Epigram: The frog, which is cold and has a large mouth and a big belly, represents the hypocrite, who is of a cold nature, loves to talk about church, but does not love Christ.

P. S., p. 75.
Motto: "Mihi terra, lacusque."
Icon: A frog.
Epigram: Frogs in Syriphia are mute and therefore represent a close secret.

See also:
PALM TREE
Whitney, p. 118.

FRUIT
See:
CROWN AND SERPENT
P. S., p. 246.
FLOWER AND FRUIT
Godyere, no. 23.
GROUND
Montenay, p. 66.
GROUND AND SUN
Wither, p. 104.
See also: APPLE, BANANA, BRAMBLE, FIG, GRAPE, PEACH, PLUMB, QUINCE.

FRUIT AND OLIVE TREE
Wither, p. 147.
R. B., no. 18.
Motto: "Above thy Knowledge, doe not rise. But, with Sobrietie, be wise."
Icon: A wind blows the top of an olive tree while fruit grows on the ground.
Epigram: Do not be ambitious and wish to graft yourself to a high tree; rather be like the low-growing fruit, lowly and wise.

FRUIT TREE
Combe, no. 80.
Motto: "The fruite of love is very strange, It hath so many kinds of change."
Icon: A fruit tree with half bare branches and half leafy branches.
Epigram: The fruits of love are diverse, some good, some bad, some sweet, some sour.

Whitney, p. 173.
Motto: Praecocia non diuturna.
Icon: A bearded aged man stands under a fruit tree which a young child climbs.
Epigram: The fruit which ripens first rots first; so with wits.

See also:
DEATH, FRUIT TREE, TAPER
Quarles, *Hier.*, no. 14.

FRUIT TREE AND SUN
Combe, no. 72.
Motto: "In time all things shall be revealed, That are most secretly concealed."
Icon: The sun shines on a fruit tree.
Epigram: As the sun ripens fruit, so time brings forth the beauty and virtue of men.

FRUIT TREE, SWORD, TAPER
Quarles, *Hier*, no. 13.
Motto: "Et Martem spirat et arma."
Icon: A taper stands in an urn with the roman numeral L (50) on the top of three segments; on one side a lion; below a sword and a fruit tree blown by the wind, its fruit falling.
Epigram: In the fifth decade of life, man forsakes love, becomes choleric, and is likened to the fruit tree, its overripe fruit falling.

FURNACE
See:
CUPID, FURNACE, TEAR
Van Veen, p. 189.
See also: OVEN.

FURNACE AND HEART
Harvey, no. 21.
Motto: "Cordis Probatio."
Icon: Divine Love holds a heart in the flames of a furnace while a human figure watches.
Epigram: As the flames of the furnace test and purify gold, so the Lord tries human hearts.

G

GALLEY
See:
OAR AND SAIL
Combe, no. 43.

GAMBLING
See:

DRINKING
Whitney, p. 17.
PLAY
Combe, no. 76.

GAME
See:

CROWN AND GATE OF THORNS
Quarles, *Emb.*, p. 104.
FIRE AND GAME
Combe, no. 59.

GANYMEDE
Peacham, p. 48.
Motto: "Crimina gravissima."
Icon: Ganymede sits naked on a cock, holds a wand, a cup of poison, and coins.
Epigram: This icon depicts abhorrent crimes: Ganymede represents sodomy; the cock, incest; the cup and wand, witchcraft and murder; the coins, counterfeiting.
Thynne, no. 45.
Motto: "Ganymede."
Icon: None.
Epigram: Ganymede's love of Jove represents the prudent man's love of God.
Wither, p. 156.
R. B., no. 44.
Motto: "Take wing, my Soule, and mount up higher;
For, Earth, fulfills not my Desire."
Icon: Ganymede sits on the eagle of Jupiter.
Epigram: Ganymede represents the human soul's love for God.

GARDEN
Astry, no. 5.
Motto: "Deleitando Ensena."
Icon: A garden.
Epigram: Children should be taught through diverson, not task; "to fix those Figures of Fortification more firmly in his memory," for example, they can be "contrived in Gardens."
Hawkins, no. 1, p. 5.
Motto: "Sacer principi."
Icon: A walled garden stands within a serpent biting its tail.
Epigram: The garden represents paradise and the Virgin Mary.
Hawkins, no. 1, p. 13.
Motto: Veni auster et perfla Hortum meum.
Icon: The wind blows on an enclosed garden.
Epigram: The garden symbolizes the Virgin; the wind, the Holy Spirit.
Jenner, no. 26.

Motto: "The danger of wicked men abiding in the Church."
Icon: A garden.
Epigram: Like the gardener who daily cares for his garden, God cares for his church, weeding out the wicked, the hypocrites, and the sinner.
Peacham, p. 183.
Motto: "Unum, et semel."
Icon: A hand picks a flower in a garden.
Epigram: The garden represents the world; the flower being picked, the one way to live.
See also:

CUPID WATERING GARDEN
Van Veen, p. 79.
FLAMING SWORD, GARDEN, HEART
Harvey, no. 31.
STATUE
Astry, no. 53.

GARDEN AND NIGHTINGALE
Hawkins, no. 13, p. 148.
Motto: "Respexit."
Icon: A nightingale sings in a tree inside an enclosed garden; an eye and ears are in a cloud above the garden.
Epigram: Eve, like a nightingale, sang in Eden until she sinned and was expelled; then God beheld Mary, like a nightingale, exalting her Lord.

GARDEN AND SUN
Jenner, no. 12.
Motto: "A remedy against spirituall pride."
Icon: A man looks at a garden filled with herbs and flowers and at the sun.
Epigram: As the man took delight in the beauty of the flowers until he looked at the sun and was blinded, so the Christian sometimes takes pride in his own graces, but, when he wisely looks at God, he is humbled.

GARLAND
Peacham, p. 23.
Motto: "His ornari aut mori."
Icon: Olive, laurel, and oak garlands are intertwined.
Epigram: The noble mind seeks to attain the qualities represented by these three wreaths: wisdom (olive), learning (laurel), and courage (oak).
Peacham, p. 37.
Motto: "Sic utile dulci."
Icon: Women weave garlands from flowers and herbs.
Epigram: Just as Spartan virgins wove flowers with herbs to adorn their heads, so men should mix pleasure and profit, delight and work.

Wither, p. 258.
 Motto: "The Garland, He alone shall weare,
 Who, to the Goale, doth persevere."
 Icon: A hand holds a garland.
 Epigram: The garland signifies God's reward of those
 who persevere.

See also:
 BEAUTY
 Peacham, p. 58.
 CHAIN AND POLEAX
 P. S., p. 71.
 LILY
 Arwaker, bk. 3, no. 3.
 REWARD
 Peacham, p. 121.
 SANGUINE
 Peacham, p. 127.
See also: CROWN, LAUREL CROWN, WREATH.

GARLAND ON SPEAR
Whitney, p. 115.
 Motto: "Marcus Sergius: Fortiter & feliciter."
 Icon: A gauntlet holds a spear from which four
 garlands hang.
 Epigram: Honors are due men like Marc Sergius
 who do their best.

GARMENT
See:
 PRIESTLY GARMENT
 Willet, no. 6.
See also: CLOTHES.

GATE
See:
 CITY OF GOD
 Van der Noodt, no. 20.
See also: DOOR, PORTCULLIS.

GATE OF HEAVEN
See:
 PILGRIM
 Montenay, p. 78.

GATE OF THORNS
See:
 CROWN AND GATE OF THORNS
 Quarles, *Emb.*, p. 104.

Gathering flowers
See: PICKING FLOWERS.

GAUNTLET AND LANCE
Peacham, p. 33.
 Motto: "Labor viris convenit."
 Icon: A gauntlet holds a lance.
 Epigram: A man achieves honor by labor and action.

GAUNTLET, PEDESTAL, SWORD
Peacham, p. 162.

 Motto: "Pro Regno, et Religione."
 Icon: A gauntlet holds a sword above a pedestal.
 Epigram: The royal impress, this emblem expresses
 the king's readiness to protect his country.

Ghost
See: APPARITION.

GIRDLE
See:
 AJAX AND HECTOR
 Whitney, p. 37.

GIVING HEART
Harvey, no. 18.
 Motto: "Cordis Donatio."
 Icon: A human figure kneels and gives his heart
 to Divine Love.
 Epigram: The faithful man gives God his heart and
 loves God alone.

Harvey, no. 24.
 Motto: "Cordis Renovatio."
 Icon: Divine Love gives a heart to a kneeling
 human figure.
 Epigram: God will give man a new heart, which will
 burn with zeal.

GLASS
Arwaker, bk. 1, no. 14.
 Motto: "O! that they were wise, that they under-
 stood this, that they would consider their
 latter end."
 Icon: A human figure looks through a glass, or
 telescope, and sees Death with a sword
 and palm, hell, and Christ sitting in
 judgment.
 Epigram: Men should see beyond their immediate
 world and think on their end.

Astry, no. 76.
 Motto: "I legan de luz i salen de fuego."
 Icon: The sun shines on a glass and starts a fire.
 Epigram: The ministers of state are like the looking
 glass: in their good or bad intention lies
 peace or war.

Combe, no. 37.
 Motto: "Herein the chiefest cause is taught,
 For which the glasses first were wrought."
 Icon: A woman looks into a glass.
 Epigram: The looking glass should teach a woman to
 strive for inward beauty, either to match
 her external beauty or to hide her other
 deformities.

Jenner, no. 10.
 Motto: "The Touch-stone of Spirituall life."
 Icon: A woman holds a glass to the mouth of a
 reclining figure.
 Epigram: A glass is held to the face of a man to see if
 he is alive or dead. Christ is like this glass:

if "the breath of faith" exists, the "life of grace" is found.

Peacham, p. 56.

Motto: "Candor immunis erit."

Icon: The sun shines through a magnifying glass, held by a man, onto a cloth on the table.

Epigram: Just as the magnifying glass can inflame all colors of cloth except white, so slander can touch everyone except one with a clear conscience.

Quarles, *Emb.*, p. 84.

Motto: "Sic decipit orbis."

Icon: Cupid looks into a glass which is the shape of the world and which reflects his image; Divine Love, behind the mirror, looks into a small glass.

Epigram: The glass of the world deceives, making a man look larger and fairer than he is; the grace of God, however, shrinks men's shadows.

Quarles, *Emb.*, p. 176.

Motto: "Oh that they were wise, then they would understand this; they would consider their latter end."

Icon: The clothed figure of Spirit looks through a telescope and sees a vision of Death holding a palm and sword and standing in front of hell and of Christ sitting in judgment, a darkened sun and flames. Seated beside Spirit is the naked figure of Flesh, who looks at a small triangular glass, or prism.

Epigram: In a dialogue between Flesh and Spirit, Spirit chides Flesh for thinking only of sensual and transient things and urges her to consider God and last things.

See also:

BEAUTY
Peacham, p. 58.
BLIND MAN AND GLASS
Bunyan, no. 48.
BOXING GLASS
P. S., p. 233.
CUPID AND GLASS
Van Veen, p. 127.
FACE AND GLASS
Combe, no. 53.
FLOWER AND GLASS
Hall, p. 96.
FLY AND GLASS
P. S., p. 85.
FOWLER AND LARK
Bunyan, no. 23.
SAGE
Whitney, p. 130.

SELF-LOVE
Peacham, p. 5.

See also: BOXING GLASS, HOURGLASS, LOOKING GLASS, MIRROR, TELESCOPE.

GLASS AND LION

Astry, no. 33.

Motto: "Siempre et mismo."

Icon: A lion looks at his reflection in a broken glass.

Epigram: Like the lion, a symbol of fortitude and constancy, the prince is a public mirror and ought to "ever appear with one Countenance."

GLASS AND SNOW

Thynne, no. 17.

Motto: "Witt."

Icon: None.

Epigram: Wits are like glass: smooth but brittle and snow white but unfirm.

GLASS AND SPITTING

Montenay, p. 330.

Motto: "O ingratum."

Icon: A man spits on a glass.

Epigram: God's commandments are like the glass; if they show us that we fail to live as God desires, we should correct ourselves rather than revile the law, like the man who spits on the mirror.

GLASS AND WOMAN

Wither, p. 249.

Motto: "In all thine Actions, have a care, That no unseemlinesse appeare."

Icon: A woman looks into a glass.

Epigram: As the woman looks into the glass to make sure her appearance will please her lover, so men should examine their actions in the glass of moral law.

GLASS, HOURGLASS, SCEPTER, SERPENT

Astry, no. 28.

Motto: "Quae sint, quae fuerint, quae mox ventura sequantur."

Icon: A serpent entwines a scepter which is on top of an hourglass and between two looking glasses.

Epigram: The serpent represents prudence; the hourglass, present time; the mirrors, past and future time; the scepter, the prince who should have the virtue of prudence.

Glasses
See:
SPECTACLES.

GLOBE
Godyere, no. 9.

Motto: "Quel che dritto da il ciel torcer non puossi."

Icon: Four men pull cords binding a globe fastened to the sky.

Epigram: It is foolish to strive against fate, heaven, or the honest heart.

See also:

CHAIN, GLOBE, WINGS
Arwaker, bk. 3, no. 9.
DOLPHIN, GLOBE, RING
P. S., p. 327.
FAME
Wither, p. 146.
R. B., no. 37.
LAWBOOK AND SWORD
Wither, p. 163.
R. B., no. 31.
SERPENT, SPADE, WREATH
Wither, p. 92.

See also: ARMILLARY SPHERE, BALL, SPHERE, WORLD.

GLOBE AND SHIP
Astry, no. 68.

Motto: "His polis."

Icon: A globe is held at each pole by a ship.

Epigram: The globe which is supported by the ships illustrates that navigation is the support of the world.

GLOBE, GOLDEN BOUGH, SWORD
Astry, no. 69.

Motto: "Ferro et avro."

Icon: A hand holds a sword and a golden bough above a globe.

Epigram: The world is ruled by arms and riches.

GLOBE, KNIFE, THREAD
Wither, p. 213.

Motto: "Repent, or God will breake the thread, By which, thy doome hangs o're thy head."

Icon: A knife cuts a thread on which a globe hangs.

Epigram: Destruction hangs on a single thread above every sinner's head; God's impartial justice holds a knife ready to cut the thread, and God's mercy keeps the ball from falling.

GLOBE OF HEAVENS
Hall, p. 84.

Motto: "O thou of little faith why did'st thou doubt."

Icon: A child blows bubbles, while above him a hand holds a globe of the heavens.

Epigram: Like a small globe of the heavens which has in it every star and planet, man's soul contains some small character of everything in the universe and thus has an infinite imagination.

GLORY
Peacham, p. 21.

Motto: "Gloria Principum."

Icon: A lady wearing a crown supports a pyramid.

Epigram: The crowned lady represents the glory of princes; her crown, the "glorious projectes of the mind"; the pyramid, the lasting monument.

Whitney, p. 42.

Motto: "Venter, pluma, Venus, laudem fugiunt."

Icon: A female figure with wings on her feet, eyes and ears on her dress, and a wreath in her hair turns her back on a man and a woman who lie in bed with wine and food on a banquet table beside them.

Epigram: Glory is not present where lust, sloth, drinking, and other pleasures reign.

Glove
See: GAUNTLET.

GNAT AND FLAME
Whitney, p. 219.

Motto: "In amore tormentum."

Icon: Gnats fly into the flame of a candle.

Epigram: Even as gnats fly into the flame and are burned, so those who are attracted by physical beauty and burn with desire.

GOAT
Whitney, p. 189.

Motto: In desciscentes.

Icon: A goat kicks over and breaks a milk jug while a woman protests.

Epigram: After the goat filled the jug with its milk, it broke the container; this tale illustrates good beginnings which have unhappy endings.

See also:

ARROW, BOW, TAPER
Quarles, *Hier.*, no. 11.
CHARIOT, DEVIL, WORLD
Quarles, *Emb.*, p. 44.
SANGUINE
Peacham, p. 127.

GOAT AND WOLF
Whitney, p. 49.

Motto: "In eum qui sibi ipsi damnum apparat."

Icon: A wolf suckles at a goat's udder.

Epigram: As the wolf betrays the goat which reared it, so man's enemies are not to be trusted.

GOAT, GREYHOUND, LION
Willet, no. 96.

Motto: "Regis dignitas."

Icon: None.

Epigram: As the greyhound, the goat, and the lion are all graceful, so the king.

GOBLET
Peacham, p. 64.
 Motto: "Deos inprimis placandos."
 Icon: A goblet stands on an altar.
 Epigram: Roman ladies yearly presented their jewels and dress to Delphos, where the riches were turned into a goblet and given as an offering to expiate the sin of pride.

God
See: JEHOVAH.

GOLD
See:
 APE AND MISER
 Whitney, p. 169.
 CHAIN OF COCKLES
 P. S., p. 25.
 CHAIN OF GOLD
 P. S., p. 43.
 CITY OF GOD
 Van der Noodt, no. 20.
 COIN
 Quarles, *Emb.*, p. 80.
 CUP OF GOLD
 P. S., p. 90.
 ETERNITY
 Peacham, p. 141.
 FIRE AND GOLD
 Van Veen, p. 45.
 OPIMUS
 Whitney, p. 209.
 RICH MAN
 Montenay, p. 178.
 USURER
 Thynne, no. 20.
See also: COIN, MONEY, RICHES.

GOLD AND TOUCHSTONE
P. S., p. 213.
 Motto: "Sic spectanda fides."
 Icon: A hand holds a touchstone to gold.
 Epigram: As gold is proved by the touchstone, so faith is proved by deeds.

GOLD COIN
P. S., p. 15.
 Motto: "Fortuna mutata fidem novavit."
 Icon: A gold coin is broken in half.
 Epigram: Guimeus broke a piece of gold in half when his friend King Childericus was deposed. He gave the king one half and promised to send him the other half when he could safely return to the throne.

GOLDEN BOUGH
See also:

GLOBE, GOLDEN BOUGH, SWORD
Astry, no. 69.

GOLDEN FLEECE
Astry, no. 39.
 Motto: "Omnibus."
 Icon: The golden fleece burns on an altar.
 Epigram: The golden fleece of Gideon was moistened by the dew of heaven when the country was dry and is a symbol of humility. The prince is like this fleece, sacrificing himself for the good of his subjects and blessed by heaven.
P. S., p. 49.
 Motto: "Pretium non vile laborum."
 Icon: The golden fleece on a chain.
 Epigram: A device of the Knights of the Garter, the golden fleece symbolizes virtue and godliness.
See also:
 PHRYXUS
 Whitney, p. 214.

GOLDEN MEAN
Wither, p. 169.
R. B., no. 11.
 Motto: "Doe not the golden Meane, exceed, In Word, in Passion, nor in Deed."
 Icon: The personified figure of the golden mean holds a bridle and a square and puts its foot on a rock.
 Epigram: The square represents law; the bridle, discipline; the figure, the golden mean.
See also: TEMPERANCE.

GOLD ON PLATTER
P. S., p. 124.
 Motto: "Finem transcendit habendi."
 Icon: Gold on a platter.
 Epigram: As punishment for his covetousness, Calephas Baldacersis was given nothing but gold to eat.

GOLD PIPPIN
See:
 RACE
 Ayres, no. 39.

GOLDSMITH
See:
 FIRE AND GOLDSMITH
 Montenay, p. 350.

GOOD SAMARITAN
See:
 WOUNDED MAN
 Jenner, no. 6.

GOOSE
See:

CUPID, GOOSE, PEACH, SILENCE
Van Veen, p. 71.
DUCK, FALCON, GOOSE
Whitney, p. 207.
See also: GOSLING.

GORDIAN KNOT AND SWORD
P. S., p. 272.
 Motto: "Nodos Virtute resolvo."
 Icon: The arm of Alexander cuts the Gordian
 Knot with a sword.
 Epigram: Alexander cutting the Gordian Knot illus-
 trates that manhood and strength accom-
 plish what seems difficult.

GOSHAWK
P. S., p. 220.
 Motto: "Renovata juventus."
 Icon: A goshawk prunes its feathers in the sun.
 Epigram: As the goshawk prunes itself in the sun, so
 the man who comes to Christ should put
 off sin and be new-apparelled.
See also:
 FALCON AND GOSHAWK
 P. S., p. 366.

GOSLING
See:
 FOOL
 Wither, p. 225.
 R. B., no. 13.
See also: GOOSE.

GOURD AND PINE TREE
Whitney, p. 34.
 Motto: "In momentaneam felicitatem."
 Icon: A gourd plant entwines a pine tree.
 Epigram: The gourd is likened to the man on for-
 tune's wheel: it climbs quickly to the top
 of the pine tree but falls and dies just as
 quickly.

GRACES
Thynne, no. 13.
 Motto: "Liberalitie."
 Icon: None.
 Epigram: The three graces are the embodiment of
 charity; their nakedness represents plainess
 of heart; their freshness, thankfulness of
 mind; their winged feet, the speed of a
 willing heart; their joined arms, the unity
 of friends.

GRAFTED TREE
Montenay, p. 394.
 Motto: "Noli altum sapere."
 Icon: A grafted tree.
 Epigram: As the olive tree can be grafted with other

fruit, so the man who has not yet received
the grace of Christ may yet do so.
P. S., p. 191.
 Motto: "Usque recurrit."
 Icon: A grafted tree.
 Epigram: A tree grafted by art will return to its
 natural shape; so nature, however altered,
 will return to its proper condition.
See also:
 CUPID AND GRAFTED TREE
 Combe, no. 81.
 Van Veen, p. 5.

GRAIN
See:
 EAR OF GRAIN AND SHEAF
 Wither, p. 50.
 SIEVE
 P. S., p. 184.
 Whitney, p. 68.

GRAPE
Whitney, p. 206.
 Motto: "Tempore cuncta mitiora."
 Icon: A man picks grapes and tramples them
 underfoot.
 Epigram: The man who picks unripe grapes, finds
 them sour, and destroys them does not
 understand that the fairest things in this
 world are hard and sour at first but become
 sweet in time.
See also:
 BACCHUS
 Peacham, pp. 96, 191.
 Whitney, p. 187.
 FOX AND GRAPE
 Whitney, p. 98.
 SANGUINE
 Peacham, p. 127.

GRAPEVINE
Combe, no. 87.
 Motto: "In every thing advise you first:
 Take the best, and leave the worst."
 Icon: Grapes hang from a vine.
 Epigram: As sweet grapes lie hidden under the leaves
 of the vines, so the moral or sense of a
 fable is concealed under the letter.
Montenay, p. 230.
 Motto: "Non est culpa vini."
 Icon: A man digs up grapevines.
 Epigram: We should not blame grape plants for men's
 drunkenness but rather the man who
 drinks excessively.
Peacham, p. 157.
 Motto: "Vini Energia."
 Icon: A husbandman fertilizes a grapevine, and

a lion, an ape, a pig, and a sheep stand beside it.

Epigram: Wine from grapes takes on the qualities of animals whose manure fertilized it; thus men when drunk act like lions, apes, pigs, sheep.

See also:

ARROW, BOW, TAPER
Quarles, *Hier.*, no. 11.

BACCHUS
Whitney, p. 187.

GRAPEVINE AND LAUREL
Peacham, p. 39.
 Motto: "Ope mutua."
 Icon: A grape vine grows around a laurel tree.
 Epigram: Just as the grapevine supports the laurel tree, so the rich should support the arts.

GRAPEVINE AND PALLAS TREE
Whitney, p. 133.
 Motto: "Prudentes vino abstinent."
 Icon: A grapevine entwines a tree.
 Epigram: Prudent virgins flee Bacchus's friendship, eschew wine.

GRASS
See:

CROWN OF GRASS
P. S., p. 311.

GRASS AND WATER
P. S., p. 217.
 Motto: "Poco à poco."
 Icon: A vessel pours water on grass.
 Epigram: Just as the growth of grass is imperceptible, so virtue cannot be perceived except by example.

GRASSHOPPER
Willet, no. 16.
 Motto: "Lubricus impiorum status."
 Icon: None.
 Epigram: As the grasshopper sings while the weather is cool, but vanishes when it gets too hot, so the wicked smile while things go well but cry when things go amiss.

See also:

ANT AND GRASSHOPPER
Whitney, p. 159.

ANT, CONY, GRASSHOPPER, SPIDER
Willet, no. 97.

SWALLOW
Whitney, p. 5.

See also: LOCUST.

GRAVE
See:

AGED MAN

Wither, p. 87.
R. B., no. 23.

SCEPTER, SKULL, SPADE
Wither, p. 48.

GRAVEYARD
See:

CHRIST AND GRAVEYARD
Montenay, p. 258.

GREEN
See:

INCONSTANCY
Peacham, p. 147.

GREYHOUND
See:

GOAT, GREYHOUND, LION
Willet, no. 96.

GRIEVING
See:

SORROW AND TIME
Arwaker, bk. 1, no. 15.
Quarles, *Emb.*, p. 180.

See also: SORROW, WEEPING.

GRIFFIN
See:

BALL, GRIFFIN, STONE
Wither, p. 139.

GROAT
See:

SEEKING
Willet, no. 28.

GROUND
Montenay, p. 66.
 Motto: "Sine operibus mortua est Christus."
 Icon: Fruit-bearing plants grow in the ground.
 Epigram: Where there is fertile ground, there is fruit; so, too, where there is true belief, there is a godly life.

See also:

PLOWMAN
Wither, p. 144.

See also: EARTH, TURF.

GROUND AND SUN
Wither, p. 104.
 Motto: "The Ground brings forth all needfull things;
 But, from the Sunne, this vertue springs."
 Icon: The sun shines on fruit and flowers growing in the ground.
 Epigram: Man, like the ground, has some natural powers, but the grace of God, like the sun, first moves those abilities.

GULF
See:

HAND, GULF, LADDER
Montenay, p. 82.
See also: PIT.

H

HAIR
See:

ARROW, HAIR, OLIVE TREE
Willet, no. 4.
BRITAIN
Peacham, p. 108.

HALCYON'S NEST AND ROCK
Wither, p. 236.

Motto: "In ev'ry Storme, hee standeth fast,
 Whose dwelling, on the Rocke is plac'd."
Icon: A halcyon and its young sit in a nest on a
 rock amid the sea.
Epigram: The halcyon's nest signifies the Church; the
 rock, God's fortress; the raging sea, the
 world.

HALTER
See:

CROWN, HALTER, PURSE
Peacham, p. 153.
See also: CORD, ROPE.

HAMMER
See:

ANVIL AND HAMMER
Wither, p. 17.
ANVIL, HAMMER, HEART
Harvey, no. 8.
CUSHION, HAMMER, STONE
Jenner, no. 4.

HAMMER AND STITH
Combe, no. 67.

Motto: "Let fire on sword their choler wreake,
 A constant heart can nothing breake."
Icon: Hammers pound on a stith.
Epigram: The constant heart is like a stith; it endures
 the heavy beat of the hammer and does not
 yield or shrink.

HAMMER, HEART, NAIL
Harvey, no. 46.

Motto: "Compunctio cordis clavo Timoris Dei."
Icon: Divine Love hammers a nail into a heart.
Epigram: The speaker asks Christ to drive holy fear
 into his heart and fasten it there.

HAND
Wither, p. 244.

Motto: "God, ever will bee present, there,
 Where, of one Faith, and Mind they are."
Icon: A hand, with the palm exposed, is dis-
 played on a standard.
Epigram: The hand signifies the Holy Church: the
 many fingers represent the differing sects;
 the single palm, the One Faith.

See also:

CANDLE AND HAND
Farlie, no. 21.
Peacham, p. 3.
CHAIN
Godyere, no. 5.
CHAIN AND HAND
P. S., p. 141.
CHRIST ON CROSS
E. M., frontispiece.
CROWN, HAND, HEART
Wither, p. 180.
CUPID DEFORMED
Quarles, *Emb.*, p. 96.
DANGER
Hall, p. 1.
DARKNESS AND HAND
Hall, p. 36.
DEATH'S-HEAD, HANDSHAKE, HEART
Wither, p. 99.
EYE AND HAND
Astry, no. 51.
FIRE, HAND, SWORD
Whitney, p. 111.
FOUNTAIN AND HAND
Astry, no. 72.
IRON HAND AND WREATH
P. S., p. 278.
MOSES
Montenay, p. 346.
ROSE
Hawkins, no. 2, p. 25.
WASHING HAND
Wither, p. 162.
WREATH
Quarles, *Emb.*, p. 252.

HAND AND OLIVE BRANCH
Montenay, p. 158.

Motto: "Non quaeras dissolutionem."
Icon: Hands holding olive branches are tied to-
 gether and framed by wings.
Epigram: God desires us to live in love and peace
 with our fellow men.

HAND AND SEMPERVIVUM
P. S., p. 351.

Motto: "Ditat servata fides."
Icon: Hands embrace the herb "semper viveus"
 (sempervivum).

Epigram: The hands embracing the herb signify that loyalty purchases great riches.

HAND AND STAFF
P. S., p. 235.
Motto: "Et l'un, et l'autre."
Icon: Hands pull a staff in opposite directions.
Epigram: When two men fight, the greatest strength does not win the victory, but rather some vexation loses it.

HAND AND WING
Van Veen, p. 111.
Motto: "Bold and redie."
Icon: Cupid's hand is winged.
Epigram: The lover's hand must be swift and ready, so he can take advantage of the occasion.

HAND AND WORLD
Wither, p. 210.
Motto: "The Earth is God's, and in his Hands Are all the Corners of the Lands."
Icon: A hand holds the world.
Epigram: God holds all the world in his hands.

HAND, GULF, LADDER
Montenay, p. 82.
Motto: "A Quo Trepidabo."
Icon: A man climbs a ladder out of the churning gulf, and a hand from a cloud helps him.
Epigram: God holds man fast, keeps him from falling into the gulf, and helps him attain heaven.

HAND, LAMP, OWL
Montenay, p. 114.
Motto: "Sic vivo."
Icon: An owl uses the hand of a man on a long pole to put out a lamp.
Epigram: Like the crafty owl who uses the hand of a man to extinguish the lamp that burns night and day, Satan uses man to quench the good and set forth the ill.

HAND ON STANDARD
P. S., p. 92.
Motto: "Fiducia concors."
Icon: A hand on a standard.
Epigram: The hand carried on a standard signifies the hand of concord.

HAND, STAR, SUN
Godyere, no. 11.
Motto: "Invidia suum torquet authorem."
Icon: The sun and a star shine, and a hand burns.
Epigram: Envy, seeking to ruin a bright star attending the sun, snatched at the star but only succeeded in burning its own fingers; the marquess of Buckingham is likened to this star, protected by the king.

HANDMAID
See also:
INFANT AND HANDMAID
Quarles, Emb., p. 216.

HANDSHAKE
Combe, no. 11.
Motto: "Try well thy friend before thou trust, Lest he do leave thee in the dust."
Icon: Two men shake hands.
Epigram: Before making a man a friend, try him and prove him true.
Peacham, p. 135.
Motto: "Etiam hosti servanda."
Icon: A handshake above a barrel.
Epigram: The handshake is a symbol of concord.
Whitney, p. 76.
Motto: Concordia.
Icon: Two soldiers shake hands.
Epigram: Concord.
See also:
CORNUCOPIA AND HANDSHAKE
Wither, p. 166.
CROWN, HANDSHAKE, HEART
Wither, p. 237.
CUPID AND HANDSHAKE
Van Veen, p. 179.
EEL AND HANDSHAKE
Combe, no. 88.
FOX'S CLOTHING
Whitney, p. 124.

HANDSHAKE AND HEART
Godyere, no. 15 (misnumbered 12).
Motto: "Unum cor unus deus una religio."
Icon: A handshake encloses a heart pierced by a dart, and drops of blood fall.
Epigram: Concord makes of many one heart which even the dart of hate cannot destroy.
Wither, p. 230.
Motto: "My Hand and Heart, on one agree, What can you more desire of mee?"
Icon: A burning heart above a handshake.
Epigram: The hand and the heart should be in agreement.

HANG
See:
PURSE
Wither, p. 167.
R. B., no. 9.

HANGING
See:
LION
Combe, no. 75.

HANNO
Whitney, p. 84 (misnumbered p. 76).

Motto: "Ridicula ambitio."
Icon: A man stands outside a house and watches birds fly away.
Epigram: The story of Hanno, who teaches birds to sing his praise, only to release them and find they immediately forget him, shows us how ridiculous ambition is.

Happiness: *see* FELICITY.

HARE
Combe, no. 61.
 Motto: "The man whose conscience is unpure, In his owne mind he is not sure."
 Icon: A hare lies on the ground with its eyes open.
 Epigram: The wicked man is like the hare who is so fearful that he cannot rest.
See also:
 CUPID AND HARE
 Van Veen, p. 187.
 CUPID, DOG, HARE
 Van Veen, p. 25.
 CUPID, HARE, LADY
 Van Veen, p. 41.
 CUPID, HARE, PALM
 Van Veen, p. 101.
 DOG, HARE, SCEPTER
 Combe, no. 92.
See also: CONY, RABBIT.

HARE AND LION
Whitney, p. 127.
 Motto: "Cum larvis non luctandum."
 Icon: Hares bite a dead lion.
 Epigram: Just as the hares who feared the lion while it lived bite its corpse, so slanderers revile dead men whom they feared when they were alive.

HARE AND SWORD
P. S., p. 263.
 Motto: "Mala undique clades."
 Icon: Swords form a circle around a hare.
 Epigram: Offenders can find no safe refuge, for the sword shall destroy them abroad and cause them fear at home.

HARE AND TORTOISE
Van Veen, p. 99.
 Motto: "Perseverance winneth."
 Icon: A tortoise, accompanied by Cupid, moves ahead of a hare.
 Epigram: The lover should imitate the tortoise, which won the race with the hare through steadiness and perseverance.

HARLOT
See:

BATH
Thynne, no. 43.

HARP
Astry, no. 61.
 Motto: "Majora minoribus consonant."
 Icon: A harp with a crown on top.
 Epigram: A harp is like a republic; in both understanding presides, several fingers govern, many strings obey, and harmony is the result.
Peacham, p. 45.
 Motto: "Hibernica Respub: ad Jacobum Regem."
 Icon: A harp.
 Epigram: God saves man from discord and creates concord and harmony.
P. S., p. 121.
 Motto: "In sibilo aurae tenuis."
 Icon: A harp.
 Epigram: Music cures melancholy.
Wither, p. 65.
 Motto: "Though Musicke be of some abhor'd. She, is the Handmaid of the Lord."
 Icon: A king kneels and plays a harp.
 Epigram: Music helps raise the mind to God.
See also:
 APOLLO AND HARP
 Wither, p. 234.

HARP AND HEART
H. A., p. 185.
 Motto: "Jesus the Sonne of David, playes on the harp in the hart."
 Icon: Jesus plays a harp in a heart.
 Epigram: Jesus creates harmony in the heart of the devout.

HARPY
Peacham, p. 115.
 Motto: "Inrepetundos, et adulatores."
 Icon: A harpy preys on food lying on a table.
 Epigram: Courtiers "hungry for their private gaine," resemble the harpy.

HARROW
P. S., p. 160.
 Motto: "Evertit & aequat."
 Icon: A harrow.
 Epigram: As the harrow breaks apart the clods of the fields, so the good prince restrains the wicked and rebellious.
P. S., p. 296.
 Motto: "Hac virtutis iter."
 Icon: A harrow.
 Epigram: Labor is the way to attain virtue.

HART
See:

 ARROW AND HART

Wither, p. 214.
ARROW, DICTANUS, HART
P. S., p. 354.
CROWN AND HART
P. S., p. 298.
DICTAMON AND HART
Van Veen, p. 155.
EAGLE AND HART
P. S., p. 107.
FOUNTAIN AND HART
Arwaker, bk. 3, no. 11.
Quarles, *Emb.*, p. 284.
ROE
Arwaker, bk. 3, no. 15.
Quarles, *Emb.*, p. 300.
ZEAL
Peacham, p. 170.
See also: BUCK, DEER, HIND, ROE, STAG.

HARVEST
Willet, no. 11.
　　Motto:　　"Militamus sub spe."
　　Icon:　　None.
　　Epigram:　As the husbandman at the harvest finds
　　　　　　ease after long labor, so man after sorrow
　　　　　　finds joy.
Wither, p. 44.
　　Motto:　　"Those Fields, which yet appeare not so,
　　　　　　When Harvest comes, will yellow grow."
　　Icon:　　Sheaves of wheat stand in front of a field
　　　　　　being harvested.
　　Epigram:　Every mortal's life parallels the seasonal
　　　　　　changes; man should hope that his life's la-
　　　　　　bor will produce a joyful harvest.

HAT
Jenner, no. 19.
　　Motto:　　"The first false putting on of Christ."
　　Icon:　　A man takes off his hat as he passes an-
　　　　　　other.
　　Epigram:　Like the man who removes his hat every
　　　　　　time he meets someone, the false Christian
　　　　　　uses Christ casually, putting him off and
　　　　　　on; instead of a hat that is worn externally,
　　　　　　Christ should be part of men.
See also:
　　CROWN AND HAT
　　Peacham, p. 171.
See also: CAP.

HATCHET AND OAK
Montenay, p. 274.
　　Motto:　　"Cui Gloria."
　　Icon:　　A man cuts a bough of an oak with a
　　　　　　hatchet.
　　Epigram:　As a man cannot cut an oak without a
　　　　　　hatchet, so men cannot live in this world
　　　　　　without God.

HAWK
See:
　　BIRD, CAGE, HAWK
　　Wither, p. 96.
　　THRUSH
　　Thynne, no. 11.

HAWK AND HEN
Hawkins, no. 16, p. 183.
　　Motto:　　"Sub tuum praesidium; Succurre miseris."
　　Icon:　　A hen protects her young as a hawk flies
　　　　　　overhead.
　　Epigram:　Like the hen protecting her young from
　　　　　　the hawk, the Virgin protects souls from
　　　　　　Satan.

HAWTHORNE
See:
　　CROWN AND HAWTHORNE
　　Peacham, p. 90.

HAY
P. S., p. 286.
　　Motto:　　"Omnis caro foenum."
　　Icon:　　A sheaf of hay hangs on a pole.
　　Epigram:　The earthly body is like hay, mutable.
Whitney, p. 217.
　　Motto:　　"Omnis caro foenum."
　　Icon:　　A sheaf of hay hangs on a pole.
　　Epigram:　All flesh is mortal and "withereth like the
　　　　　　haie."
Wither, p. 256.
R. B., no. 49.
　　Motto:　　"All Flesh, is like the wither'd Hay,
　　　　　　And, so it springs, and fades away."
　　Icon:　　An infant holds a truss of hay.
　　Epigram:　Flesh is like hay, flourishing and then
　　　　　　perishing.
See also:
　　ASS AND DOG
　　Combe, no. 46.

HEAD
See:
　　CHRIST ON CROSS
　　E. M., frontispiece.
　　SEED
　　Ayres, no. 1.

HEADLESS WOMAN
Combe, no. 16.
　　Motto:　　"Search for strange monsters farre or wide,
　　　　　　None like the woman wants her guide."
　　Icon:　　A headless woman.
　　Epigram:　The most hideous of all monsters is a
　　　　　　woman without a head, i.e., a woman with-
　　　　　　out sense, or a woman without a man to
　　　　　　guide her.

HEAD OF STATE
Peacham, p. 22.
 Motto: "Ragione di stato."
 Icon: A man with eyes and ears on his robe and
 holding a wand stands beside broken pop-
 pies and a lion.
 Epigram: This man represents the head of state; the
 eyes and ears illustrate his need to see and
 listen to everything; the wand, his au-
 thority; the broken poppies, his wisdom
 that will cut down the rank or proud; the
 lion, his noble thoughts; the book, his em-
 phasis on the law.

HEARING
See:
 FLEEING, HEARING, SILENCE
 Whitney, p. 191.

HEART
H. A., p. 14.
 Motto: "The consecration of the hart."
 Icon: A flaming heart is supported by a number
 of men.
 Epigram: Man's heart aspires to God but is oppressed
 by sin; God lifts it to heaven.
Arwaker, bk. 2, p. 6.
 Motto: "O let my heart be sound in thy Statutes,
 that I be not ashamed."
 Icon: A woman kneels, holding a heart which is
 reflected in laws held by Divine Love; be-
 side her are a dressing table with a mirror,
 cosmetics ("paint" and "beauty-water"),
 and jewels.
 Epigram: Beauty should be rejected in favor of the
 beauty of a "spotless heart."
Ayres, no. 7.
 Motto: "The Impossibility."
 Icon: Two cupids attempt to kindle a heart with
 a flint and a tinderbox.
 Epigram: It is impossible to kindle love in a cold
 woman.
Hall, p. 32.
 Motto: "O Lord behold my heart, which thou
 pitiedst in the bottomless pit."
 Icon: A flaming winged heart, pierced by a dart,
 flies heavenward, rising above a chain and
 shackles on earth; Divine Love watches.
 Epigram: Man's heart, inflamed by love, flies to God,
 leaving below the chains and shackles of
 earthly existence.
Montenay, p. 166.
 Motto: "Vae."
 Icon: A man holds a heart in front of himself.
 Epigram: God knows the heart of man and can see
 through the appearance of piety in the
 hypocrite.

Montenay, p. 358.
 Motto: "Quas iam quaeras late bras."
 Icon: A hand in clouds holds a rod which pene-
 trates a heart on the ground.
 Epigram: God sees into men's hearts.
Quarles, *Emb.*, p. 120.
 Motto: "Patet aethrae; clauditur orbi."
 Icon: Divine Love holds a heart to heaven's eye,
 which beams light into it; Cupid holds the
 world up to a heart.
 Epigram: The heart which is given to heaven scorns
 worldly things.

See also:
 ALTAR AND HEART
 Wither, p. 77.
 ANVIL, HAMMER, HEART
 Harvey, no. 8.
 ARROW AND HEART
 H. A., p. 214.
 Hall, p. 52.
 BALANCE, HEART, LAW
 Harvey, no. 20.
 BELLOWS, HEART, TREASURE
 Harvey, no. 5.
 BLOOD AND HEART
 H. A., p. 95.
 BLOOD, FOUNTAIN, HEART
 H. A., p. 83.
 BOOK
 Peacham, p. 40.
 BOOK, HEART, SMOKE, WING
 Wither, p. 91.
 BROOM AND HEART
 H. A., p. 71.
 CAGE AND HEART
 Hall, p. 44.
 CHAIN
 Godyere, no. 5.
 CIRCUMCISION AND HEART
 Harvey, no. 13.
 CORD AND HEART
 Harvey, no. 42.
 CROSS AND HEART
 H. A., p. 148.
 CROWN AND HEART
 Montenay, p. 150.
 CROWN, HAND, HEART
 Wither, p. 180.
 CROWN, HANDSHAKE, HEART
 Wither, p. 237.
 CROWN OF THORNS AND HEART
 Harvey, no. 45.
 CUPID AND HEART
 Van Veen, p. 47.
 CUPID AND STILL
 Combe, no. 79.

DARKNESS AND HEART
Harvey, no. 3.
DEATH'S-HEAD, HANDSHAKE, HEART
Wither, p. 99.
DEVIL, HEART, SLEEP
Harvey, no. 2.
DOOR, HEART, KNOCKING
H. A., p. 45.
DOVE AND HEART
Harvey, no. 34.
DRINK, FOOD, HEART
Harvey, no. 6.
EAR AND HEART
Montenay, p. 44.
EATING HEART
Combe, no. 8.
ENLARGING HEART
Harvey, no. 35.
ENVY
Whitney, p. 94.
EVE, HEART, SERPENT
Harvey, no. 1.
EYE, FIRE, HEART
Hall, p. 76.
EYE, HEART, SLEEP
Harvey, no. 32.
EYE, HEART, SUN
Wither, p. 43.
FIRE AND HEART
Harvey, no. 36.
FLAME AND HEART
H. A., p. 226.
Hall, p. 72.
FLAMING SWORD, GARDEN, HEART
Harvey, no. 31.
FLOWER AND HEART
Harvey, no. 30.
FOOL AND HEART
Harvey, no. 4.
FOUNTAIN
Hall, p. 88.
FOUNTAIN AND HEART
Harvey, no. 17.
FRIENDSHIP
Peacham, p. 181.
FURNACE AND HEART
Harvey, no. 21.
GIVING HEART
Harvey, nos. 18, 24.
HAMMER, HEART, NAIL
Harvey, no. 46.
HANDSHAKE AND HEART
Godyere, no. 15 (misnumbered 12).
Wither, p. 230.
HARP AND HEART
H. A., p. 185.

HOURGLASS
Wither, p. 212.
PHOENIX
Hawkins, no. 2, p. 66.
ROSE
Hawkins, no. 2, p. 25.
SHIELD
Peacham, p. 166.
SIN
Peacham, p. 146.
TRUTH
Whitney, p. 4.
TYING HEART
Harvey, no. 39.
WATERING HEART
Harvey, no. 29.

HEART AND JEHOVAH
Montenay, p. 286.
 Motto: "Glorificate et portate."
 Icon: A soldier holds a heart on which the word *Jehovah* is inscribed; a wreath crowns the heart.
 Epigram: Happy is the man who has Jehovah written in his heart.

HEART AND LADDER
Harvey, no. 37.
 Motto: "Cordis Scalae."
 Icon: A human figure puts a ladder inside his heart.
 Epigram: Man should frame a ladder in his heart and meditate on the steps necessary to ascend to heaven.

HEART AND LAW
Harvey, no. 26.
 Motto: "Cordis Tabula Leges."
 Icon: Divine Love inscribes the law in a heart-shaped tablet.
 Epigram: God writes a new law in the hearts of men.

HEART AND LEVEL
Harvey, no. 23.
 Motto: "Cordis Rectificatio."
 Icon: A human figure sets a heart upright on an altar while he and Divine Love use a level to correct its position.
 Epigram: God demands an upright heart which does not lean toward the self.

HEART AND MAGNET
Montenay, p. 50.
 Motto: "Non tuis viribus."
 Icon: A magnet hangs above a heart.
 Epigram: As the magnet draws iron, so Christ draws men's hearts, bringing them out of misery to heaven.

HEART AND MIRROR
H. A., p. 288.
 Motto: "Jesus manifests himself and the most holy Trinity in the mirrour of the hart."
 Icon: None.
 Epigram: The devout heart, like a mirror, reflects the true essence of Jesus and the Trinity.

HEART AND MONARCH
H. A., p. 108.
 Motto: "Jesus rules and reignes in the loving & devout hart."
 Icon: Jesus, dressed as a monarch, sits on a throne in a heart.
 Epigram: Jesus rules and guides the devout.

HEART AND MONSTER
H. A., p. 58.
 Motto: "Jesus searcheth out the monsters lurking in the darke corners of the hart."
 Icon: Jesus holds a lantern, looks for monsters inside a dark heart.
 Epigram: Jesus sees man's sins, even though they lie hidden in the heart.

HEART AND NET
H. A., p. 30.
 Motto: "The world, the flesh, the Divel assaile the hart, Jesus saves it for himself."
 Icon: A woman with worldly goods, a devil, and a naked man throw a net over a heart which Jesus protects.
 Epigram: The world, the flesh, and the devil tangle the heart in sin, but Christ saves it.

HEART AND PAINTING
H. A., p. 134.
 Motto: "Jesus paints the images of the last things in the table of the heart."
 Icon: Jesus paints images of the four last things on a heart.
 Epigram: Jesus, "the divine painter," enters the heart and paints images of heaven and the last things.

HEART AND PILLAR
Harvey, no. 43.
 Motto: "Fulcrum Cordis Christi Columna."
 Icon: A human figure props a heart on a pillar while Divine Love holds a scourge.
 Epigram: Christ is a pillar which props up man's heart when life and the devil scourge it.
Montenay, p. 62.
 Motto: "Maxima non confundet justificat Christus."
 Icon: A burning heart sits on top of a winged pillar.
 Epigram: Christ is the ground upon which every

Christian should build; if a man sets his heart upon Christ, he shall enjoy eternal glory.

HEART AND PLOW
Harvey, no. 27.
 Motto: "Aratio Cordis."
 Icon: A plow turns and tills a heart.
 Epigram: As the plow tills the ground, so God tills the human heart, breaking up sin and planting hope.

HEART AND PLUMMET
Harvey, no. 22.
 Motto: "Cordis Scrutinium."
 Icon: Divine Love uses a plummet to sound the interior of a heart, held by a human figure.
 Epigram: God alone can tell what is within man's heart.

HEART AND PRESS
Harvey, no. 15.
 Motto: "Cordis Humiliatio."
 Icon: A heart is flattened in a press.
 Epigram: The speaker asks God to crush his proud heart so that he can learn humility and patience.

HEART AND PURSE
Montenay, p. 138.
 Motto: "Illic erit et cor vestrum."
 Icon: A man carries a heart in a purse.
 Epigram: The rich man puts mammon above God and therefore cannot enter the kingdom of heaven.

HEART AND REST
Harvey, no. 40.
 Motto: "Cordis Quies."
 Icon: A human figure sits on the ground while Divine Love in Heaven holds a heart.
 Epigram: The busy heart can find no rest on earth, for God alone is its only rest.

HEART AND ROSE
H. A., p. 159.
 Motto: "The hart consecrated to the love of Jesus is a flourishing garden."
 Icon: Jesus gathers flowers inside a heart bordered by roses.
 Epigram: Jesus makes the devout heart a garden, cultivating roses of virtue.

HEART AND SACRIFICE
Harvey, no. 19.
 Motto: "Cordis Sacrificium."
 Icon: A heart is sacrificed on an altar.
 Epigram: The speaker vows to sacrifice his own heart to God.

HEART AND SATAN
Montenay, p. 146.
Motto: "Impossible est."
Icon: A man holds a heart and kneels to Satan.
Epigram: A man cannot serve both God and Satan but will in the end forsake God and flee to Satan.

HEART AND SCHOLAR
H. A., p. 122.
Motto: "Jesus teacheth the devout hart."
Icon: Jesus as a scholar sits with an open book inside a heart.
Epigram: God instructs the devout.

HEART AND SCOURGE
Harvey, no. 44.
Motto: "Stimulus Cordis Christi Flagella."
Icon: Divine Love scourges a heart.
Epigram: God scourges man's heart when it sins or wanders to correct it.

HEART AND SEED
Harvey, no. 28.
Motto: "Seminatio in Cor."
Icon: Divine Love plants seeds in a heart.
Epigram: God sows seed (his Word) in the human heart.

HEART AND SERPENT
Hall, p. 100.
Motto: "For I carried my soul as it were torn in sunder, and gored with blood, and impatient even to be carried by me."
Icon: A man sits beneath a tree and points to his breast, which is open to reveal a heart gnawed by serpents.
Epigram: Man is a traitor to himself; he harbors passions which, like poisonous serpents, gnaw on his tortured heart.

HEART AND SHAFT
Harvey, no. 33.
Motto: "Cordis Vulneratio."
Icon: Divine Love shoots an arrow at the heart of a human figure.
Epigram: The speaker asks God to wound his heart because God's shafts heal sick hearts.

HEART AND SINGING
H. A., p. 171.
Motto: "Jesus sings in the quire of the hart."
Icon: Jesus sings in the heart.
Epigram: The heart which accepts Jesus experiences the joy of celestial music.

HEART AND SMOKE
Wither, p. 39.
Motto: "Where strong Desires are entertain'd,
The Heart 'twixt Hope, and Feare, is pain'd."
Icon: A smoking heart sits between an anchor and a bow and arrow.
Epigram: The smoking heart signifies strong desire; the anchor, hope; the bow and arrow, fear.

HEART AND TEAR
Harvey, no. 41.
Motto: "Balneum Cordis, ex sudore sanguineo."
Icon: Divine Love weeps; his tears bathe a heart held by a human figure.
Epigram: Christ shed blood to cleanse man's heart.

HEART AND TONGUE
Combe, 73.
Motto: "A traitor and a flattering friend,
Say that they never do intend."
Icon: A man holds a dish with a tongue in it and conceals a heart behind him.
Epigram: The hypocrite's words do not match his thoughts; with his tongue the hypocrite professes friendship, but he conceals the actual feelings of his heart.

HEART AND TORCH
Wither, p. 178.
Motto: "They, best injoy their Hearts desires,
In whom, Love, kindles mutuall-fires."
Icon: A man and a woman each hold flaming torches which are crossed and above which is a flaming heart.
Epigram: The flaming torches signify equal and mutual love; the flaming heart, that the two lovers are one in mind.

HEART AND TREASURE
Harvey, no. 7.
Motto: "Cordis Avaritia."
Icon: A human figure holds a heart in an open treasure chest.
Epigram: The heart of the covetous person lies with his earthly treasure, which he values above God.

HEART AND WANDERER
Harvey, no. 11.
Motto: "Cordis Reversio."
Icon: Divine Love approaches a wanderer and urges him to return to his heart, which lies abandoned on the ground.
Epigram: Christ brings the sinful, wandering soul back to his heart.

HEART AND WASHING
Montenay, p. 354.
Motto: "Beati mundo corde."
Icon: A man holds a heart in a cup while a hand from heaven pours blood onto it.

Epigram: Blessed is the man whose heart is clean, washed in the blood of Christ.

HEART AND WATER
Harvey, no. 12.
Motto: "Cordis Effusio."
Icon: A human figure pours water out of his heart.
Epigram: Confess and pray to God, and he will restore you.

HEART AND WINE
Hall, p. 40.
Motto: "Inebriate my heart, (Oh God!) with the sober intemperance of thy love."
Icon: Divine Love holds a heart while a hand from a cloud pours wine into it.
Epigram: God cheers man's heart with love.

HEART AND WINEPRESS
Harvey, no. 47.
Motto: "Mustum Cordis e Torculari Crucis."
Icon: Divine Love stands in a winepress while a human figure fills a heart with wine from the press.
Epigram: Christ is the true vine; the blood he shed on the Cross, like the wine from a winepress, gladdens the hearts of men.

HEART AND WING
Harvey, no. 38.
Motto: "Cordis Volatus."
Icon: A winged heart flies from a human figure to Divine Love in the clouds.
Epigram: The speaker wishes his heart had wings so that he could leave the world and fly to God.

HEART AND WORLD
Harvey, no. 10.
Motto: "Cordis insatiabilitas."
Icon: A human figure attempts to encompass a heart with the world.
Epigram: The whole world cannot fill the heart, which is triangular and can be encompassed only by the Trinity, which made it.
Montenay, p. 282.
Motto: "Beati pauperes."
Icon: A naked boy holds up a heart on a stick to the heavens and stands beside the world.
Epigram: The godly will, like this boy, hold his heart up to God and not down to the world.
Montenay, p. 338.
Motto: "Tibi imputa."
Icon: A man lays a heart upon the world and digs a pit.
Epigram: The man who lays his heart solely upon the world, rather than upon God, is damned to Satan's dark pit.

HEART DIVIDED
Harvey, no. 9.
Motto: "Cordis divisio."
Icon: A human figure divides a heart in two, gives one half to a worldly woman, the other half to Divine Love.
Epigram: God rebukes man for dividing his heart between God and the world.

HEART, LAMB, NUPTIAL SUPPER
H. A., p. 254.
Motto: "Jesus celebrates the heavenly nuptials in the heart."
Icon: None.
Epigram: The heart is the banqueting room of the nuptials; Jesus, the spouse; Jesus' body and blood, the nuptial supper.

HEART, LAUREL, PALM
H. A., p. 235.
Motto: "Jesus crownes his deare hart with palms and laurels."
Icon: Jesus and angels adorn a heart with a crown, laurel wreaths, and a palm.
Epigram: Jesus rewards the devout with eternal crowns.

HEART, LIGHT, SUNDIAL
Harvey, no. 25.
Motto: "Cordis Illuminatio."
Icon: Divine Love and a human figure holds up a heart from which a light emanates; on the front of the heart is a sundial.
Epigram: The speaker asks God to enlighten his heart and dispel the darkness.

HEART, MORTAR, PESTLE
Harvey, no. 14.
Motto: "Cordis Contritio."
Icon: A human figure with a pestle pounds a heart in a mortar.
Epigram: The contrite man breaks his heart into pieces in his conscience to rid himself of sin.

HEART, NUN, TONGUE
Montenay, p. 130.
Motto: "Frustra me colunt."
Icon: A pious-looking nun holds a tongue in front of her and drags a heart on a thread behind her.
Epigram: The hypocrite espouses religion without believing in his heart, but God requires the union of tongue, heart, and mind.

HEART OF ICE AND SUN
Harvey, no. 16.
Motto: "Cordis Emollitio."
Icon: Divine Love radiates sun beams which melt a heart of ice.

Epigram: With the fire of love God thaws the heart of ice.

HEART PIERCED BY ARROW
Ayres, no. 15.
 Motto: "Rather Deedes, than words."
 Icon: Cupid holds up a heart pierced by an arrow to a woman.
 Epigram: Rather than speaking of love, show the wounded heart.

HEART, SHAFT, WHITE
Van Veen, p. 153.
 Motto: "The lovers hart is Cupids whyte."
 Icon: Cupid aims his shafts at a lover's heart, which is marked by a target with a white circle.
 Epigram: Cupid's target is the heart.

HEART, SLEEP, WIND
H. A., p. 199.
 Motto: "Jesus rests in the lovers hart."
 Icon: Jesus sleeps in a heart while winds blow.
 Epigram: Even though the winds of temptation rage, the heart where God rests remains calm.

HEAVEN
Arwaker, bk. 3, no. 14.
 Motto: "O how amiable are thy Tabernacles, thou Lord of Hosts!"
 Icon: A human figure sits on the earth and sees a vision of God on a throne attended by angels in the heavenly court.
 Epigram: The speaker anticipates the joys of heaven.
Hawkins, no. 8, p. 81.
 Motto: "Capacitatis immensae."
 Icon: The heavens.
 Epigram: The Virgin is like heaven, a place of beatitude where God manifests himself.
Hawkins, no. 8, p. 89.
 Motto: "Coelum coeli Domino."
 Icon: Angels in heaven look down on a naked human who holds an armillary sphere and is encircled by a minature heaven.
 Epigram: The Virgin is like a heaven on earth.
Quarles, *Emb.*, p. 296.
 Motto: "How amiable are thy Tabernacles O Lord of Hosts, my Soule longeth, yea even fainteth for the courts of the Lord."
 Icon: A human figure sits on the earth and sees a vision of God on a throne attended by angels in the heavenly court.
 Epigram: The speaker envisions the glory of heaven.
See also:
 ASS AND STAG
 Quarles, *Emb.*, p. 52.
 CUPID, EARTH, HEAVEN
 Van Veen, pp. 35, 37.
 CUPID, TOY, VENUS

 Quarles, *Emb.*, p. 92.
 EARTH AND HEAVEN
 Arwaker, bk. 3, p. 6.
 Quarles, *Emb.*, p. 264.
 GLOBE OF HEAVENS
 Hall, p. 84.
 HEART
 Quarles, *Emb.*, p. 120.
 INNOCENCE AND LEARNING
 Hall, p. 28.
 WAY TO HEAVEN
 Montenay, p. 406.

HEAVEN AND WORLD
Whitney, p. 225.
 Motto: "Superest quod suprà est."
 Icon: A man turns from the world and looks to heaven.
 Epigram: Have contempt for the world and its pleasures and put your hope in heaven.

HEAVENLY CITY
See:
 HUNGER
 Hall, p. 16.

HECTOR
See:
 AJAX AND HECTOR
 Whitney, p. 37.

HEDGEHOG
Astry, no. 59.
 Motto: "Ol senno e con la mano."
 Icon: A hedgehog is held by a gloved hand.
 Epigram: As the hedgehog is easy to find but must be held with prudence and its bristles flattened, so government depends on both arms and prudence, strength and counsel.
P. S., p. 177.
 Motto: "Magnum vectigael."
 Icon: A hedgehog.
 Epigram: The hedgehog teaches man to be diligent in making a living.

HELIOTROPE
Ayres, no. 14.
 Motto: "The Powerfull attraction."
 Icon: A heliotrope turns toward Cupid.
 Epigram: The lover seeks his beloved, wherever she is.
Hawkins, no. 5, p. 48.
 Motto: "Ad me Conversio eius.
 Icon: A heliotrope is encircled by a wreath of flowers."
 Epigram: Because the heliotrope follows the sun, it is likened to the Virgin, who follows God.
Hawkins, no. 5, p. 56.
 Motto: "Trahit Sua quamque voluptas."

Icon: A heliotrope bends toward the sun, and a different flower bends toward the moon.

Epigram: The Virgin Mary is like the heliotrope and follows the Sun of Justice, God; Eve, however, is like the flower which follows the moon and is changeable.

Thynne, no. 18.

Motto: "The subject."

Icon: None.

Epigram: As the heliotrope follows the sun, so the pliant subject follows the ruling prince.

Van Veen, p. 75.

Motto: "Loves shyning Sunne."

Icon: A heliotrope bends toward the sun as Cupid looks on.

Epigram: As the heliotrope bends toward the sun, the lover inclines toward his beloved.

See also: MARIGOLD.

HELIOTROPE AND LODESTONE

Arwaker, bk. 3, p. 4.

Motto: "I am my Beloved's, and his desire is towards me."

Icon: A heliotrope turns toward the sun, and the needle of a lodestone points to Divine Love.

Epigram: As the heliotrope turns toward the sun and the lodestone's needle points to the north, so men turn to God.

HELL

See:

GLASS

Arwaker, bk. 1, no. 14.

Quarles, *Emb.*, p. 176.

SLEEP

Quarles, *Emb.*, p. 28.

HELL AND SNARE

Arwaker, bk. 1, no. 9.

Motto: "The pains of Hell came about me, the snares of Death overtook me."

Icon: Man is caught in a snare set by Death; behind him, devils torment souls in a fiery hell; above him is a spider web.

Epigram: Man is snared by sin and pleasures.

Quarles, *Emb.*, p. 156.

Motto: "The sorrowes of hell have encompassed me, the snares of death have overtaken me."

Icon: Devils pursue a human figure through the fires of hell; another figure is ensnared in a trap; above him is a spider web.

Epigram: The devil pursues men's souls, tempting and ensnaring them with worldly things.

HELMET

Peacham, p. 78.

Motto: "Sine pluma."

Icon: A plain, bullet-ridden helmet is shown.

Epigram: Like the plain, unadorned helmet, the valiant heart is content and needs no material rewards.

See also:

ALTAR, BOOK, CUP, HELMET, MONEY

P. S., p. 371.

BEE AND HELMET

Whitney, p. 138.

Wither, p. 90.

HELMET AND PORCUPINE

Astry, no. 82.

Motto: "Decus in armis."

Icon: A porcupine sits on top of a helmet.

Epigram: The porcupine, whose quills both defend and assault, adorns the helmet to show what a price the prince ought to set upon arms.

HELMET AND RAVEN

P. S., p. 133.

Motto: "Insperatum auxilium."

Icon: A raven sits on a helmet.

Epigram: Valerius overcame his enemy when a raven lighted on his enemy's helmet, pecking the foe; the raven on the helmet signifies the worthy exploit.

Whitney, p. 113.

Motto: "M. Valerius Corvinus: Insperatum auxilium."

Icon: A raven sits on a helmet.

Epigram: Just as a raven appeared in the middle of a fight between Valerius and a Gaul and helped Valerius to victory by pecking the opponent, so God will preserve us when we are in danger.

HELMET AND SPEAR

P. S., p. 77.

Motto: "Ultorem ulciscitur ultor."

Icon: A spear hits a helmet.

Epigram: When Charles I tried to avenge a friend's wrongs, he almost killed his brother; this story teaches the dangers of revenge.

HEN

Bunyan, no. 52.

Motto: "On the Kackling of a Hen."

Icon: None.

Epigram: Like the hen which cackles when it lays an egg, some professors of the faith call attention to their good works.

Hawkins, no. 16, p. 175.

Motto: "Tutela fidissima."

Icon: A hen.

Epigram: Like the hen, the Virgin is gentle, kind-hearted, and protective.

Whitney, p. 64.
 Motto: "Quae ante pedes."
 Icon: A hen on the roof of a cottage eats her eggs and discards the shell.
 Epigram: The person who is ungrateful to his friends, ignores his offspring, or wastes his inheritance is like the hen who eats her eggs, leaving only the empty shell.

See also:
 HAWK AND HEN
 Hawkins, no. 16, p. 183.

HEN AND KITE
Montenay, p. 366.
 Motto: "Ibi licet esse securis."
 Icon: A hen protects her chicks from a kite.
 Epigram: Like the hen which protects her chicks from the kite, Christ protects man from Satan.

Hephaestus
See: VULCAN.

Hera
See: JUNO.

Heracles
See: HERCULES.

HERACLITUS
See:
 DEMOCRITUS AND HERACLITUS
 Whitney, p. 14.

HERALDIC FLAG
Peacham, p. 101.
 Motto: "Presidium et dulce decus."
 Icon: A gauntleted hand places a heraldic flag on a mountain top.
 Epigram: Dedicated to a German prince, this emblem is a monument to him as a glorification of his virtues.

HERALDIC SHIELD
Peacham, p. 15.
 Motto: "Auspice coelo."
 Icon: A hand holds a heraldic shield on which are three fleurs-de-lis.
 Epigram: The blue color symbolizes a heavenly mind; the gold, plenty; the lilies, harmony. The device is dedicated to Louis XIII of France.
Peacham, p. 102.
 Motto: "Distantia jungo."
 Icon: A hand holds a heraldic shield with three fleurs-de-lis.
 Epigram: Dedicated to the duke of Lennox, this emblem praises the Stuart name and the peace made between England and Scotland.

HERB
Thynne, no. 14.
 Motto: "Vertue of Herbes."
 Icon: None.
 Epigram: The story of Epidaurus discovering the power of certain herbs to restore life illustrates the health-giving properties of herbs.

See also:
 GARLAND
 Peacham, p. 37.
 REWARD
 Peacham, p. 121.
 SAGE
 Whitney, p. 130.
See also: DICTAMON, DICTANUS, DOCK, HYOSCYANUS, HYSSOP, MUSTARD SEED, RUMICE, SAFFRON, SEMPERVIVUM, WORMWOOD.

HERCULES
Astry, no. 1.
 Motto: "Hinc labor et virtu."
 Icon: Hercules, shown as a baby in a cradle, strangles a serpent.
 Epigram: Valor is innate, not acquired.
Peacham, p. 36.
 Motto: "Virtus Romanaet antiqua."
 Icon: Hercules, wearing a lion skin and holding a club, carries the three golden apples of Hesperides.
 Epigram: Hercules represents the heroic, virtuous mind; the apples, the three heroic virtues; the skin, fortitude; the club, the pain necessary to achieve greatness.
Peacham, p. 95.
 Motto: "Vis Amoris."
 Icon: Hercules, dressed in a woman's gown, holds a distaff and spins wool.
 Epigram: As Hercules, the conqueror of the world, was conquered by his love for Omphale, who disgraced and effeminized him, so men who have earned honor lose it through lewd actions.
Whitney, p. 16.
 Motto: "Quod potes, tenta."
 Icon: Hercules, wearing a lion skin and holding a club, sleeps; a group of pygmies with swords and shields surround and threaten him.
 Epigram: As it is foolish for pygmies to fight Hercules, who will crush them, so it is foolish for the weak to strive against the strong.
Whitney, p. 40.
 Motto: "Bivium virtutis & vitii."
 Icon: Hercules, wearing a lion skin and holding a club, chooses between virtue, in armor, and vice, with Cupid.

Epigram: Those who choose vice gain immediate pleasure but nothing lasting; those who choose virtue, like Hercules, must labor now but will gain lasting fame.

See:

BOOK, CUPID, DISTAFF, HERCULES
Van Veen, p. 83.
CERBERUS AND HERCULES
Thynne, no. 26.
CUPID AND HERCULES
Van Veen, pp. 33, 53.
PILLARS OF HERCULES
P. S., p. 32.
VICE AND VIRTUE
Wither, p. 22.
R. B., no. 2.

HERCULES AND HYDRA
Combe, no. 99.
Motto: "When some thinke most themselves in peace,
 Their dangers oft do most increase."
Icon: Hercules in a lion skin fights Hydra with a club.
Epigram: When Hercules thought his troubles were over, the Hydra attacked him; so virtue is never safe and must always be on guard.

HERETIC
See:

CASTLE, CHRIST, HERETIC
Godyere, no. 29.

Hermes
See: MERCURY.

Heron
See: FENNY BITTERN.

HESPERIDES
See:

APPLES OF HESPERIDES
P. S., p. 67.

Hester
See: ESTHER.

HIDING
See:

ADAM
Montenay, p. 290.
Whitney, p. 229.
See also: COVERING.

HIDING FACE
See:

ECLIPSE
Arwaker, bk. 1, no. 7.
Quarles, *Emb.*, p. 148.

HILL
Montenay, p. 214.
Motto: "Trahe Fratres."
Icon: A man on a hill reaches toward men below.
Epigram: When a man is blessed with riches, he should help those beneath him and never assume that he can dwell forever on the hill.

See also:

SUN
Whitney, p. 20.

HIND
Peacham, p. 4.
Motto: "Nusquam tuta."
Icon: A hind is pierced in the side by an arrow.
Epigram: As the wounded hind runs from place to place without resting, so the man with a bad conscience madly shifts his ground, neglecting what might heal him.

See also:

DOG AND HIND
Van der Noodt, no. 1.
See also: BUCK, DEER, HART, ROE, STAG.

HIPPOMENES
See:

RACE
Ayres, no. 39.

HIVE
See:

BEE AND HIVE
Astry, no. 62.
Whitney, p. 200.
Wither, p. 250.
FORTUNE
Combe, no. 29.

HOBBYHORSE
See:

BOY AND HOBBYHORSE
Bunyan, no. 67.

HOG
Bunyan, no. 24.
Motto: "Of the fatted Swine."
Icon: None.
Epigram: The hog fatted for slaughter represents the man who must die for his sin.

See also: BOAR, PIG, SOW, SWINE.

HOGSHEAD
P. S., p. 186.
Motto: "Hac illae perfluo."
Icon: A hogshead full of holes and leaks.
Epigram: The hogshead full of holes and leaking its contents is compared to men who cannot

keep secrets, ungrateful men, and covetous men.

HOLE
See:

BARREL
Wither, p. 246.
BARREL, FIRE, HOLE
Van Veen, p. 145.
HOGSHEAD
P. S., p. 186.
TUN
Whitney, p. 12.

HOLY-WATER BRUSH
See:

FAVOR
Peacham, p. 206.

HOMER AND MUSE
Whitney, p. 168.
Motto: "Si nihil attuleris, ibis Homere foras."
Icon: Homer and nine Muses stand, unwelcomed, in a courtyard.
Epigram: Wisdom is no longer esteemed and must go begging.

Honor
See: EUPHEMEN, GLORY.

HOODWINK
See:

HORSE AND MILL
Bunyan, no. 28.
See also: BLINDFOLD.

HOOK
See:

FAVOR
Peacham, p. 206.

HOOP
See:

COOPER
Ayres, no. 31.

HOP AND WATER
Thynne, no. 30.
Motto: "Unitinge of Contraries make sound Judgement."
Icon: None.
Epigram: When bitter hops are mixed with fair water, a sweet liquor is produced; so the joining of contraries produces a mean which allows for sound judgment.

HOPE
See:

CUPID AND HOPE
Van Veen, p. 59.

HOPE AND NEMESIS
Whitney, p. 139.
Motto: "Illicitum non sperandum."
Icon: Nemesis with a bridle faces Hope with a bow.
Epigram: Do not hope for that which justice denies.

HORN
See:

DRAGON WITH TEN HORNS
Willet, no. 22.

HORNED LAMB
See:

SEVEN-HEADED BEAST
Van der Noodt, no. 17.

HORSE
P. S., p. 345.
Motto: "Solus promeritus."
Icon: A horse runs ahead of other horses.
Epigram: The wise captain is like the lone horse which runs before all the rest.

Whitney, p. 6.
Motto: "Temeritas."
Icon: Two horses, harnessed to a wagon, are out of control and throw the wagon and its driver off balance.
Epigram: These horses are like man's passions; the wagoner, like the man who does not tame or control his passions with reason.

Whitney, p. 227.
Motto: "Sic aetas fugit."
Icon: A riderless horse is pursued by two horses with riders and whips.
Epigram: The riderless horse represents time; the two pursuing horses represent night and day, which follow us until we yield to them at death.

See also:

BLINDFOLD AND HORSE
P. S., p. 176.
BUCEPHALUS
Combe, no. 101.
DRUM AND HORSE
Bunyan, no. 51.
FLY AND HORSE
Montenay, p. 126.
TROJAN HORSE
Astry, no. 27.
See also: COLT.

HORSE AND MILL
Bunyan, no. 28.
Motto: "Upon the Horse in the Mill."
Icon: None.
Epigram: The horse which, hoodwinked, works the

mill, is like the sinner who, blinded, goes Satan's round.

HORSE AND RIDER
Bunyan, no. 41.
> Motto: "Upon the Horse and his Rider."
> Icon: None.
> Epigram: The horse represents man; the rider who controls the horse, the spirit; by the nature of the horse's going, the rider can be known.

Peacham, p. 17.
> Motto: "Par Achillis, Puer une vinces."
> Icon: A knight in armor on a horse.
> Epigram: Dedicated to Prince Henry, son of James I, this device symbolizes the courage and skill of the soldier-knight-leader.

Whitney, p. 38.
> Motto: "Non locus virum, sed vir locum ornat."
> Icon: A rider on a rearing horse.
> Epigram: Just as a good rider can control the spirited horse but a fool cannot, so men of judgment, learning, and conscience are fit men to be judges, but fools, who would fail, are not.

Willet, no. 85.
> Motto: "Peccatorum gradus."
> Icon: None.
> Epigram: The rider who cannot control his horse is compared with a sinner.

HORSE AND TAPER
Quarles, *Hier.*, no. 10.
> Motto: "Proles tua, Maja, Juventus."
> Icon: A taper is in a globelike urn with the roman numeral *20* in the top of six segments and a peacock; below, a boy falls from a horse.
> Epigram: In the second decade of life a man gains use of reason, grows proud, disdains counsel, and enjoys life.

HORSE AND WHEEL
Willet, no. 23.
> Motto: "Nihil fortuito."
> Icon: None.
> Epigram: As the wheel is controlled by the horse, so man is ruled by God's will.

HORSE AND WHIP
Jenner, no. 16.
> Motto: "The impediments of Christian conversation."
> Icon: A man rides a horse and holds a whip in each hand.
> Epigram: Like the man who hires a horse and whips it until it is unable to carry him, some sad Christians fix their eyes only on the

rigor of the law and on their faults, ignore what is uplifting, and hinder their own salvation.

Horseman
See: RIDER.

HORSEMAN, SEVEN-HEADED BEAST, SWORD
Van der Noodt, no. 19.
> Motto: None.
> Icon: A man with a sword coming from his mouth, a crown, and a bloody robe rides a white horse and drives the seven-headed beast into a pit of fire. An army led by an angel accompanies him.
> Epigram: In this scene from the Apostle John's apocalyptic vision, the forces of God defeat evil.

HOUND
See:
ACTEON
Whitney, p. 15.
CAT, FOX, HOUND
Peacham, p. 138.
See also: DOG.

HOURGLASS
Bunyan, no. 53.
> Motto: "Upon an Hour-Glass."
> Icon: None.
> Epigram: Like the hourglass which will mark an hour, no more nor less, man's life is measured out.

Hall, p. 104.
> Motto: "I said in the cutting off of my daies, I shall goe to the gates of the grave."
> Icon: A human figure sits with his hand to his head, beside a table with an open book, a candle, a winged hourglass, a skull, and a clock.
> Epigram: A man's life is transient, measured like the sand of an hourglass.

Wither, p. 212.
> Motto: "Pursue thy Workes, without delay, For, thy short houres runne fast away."
> Icon: A burning heart on top of an hourglass.
> Epigram: The hourglass reminds man that his life is short; its glass signifies the body's frailty; its four pillars, the four cardinal virtues; its sand, the quickly passing lifetime.

Wither, p. 257.
> Motto: "Make use of Time, that's comming on; For, that is perish'd, which is gone."
> Icon: An hourglass.
> Epigram: Consider how swiftly time passes and make use of it.

See also:
BOOK, CANDLE, HOURGLASS

Whitney, p. 172.
CANDLE, HOURGLASS, SKULL
Wither, p. 184.
CHILD AT WATCH
Wither, p. 94.
DEATH AND TIME
Quarles, *Hier.*, no. 6.
FLAME AND TIME
Farlie, no. 57.
FORTUNE, TIME, WORLD
Quarles, *Emb.*, p. 36.
GLASS, HOURGLASS, SCEPTER, SERPENT
Astry, no. 28.
SKULL AND WHEAT
Wither, p. 21.
SORROW AND TIME
Arwaker, bk. 1, no. 15.
Quarles, *Emb.*, p. 180.
TIME AND WISDOM
Godyere, no. 28.

HOURGLASS AND SKULL
Wither, p. 152.
R. B., no. 24.
 Motto: "Whereer'e we dwell, the Heav'ns are
 neere;
 Let us but fly, and wee are there."
 Icon: A winged figure stands with one foot on
 an hourglass and the other on a skull and
 holds a cross.
 Epigram: From life to death there is but one step;
 after death our souls, if faithful, fly to
 heaven.
Wither, p. 235.
 Motto: "Live, ever mindfull of thy dying;
 For, Time is always from thee flying."
 Icon: A skull above a winged hourglass.
 Epigram: The winged hourglass signifies the swift-
 ness of time; the skull, the effect of time.

HOURGLASS AND WING
Wither, p. 49.
 Motto: "What cannot be by Force attain'd,
 By Leisure, and Degrees, is gain'd."
 Icon: A winged hourglass.
 Epigram: Some things cannot be achieved with force
 or rashness but can be with leisure and
 advice.

HOUSE
Hawkins, no. 15, p. 163.
 Motto: "Sedes sapientiae."
 Icon: A house.
 Epigram: The womb of the Virgin Mary housed
 Christ, who is wisdom.
Whitney, p. 69.
 Motto: "Interiora vide."

 Icon: A man with a raised sword peers through a
 window into the interior of a house.
 Epigram: Do not trust external appearances, how-
 ever appealing; seek instead to discover the
 inner mind.
Willet, no. 87.
 Motto: "Corpus non animae domicilium sed di-
 versum est."
 Icon: None.
 Epigram: A house is compared with the body, where
 man dwells on earth.

See also:
 ANGEL AND HOUSE
 Hawkins, no. 15, p. 172.
 BODY AND HOUSE
 Bunyan, no. 12.

Houseleek
See: SEMPERVIVUM.

HUNGER
Hall, p. 16.
 Motto: "I was hungry within, because I wanted
 thee my inward meat O my God."
 Icon: A hungry man kneels before Divine Love,
 who takes his hand; in the background are
 a shepherd with flocks and a heavenly city,
 and in the foreground, a bow.
 Epigram: Man's hunger can be satisfied not by nature
 but by the spiritual food of God.

HUNT
Ayres, no. 26.
 Motto: "Platonique Love."
 Icon: Cupid hunts and shoots a stag.
 Epigram: The speaker chides fools who woo women
 without intending to succeed.
Ayres, no. 30.
 Motto: "The Hunter caught by his own Game."
 Icon: Cupids hunt and corner an animal.
 Epigram: The hunt of love can be reversed, and the
 hunter become the prey.
Ayres, no. 43.
 Motto: "All grasp, all Lose."
 Icon: Cupid and hounds pursue two different
 animals.
 Epigram: In the hunt of love man should pursue one
 woman at a time.
Van Veen, p. 241.
 Motto: "Onlie for the chase."
 Icon: Cupid hunts deer.
 Epigram: Love sometimes delights more in the chase
 than in the deer.

See also:
 CUPID AND HUNT
 Van Veen, p. 131.
 CYNTHIA

Wither, p. 24.
R. B., no. 47.
ERMINE
Peacham, p. 75.
STAG
Whitney, p. 153.

HUNTER
See:
BEAVER
Whitney, p. 35.

HUSBANDMAN
Wither, p. 106.
R. B., no. 32.
 Motto: "The Husbandman, doth sow the Seeds;
 And, then, on Hope, till Harvest, feeds."
 Icon: A husbandman plows a field and holds an
 anchor.
 Epigram: The husbandman labors hard and then
 feeds on hope until harvest.
See also:
GRAPEVINE
Peacham, p. 157.

Husk
See: CHAFF.

HYDRA
See:

CUPID AND HERCULES
Van Veen, p. 33.
HERCULES AND HYDRA
Combe, no. 99.

HYOSCYAMUS
Peacham, p. 51.
 Motto: "Sic opibus mentes."
 Icon: Birds eat the seed of a hyoscyamus bush
 and fall down.
 Epigram: Just as the hyoscyamus attracts birds which
 eat from it and are intoxicated, so riches
 allure men and then destroy them.

Hyperion
See: APOLLO, PHOEBUS.

HYPOCRITE
Peacham, p. 198.
 Motto: "Personam non animum."
 Icon: A man in a religious robe holds a staff and
 a rosary.
 Epigram: The hypocrite feigns zeal and piety and
 hides his sinfulness.

HYSSOP BRANCH
See:
BOOK
Peacham, p. 40.

I

ICARUS
Whitney, p. 28.
 Motto: "In Astrologos."
 Icon: Icarus falls headfirst into the sea.
 Epigram: As Icarus flew into the heavens, and then
 fell into the sea, so mortal men who am-
 bitiously search the heavens to explain their
 mysteries should beware of falling.
See also:
DEDALUS AND ICARUS
Van Veen, p. 43.

ICE
Hall, p. 60.
 Motto: "Love doth repress the motions and with-
 hold the slipperiness of youth."
 Icon: A human figure stands on ice and holds
 onto Divine Love; behind them figures
 skate and fall on the ice.
 Epigram: Love of God represses lust and guides man
 in the slipperiness of youth.
See also:
BAR AND ICE
Jenner, no. 5.
FOX
Whitney, p. 22.
Peacham, p. 62.
HEART OF ICE AND SUN
Harvey, no. 16.

IDLENESS
See:
DILIGENCE AND IDLENESS
Combe, no. 100.
See also: SLOTHFULNESS.

IDLENESS AND LABOR
Whitney, p. 175.
 Motto: "Otiosi semper egentes."
 Icon: Labor, holding a cornucopia, sits in a
 chariot drawn by ants and whips Idleness
 who weeps.
 Epigram: The fable of the ant and the grasshopper
 teaches us to work while we are young so
 that we can provide for ourselves in old
 age.

IDOL AND PURSE
Montenay, p. 314.
 Motto: "Idolorum servitus."
 Icon: A human figure holds a purse and kneels
 before an idol.
 Epigram: The man who worships idols and Mam-
 mon forsakes God and shall not enter the
 kingdom of heaven.

IGNORING
See:
ENTREATING AND IGNORING
Van Veen, p. 163.

Illness
See: SICKNESS.

IMAGE IN EYE
Bunyan, no. 68.
Motto: "Upon the Image in the Eye."
Icon: None.
Epigram: If a man looks steadfastly at another, he will have that person's image in his eye; likewise, if a man believes in Christ, he will retain his image in his heart.

INCONSTANCY
Peacham, p. 147.
Motto: "Inconstantia."
Icon: A woman stands on a crab, holds a crescent moon, and is dressed in green.
Epigram: Inconstancy, like the crab, goes backward and forward, is, like the moon, ever changing, and like the green ocean, continually moves.

INDIAN DIADEM
Peacham, p. 199.
Motto: "Honores isti aliunde."
Icon: An Indian headdress of feathers is shown.
Epigram: The Indian headdress made from a bird's feathers represents the sum of the honors we imagine for ourselves—trivial, patched together, and not rightfully ours.

Indolence
See: IDLENESS.

INFANT
See:
HAY
Wither, p. 256.
R. B., no. 49.
See also: BABE, BABY, CHILD.

INFANT AND HANDMAID
Quarles, *Emb.*, p. 216.
Motto: "O that thou wert as my Brother, that Sucked the Brests of my Mother."
Icon: A handmaid holds a baby in the image of Divine Love and stands beside a walker and a cradle.
Epigram: The handmaid represents man; the baby, Christ, who shall redeem man.

INFANT AND SISTER
Arwaker, bk. 2, no. 9.
Motto: "O that thou wert as my brother, that sucked the breasts of my mother; when I

should find thee without, I would kiss thee, yet I should not be despised."
Icon: A mother holds an infant Divine Love in her arms and stands beside a cradle and a walker.
Epigram: A man wishes God were an infant so that he could kiss and tend him.

INN
See:
CUPID AND INN
Van Veen, p. 197.

INNOCENCE AND LEARNING
Hall, p. 28.
Motto: "The unlearned rise and take heaven by violence; and we with our learning without affection, behold! where we wallow in flesh and bloud!"
Icon: Figures of learning, with a laurel wreath, a book, and an armillary sphere, stand on the ground while small figures of innocence dance to heaven.
Epigram: All of man's learning does not gain him heaven; the greatest wisdom is innocence.

Insect
See: ANT, BEE, BEETLE, BUTTERFLY, FLY, GNAT, GRASSHOPPER, LOCUST, LOUSE, MOTH, PISMIRE, SCARABEE, SCORPION, SILKWORM, SPIDER, WASP, WORM.

IRON HAND AND WREATH
P. S., p. 278.
Motto: "Etiam fortunam."
Icon: An iron hand holds a lance ringed with four wreaths.
Epigram: Sergius, who lost his right hand, had an iron hand made and went on to win victories; he represents valor overcoming fortune.

Iris
See: RAINBOW.

ISIS
See:
ASS
Whitney, p. 8.

ISTHMUS
Astry, no. 95.
Motto: "Nevtri adhaerendum."
Icon: An isthmus and the sea.
Epigram: As the isthmus maintains itself between two contrary seas, so a country between two great powers can maintain neutrality.

IVY
Whitney, p. 222.
Motto: "Neglecta virescunt."

Icon: Ivy grows on a wall, while a man looks away from it.

Epigram: Just as the ivy grows and spreads even when it is ignored, so the virtuous man rises in spite of the world's neglect.

See also:
CUPID AND OCCASION
Van Veen, p. 175.
See also: VINE.

IVY AND OAK
Combe, no. 82.

Motto: "Ungratefull men breed great offence, As persons void of wit or sence."

Icon: Ivy entwines an oak.

Epigram: As the ivy kills the oak which supports it, so some men are ungrateful to those who support them.

IVY AND PYRAMID
Wither, p. 226.

Motto: "Though weaknesse unto mee belong, In my Supporter, I am strong."

Icon: Ivy entwines a pyramid.

Epigram: Man is like the ivy which creeps on earth unless God's grace, like the pyramid, uplifts and supports him.

IVY AND SPEAR
P. S., p. 270.

Motto: "Là, le danger."

Icon: Ivy entwines a spear.

Epigram: Policy should direct war, for force is subject to art.

IVY AND SPIRE
Whitney, p. 1.

Motto: "Te stante, virebo."

Icon: Ivy entwines a spire.

Epigram: Like ivy, the Church thrives as long as the monarch stands.

IVY AND TREE
P. S., p. 265.

Motto: "Improbitas subigit rectum."

Icon: Ivy entwines a tree.

Epigram: As the ivy chokes a tree, stunting its growth, so an eloquent lawyer may abuse the law.

IVY, MOON, PILLAR
P. S., p. 87.

Motto: "Te stante, virebo."

Icon: Ivy entwines a pillar, on top of which is the moon.

Epigram: The pillar signifies Christ, who triumphs in heaven for us; the ivy, the bishop who lives the godly life; the moon, men's praise of Christ's virtue.

IXION
Wither, p. 69.

Motto: "By Guiltines, Death entred in, And, Mischiefe still pursueth Sinne."

Icon: Ixion is bound to a wheel.

Epigram: Ixion represents the guilty man who suffers eternal torture for his sin.

J

JACOB
Willet, no. 15.

Motto: "Certanti & resistenti victoria cedit."

Icon: None.

Epigram: The story of Jacob and the angel teaches us how God overpowers men.

See also:
ESAU AND JACOB
Willet, no. 44.

JACOB'S LADDER
Willet, no. 14.

Motto: "Divina providentia."

Icon: None.

Epigram: Jacob's dream of the ladder shows us that God will guide us.

Jail
See: PRISON.

JANUS
Combe, no. 1.

Motto: "According to the time forepast, Be wisely warned at the last."

Icon: Janus with his double face holds a key and the sun.

Epigram: Like Janus, the wise should think on both the past and the future.

Whitney, p. 108.

Motto: "Respice, & prospice."

Icon: Janus, double-faced, looks backward and forward, holding a mirror in his left hand and a scepter in his right hand.

Epigram: Whitney chooses this image to mark the half-way point in his book; he emphasizes Janus's double perspective, which looks into the past and the future.

Wither, p. 138.

Motto: "He, that concealed things will finde, Must looke before him, and behinde."

Icon: The double-faced head of Janus is on a door.

Epigram: The head of Janus signifies God, who sees all things that were, are, and shall be; it also represents the wise man who looks both before him and behind him.

See also:
TAPER
Quarles, *Hier.*, no. 2.

JAWBONE OF ASS AND WATER
P. S., p. 234.
 Motto: "Fons invocantis."
 Icon: Water streams from the jawbone of an ass.
 Epigram: When Samson called on God for help, water flowed from the jawbone of an ass; thus may miracles result when God's word is invoked.

JEHOVAH
See:
HEART AND JEHOVAH
Montenay, p. 286.

JERUSALEM
See:
CITY OF GOD
Van der Noodt, no. 20.
FLAME
Arwaker, bk. 3, no. 1.

JESUS
See:
ARROW AND HEART
H. A., p. 214.
BLOOD, FOUNTAIN, HEART
H. A., p. 83.
BROOM AND HEART
H. A., p. 71.
CROSS AND HEART
H. A., p. 148.
DOOR, HEART, KNOCKING
H. A., p. 45.
HARP AND HEART
H. A., p. 185.
HEART AND MONARCH
H. A., p. 108.
HEART AND MONSTER
H. A., p. 58.
HEART AND NET
H. A., p. 30.
HEART AND PAINTING
H. A., p. 164.
HEART AND ROSE
H. A., p. 159.
HEART AND SCHOLAR
H. A., p. 122.
HEART AND SINGING
H. A., p. 171.
HEART, LAMB, NUPTIAL SUPPER
H. A., p. 254.
HEART, LAUREL, PALM
H. A., p. 235.
HEART, SLEEP, WIND
H. A., p. 199.

JEWEL
Willet, no. 99.
 Motto: "Donorum fallacia."
 Icon: None.
 Epigram: Gifts are like the precious stone which continues to shine even though it is often turned.
See also:
COCK AND JEWEL
Thynne, no. 19.
HEART
Arwaker, bk. 2, no. 6.
REWARD
Peacham, p. 121.
See also: DIAMOND, PEARL.

JEZABEL
Willet, no. 58.
 Motto: "Sanguinis pretium sanguis."
 Icon: None.
 Epigram: Jezabel's death at the place where Naboth died shows that God takes vengeance on the guilty.

JOAB
Willet, no. 57.
 Motto: "Religio hypocritarum velum."
 Icon: None.
 Epigram: Joab fled to the altar and was killed before it; he represents the hypocrite who futilely hides his sin.

JOHN (APOSTLE)
See:
CITY OF GOD
Van der Noodt, no. 20.

JONAH
Willet, no. 53.
 Motto: "Jonae naufraugium."
 Icon: None.
 Epigram: When Jonah tried to flee God, God sent a storm during which Jonah was tossed into the sea and swallowed by a whale; this story teaches that men cannot escape God's wrath and that God sends succor to men in trouble.

JOVE
Thynne, no. 34.
 Motto: "Sylver worlde."
 Icon: None.
 Epigram: Jove, with a crown, a mace, and an eagle, reigned over the silver age after deposing his father, Saturn, who ruled over the golden age.
See also:
APOLLO, JOVE, MINERVA
Godyere, no. 26.

BIRTH OF PALLAS
Peacham, p. 188.
Thynne, no. 38.

CUPID AND OATH
Van Veen, p. 141.

CUPID, JOVE, LADY
Van Veen, p. 181.

FORTUNE
Wither, p. 6.
R. B., no. 17.

LAUREL TREE AND LIGHTNING
Whitney, p. 67.

OATH MAKING
Ayres, no. 38.

PROMETHEUS
Peacham, p. 189.

TERMINUS
Peacham, p. 193.
See also: JUPITER.

JUDGE AND JUSTICE
Arwaker, bk. 1, no. 10.
> Motto: "Enter not into Judgment with thy servant, O Lord."
> Icon: Justice—blindfolded, holding a balance and a sword—stands before Divine Love with a human figure in a court.
> Epigram: When the speaker considers divine justice, he thinks of his many sins and is afraid.

Quarles, *Emb.*, p. 160.
> Motto: "Enter not into judgment with thy servant for no man living shall be justified in thy sight."
> Icon: Justice—blindfolded, holding a balance and a sword—stands before Divine Love with a human figure in court.
> Epigram: Christ intercedes on man's behalf, redeeming man with his own life.

JUDGMENT OF PARIS
Whitney, p. 83.
> Motto: "Judicium Paridis."
> Icon: Paris gives a golden apple to Venus as Pallas and Juno watch; Mercury and Cupid stand in the background.
> Epigram: Paris is an example of the worldly man who judges by surfaces and shadows; the wise person will reject this judgment and choose Pallas.

See also:
 PARIS
 Thynne, no. 29.

Jug
See: EWER, PITCHER.

JUNO

See:
 JUDGMENT OF PARIS
 Whitney, p. 83.
 PARIS
 Thynne, no. 29.

JUPITER
Combe, no. 57.
> Motto: "He that is prowd'st of good hap, Sorrow fals soonest in his lap."
> Icon: Jupiter, with a crown, a mace, and an eagle.
> Epigram: Jupiter, Homer writes, mingled the good and the bad; this illustrates that pleasure is mixed with pain, gladness with sorrow.

See also: JOVE.

JUSTICE
See:
 JUDGE AND JUSTICE
 Arwaker, bk. 1, no. 10.
 Quarles, *Emb.*, p. 160.

K

KEDAR
See:
 PILGRIM AND TENT OF KEDAR
 Arwaker, bk. 3, no. 7.
 Quarles, *Emb.*, p. 268.

KEEPER
See:
 BIRD AND KEEPER
 Combe, no. 90.

Kettle
See: POT.

KEY
Peacham, p. 9.
> Motto: "Psalmi Davidici."
> Icon: Keys on a key ring.
> Epigram: The Psalms are like keys, each opening a door to the heavenly throne, and bringing sinful men to God.

P. S., p. 9.
> Motto: "Hic ratio tentandi aditus."
> Icon: A key.
> Epigram: The key represents the power and authority of Christ in his Church.

See also:
 BALL, KEY, TURF, SHILLING
 P. S., p. 307.
 CAGE
 Quarles, *Emb.*, p. 280.

JANUS
Combe, no. 1.
STUDY
Godyere, no. 7.
WIFE
Combe, no. 18.
Whitney, p. 93.

KEY AND SERPENT
P. S., p. 94.
 Motto: "Scilicet is superis labor est."
 Icon: A serpent entwines a key.
 Epigram: When a serpent wrapped itself around a
 key, the common people foolishly believed
 it a sign, but the soothsayer laughed at their
 superstition, saying that if the key had
 wrapped around the serpent that would be
 a wonder.

KEY AND WING
Peacham, p. 38.
 Motto: "Tandem divulganda."
 Icon: A winged key.
 Epigram: Great secrets, though well secured, come
 to light and fly quickly.

KICKING
See:
 SPUR
 Montenay, p. 98.

KING
Wither, p. 31.
R. B., no. 35.
 Motto: "Hee, over all the Starres doth raigne,
 That unto Wisdome can attaine."
 Icon: A king stands on a sphere of the heavens,
 holds a scepter and a book, and wears an
 eye on his chest.
 Epigram: The man who can attain wisdom reigns
 over all the stars.
See also:
 BEAST AND TRUMPET
 Montenay, p. 110.
 BOOK AND SWORD
 Wither, p. 32.
 CAPTIVE AND KING
 Bunyan, no. 50.
 CHILD AND FOOL
 Whitney, p. 81.
 CODRUS, DIOGENES, KING
 Whitney, p. 198.
 DEATH AND KING
 Montenay, p. 106.
 FOX, KING, LION
 Combe, no. 22.
 LAWBOOK AND SWORD

Wither, p. 163.
R. B., no. 31.
 SHIP
 Wither, p. 37.
 R. B., no. 45.
 SPONGE
 Whitney, p. 151.
 WOMAN
 Wither, p. 7.
 R. B., no. 6.
See also: MONARCH, PRINCE.

KING AND SPONGE
Combe, no. 40.
 Motto: "Let honest truth be shield & gaurd,
 For hanging is the theeves reward."
 Icon: A king squeezes a sponge; in the back-
 ground men hang.
 Epigram: The king may tolerate corrupt officials
 for a time, but when he sees they "waxe
 full," he strips them of their authority and
 squeezes them like a sponge.
Whitney, p. 151.
 Motto: "Quod non capit Christus, rapit fiscus."
 Icon: A king holding a scepter squeezes a
 sponge.
 Epigram: Greedy men who fawn on the king are like
 sponges: dry at first, they soak up the
 king's favor, but are then squeezed dry.

KING WITH SIX ARMS
Wither, p. 179.
R. B., no. 15.
 Motto: "Where many-Forces joyned are,
 Unconquerable-pow'r, is there."
 Icon: A king with six arms, each holding a
 weapon, instrument, or scepter.
 Epigram: The man who has many faculties attains
 great strength.

KISS
See:
 DARKNESS
 Van Veen, p. 113.

KITE
Whitney, p. 170.
 Motto: "Ferè simile praecedenti, ex Alciato."
 Icon: A kite vomits its food while another bird
 watches.
 Epigram: When a greedy kite complained that the
 prey he had devoured sickened him, he
 was given no sympathy since "goodes ill
 got, awaie as ill will goe."
See also:
 HEN AND KITE
 Montenay, p. 366.

KNEELING

See:

CONQUEROR AND KNEELING FOE
Arwaker, bk. 1, no. 6.
Quarles, *Emb.*, p. 144.
HEART
Arwaker, bk. 2, no. 6.
HEART AND SATAN
Montenay, p. 146.
LIGHTNING
Arwaker, bk. 2, no. 4.
LOADSTONE
Whitney, p. 43.
RAINBOW
Hawkins, no. 9, p. 100.
See also: PRAYING.

KNIFE

See:

ANVIL AND KNIFE
P. S., p. 68.
CANDLE AND KNIFE
Farlie, no. 29.
CIRCUMCISION AND HEART
Harvey, no. 13.
GLOBE, KNIFE, THREAD
Wither, p. 213.
OCCASION
Combe, no. 63.
TONGUE
Peacham, p. 156.
See also: RAZOR.

KNIFE AND LION

Combe, no. 3.

Motto: "Who doth presume above his state,
 Doth still incurre the greater hate."
Icon: A man with a knife shaves a lion.
Epigram: As the man who shaves the lion is in a dan-
 gerous position, so the man who meddles
 with his superiors.

KNIFE AND ROCK

P. S., p. 231.

Motto: "Superstitio religioni proxima."
Icon: A knife cuts a rock.
Epigram: Satan bewitches men with superstition,
 as when he persuaded the Romans that a
 soothsayer divided a rock with a small
 knife.

KNIGHT

See:

HORSE AND RIDER
Peacham, p. 17.
TYPHAEUS'S SISTER
Van der Noodt, no. 16.

KNOCKING

See:

DOOR, HEART, KNOCKING
H. A., p. 45.

KNOT

See:

CHAIN OF COCKLES
P. S., p. 25.
GORDIAN KNOT AND SWORD
P. S., p. 272.
TYING HEART
Harvey, no. 39.

L

LABOR

See:

IDLENESS AND LABOR
Whitney, p. 175.

LABYRINTH

Combe, no. 35.

Motto: "The way to pleasure is so plaine,
 To tread the paths few can refraine."
Icon: Man stands in the middle of a labyrinth.
Epigram: Pleasure is like the labyrinth, easy to enter
 into but hard to return from.

P. S., p. 118.

Motto: "Fata viam invenient."
Icon: A labyrinth.
Epigram: The labyrinth signifies that man is led by
 the grace of God to find the path to eternal
 life.

LABYRINTH AND PILGRIM

Arwaker, bk. 2, no. 2.

Motto: "O that my ways were made so direct, that
 I might keep thy Statutes!"
Icon: A human figure with a pilgrim's staff and
 hat stands in the middle of a labyrinth and
 holds a thread stretching to a tower outside
 the labyrinth where Divine Love sits and
 guides him.
Epigram: Man is a pilgrim who strays in "a maze of
 error" unless God guides him.

Quarles, *Emb.*, 188.

Motto: "Oh that my wayes were Directed to keepe
 thy Statutes."
Icon: A human figure with a pilgrim's staff and
 hat stands in the middle of a labyrinth and
 holds a thread stretching to a tower outside
 the labyrinth where Divine Love sits and
 guides him.
Epigram: Man is a pilgrim; the world, a confus-

ing labyrinth; and God, the thread which guides man through the world.

LADDER
See:

HAND, GULF, LADDER
Montenay, p. 82.
HEART AND LADDER
Harvey, no. 37.
JACOB'S LADDER
Willet, no. 14.

LADY
See:

CLOUD, LADY, SERPENT
Van der Noodt, no. 6.
CUPID, HARE, LADY
Van Veen, p. 41.
CUPID, JOVE, LADY
Van Veen, p. 181.
See also: DAUGHTER, MATRON, MOTHER, OLD WOMAN, WIFE, WOMAN.

LAIS
Whitney, p. 79.

Motto: "Saepius in auro bibitur venenum."
Icon: A woman is shown dressed in furs and finery.
Epigram: Lais's beauty made all men desire her, but not everyone could have her; so men should learn to be content with their lot.

See also:

TOMB OF LAIS
Thynne, no. 54.

LAMB
Peacham, p. 130.

Motto: "Ad Jesum Christum opt: Max: Thou art that sheepe."
Icon: A sacrificial lamb lies on an altar with a knife at its throat.
Epigram: The sacrificial lamb represents Christ in his innocence and humility.

Wither, p. 252.
R. B., no. 21.

Motto: "Who, Patience tempts, beyond her strength,
 Will make it Fury, at the length."
Icon: A lamb butts a child.
Epigram: Even the patient lamb, when tempted and provoked, will grow enraged.

See also:

HEART, LAMB, NUPTIAL SUPPER
H. A., p. 254.
See also: HORNED LAMB, SHEEP.

LAMB AND LION
Montenay, p. 142.

Motto: "Deus superbis resistit humilabus dat gratiam."
Icon: A lamb walks in front of two lions which are bridled and restrained by a hand in the clouds.
Epigram: God keeps the wicked bridled and does not permit them to kill and spoil the innocent.

LAMB, LION, WOLF
Montenay, p. 222.

Motto: "Foedere perfecto."
Icon: A lamb, a lion, and a wolf eat from one fodder.
Epigram: Like the lamb, lion, and wolf which eat from one fodder, the Jew and the infidel will someday embrace Christ's Gospel.

LAME
See:

BLIND AND LAME
Van Veen, p. 15.
Whitney, p. 65.
See also: CRIPPLE.

LAMP
Farlie, no. 47.

Motto: "Exiguo melius."
Icon: A lamp burns.
Epigram: The light of a lamp is best maintained with a little oil; so, too, moderation is best for mind and body.

Farlie, no. 55.

Motto: "Virginum Lampas."
Icon: A lamp burns.
Epigram: The parable of the wise and foolish virgins teaches that he who has faith shall be prepared for the coming of the Lord.

See also:

CANDLESTICK, LAMP, OIL, OLIVE TREE, PIPE
Willet, no. 8.
COLOSSUS OF RHODES
Peacham, p. 161.
DARKNESS AND LAMP
Quarles, *Emb.*, p. 128.
HAND, LAMP, OWL
Montenay, p. 114.

LAMP, MOUNTAIN, PRELATE
Combe, no. 86.

Motto: "The Prelates life should shine as cleare,
 As lampe on mountaine doth appeare."
Icon: A prelate puts a lamp on top of a mountain.
Epigram: A prelate should be like a lamp at the top of a mountain, his virtues and good deeds shining for all to see.

LANCE
See:

GAUNTLET AND LANCE
Peacham, p. 33.
PHOENIX
Hawkins, no. 2, p. 66.
PURSE
Peacham, p. 53.
SCHOLAR AND SOLDIER
Godyere, no. 30.

LANCE AND VINE
Astry, no. 74.
 Motto: "In fulcrum pacis."
 Icon: A vine entwines a lance.
 Epigram: A good prince prefers peace to war.

LANDSCAPE
Peacham, p. 185.
 Motto: "Rura mihi et silentium."
 Icon: A pastoral landscape.
 Epigram: The speaker celebrates the country and
 pastoral values.
See also: COUNTRY.

LANTERN
Arwaker, bk. 1, no. 1.
 Motto: "With my soul have I desired thee in the
 night."
 Icon: A human figure meets Divine Love, who
 holds a lantern in the night.
 Epigram: The speaker is in darkness and desires the
 light of God.
Bunyan, no. 49.
 Motto: "Upon a Lanthorn."
 Icon: None.
 Epigram: The lantern which contains a lighted can-
 dle, protecting it from the wind, is like
 the man who has a work of grace within
 his heart.
Farlie, no. 5.
 Motto: "Diogenis Lucerna."
 Icon: Diogenes stands outside his barrel holding
 a lantern as the sun shines.
 Epigram: Diogenes went at noontime with his lan-
 tern, searching for an upright person who
 was not a hypocrite, masking by day the
 sin he showed at night.
Farlie, no. 49.
 Motto: "Luceo and Lateo."
 Icon: A lantern.
 Epigram: As the lantern protects the light, so virtue
 protects honor.
Quarles, *Hier.*, no. 8.
 Motto: "Nec Virtus obscurapetit."
 Icon: A closed lantern sits on a coffin; a snail and
 a turtle crawl beside it; a new moon shines.
 Epigram: Man should not hide the light of the soul
 which is the gift of God.

See also:
 BOREAS AND LANTERN
 Farlie, no. 53.
 Farlie, no. 57.
 HEART AND MONSTER
 H. A., p. 58.

LANTERN AND SHIP
Farlie, no. 40.
 Motto: "Dux Laterna Viae."
 Icon: A lantern guides ships at sea.
 Epigram: As the lantern guides ships through the
 darkness, so Christ guides men.
Farlie, no. 44.
 Motto: "Nauplii faces."
 Icon: Lanterns hang on rocky cliffs as ships sail
 toward them.
 Epigram: The lanterns which Naplius hung on rocky
 cliffs deceived and destroyed the Greeks;
 so, too, honor and glory seduce us, caus-
 ing our destruction.

LANTERN AND WIND
Farlie, no. 51.
 Motto: "Sic pio perii officio."
 Icon: A hand holds a match to the light of the
 lantern as the wind blows.
 Epigram: In lending its light, the lantern is extin-
 guished by the wind; so, charitable people
 sometimes hurt themselves.

LARK
See:
 FOWLER AND LARK
 Bunyan, no. 23.
 TURTLEDOVE
 Peacham, p. 110.

LARK AND MERLIN
Peacham, p. 176.
 Motto: "Gratis servire libertas."
 Icon: A merlin holds a lark in a tree.
 Epigram: The merlin, which carefully holds and
 keeps a different lark each night, repre-
 sents thankfulness.

LAST JUDGMENT
See:
 GLASS
 Arwaker, vol. 1, no. 14.
 Quarles, *Emb.*, p. 176.

LAST THINGS
See:
 HEART AND PAINTING
 H. A., p. 134.

LAUGHING
Quarles, *Emb.*, p. 32.

Motto: "Et risu necat."

Icon: An earthly Cupid laughs; behind him is a globe on which three figures play.

Epigram: The fool laughs in momentary mirth, but his pleasure is vain and leads to death.

See also;

DEMOCRITUS AND HERACLITUS
Whitney, p. 14.

LAUREATE HEAD AND PILLAR
Wither, p. 2.

Motto: "The Man that hath true Wisdome got, Continues firme, and wavers not."

Icon: A statue of a man's head crowned with laurel sits on a pillar.

Epigram: Like this statue, wisdom is constant, fixed, and, as the laurel indicates, achieves victory.

LAUREL
Peacham, p. 200.

Motto: "Non alit, enecat."

Icon: A laurel tree grows beside water, which erodes the soil.

Epigram: The laurel tree represents "Learning and the Arts," which are presently abused.

See also:

BALL, LAUREL, SNAKE, SWORD
Wither, p. 109.

BEARDED MAN AND POT
Van der Noodt, no. 12.

EMBRACE
Whitney, p. 216.

GRAPEVINE AND LAUREL
Peacham, p. 39.

HEART, LAUREL, PALM
H. A., p. 235.

INNOCENCE AND LEARNING
Hall, p. 28.

LAUREATE HEAD AND PILLAR
Wither, p. 2.

LAUREL BOUGH
See:

CROSS, LAUREL BOUGH, ROSE
P. S., p. 259.

FIRE AND LAUREL BOUGH
P. S., p. 52.

LAUREL CROWN
See:

AESCULAPIUS
Whitney, p. 212.

See also: CROWN, GARLAND, WREATH.

LAUREL GARLAND
See:

GARLAND
Peacham, p. 23.

LAUREL TREE AND LIGHTNING
Whitney, p. 67.

Motto: "Murus aeneus, sana conscientia."

Icon: A man stands beside a laurel tree while Jove threatens with lightning.

Epigram: Just as the laurel tree stands fresh, green, and sound during a storm, so the man with a clear conscience is fearless.

Van der Noodt, no. 3.

Motto: None.

Icon: A laurel tree is struck by lightning.

Epigram: Like the young laurel tree rent by lightning, youth and beauty are struck down.

LAUREL TREE AND SERPENT
Wither, p. 142.

Motto: "By Wisedome, things which passe away, Are best preserved from decay."

Icon: Two serpents intertwine a laurel tree.

Epigram: Wisdom, represented by the serpents, is the surest way to achieve lasting fame, represented by the laurel.

LAW
See:

BALANCE, HEART, LAW
Harvey, no. 20.

CUPID AND LAW
Arwaker, bk. 2, no. 1.
Quarles, *Emb.*, p. 184.

DIVINE LAW AND WORLD
Whitney, p. 223.

HEART
Arwaker, bk. 2, no. 6.

HEART AND LAW
Harvey, no. 26.

LAW AND SWORD
Wither, p. 3.

Motto: "The Law is given to direct; The Sword, to punish and protect."

Icon: A hand holds a sword before the tables of Mosaic law.

Epigram: The law directs, and the sword executes, protects, and punishes.

LAWBOOK AND SWORD
Wither, p. 163.
R. B., no. 31.

Motto: "When Law, and Armes, together meet, The World descends, to kisse their feet."

Icon: A king stands on a globe holding a lawbook and a sword.

Epigram: A king who understands both the law and military arms will command the world.

LAWYER AND MONEY
Combe, no. 66.

Motto: "Annoint the Lawyer in his fist,
And he shall pleede ev'n what you list."
Icon: A man gives a lawyer money.
Epigram: Lawyers are easily bribed and will argue
anything for money.

LEAF
See:
SPEAR
Astry, no. 87.

LEAF, TREE, WIND
Hall, p. 64.
Motto: "The Heart of man not fixt in desires of
Eternitie can neither be firm nor stable."
Icon: A wind blows a tree; Cupid gathers fallen
leaves while Divine Love reaches up to a
branch; above are an eye and branches.
Epigram: Without God man is unstable, empty, and
centerless.

LEANDER AND LIGHT
Farlie, no. 38.
Motto: "Herus Lucerna."
Icon: Leander swims toward a light.
Epigram: As Hero's light guides Leander in the
darkness, so God directs us toward heav-
enly joy.

LEARNING
Peacham, p. 26.
Motto: "Doctrina."
Icon: An old woman sits with her arms out-
stretched as dew falls from the heavens
onto her; an open book lies in her lap,
and she holds in her right hand a scepter
topped by a sun.
Epigram: The woman represents learning; the dew,
sacred graces from heaven; the out-
stretched arms and open book, her readi-
ness to embrace all men; the scepter, her
power; the sun, her ability to expel igno-
rance; her age, the years it takes to attain
knowledge.
See also:
INNOCENCE AND LEARNING
Hall, p. 28.

LEOPARD
Peacham, p. 97.
Motto: "Honos venalis."
Icon: A leopard stands on the world on which a
wreath and a crown lie.
Epigram: Promotion is no longer based on merit.
Instead "th' *Athenian* Cat" rules, without
whose favor one cannot hope to rise.
See also:
BEAST
Willet, no. 30.

LEOPARD AND LION
Whitney, p. 178.
Motto: "Caelum, non animum."
Icon: A lion and a leopard fight.
Epigram: The natural enmity between certain beasts
is not altered by long separation, for it is
impossible to alter nature.

LETTER
See:
CHAIN OF GOLD
P. S., p. 43.
CUPID AND LETTER
Van Veen, p. 133.

LEVEL
See:
HEART AND LEVEL
Harvey, no. 23.

LEVITES
Willet, no. 60.
Motto: "Non vi sed virtute, non armis sed arte
paritur victoria."
Icon: None.
Epigram: When the Levites make wars, they carry
the holy Ark with them; their triumph
teaches that the prince should make war
with a godly mind.

LEVITY
Peacham, p. 149.
Motto: "Levitas."
Icon: A colorfully dressed youth holds a spur
and puts a bellows to his ear.
Epigram: The figure personifies levity ("Capriccio"),
whose mind is filled with fancies.

Lice
See: LOUSE.

LIGHT
Montenay, p. 234.
Motto: "Vigilate."
Icon: A human figure holds two burning candles
in each hand.
Epigram: God's word is the light that shines in this
world; men should be careful not to ex-
tinguish it.
See also:
ADAM
Whitney, p. 229.
CAGE AND HEART
Hall, p. 44.
CHILD AT WATCH
Wither, p. 94.
HEART, LIGHT, SUNDIAL
Harvey, no. 25.
LEANDER AND LIGHT
Farlie, no. 38.

LIGHT AND THIEF
Jenner, no. 17.
 Motto: "The cause of ignorance in lay Papists."
 Icon: A thief appears in a dark room with one light.
 Epigram: As the thief hates light and tries to extinguish it to work his mischief, so the papist tries to obscure the light of God's word lest it reveal his villainy.

Lighting
See: CANDELABRA, CANDLE, CANDLESTICK, FIREBRAND, FLAME, LAMP, LANTERN, LIGHT, MATCH, TAPER, TORCH.

LIGHTNING
See:
 EAGLE
 P. S., p. 250.
 LAUREL TREE AND LIGHTNING
 Van der Noodt, no. 3.
 Whitney, p. 67.
See also: THUNDERBOLT.

LIGHTNING AND ROD
Arwaker, bk. 2, no. 4.
 Motto: "My flesh trembleth for fear of thee, and I am afraid of thy Judgments."
 Icon: Divine Love wears a frightening mask, holds a rod, and throws a lightning bolt at a kneeling figure.
 Epigram: Fear of divine vengeance leads to eternal security.
Quarles, *Emb.*, p. 196.
 Motto: "My flesh trembleth for feare of thee: & I am afraide of thy judgments."
 Icon: Divine Love wears a frightening mask, holds a rod, and throws a lightning bolt at a kneeling human figure.
 Epigram: Fear of divine vengeance leads to eternal security.

LIGHTNING AND WING
P. S., p. 166.
 Motto: "Sic terras turbine perflat."
 Icon: Lightning strikes a winged object.
 Epigram: As lightning strikes high objects, not low things, so God troubles the proud and arrogant, not the humble.

LILY
Hawkins, no. 3, p. 28.
 Motto: "Niveo candore nitescens."
 Icon: A lily is encircled by a serpent biting its tail.
 Epigram: The white lily is a symbol of chastity and of the Virgin Mary.
Hawkins, no. 3, p. 35.
 Motto: "Ego dilecto meo qui pascitur inter lilia."

 Icon: A hand holds a lily on which the sun shines.
 Epigram: The Virgin is compared to the lily: her steadfast, lowly heart is like the flower's root; her intention, the stem; her soul, the flower; her love, the "yellow knobbes" which sprout; her virtues, perfumes offered to God.
Peacham, p. 80.
 Motto: "Vita tota dies unus."
 Icon: A lily has three flowers, one budding, one in full bloom, and one withered.
 Epigram: Man's life resembles this lily, which lives but a day.
Peacham, p. 116.
 Motto: "Salomone pulchrius."
 Icon: A hand holds a lily.
 Epigram: The speaker cautions the court ladies to think on the lily, clothed by God, and forsake their costly dress.
See also:
 BEAUTY
 Peacham, p. 58.
 BRIAR AND LILY
 Whitney, p. 221.
 CROWN, LILY, SWORD
 P. S., p. 277.
 CUPID AND LILY
 Van Veen, p. 123.
 HERALDIC SHIELD
 Peacham, pp. 15, 102.

LILY AND MARIGOLD
P. S., p. 331.
 Motto: "Mirandum natura opus."
 Icon: Two marigolds grow from the sides of a lily.
 Epigram: This device represents the two Margarets, of Navarre and of France.

LILY AND WHEAT
Astry, no. 6.
 Motto: "Politioribus ornantur littera."
 Icon: Stalks of wheat lie within a circle of lilies.
 Epigram: The wheat represents science; the lilies, "polite learning."

LILY AND WREATH
Arwaker, bk. 3, no. 3.
 Motto: "My Beloved is mine, and I am his; he feedeth among the Lillies."
 Icon: Divine Love and a human figure sit beside lilies; they hold hands and exchange wreaths of flowers.
 Epigram: The lilies are emblems of "pure desires" which characterize man's love for God.
Quarles, *Emb.*, 252.
 Motto: "My Beloved is mine and I am his. Hee feedeth among the Lillies."

Icon: Divine Love and a human figure sit be-
 side lilies; they hold hands and exchange
 wreaths of flowers.
Epigram: God crowns the soul with grace, and man
 crowns God with praise.

Limestone
See: CHALKSTONE.

LINE
Wither, p. 158.
 Motto: "Each Day a Line, small tasks appeares:
 Yet, much it makes in threescore Yeares."
 Icon: A hand holding a pen draws a line.
 Epigram: Authors who compose but one line a day
 will have written, in a lifetime, major
 works; thus small things in time become
 great matters.

LION
Astry, no. 45.
 Motto: "Non majestate securus."
 Icon: A lion sleeps with its eyes open.
 Epigram: The prince should be like the lion, ever
 vigilant.
Combe, no. 75.
 Motto: "Reason bids us have a care,
 That others harmes make us beware."
 Icon: A lion flees from a corpse of another lion
 hung on a gallows.
 Epigram: Although lions are terrified when they see
 their fellow lion hanged, thieves are less
 fearful when they see their fellow thief
 punished.
Godyere, no. 2.
 Motto: "Nullum bonum inremuneratum."
 Icon: A lion sits on a three-headed mountain and
 holds a balance, a sword, and a cornucopia
 while a hand holds a caduceus above him.
 Epigram: Great Britain's monarchy: the three-headed
 mountain represents the three countries of
 Great Britain; the sword, power; the bal-
 ance, justice; the cornucopia, abundance;
 the caduceus, wisdom.
Peacham, p. 88.
 Motto: "Paulatim."
 Icon: A hand pats a lion.
 Epigram: Gentleness, not violence, makes the lion
 obey; so, too, with strong natures.
Peacham, p. 107.
 Motto: "Non Honos, sed Onus."
 Icon: A crowned lion holding a scepter and a
 sword sits on a crown.
 Epigram: The ruler is not happy but rather is bur-
 dened with cares.
Peacham, p. 123.
 Motto: "Tu contra audentior."

Icon: A lion attacks a sword and a burning torch
 which threaten it.
Epigram: The lion represents the valiant heart which
 courageously fights fortune.

See also:
AGAMEMNON
Whitney, p. 45.
ALTAR AND LION
Peacham, p. 20.
ANGEL
Willet, no. 5.
ASS, FOX, LION
Whitney, p. 154.
BEAR AND LION
Willet, no. 17.
BEAST
Willet, no. 30.
BEE AND LION
Astry, no. 99.
BIRD AND LION
Peacham, p. 91.
BOOK, LION, SWORD
Godyere, no. 25.
BRIDLE AND LION
Peacham, p. 32.
BUCK AND LION
Combe, no. 39.
CHAIN AND LION
Peacham, p. 82.
CHOLER
Peacham, p. 128.
COCK AND LION
Whitney, p. 120.
CROWN AND LION
Peacham, p. 11.
P. S., p. 337.
CUPID
Whitney, p. 63.
DOG AND LION
Whitney, p. 44.
Willet, no. 69.
FEAR
Whitney, p. 52.
FOX AND LION
Whitney, pp. 156, 161, 210.
FOX, KING, LION
Combe, no. 22.
FRUIT TREE, SWORD, TAPER
Quarles, *Hier.*, no. 13.
GLASS AND LION
Astry, no. 33.
GOAT, GREYHOUND, LION
Willet, no. 96.
GRAPEVINE
Peacham, p. 157.

HARE AND LION
Whitney, p. 127.

HEAD OF STATE
Peacham, p. 22.

KNIFE AND LION
Combe, no. 3.

LAMB AND LION
Montenay, p. 142.

LAMB, LION, WOLF
Montenay, p. 222.

LEOPARD AND LION
Whitney, p. 178.

LYSIMACHUS
Peacham, p. 143.

TONGUE OF LION
P. S., p. 189.

VULTURE
Whitney, p. 119.

LION AND MASK
Combe, no. 60.
 Motto: "A man of courage and of spright,
 No foolish threatning can affright."
 Icon: A man holds up a mask to a lion.
 Epigram: The man who tries to frighten a lion with
 a mask is foolish; so, too, the men who try
 to frighten brave men with vain boasts.

LION AND SWORD
P. S., p. 105.
 Motto: "Celsa potestatis species."
 Icon: A lion carries a sword.
 Epigram: The lion with the sword signifies the bold
 enterprise.

LION AND THREAD
Combe, no. 58.
 Motto: "Vaine hope doth oft a man allure,
 A needlesse bondage to endure."
 Icon: A man leads a lion by a thread.
 Epigram: The men who submit to bondage are like
 the lion who permits a simple man to hold
 him with a thread.

LION AND WOLF
Godyere, no. 10.
 Motto: "Non manca al fin se ben tarda a venire."
 Icon: A lion attacks a wolf as a hand from heaven
 holds wreaths on a cord.
 Epigram: The lion which attacked the greedy wolf to
 protect lesser beasts is like the English
 monarch who attacked insatiate Rome.

LIONESS
See:

TOMB OF LAIS
Thynne, no. 54.

LION HOLDING SWORD
Whitney, p. 116.
 Motto: "Cr. Pompeius Magnus: Celsa potestatis
 species."
 Icon: A lion holds a sword.
 Epigram: This image expresses the force and noble
 mind of Pompey.

LION SKIN
Astry, no. 97.
 Motto: "Fortior spoliis."
 Icon: A lion skin and the club of Hercules.
 Epigram: As Hercules wore the skin of the lion he
 had conquered to increase his power, so
 princes ought to use their victories to aug-
 ment their power.
Astry, no. 43.
 Motto: "Ut sciat regnare."
 Icon: A lion's skin.
 Epigram: The lion skin is an emblem of valor and
 therefore is appropriate for the prince.
See also:

BACCHUS AND LION SKIN
Combe, no. 48.

HERCULES
Peacham, p. 36.
Whitney, pp. 16, 40.

LISIMACHUS
See:

TONGUE OF LION
P. S., p. 189.
See also: LYSIMACHUS.

LIZARD
Astry, no. 48.
 Motto: "Sub luce lues."
 Icon: A lizard is shown with stars on its back
 and a poisoned breast.
 Epigram: The flatterer is like this lizard, which seems
 to shine with zeal but conceals its poison.

LOAF
See:

PENNY LOAF
Bunyan, no. 44.

LOCK
Peacham, p. 180.
 Motto: "Sorte, aut Labore."
 Icon: A combination lock with letters.
 Epigram: The best way to find the words "to live" is
 through labor; i.e., the best way to make a
 living is by working.

LOCUST
Willet, no. 83.
 Motto: "Haeresium contagium."

Icon: None.
Epigram: Locusts which spoil corn are compared to heretics.
See also: GRASSHOPPER.

LODESTAR
Peacham, p. 145.
 Motto: "Ex utroque Immortalitas."
 Icon: A star shines in the heavens above two crossed branches.
 Epigram: Dedicated to King James, this emblem likens the monarch to the "Loade-starre."
See also: NORTH STAR, POLESTAR.

LODESTONE
Whitney, p. 43.
 Motto: "Mens immota manet."
 Icon: A man kneels and prays to heaven as a lodestone points to a star.
 Epigram: As the lodestone always points to the North Star, so should man always be drawn to God.
See also:
 HELIOTROPE AND LODESTONE
 Arwaker, bk. 3, no. 3.
 POLESTAR
 Ayres, no. 37.
See also: ADAMANT, MAGNET.

LODESTONE AND SWORD
Astry, no. 88.
 Motto: "Volentes trahimur."
 Icon: A lodestone attracts and holds a sword.
 Epigram: Divine will is like the lodestone; it exerts irresistible power over princes, who, like iron, obey it.

LOG
Jenner, no. 29.
 Motto: "The Ruine of spirituall comfort."
 Icon: A man carries a log.
 Epigram: Like the man who, seeking fuel, finds a log but does not take the trouble to carry it home, so the man who hears God's word but does not keep it in mind finds no profit.
See also: TIMBER, WOOD.

LOOKING GLASS
See:
 CUPID AND LOOKING GLASS
 Van Veen, p. 183.
See also: GLASS, MIRROR.

LORD, MONSTER, AND SNAKE
Hall, p. 1.
 Motto: "What am I without thee but one running headlong?"
 Icon: A snake hides beneath flowers, and mon-

sters threaten a small winged figure who is protected by a larger figure of the Lord stretching his hand toward the sun.
 Epigram: God protects man from danger and from his own sinfulness.

LORD'S PRAYER
Bunyan, no. 4.
 Motto: "Upon the Lord's Prayer."
 Icon: None.
 Epigram: [The Lord's Prayer is printed in full.]

LOUSE
Combe, no. 94.
 Motto: "No kind of friend will longer stay, When riches once are gone away."
 Icon: Lice desert a corpse.
 Epigram: As lice desert their host when he dies, so flatterers desert the man who has fallen from fortune or lost wealth.

LOVER
See:
 CUPID AND LOVER
 Van Veen, p. 29.
 MONEY
 Wither, p. 83.
 R. B., no. 36.

LUNA
Godyere, no. 32.
 Motto: "Sic ubique."
 Icon: A female figure of Luna holds a bow and arrow and wears a half-moon on her head.
 Epigram: As Luna shines all night and hunts all day, so should magistrates be watchful in the night and pursue criminals in the day.

LURE
Whitney, p. 191.
 Motto: "Spes vana."
 Icon: A lure for hawks.
 Epigram: Just as the hawk sees the lure and strikes, so men are baited by friendly looks and speeches.
See also:
 SNARE
 P. S., p. 195.

LUTE
Arwaker, bk. 2, no. 15.
 Motto: "How shall we sing the Lord's Song in a strange land."
 Icon: A human figure pushes away a lute while Divine Love holds an open songbook.
 Epigram: Although the speaker objects that he is too grief-stricken to sing, God urges him to relieve his grief through music.

Godyere, no. 18.
 Motto: "Musica dii placantur musica manes."
 Icon: A woman playing a lute is surrounded by a ring of ears.
 Epigram: The power and harmony of music are praised.
Godyere, no. 20.
 Motto: "Sott humano sembiante empio veneno."
 Icon: A man, partly immersed in water, plays a lute as a sheep listens.
 Epigram: This emblem illustrates the deceptive words used by the sycophant, the sinner, the whore, the man who takes bribes, and the politician.
Jenner, no. 27.
 Motto: "The New Creation."
 Icon: A man tunes a lute.
 Epigram: Man is like a musical instrument: he needs to be tuned by God's ministers and transformed by God's word.
Quarles, *Emb.*, p. 240.
 Motto: "How shall we sing the song of the Lord in a strange land?"
 Icon: A human figure pushes away a lute while three men hold an open songbook.
 Epigram: The speaker complains that the times are inappropriate for song and music and calls instead for tears and groans.
See also:
 ASS AND CUPID
 Combe, no. 62.
 CUPID AND LUTE
 Wither, p. 82.
 SANGUINE
 Peacham, p. 127.

LUTE AND MERCURY
Whitney, p. 92.
 Motto: "Industria naturam corrigit."
 Icon: Mercury, in the foreground, repairs a lute; a man, in the background, plays a lute while a woman dances.
 Epigram: As Mercury repaired the broken lute that had been discarded as useless, so art may improve on nature, making the person who is ill-favored renowned.

LYRE
See:
 BAY TREE, LYRE, TAPER
 Quarles, *Hier.*, no. 12.

LYSIMACHUS
Peacham, p. 143.
 Motto: "Sic audaces fortuna."
 Icon: Lysimachus kills a lion.
 Epigram: Thrown to a lion to be killed, Lysimachus

killed the lion; Alexander then rewarded him as an example of virtue overcoming fortune.
See also: LISIMACHUS.

M

MACE
See:
 JOVE
 Thynne, no. 34.
 JUPITER
 Combe, no. 57.
See also: SCEPTER.

MACE AND SWORD
Wither, p. 137.
 Motto: "To Kings, both Sword and Mace pertaine;
 And, these they doe not beare in vaine."
 Icon: A hand holds a mace; above it a hand in a gauntlet holds a sword.
 Epigram: The mace and sword are symbols of authority.

MAGNET
See:
 HEART AND MAGNET
 Montenay, p. 50.
See also: ADAMANT, LODESTONE.

MAGNET AND NORTH STAR
Astry, no. 24.
 Motto: "Immobilis ad immobile numen."
 Icon: The needle of a magnet points to the North Star.
 Epigram: As the needle of the magnet always seeks the North Star, so should states be guided by religion.

Magnifying glass
See: GLASS.

Mail, suit of
See: ARMOR.

Male
See: BOY, FATHER, MAN, OLD MAN, YOUTH.

MAMMON
See:
 BOWLING
 Quarles, *Emb.*, p. 40.

MAN
Combe, no. 64.
 Motto: "The praise of beauty is but small,
 Where vertue is not joyned withall."

Icon: A man.

Epigram: The proportion of a man's body tells us nothing about his nature.

See also:

ANGEL
Willet, no. 5.

BOAR AND MAN
Wither, p. 110.

EARTH AND MAN
Montenay, p. 218.

NATURAL MAN
Bunyan, no. 61.

SKELETON IMPRISONS MAN
Arwaker, bk. 3, no. 8.
Quarles, *Emb.*, p. 272.

WORLD
Thynne, no. 16.

MAN AND UNIVERSE
Peacham, p. 190.

Motto: "Homo Microcosmus."

Icon: A man stands inside the sphere of the universe.

Epigram: Man is a microcosm of the universe.

MANNA
P. S., p. 65.

Motto: "Non quae super terram."

Icon: Hands reach out to manna falling from the sky.

Epigram: Manna prefigured the Sacrament of the Body and Blood and represents the food of the spirit.

Willet, no. 41.

Motto: "Post hac occasio calva."

Icon: None.

Epigram: As the sweet manna lasted only a brief time but was life-sustaining, so when salvation comes, man must "lay hold of it."

Manure
See: DUNG.

MARBLE
P. S., p. 338.

Motto: "Scribit in marmore laesus."

Icon: A man writes a motto in marble.

Epigram: The wounded man does not forget his injuries but records them in marble.

Whitney, p. 136.

Motto: "Abstinentia."

Icon: A ewer, a basin, and a towel are set on a marble tomb.

Epigram: An emblem of justice, the marble indicates that a judge should be firm and unbending from truth; the ewer, basin, and towel, that a judge should be pure and have a clear conscience.

Whitney, p. 183.

Motto: "Scribit in marmore laesus."

Icon: Man chisels words in marble.

Epigram: Man engraves his harms in marble but writes his benefits in dust; instead he should forget the wrongs done to him and remember the good.

See also:

ARROW AND MARBLE
Whitney, p. 138.

MARGARITE
See:

CROSS, CROWN, RING OF MARGARITES
P. S., p. 323.

MARIGOLD
See:

LILY AND MARIGOLD
P. S., p. 331.
See also: HELIOTROPE.

MARIGOLD AND SUN
P. S., p. 46.

Motto: "Non inferiora secutus."

Icon: A marigold bends toward the sun.

Epigram: As the marigold follows the sun, so Margaret, Queen of Navarre, wished to follow God.

Wither, p. 209.

Motto: "Whil'st I, the Sunne's bright Face may view,
 I will no meaner Light pursue."

Icon: A marigold bends toward the sun.

Epigram: As the marigold bends toward the sun, so man to God.

MARINER
See:

BEACON AND MARINER
Jenner, no. 8.

Marriage
See: MATRIMONY, NUPTIAL SUPPER.

MARS
See:

CUPID AND MARS
Van Veen, p. 209.

PEACE
Thynne, no. 32.

MARS AND MERCURY
Godyere, no. 14 (misnumbered 13).

Motto: "In utraque perfectus."

Icon: A male figure appears, half Mars in armor, half Mercury with a caduceus, a winged helmet, and a sandal.

Epigram: This emblem stresses the importance of uniting victory and arts.

See also: SCHOLAR AND SOLDIER.

MARS AND PALLAS
Wither, p. 80.
- Motto: "When Mars, and Pallas, doe agree,
 Great workes, by them, effected bee."
- Icon: Mars and Pallas.
- Epigram: Great works are accomplished by joining the powers of Mars and Pallas: strength and wisdom, body and mind, martial discipline and the arts.

MARTYR
Ayres, no. 22.
- Motto: "Tis honourable to be loves Martyr."
- Icon: Cupid is burned at the stake.
- Epigram: Love is a noble martyrdom.
Whitney, p. 224.
- Motto: "Sic probantur."
- Icon: Three Christians, standing in prayer, are threatened by fire, dogs, and men with swords while a hand from a cloud holds a circular crown above them.
- Epigram: Faithful Christians are able to endure persecution in hopes of gaining "a glorious crowne."
Willet, no. 59.
- Motto: "Patientia sanctorum."
- Icon: None.
- Epigram: The martyrs, enduring cruel torture and maintaining their belief in God, teach us faith.

MASK
Combe, no. 6.
- Motto: "Most men do use some colour'd shift
 For to conceal their craftie drift."
- Icon: Four masks.
- Epigram: Men in these times hide their true nature and are double-faced.
Peacham, p. 205.
- Motto: "Per far denari."
- Icon: Masks of people and animals.
- Epigram: The worldly man cultivates different shapes and masks to deceive others.
Wither, p. 229.
R. B., no. 27.
- Motto: "Deformitie, within may bee,
 Where outward Beauties we doe see."
- Icon: A woman holds a mask over her face.
- Epigram: Outward beauty may cover inner deformity.
See also:
ARROW
Arwaker, bk. 1, frontispiece.
CUPID, MASK, RING
Van Veen, p. 54.
LIGHTNING AND ROD
Arwaker, bk. 2, no. 4.

Quarles, *Emb.*, p. 196.
LION AND MASK
Combe, no. 60.
VICE AND VIRTUE
Wither, p. 22.
R. B., no. 2.
See also: DISGUISE.

MASS
Jenner, no. 11.
- Motto: "The sacrifice of the Masse."
- Icon: A priest performs a mass in a church.
- Epigram: The papist mass is an unnecessary ceremony because Christ, when he offered himself, made the supreme sacrifice that ended all sacrifices.

MATCH
Van Veen, p. 233.
- Motto: "Even to the end."
- Icon: Cupid holds a burning match.
- Epigram: Like the match which when kindled burns to the end, true love endures.
See also:
CANDLE AND MATCH
Farlie, no. 43.

MATRIMONY
Peacham, p. 132.
- Motto: "Matrimonium."
- Icon: A man stands in stocks, wears a yoke, and holds a quince.
- Epigram: Matrimony is personified: the stocks represent the loss of liberty; the yoke, servility; the quince, fertility.
See also: NUPTIAL SUPPER.

MATRON
See:
CANDLE AND MATRON
Farlie, no. 16.
See also: LADY, MOTHER, OLD WOMAN, WIFE.

MATTOCK
See:
DEATH'S-HEAD, MATTOCK, SCEPTER
P. S., p. 373 (misnumbered 273).

MATTOCK AND PURSE
Peacham, p. 179.
- Motto: "Negatur utrumque."
- Icon: A purse hangs over a mattock.
- Epigram: The speaker worries about his financial future, knowing that he can neither do physical labor nor beg.

MAVIS
See:
TURTLEDOVE
Peacham, p. 110.

Maze
See: LABYRINTH.

MEAL AND WATER
P. S., p. 174.
 Motto: "Satis."
 Icon: A hand throws meal into water.
 Epigram: Heraclitus cast meal into water to teach
 man to be content with the gifts of nature.

MEASURE
See:
 BRIDLE, CUPID, MEASURE
 Van Veen, p. 31.
See also: EPHAH.

MEASURE AND RING
Bunyan, no. 72.
 Motto: "Upon Time and Eternity."
 Icon: None.
 Epigram: Time is like a measure, finite; eternity is
 like a ring, with no beginning, middle, or
 end.

MEAT
See also:
 FLY AND MEAT
 Bunyan, no. 60.

MEDEA
Whitney, p. 33.
 Motto: "Ei, qui semel sua prodegerit aliena credi
 non oportere."
 Icon: A swallow builds its nest on a statue of
 Medea slaying her child with a sword.
 Epigram: Unlike this sparrow, man should not trust
 people who hate their own kin.

Medicine
See PHYSIC.

MELANCHOLY
Hall, p. 24.
 Motto: "Take up and Read; Take up and Read."
 Icon: A man sits in the position of melancholy,
 his head resting on his hand.
 Epigram: Man's unhappiness and discontent can be
 purged if man will only take up and read
 God's Book.
Peacham, p. 126.
 Motto: "Melancholia."
 Icon: A male figure sits on a bench in a woods;
 he holds an open book and a purse and
 puts his foot on a cube. A band covers his
 mouth, and a cat and an owl accompany
 him.
 Epigram: Melancholy is solitary, studious, avari-
 cious, constant, and silent.

MELCHIZEDEK
Willet, no. 63.

 Motto: "Melchisedechus rex and sacerdos Christi
 praecursor and ante ambulo."
 Icon: None.
 Epigram: Melchizedek, who brought Abraham
 bread and wine, is a type of Christ.

MELTING
Arwaker, bk. 3, no. 5.
 Motto: "My Soul melted as my Beloved spoke."
 Icon: Flames come from Divine Love's mouth
 and melt a human figure.
 Epigram: The fire of God warms man, who dis-
 solves like wax in the sun.
Quarles, *Emb.*, p. 260.
 Motto: "My Soule melted, when my beloved
 spake."
 Icon: Flames come from Divine Love's mouth
 and melt a human figure.
 Epigram: God has the power to melt the cold heart
 and inflame the soul.
See also:
 HEART OF ICE AND SUN
 Harvey, no. 16.

Merchant
See: CHAPMAN.

MERCURY
Whitney, p. 2.
 Motto: "Qua dii vocant, eundum."
 Icon: Mercury, with caduceus and a winged hel-
 met, points the way to a man at the fork of
 a road.
 Epigram: As Mercury shows the "perfect path" to
 the uncertain traveler, so God guides man,
 in "wandering state" on this earth.
See also:
 CUPID AND MERCURY
 Van Veen, p. 80.
 FORTUNE AND MERCURY
 Thynne, no. 5.
 LUTE AND MERCURY
 Whitney, p. 92.
 MARS AND MERCURY
 Godyere, no. 14 (misnumbered 13).
 OWL
 Wither, p. 9.

MERLIN
See:
 LARK AND MERLIN
 Peacham, p. 176.

MERMAID
Astry, no. 78.
 Motto: "Formosa superne."
 Icon: A mermaid plays a fiddle.
 Epigram: As the mermaid looks beautiful and sounds
 melodious but is in fact monstrous, so

many courtiers are friendly and eloquent but in reality malicious.

MICHAEL, SAINT
See:
 CHAIN OF COCKLES
 P. S., p. 25.

MIDAS
Whitney, p. 218.
 Motto: "Perversa judicia."
 Icon: Midas, with the ears of an ass, judges a musical contest between Pan and Apollo.
 Epigram: When Midas judged Pan's music superior to Apollo's, Apollo gave him the ears of an ass. This story shows that men should not judge matters they do not understand.

MIDWIFE
See:
 BIRTH OF PALLAS
 Peacham, p. 188.

Military terminology
See: ARMOR, BUCKLER, CANNON, CAPTAIN, ENSIGN, GAUNTLET, HELMET, HERALDIC SHIELD, LANCE, PIKE, POLEAX, SHIELD, SLING, SPEAR, SOLDIER, STANDARD, SWORD, WAR.

MILK
Willet, no. 98.
 Motto: "Contentionis fructus."
 Icon: None.
 Epigram: As churned milk turns into butter, so angry words stir up contentious men.
See also:
 FLY AND MILK
 Combe, no. 4.

MILL
Astry, no. 84.
 Motto: "Plura consilio quam vi."
 Icon: Water turns a millwheel which hammers iron and steel into breastplates.
 Epigram: Man is like the mill, improving nature through wit and art.
Ayres, no. 29.
 Motto: "All not worth a Reward."
 Icon: A mill in operation.
 Epigram: Courtship is likened to the labor in a mill, toiling for others.
See also:
 ANELLUS'S WIFE AND MILLER
 Whitney, p. 80.
 HORSE AND MILL
 Bunyan, no. 28.

MILLER
See:
 ANELLUS'S WIFE AND MILLER
 Whitney, p. 80.

MILLSTONE
Thynne, no. 37.
 Motto: "God slowlie punisheth."
 Icon: None.
 Epigram: The millstone is slow to move, but once the wind forces it to turn, it grinds to powder; so, too, God is slow to anger, but once our sin violates his mercy, he torments us.
See also:
 SISYPHUS
 Wither, p. 11.
 R. B., no. 5.

MILLWHEEL AND SCOURGE
Arwaker, bk. 1, no. 4.
 Motto: "Look upon my adversity and misery, and forgive me all my sin."
 Icon: Divine Love beats a human figure, who is harnessed to a millwheel, with a scourge.
 Epigram: Man's sufferings are compared to the yoke and labor of the millwheel; the world, to the mill; God's punishment, to the scourge.
Quarles, *Emb.*, p. 136 (note: the second of two pages numbered 136).
 Motto: "Looke upon my Affliction and my misery & forgive mee all my Sinne."
 Icon: Divine Love beats a human figure, who is harnessed to a millwheel, with a scourge.
 Epigram: God punishes men with the mill of labor for sinning, with the scourge for not repenting.

MINERVA
See:
 APOLLO, JOVE, MINERVA
 Godyere, no. 26.
 NET
 Combe, no. 2.
See also: PALLAS.

MIRROR
See:
 HEART
 Arwaker, bk. 2, no. 6.
 HEART AND MIRROR
 H. A., p. 288.
See also: LOOKING GLASS.

MISER
See:
 APE AND MISER
 Whitney, p. 169.
 CROWN AND MITER
 Godyere, no. 1.

Moderation
See: TEMPERANCE.

MOLE
Bunyan, no. 19.
 Motto: "Of the Mole in the Ground."
 Icon: None.
 Epigram: Like the mole which digs in the earth,
 stays underground, and prides itself in dirt
 piles, the worldly man chooses earth in-
 stead of heaven.
See also:
 APE, ASS, MOLE
 Whitney, p. 93.
 BLIND MAN AND CANDLE
 Farlie, no. 22.

MOMUS AND VENUS
Thynne, no. 2.
 Motto: "Vertue should not be condempned for one
 smale imperfection."
 Icon: None.
 Epigram: Momus foolishly finds fault with Venus,
 ignoring her beauty and grace and criticiz-
 ing the noise of her shoe.

MONARCH
See:
 HEART AND MONARCH
 H. A., p. 108.
See also: KING, PRINCE, QUEEN.

MONEY
Wither, p. 83.
R. B., no. 36.
 Motto: "Thy seeming-Lover, false will bee,
 And, love thy Money, more than Thee."
 Icon: A man sits near a woman and reaches for
 money on her lap.
 Epigram: A false lover feigns affection but desires
 money.
See also: COIN, GOLD, RICHES, SHILLING, SILVER
 GROAT.
See also:
 ALTAR, BOOK, CUP, HELMET, MONEY
 P. S., p. 371.
 APE AND USURER
 P. S., p. 367.
 LAWYER AND MONEY
 Combe, no. 66.

MONEYBAG
See:
 FAITH
 Jenner, no. 1.
See also: PURSE.

Moneylender
See: USURER.

MONKEY
P. S., p. 37.

 Motto: "Inextricabilis error."
 Icon: A female figure with a human head and
 breasts, wings, and an animal body.
 Epigram: This image of a harpy is identified as a
 monkey; it signifies that the serious affairs
 of the prince should not be committed to
 the common people.
See also: APE.

MONSTER
See also:
 ADAM SOWS EARTH
 Quarles, *Emb.*, p. 8.
 HEART AND MONSTER
 H. A., p. 58.
 LORD, MONSTER, AND SNAKE
 Hall, p. 1.

MONUMENT
P. S., p. 264.
 Motto: "Grandeur, per grand heur."
 Icon: Three triumphal monuments.
 Epigram: Pompey used a seal with three monuments
 of triumph engraved on it to signify his
 noble exploits.

MOON
Astry, no. 49.
 Motto: "Lumine solis."
 Icon: A moon shines in the night sky.
 Epigram: As the sun imparts light to the moon to
 shine at night, so the prince may choose a
 minister to serve in his absence.
Hawkins, no. 10, p. 103.
 Motto: "Benigna et Facilis."
 Icon: A half-moon with a face is encircled by a
 cloud.
 Epigram: The moon, which rules heaven with the
 sun, symbolizes the Virgin.
Wither, p. 182.
 Motto: "The Moone, which is decreasing now,
 When shee returnes, will fuller, grow."
 Icon: The moon shines above the earth.
 Epigram: As the waning moon will eventually grow
 full again, so man, diminished when he
 becomes flesh, will return to God and be-
 come full again.
See also:
 CANDLE
 Farlie, no. 7.
 CRESCENT MOON
 Wither, p. 111.
 CROWN AND MOON
 P. S., p. 21.
 DIANA
 Hawkins, no. 10, p. 111.
 DOLPHIN, GLOBE, RING
 P. S., p. 327.

ECLIPSE
Astry, no. 77.
ECLIPSE OF MOON
Astry, no. 94.
FORTUNE
Wither, p. 174.
HELIOTROPE
Hawkins, no. 5, p. 56.
INCONSTANCY
Peacham, p. 147.
IVY, MOON, PILLAR
P. S., p. 87.
LANTERN
Quarles, *Hier.*, no. 8.
LUNA
Godyere, no. 32.
PLANT AND TAPER
Quarles, *Hier.*, no. 9.
SCEPTER
Astry, no. 18.
SORROW AND TIME
Arwaker, bk. 1, no. 15.
Quarles, *Emb.*, p. 180.
WORLD IN ARMS
Quarles, *Emb.*, p. 68.

MOON AND SUN
P. S., p. 332.
 Motto: "Simul & semper."
 Icon: A moon and sun within a ring.
 Epigram: This device represents the love of the king and queen of Navarre.
Thynne, no. 61.
 Motto: "Benefitts."
 Icon: None.
 Epigram: As the moon shines the light it receives from the sun onto the earth, so man should bestow the benefit he receives from God on his needy neighbors.

Morning
See: DAWN.

MORNING STAR
See:
 CANDLE AND MORNING STAR
 Farlie, no. 17.

MORTAR
See:
 HEART, MORTAR, PESTLE
 Harvey, no. 14.

Mosaic law
See: LAW, TEN COMMANDMENTS.

MOSES
Montenay, p. 346.
 Motto: "Fulcrum optimum."

 Icon: Moses prays on a mountaintop as two hands from a cloud support him.
 Epigram: The man that prays to God will, like Moses, be supported by God.
Wither, p. 170.
R. B., no. 10.
 Motto: "Wee then have got the surest prop,
 When God, alone, becomes our Hope."
 Icon: Moses is lifted into heaven by outstretched hands.
 Epigram: God is our support and surest hope.

MOSES AND WIFE
Bunyan, no. 32.
 Motto: "Of Moses and his Wife."
 Icon: None.
 Epigram: Moses, who was fair and comely, represents the Holy Law; his wife, who was an Aethiopian, represents the person who adores life and flesh and cannot partake of the goodness of the law.

MOTH
See:
 CANDLE AND MOTH
 Van Veen, p. 103.
See also: BUTTERFLY.

MOTHER
See:
 CHILD AND MOTHER
 Montenay, p. 266.
 CHILD, MOTHER, WOLF
 Whitney, p. 162.
See also: DAUGHTER, MATRON, OLD WOMAN, WIFE.

MOTHER AND THIEF
Whitney, p. 155.
 Motto: "Indulgentia parentum, filiorum pernicies."
 Icon: A mother embraces her condemned son, who bites off her nose.
 Epigram: When the mother of a thief condemned to die kissed her son before his execution, he bit off her nose and then justified his act by accusing her of indulging him when he was a child.

MOUNTAIN
Astry, no. 40.
 Motto: "Quae tribuunt tribuit."
 Icon: A mountain.
 Epigram: The prince is like the mountain, superior to other works of nature, closer to heaven, and generous.
Hawkins, no. 20, p. 223.
 Motto: "In Vertice montium."
 Icon: A mountain.

Epigram: The Virgin is likened to a mountain, raised above all the blessed spirits of heaven.

Hawkins, no. 20, p. 231.
 Motto: "Lapis abscissus sine manibus. Super quem ceciderit conteret eum."
 Icon: A man and a serpent lie beside a mountain.
 Epigram: The Virgin Mary is likened to the mountain; from her Christ, like a stone, destroys the statue of Nebuchadnezzar and crushes the serpent.

Peacham, p. 163.
 Motto: "Non Nubila tangant."
 Icon: A mountain rises through clouds, its peak in the sunshine.
 Epigram: The mountain symbolizes the godly mind, unafraid of fortune.

Willet, no. 7.
 Motto: "Piorum conditio."
 Icon: None.
 Epigram: The righteous are compared to a mountain, stable, enduring.

See also:
 FIRE, MOUNTAIN, WIND
 Wither, p. 97.
 LAMP, MOUNTAIN, PRELATE
 Combe, no. 86.
 LION
 Godyere, no. 2.
 ROE
 Arwaker, bk. 3, no. 15.
 Quarles, *Emb.*, p. 300.

MOUNTAIN AND THUNDERBOLT
Astry, no. 50.
 Motto: "Jovi et Fulmini."
 Icon: A thunderbolt strikes a mountain.
 Epigram: The mountain rises in glory above the earth but is also vulnerable to the thunderbolt; so, too, the prince.

MOUNTAIN AND VALLEY
Peacham, p. 55.
 Motto: "Humilibus dat gratiam."
 Icon: Barren mountains rise above a fertile valley.
 Epigram: Just as the imposing mountains are often barren while the lowly valleys are fertile, so men of greatness often lack gifts of nature with which lesser men are blessed.

Mourning
See: GRIEVING, SORROW, WEEPING.

MOUSE
See also:
 CAT AND MOUSE
 Whitney, p. 222.

Wither, p. 215.
R. B., no. 28.

MOUSE AND OYSTER
Whitney, p. 128.
 Motto: "Captiuus, ob gulam."
 Icon: An oyster closes its shell on a mouse.
 Epigram: A mouse became discontented with its daily diet of crumbs and ventured to the shore, where it put its head inside an oyster and was crushed to death. This mouse is like the glutton.

MOUTH
See:
 CHRIST ON CROSS
 E. M., frontispiece.

MOVING
See:
 CHURN AND CUPID
 Van Veen, p. 119.

MUDDY WATER
See:
 FISHING FOR EEL
 Combe, no. 44.

MULCIBER
See:
 BIRTH OF PALLAS
 Peacham, p. 188.

MUSE
See:
 EUPHEMEN
 Thynne, no. 41.
 HOMER AND MUSE
 Whitney, p. 168.
 PEGASUS
 Godyere, no. 24.

MUSE AND SIREN
Thynne, no. 57.
 Motto: "Sophistrie."
 Icon: None.
 Epigram: The Muses defeat the Sirens in a singing contest and pluck the Sirens' feathers for their crowns; the Muses represent true wisdom; the Sirens, sophistry; the feathers, foolish words.

MUSE AND SPRING
Van der Noodt, no. 4.
 Motto: None.
 Icon: Muses sit beside a spring.
 Epigram: As the earth suddenly destroys a beautiful spring, so the transience of human art.

MUSHROOM BALL AND SMOKE
Wither, p. 85.

Motto: "Hee, that on Earthly-things, doth trust, Dependeth, upon Smoake, and Dust."
Icon: Smoke rises from a split mushroom ball.
Epigram: Earthly things are no more than mushroom balls, rotten on the outside, filled with smoke or dust on the inside.

MUSIC
Peacham, p. 204.
Motto: "Tanto dulcius."
Icon: Musical notation.
Epigram: This emblem discusses the power of music and the sweetness of concord.
See also:
CUPID, TOY, VENUS
Quarles, *Emb.*, p. 92.

MUSICAL INSTRUMENT
See:
BUBBLE AND TOY
Hall, p. 4.
MUSICIAN
Bunyan, nos. 40, 59.
See also: BAGPIPE, BELL, FIDDLE, HARP, LUTE, PIPE, TRUMPET.

MUSICIAN
Bunyan, no. 40.
Motto: "Upon an Instrument of Musick in an unskilful Hand."
Icon: None.
Epigram: The unskilled musician who tries to play an instrument and makes only noise is like the unlearned novice in religion who tries to enlighten but only abuses the Bible.
Bunyan, no. 59.
Motto: "Upon a Skilful Player on an Instrument."
Icon: None.
Epigram: Like the skillful musician who can captivate the mind with his music, the skillful "Gospel minister" can reach the heart of man.
See also:
WOMAN
Wither, p. 7.
R. B., no. 16.

Mussel: *See* COCKLEFISH.

MUSTARD SEED
Willet, no. 79.
Motto: "De sinapi: veritas magna est & praevalet."
Icon: None.
Epigram: As the mustard seed is very small but grows into a tree, so truth and faith often lie unseen, then flourish.

Mutability
See: INCONSTANCY.

MYRRH TREE
E. M., no. 3.
Motto: "Tam lachrymosus homo."
Icon: A myrrh tree pierced by swords sheds tears.
Epigram: The myrrh tree, which sheds tears when it is pierced, represents the man who mourns.

MYRTILUS
See:
SHIELD
Thynne, no. 21.

MYRTLE TREE AND POMEGRANATE TREE
Peacham, p. 41.
Motto: "Vicinorum amicitia."
Icon: A myrtle tree intertwines with a pomegranate tree.
Epigram: The myrtle and the pomegranate trees seek each other's friendship and thus are an example of good neighbors.

N

NAIL
See:
HAMMER, HEART, NAIL
Harvey, no. 46.

NAKED
See:
FORTUNE
Wither, p. 174.

NAKED MAN
Wither, p. 12.
R. B., no. 4.
Motto: "As, to the World I naked came, So, naked-strip I leave the same."
Icon: A naked man floats above a pile of crowns, scepters, etc.
Epigram: The speaker praises the man whose thoughts transcend earthly things.

NAKEDNESS
See:
BEAUTY
Peacham, p. 58.
CHRIST ON CROSS
E. M., frontispiece.
NOAH
Willet, no. 54.
SIN
Peacham, p. 146.
TRUTH
Peacham, p. 134.

NAKED WOMAN
Ayres, no. 20.
 Motto: "Ever present."
 Icon: A naked woman appears to a man in bed.
 Epigram: The beloved is always before the lover's eyes.
Willet, no. 50.
 Motto: Pepigi cum oculis meis.
 Icon: None.
 Epigram: The king's lust for the bathing woman is an example of the danger of sloth.

Narcissism
See: SELF-LOVE.

NARCISSUS
Whitney, p. 149.
 Motto: "Amor sui."
 Icon: Narcissus looks at his reflection in the water.
 Epigram: The danger of self-love.

NATURAL MAN
Bunyan, no. 61.
 Motto: "Of Man by Nature."
 Icon: None.
 Epigram: A man by nature is a sinner.

Nature
See: COUNTRY, LANDSCAPE, NATURAL MAN.

NEBUCHADNEZZAR
See:
 MOUNTAIN
 Hawkins, no. 20, p. 231.

NEEDLE
See:
 FINGER AND NEEDLE
 P. S., p. 125.

NEEDLE OF COMPASS
Quarles, *Emb.*, p. 258.
 Motto: "I am my beloveds, & his Desire is to-wards mee."
 Icon: A human figure holds a compass; its needle points to and shines on Divine Love.
 Epigram: Man's soul is likened to the needle of a compass, wandering at first but ultimately drawn to and fixed on God.

NEGRO
See:
 BATH
 Thynne, no. 43.
See also: AETHIOPIAN.

NEMESIS
Whitney, p. 19.
 Motto: "Nec verbo, nec facto, quenquam laeden-dum."

 Icon: Nemesis holds a bridle.
 Epigram: Nemesis, "the Goddess just," measures our ways with the rein of her bridle and controls the lewd with the bit.
See also:
 HOPE AND NEMESIS
 Whitney, p. 139.

NEPTUNE
See:
 DIANA
 Hawkins, no. 10, p. 111.

NERO
See:
 AENEAS AND NERO
 Thynne, no. 1.
 TOMB OF NERO
 Peacham, p. 144.

NET
Astry, no. 29.
 Motto: "Non semper tripodem."
 Icon: A hand holds a net.
 Epigram: A fisherman cast his nets into the sea, drew out a valuable *tripos* (table), and thus caused all the other fishermen to try in vain for the same catch; likewise, the successful prince is often imitated in vain.
Ayres, no. 3.
 Motto: "The voluntary Prisoner."
 Icon: Cupid holds the end of a net and entraps birds.
 Epigram: Love uses wiles to ensnare men.
Combe, no. 2.
 Motto: "Ven'rie and drinke do now and then Besot some of the wisest men."
 Icon: Bacchus and Venus catch Minerva in a net.
 Epigram: Wine and the love of women ensnare even the wisest of men.
Peacham, p. 71.
 Motto: "Patientia laesa furorem."
 Icon: A hand reaches into a net which has caught fish.
 Epigram: Do not underestimate your enemy just because you have caught him; the desperate foe is a dangerous foe.
Peacham, p. 197.
 Motto: "Sapientiam, Avaritia, et Dolus, decipiunt."
 Icon: Pallas is captured in a net by Avarice and double-faced Dissimulation.
 Epigram: Even the wisest are trapped by avarice and dissimulation.
P. S., p. 306.
 Motto: "Nil amplius optat."
 Icon: Nets are woven together.

Epigram: He who lives contented easily rejects desire for transitory things.
Whitney, p. 27.
 Motto: "Dolus in Suos."
 Icon: Men trap ducks in a net.
 Epigram: As a tame duck tricked the wild ducks into the men's net, so some men betray their kin and close friends through subtlety.

See also:
 BIRDER AND PIPE
 Combe, no. 54.
 CUPID, FOOL, NET
 Quarles, *Emb.*, p. 72.
 FISHERMAN AND SCORPION
 Combe, no. 23.
 FISHING
 Ayres, no. 9.
 FORTUNE
 Combe, no. 29.
 FOWLER AND LARK
 Bunyan, no. 23.
 FOWLER AND NET
 Montenay, p. 370.
 HEART AND NET
 H. A., p. 30.
 HELL AND SNARE
 Quarles, *Emb.*, p. 156.
 SNARE
 Hall, p. 68.
See also: SNARE.

NET AND PARTRIDGE
Peacham, p. 85.
 Motto: "Te Duce."
 Icon: Young partridges are caught in a fowler's net.
 Epigram: The young partridges are caught because their mother brought them into danger; similarly, many lives are lost because of the errors of kings.

NET AND WIND
Combe, no. 36.
 Motto: "Its hard to change an old abuse, Wherein the heart hath taken use."
 Icon: A man throws a net into the wind.
 Epigram: As it is impossible to catch the wind in a net, so it is impossible to change an old abuse.

NIGHT
Bunyan, no. 18.
 Motto: "Meditations upon day before Sun-rising."
 Icon: None.
 Epigram: Like the man who longs in the dark night for the sun, the partakers of grace long for their Redeemer's face.

See also:
 LANTERN
 Arwaker, bk. 1, no. 1.
 SORROW AND TIME
 Arwaker, bk. 1, no. 15.
 Quarles, *Emb.*, p. 180.
See also: DARK, DARKNESS.

NIGHT AND SUN
Astry, no. 12.
 Motto: "Excaecat candor."
 Icon: The sun shines on half the world while the other half is in the darkness of night.
 Epigram: The sun represents truth; the darkness, lies and falsehoods.

NIGHTINGALE
Combe, no. 34.
 Motto: "Some that in knowledge dive most deepe, Know least from hurt themselves to keep."
 Icon: A nightingale sings in a tree.
 Epigram: As the nightingale sometimes tries so hard to perfect her song that she dies, so some students study so hard that they kill themselves.
Hawkins, no. 13, p. 138.
 Motto: "In ore melos, corde jubilus."
 Icon: A nightingale sits on a branch.
 Epigram: Like the nightingale, the Virgin Mary is a musician, innocent and cheerful in adversity, full of divine music.
Thynne, no. 52.
 Motto: "The meane."
 Icon: None.
 Epigram: A nightingale sings so sweetly of nature's delights that she dies; likewise, excess in every earthly thing is harmful.

See also:
 GARDEN AND NIGHTINGALE
 Hawkins, no. 13, p. 148.
See also: PHILOMEL.

NIGHTINGALE IN CAGE
Whitney, p. 101.
 Motto: "Animi scrinium servitus."
 Icon: A nightingale sits in a birdcage.
 Epigram: Just as the nightingale ceases to sing when put in a cage, so man is silenced by bondage which is a "Prison of the minde."

NIOBE
Whitney, p. 13.
 Motto: "Superbiae ultio."
 Icon: Niobe grieves while all her children are killed by supernatural beings.
 Epigram: Niobe's story should serve as a warning to men not to be presumptuous or proud.

NOAH
Willet, no. 54.
 Motto: "Officium in principes."
 Icon: None.
 Epigram: When Noah lay drunken and naked, Cham [Shem] jeered, but Sem [Hem] and Japhet [Japheth] covered him; even so, children should overlook their parents' errors.

NOAH'S ARK
Willet, no. 18.
 Motto: "De Ecclesia."
 Icon: None.
 Epigram: Noah's ark represents the Church.

Noose
See: HALTER.

NORTH STAR
See:
 ADAMANT AND NORTH STAR
 Van Veen, p. 39.
 MAGNET AND NORTH STAR
 Astry, no. 24.

Nude
See: NAKED, NAKED MAN, NAKED WOMAN, NAKEDNESS.

NUMBER I
See:
 CUPID AND NUMBER I
 Van Veen, p. 3.

NUN
See:
 HEART, NUN, TONGUE
 Montenay, p. 130.

NUPTIAL SUPPER
See:
 HEART, LAMB, NUPTIAL SUPPER
 H. A., p. 254.

NUT, RAVEN, STONE
Montenay, p. 94.
 Motto: "Sic fiet filus iniquitatis."
 Icon: A raven flying in the sky drops a nut or stone.
 Epigram: Like the raven which drops a nut or stone, shattering it, God destroys the proud.

NUTTING
Whitney, p. 174.
 Motto: "In foecunditatem, sibiipsi damnosam."
 Icon: Two boys hit a tree to harvest its nuts.
 Epigram: The tree complains that it suffers because of its fruits; the tree is likened to mothers, whose children cause them suffering.

NYMPH
Van der Noodt, no. 13.
 Motto: None.
 Icon: A nymph sits beside a river.
 Epigram: The nymph bewailing her captivity by a monster represents the Church, tyrannized by the pope.

See also:
 FAUN, NYMPH, SPRING
 Van der Noodt, no. 15.

O

OAK
Ayres, no. 21.
 Motto: "Tis constancy that gains the pryze."
 Icon: The wind blows an oak tree as Cupid pushes it.
 Epigram: The lover is like the storm-beaten oak, tough and enduring.
Whitney, p. 220.
 Motto: "Vincit qui patitur."
 Icon: An oak tree breaks in the wind.
 Epigram: The oak does not bend in the raging wind and, as a consequence, breaks; when envy, hate, and slander rage against you, you must—unlike this tree—patiently suffer the attack.

See also:
 AX AND OAK
 Ayres, no. 35.
 BEECH, CORN, OAK
 Thynne, no. 56.
 CEDAR AND OAK
 Willet, no. 80.
 CHOPPING OAK
 Wither, p. 29.
 R. B., no. 40.
 CROWN OF OAK
 P. S., p. 313.
 HATCHET AND OAK
 Montenay, p. 274.
 IVY AND OAK
 Combe, no. 82.

OAK AND SUNSET
Whitney, p. 230.
 Motto: "Tempus omnia terminat."
 Icon: The sun sets behind a fallen oak.
 Epigram: As even the longest day comes to an end and the greatest oak dies, so all must end: and, so, this book ends.

OAK AND WIND
Montenay, p. 262.
 Motto: "Deposuit potent et exaltavit."
 Icon: A wind breaks an oak tree while a smaller tree bends.

Epigram: The wind breaks the rigid oak tree while a lighter tree survives; so, too, God will destroy the stubborn man and raise the humble one.

Van Veen, p. 117.
 Motto: "Strengthened by travaile."
 Icon: Winds blow an oak on which Cupid leans.
 Epigram: As the oak fastens its root more firmly the more it is blown by gales, so love grows firmer in adversity.

OAK GARLAND
See:
 GARLAND
 Peacham, p. 23.

O AND WORLD
P. S., p. 347.
 Motto: "Aut Caesar aut nihil."
 Icon: A man holds a paper with the letter *O* on it and a world.
 Epigram: Caesar Borgia adopted this device to signify that he would conquer either the world or nothing.

OAR
Astry, no. 46.
 Motto: "Fallimur opinione."
 Icon: An oar lies in the water.
 Epigram: As the oar under water appears crooked, so opinion often deceives us.

P. S., p. 116.
 Motto: "Pour un aultre non."
 Icon: A burning oar.
 Epigram: The burning oar represents fervant and dutiful zeal toward one's country.

See also:
 SHIP
 Wither, p. 13.

OAR AND SAIL
Combe, no. 43.
 Motto: "When one meane failes, then by and by, Another meane we ought to try."
 Icon: Winds blow the sail of a galley one way, while oars pull the galley in the other direction.
 Epigram: Even though the wind is against a boat, oars may bring it to shore; this illustrates that when one means fails another should be tried.

OATH
See:
 CUPID AND OATH
 Van Veen, p. 141.

OATH MAKING
Ayres, no. 38.
 Motto: "No perjury in Love."

Icon: Cupid makes an oath as Jove watches.
 Epigram: Heaven considers the oaths of lovers no more than ordinary speech.

Willet, no. 29.
 Motto: "Qui lingua jurat, mentem non injuratam gerit."
 Icon: None.
 Epigram: Old customs of making oaths are described to emphasize that God punishes the oath breaker.

OCCASION
Combe, no. 63.
 Motto: "It is a point of no small cunning, To catch Occasion at her coming."
 Icon: Occasion with a forelock and a bald head holds a knife and wears wings on her feet.
 Epigram: Occasion holds a knife to illustrate that she cuts off long delay; her forelock shows that she must be seized before she flees; her baldness, that she cannot be caught once past; her wings, that she cannot be stayed.

Whitney, p. 181.
 Motto: "In occasionem."
 Icon: Occasion—with a forelock, a bald head, and winged feet—holds a razor in one hand and stands on a wheel in the sea.
 Epigram: Occasion is tossed to and fro, is capable of dividing armies, is quick, and must be seized when she makes her appearance for she will slip by.

Wither, p. 4.
R. B., no. 41.
 Motto: "Occasions-past are sought in vaine; But, oft, they wheele-about againe."
 Icon: Occasion with a forelock and a bald head holds a razor and stands on a wheel.
 Epigram: The occasion must be seized before it slips by.

See also:
 CUPID AND OCCASION
 Van Veen, p. 175.

Ocean
See: SEA.

OCNUS
See:
 ASS AND OCNUS
 Whitney, p. 48.

Octopus
See: POLIPUS.

OIL
Willet, no. 62.
 Motto: "Habenti dabitur."
 Icon: None.
 Epigram: While the oil is poured in, the vessels fill

up to the brim, but when the pouring ceases, the oil runs thin; so too with our gifts, which increase when used but slaken otherwise.

See also:

 CANDLESTICK, LAMP, OIL, OLIVE TREE, PIPE
 Willet, no. 8.
 FLASK AND SWORD
 Peacham, p. 83.

OIL AND YOKE
P. S., p. 139.
 Motto: "Putrescet Ingum."
 Icon: A yoke drips with oil.
 Epigram: Christ, the true oil, will release man from bondage.

OINTMENT
See also:
 DEW AND OINTMENT
 Willet, no. 63.
 DRAWING AND RUNNING
 Arwaker, bk. 2, no. 8.
 Quarles, *Emb.*, p. 212.

OLD MAN
See:
 FRUIT TREE
 Whitney, p. 173.
See also: AGED MAN, FATHER, MAN.

OLD WOMAN
See:
 LEARNING
 Peacham, p. 26.
See also: MATRON, MOTHER, WIFE, WOMAN.

OLIVE
See:
 BEARDED MAN AND POT
 Van der Noodt, no. 12.
 BEE AND OLIVE
 Thynne, no. 63.

OLIVE BRANCH
See:
 BAY WREATH, OLIVE BRANCH, SWORD
 Wither, p. 24.
 BROTHER
 Montenay, p. 310.
 CLUB AND OLIVE BRANCH
 P. S., p. 150.
 DOLPHIN, GLOBE, RING
 P. S., p. 327.
 HAND AND OLIVE BRANCH
 Montenay, p. 158.

OLIVE BRANCH AND SERPENT
P. S., p. 291.
 Motto: "Rerum Sapientia custos."
 Icon: Two serpents intertwine an olive branch.
 Epigram: The olive branch intertwined with serpents signifies that true government is upheld best by wisdom and policy.

OLIVE BRANCH AND SHIELD
Astry, no. 98.
 Motto: "Sub clypeo."
 Icon: An arm, protected by a shield, holds an olive branch.
 Epigram: The best way to make peace is through arms.

OLIVE BRANCH AND SWORD
Wither, p. 238.
 Motto: "The Sword hath place, till War doth cease; And, usefull is, in time of Peace."
 Icon: A sword is flanked by olive branches.
 Epigram: The authority of the sword is necessary, but its end should be peace.

OLIVE GARLAND
See:
 GARLAND
 Peacham, p. 23.

OLIVE TREE
Hawkins, no. 12, p. 126.
 Motto: "Speciosa et fructifera."
 Icon: An olive tree.
 Epigram: Only the Virgin Mary is both fair and fruitful.
Hawkins, no. 12, p. 135.
 Motto: "Ab infantia mea crevit mecum miseratio, et de utero matris meae e gressa est mecum."
 Icon: An olive tree bears fruit.
 Epigram: As the olive tree is slow to grow but produces fruit which yields the precious oil, so the Virgin Mary gives birth to the long-awaited Christ, from whom came the oil of mercy.
Peacham, p. 13.
 Motto: "In Anna regnantium arbor."
 Icon: An olive tree with branches forming wreaths, each inscribed with a letter (*E*, *H*, and *C*).
 Epigram: The tree represents Queen Ann; the three wreaths, her children.
See also:
 ARROW, HAIR, OLIVE TREE
 Willet, no. 4.
 CANDLESTICK, LAMP, OIL, OLIVE TREE, PIPE
 Willet, no. 8.
 FRUIT AND OLIVE TREE
 Wither, p. 147.
 R. B., no. 18.
 GRAFTED TREE
 Montenay, p. 396.

OLIVE TREE, RING, TURTLEDOVE
Peacham, p. 92.
- Motto: "Amor conjugalis aeternus."
- Icon: A turtledove and a ring are on the branch of an olive tree.
- Epigram: Dedicated to a married couple, this device expresses their matrimonial love: the dove represents the husband; the ring, the wife; the olive tree, the eternal love; the branches, their children.

ONE
Ayres, no. 34.
- Motto: "True Love knowe but one."
- Icon: Cupid trods on a tablet with many numbers and holds up a tablet with the number 1 inscribed on it.
- Epigram: True love concentrates all desire and pleasure in one person.

See also:
CUPID AND NUMBER I
Van Veen, p. 3.

OPIMUS
Whitney, p. 209.
- Motto: "Ex morbo medicina."
- Icon: Opimus lies dying in bed, while others look at his chests of gold.
- Epigram: The miser who rose from his deathbed when he saw his heirs regarding his treasure shows how the man who loves gold cannot die in peace.

ORPHEUS
Whitney, p. 186.
- Motto: "Orphei Musica."
- Icon: Orpheus plays on a harp while animals surround him.
- Epigram: As Orpheus tamed the wild beasts with his music, so a neighbor of the author possesses great musical talent.

OSTRICH
P. S., p. 55.
- Motto: "Nil penna sed usus."
- Icon: An ostrich.
- Epigram: A hypocrite is like the ostrich, which makes great ostentation with its feathers and wings but cannot fly.

Whitney, p. 51.
- Motto: "Nil penna, sed usus."
- Icon: An ostrich spreads its wings.
- Epigram: As the ostrich spreads its wings but rarely flies, so the hypocrite makes great show of his religion but merely dissembles.

Willet, no. 88.
- Motto: "Matres improvidae."
- Icon: None.

- Epigram: As the ostrich leaves eggs in the sand, so the unwise mother ignores her child.

Wither, p. 36.
- Motto: "To Have, and not to Use the same; Is not our Glory, but our Shame."
- Icon: An ostrich with a horseshoe in its mouth.
- Epigram: Although the ostrich has wings and feathers, it cannot fly; it represents men of high birth who do nothing of worth or men who seem learned but have no knowledge or men who are powerful but do nothing for the public good.

OVEN
Ayres, no. 44.
- Motto: "Tears the symptoms of Love."
- Icon: Cupid kneels beside an oven from which flames shoot.
- Epigram: Like the flames in an oven, pent up passion eventually can be seen.

See also: FURNACE.

OWL
Wither, p. 9.
- Motto: "Before thou bring thy Workes to Light, Consider on them, in the Night."
- Icon: An owl sits on a crowned caduceus between two cornucopias held by Mercury and Pallas.
- Epigram: To acquire wit (caduceus) and wealth (cornucopia) and achieve the crown, man must employ "a studious watchfulness" (owl) and meditate on his actions in the night.

Wither, p. 63.
- Motto: "We best shall quiet clamorous Thronges, When, we our selves, can rule our Tongues."
- Icon: Birds surround and threaten an owl.
- Epigram: As the owl ignores and disdains the clamor and affronts of other birds, so men should ignore the slanders of injurious tongues.

Wither, p. 253.
- Motto: "Hee that is blind, will nothing see, What light soe're about him bee."
- Icon: A bespectacled owl sits in the sun holding torches and flanked by burning candles.
- Epigram: The owl is blind in the day, despite spectacles, candles, torches, and the sun, signifying those who are blind to virtue and those who are blind to divine truth.

See also:
BOOK AND OWL
Wither, p. 79.
HAND, LAMP, OWL
Montenay, p. 114.
MELANCHOLY
Peacham, p. 126.

OWL AND SKULL
Wither, p. 168.
 Motto: "Whil'st thou dost, here, injoy thy breath,
 Continue mindfull of thy Death."
 Icon: An owl sits on a skull.
 Epigram: Remember death and prepare yourself for
 your parting from this world.

OX
P. S., p. 350.
 Motto: "Pas à pas."
 Icon: An ox with the ensign of King Renatus of
 Sulie.
 Epigram: The oxen represents the man who under-
 takes great journeys, step by step.
Wither, p. 173.
 Motto: "They, who but slowly paced are,
 By plodding on, may travaile farre."
 Icon: An ox.
 Epigram: The slow ox outlasts the swift horse through
 steady plodding; likewise, lesser wits may
 surpass greater wits through constancy and
 perseverance.

See also:
 ANGEL
 Willet, no. 5.
 CRANE AND OX
 Willet, no. 82.
 DOG IN MANGER
 Whitney, p. 184.
 FIREBRAND AND OX
 P. S., p. 215.
 YOKE
 Ayres, no. 6.
See also: BULL.

OX AND PICK
Montenay, p. 382.
 Motto: "Ex corpore ruina."
 Icon: A man goads an ox with a pick.
 Epigram: Like the ox which will not move until
 goaded with a pick, the rich man will not
 call on God until he suffers.

OX AND PLOW
P. S., p. 344.
 Motto: "Sic vos non vobis."
 Icon: Oxen draw a plow.
 Epigram: Like the oxen drawing the plow, men whose
 exploits are ascribed to their rulers have
 the pains but not the profit.

OX AND YOKE
Van Veen, p. 27.
 Motto: "By litle and litle."
 Icon: Cupid puts a yoke on an ox.
 Epigram: As the ox must be trained to bear the yoke,
 so the lover must learn to bear love.

OXFORD
Peacham, p. 98.
 Motto: "Divinitùs."
 Icon: A hand holds a walled city of Oxford on a
 string.
 Epigram: Dedicated to the University of Oxford,
 this poem associates the school with truth,
 light, fame, and art.

OYSTER
See:
 MOUSE AND OYSTER
 Whitney, p. 128.

OYSTER AND PEARL
Astry, no. 32.
 Motto: "Ne te quaesiveris extra."
 Icon: An oystershell with a pearl inside.
 Epigram: As no one would expect the coarse and un-
 polished shell to contain a delicacy like a
 pearl, so appearances are deceiving. The
 prince should therefore not trust opinion
 but search for truth.

P

Pail
See: BUCKET.

PAINT
See:
 HEART
 Arwaker, bk. 2, no. 6.

PAINTER
Combe, no. 15.
 Motto: "He that infinenesse would excell,
 Oft marres the worke before was well."
 Icon: A painter works on a canvas on an easel.
 Epigram: As the painter who overworks every detail
 of his painting mars the piece, so the man
 who tries to know divine things fails to
 know either the divine or himself.

PAINTING
See:
 HEART AND PAINTING
 H. A., p. 134.
See also: PORTRAIT.

PALE
See:
 CHAIN
 Godyere, no. 5.

PALLAS
Thynne, no. 51.
 Motto: "Wisdome and Strength are to be Joyned."

Icon: None.
Epigram: The birth of Pallas from Jove's head signifies that wisdom descends from good; the armor of Pallas signifies that wisdom joined with strength can conquer all.

See also:
BIRTH OF PALLAS
Peacham, p. 188.
Thynne, no. 38.
JUDGMENT OF PARIS
Whitney, p. 83.
MARS AND PALLAS
Wither, p. 80.
NET
Peacham, p. 197.
OWL
Wither, p. 9.
PARIS
Thynne, no. 29.
SAGE
Whitney, p. 135.
SITTING
Whitney, p. 103.
See also: MINERVA.

PALLAS AND ULYSSES
Peacham, p. 69.
Motto: "Tutissima comes."
Icon: Pallas Athena, holding a lance and wearing a helmet, leads Ulysses, who carries a walking stick.
Epigram: As Pallas led Ulysses on his journey, so wisdom should be men's guide.

PALLAS'S TREE
See:
GRAPEVINE AND PALLAS'S TREE
Whitney, p. 133.

PALM
See:
ANTEROS, CUPID, PALM
Van Veen, p. 11.
BEARDED MAN AND POT
Van der Noodt, no. 12.
BOUNTY
Godyere, no. 31.
COAT OF ARMS, CUPID, PALM
Van Veen, p. 65.
CUPID, HARE, PALM
Van Veen, p. 101.
GLASS
Arwaker, bk. 1, no. 14.
Quarles, *Emb.*, p. 176.
HEART, LAUREL, PALM
H. A., p. 235.
SHIELD
Thynne, no. 21.

TRUTH
Peacham, p. 134.
WREATH
Wither, p. 254.

PALM BRANCH
See:
CAGE AND HEART
Hall, p. 44.
DOLPHIN, GLOBE, RING
P. S., p. 327.

PALM TREE
Astry, no. 96.
Motto: "Memor adversae."
Icon: A palm tree is reflected in a pool.
Epigram: The prince, at the height of victory, should be fearful of being overthrown.
Hawkins, no. 14, p. 151.
Motto: "Depressa resurgens."
Icon: A palm tree.
Epigram: The palm tree bears oppression without shrinking and therefore represents the patience and fortitude of the Virgin Mary.
P. S., p. 261.
Motto: "Ipsa suae testis victoria cladis."
Icon: A palm tree.
Epigram: The high palm tree signifies the region of Jurie and its destruction.
Whitney, p. 118.
Motto: "Invidia integritatis assecla."
Icon: Snakes and frogs crawl beneath a tall palm tree.
Epigram: As small serpents and frogs annoy the tall palm tree with noise and poison, trying to destroy it, so the envious attack and wound men of high estate.

See also:
CROCODILE AND PALM TREE
P. S., p. 81.
CROWN, PALM TREE, SWORD
P. S., p. 255.
TOMB OF ACHILLES
Whitney, p. 193.

PALM TREE AND PHOENIX
Hawkins, no. 14, p. 159.
Motto: "Quasi Φοίνιξ Palma exaltata sum."
Icon: A phoenix sits in a palm tree and looks toward the sun.
Epigram: The Virgin is like the palm tree, bearing Christ who, like the Phoenix, is resurrected.

PALM TREE AND STONE
Wither, p. 172.
Motto: "Truth, oft oppressed, wee may see, But, quite supprest it cannot bee."

Icon: A stone weighs down a palm tree.

Epigram: The more the palm tree is weighed down,
 the more it thrives and spreads; so, too,
 the more the righteous man is oppressed
 and persecuted, the more he flourishes.

PAN

See:

MIDAS

Whitney, p. 218.

PANTHER

See:

DECEIT

Peacham, p. 47.

PAPAL CROWN

Astry, no. 94.

Motto: "Librata refulget."

Icon: The papal crown shines over the world.

Epigram: As the sun shines on earth, so the papacy
 illuminates the world.

See also:

WHORE OF BABYLON

Godyere, no. 21.

PAPER

Bunyan, no. 70.

Motto: "Upon a Sheet of White Paper."

Icon: None.

Epigram: Like the blank piece of paper on which
 anyone can write and which will retain blots
 and blurs, some souls are open to any
 erring doctrine and will exhibit its foul-
 ness.

See also:

BOY AND PLUM

Bunyan, no. 47.

PARIS

Thynne, no. 29.

Motto: "Pleasures to be eschewed."

Icon: None.

Epigram: By choosing Venus over Pallas and Juno,
 Paris unwisely chose fading pleasure over
 the contemplative life and the active life.

See also:

JUDGMENT OF PARIS

Whitney, p. 83.

PARROT AND SERPENT

Astry, no. 79.

Motto: "Consilia consiliis frustrantur."

Icon: A serpent in a tree looks at a parrot in a
 nest hanging from a branch of the tree.

Epigram: The parrot evades the serpent's artifice by
 hanging in a nest on the highest branch,
 where the serpent cannot reach; so artifice
 must be frustrated by artifice.

PARROT AND TORTOISE

Thynne, no. 46.

Motto: "Eloquent wisdome."

Icon: None.

Epigram: The parrot, which talks in a human voice,
 and the tortoise, which has armor that can-
 not be pierced, signify eloquent wisdom.

PARTRIDGE

See:

NET AND PARTRIDGE

Peacham, p. 85.

PARTRIDGE AND WHEAT

Peacham, p. 131.

Motto: "Nec amicis, nec cognatis fidendum."

Icon: A partridge flies to its young in a nest in
 the wheatfield.

Epigram: When the wheat is to be harvested, it is
 time for the partridge to leave the field.

PATH

See:

MERCURY

Whitney, p. 2.

See also: WAY.

PATIENT AND PHYSICIAN

Arwaker, bk. 1, no. 3.

Motto: "Have mercy upon me, O Lord, for I am
 weak; O Lord, heal me, for my bones are
 vexed."

Icon: A human figure lies sick in bed while
 Divine Love, as a physician, attends him.

Epigram: Christ acts as a physician; his blood cures
 the sick soul.

Quarles, *Emb.*, p. 136 (note: first of two pages num-
bered 136).

Motto: "Have mercy on me O Lord, for I am
 weake, O Lord heale me, for my bones
 are vexed."

Icon: A human figure lies sick in bed while
 Divine Love attends him.

Epigram: Christ acts as a physician; his blood cures
 the sick soul.

PAUL (APOSTLE) AND VIPER

P. S., p. 242.

Motto: "Quis contra nos?"

Icon: A viper bites the hand of the apostle Paul.

Epigram: As Paul received no hurt from the viper,
 so men who have God's mercy cannot be
 harmed.

Whitney, p. 166.

Motto: "Si Deus nobiscum, qui contra nos?"

Icon: A serpent bites a finger as a fire burns
 below.

Epigram: As God protected Paul from the bite of the
 viper, so God will preserve his servants.

PEACE
Thynne, no. 32.
 Motto: "Peace."
 Icon: None.
 Epigram: Peace leads Pluto, the god of wealth, from
 Bellona, the cause of war; she holds
 Amalthea, "the fruitfule horne," in her
 left hand and takes a sword away from
 Mars, the god of war.

PEACH
See:
 CUPID, GOOSE, PEACH, SILENCE
 Van Veen, p. 71.

PEACOCK
See:
 CUPID AND PEACOCK
 Van Veen, p. 195.
 HORSE AND TAPER
 Quarles, *Hier.*, no. 10.

PEACOCK FEATHER
See:
 FLY AND PEACOCK FEATHER
 P. S., p. 288.

PEARL
Hawkins, no. 17, p. 187.
 Motto: "Praetiosa et coelestis."
 Icon: A pearl hangs from a string.
 Epigram: The Virgin Mary is like the precious pearl,
 valuable and worthy, and is also the mother
 of the true pearl, the perfect Christ.
Hawkins, no. 17, p. 194.
 Motto: "Non est huic Similis; una est dilecta Mea."
 Icon: A haloed figure stands beside a table laden
 with pearls; behind him is a shell with a
 pearl inside.
 Epigram: The Virgin Mary is both the precious
 pearl and the mother of the perfect pearl,
 Christ.
See also:
 CITY OF GOD
 Van der Noodt, no. 20.
 OYSTER AND PEARL
 Astry, no. 32.
 RING AND SWINE
 Wither, p. 224.
See also: JEWEL, MARGARITE.

PEAR TREE
Peacham, p. 136.
 Motto: "Justitia militaris."
 Icon: A pear tree is surrounded by military tents.
 Epigram: Scaurus, who did not destroy the pear tree
 in his conquest, is an example to contem-
 porary soldiers who needlessly plunder and
 spoil what they conquer.

PEDESTAL
See:
 GAUNTLET, PEDESTAL, SWORD
 Peacham, p. 162.

PEGASUS
Godyere, no. 24.
 Motto: "Chiaro quieto profondo e divino."
 Icon: Pegasus digs a well as Phoebus and the
 Muses watch.
 Epigram: Like Pegasus, who dug the well of art and
 skill, divines move men to heavenly wis-
 dom with wit and harmony.
Wither, p. 105.
 Motto: "No passage can divert the Course,
 Of Pegasus, the Muses Horse."
 Icon: Pegasus.
 Epigram: Pegasus represents the "winged-contem-
 plation / On which the Learned mount
 their best Invention."
See also:
 BACCHUS
 Peacham, p. 191.
 BACCHUS AND PEGASUS
 Thynne, no. 15.
 BELLEROPHON
 Thynne, no. 28.

PELICAN
Whitney, p. 87.
 Motto: "Quod in te est, prome."
 Icon: A pelican pierces its breast and feeds its
 young with its own blood.
 Epigram: As the pelican sacrifices itself for its young,
 so should the person here addressed use his
 learning and talent to help his country.
Wither, p. 154.
R. B., no. 7.
 Motto: "Our Pelican, by bleeding, thus,
 Fulfill'd the Law, and cured Us."
 Icon: A pelican pecks its breast and feeds its
 young with its own blood; in the back-
 ground is Christ's Crucifixion.
 Epigram: As the pelican sacrifices itself for its young,
 so Christ sacrificed himself for mankind.

PEN
P. S., p. 197.
 Motto: "Ulterius ne tende odiis."
 Icon: A hand reaches for a pen.
 Epigram: When Valentinus tried to order the banish-
 ment of Basil, his pen refused to write;
 this teaches that man cannot, and should
 not, go against God.
See also:
 BALANCE
 Peacham, p. 44.
 CRAYFISH AND PEN

Peacham, p. 57.
FAME
Whitney, p. 196.
LINE
Wither, p. 158.
See also: QUILL.

PEN AND SWORD
P. S., p. 230.
 Motto: "Police souveraine."
 Icon: A pen and a sword.
 Epigram: The perfect commonwealth requires the pen—counsel—and the sword—execution.

PENCIL
See:
 CANVAS
 Astry, no. 2.

Penitence
See: REPENTANCE.

PENNY LOAF
Bunyan, no. 44.
 Motto: "Upon a Penny Loaf."
 Icon: None.
 Epigram: The loaf, which costs only a penny in a time of plenty but is priceless in a time of famine, represents the word of God, which is held in low esteem during good times but is man's all when the soul faces death.

PESTLE
See:
 HEART, MORTAR, PESTLE
 Harvey, no. 14.

PETER APOSTLE
Willet, no. 47.
 Motto: "Deus non est."
 Icon: None.
 Epigram: As God commanded the Apostle Peter to eat meat that had been forbidden, so we should not lose hope that the wicked are lost.

PHILOMEL
Peacham, p. 74.
 Motto: "Erit altera merces."
 Icon: The bird Philomel sits on a bare brier in a desolate landscape.
 Epigram: Philomel sitting in silence, alone, on a bare brier in winter represents the aged who are forgotten by those they once pleased.
See also: NIGHTINGALE.

PHLEGM
Peacham, p. 129.

 Motto: "Phlegma."
 Icon: A man sleeps by a fire, his arms folded in his bosom; a tortoise lies beside him.
 Epigram: Phlegm suffers from dropsy and is slothful like the tortoise.

PHOEBUS
See:
 CUPID, PHOEBUS, PYTHON
 Van Veen, p. 21.
 PEGASUS
 Godyere, no. 24.
See also: APOLLO.

PHOENIX
Godyere, no. 3.
 Motto: "Unica eterna al mondo."
 Icon: The phoenix rises from a fire.
 Epigram: The queen is compared to the phoenix, for she is matchless, unparalleled, and unique.
Hawkins, p. 262.
 Motto: "Nec similis visa, nec secunda."
 Icon: The phoenix.
 Epigram: The Virgin Mary is unique, like the phoenix.
Hawkins, p. 266.
 Motto: "Eadem inter se Sunt eadem uni tertio."
 Icon: A lance pierces the twin hearts of the phoenix.
 Epigram: Just as death pierces the twin hearts of the phoenix, so when Christ's side was pierced, Mary's was also.
Peacham, p. 19.
 Motto: "Is coelebs, Urit cura."
 Icon: The phoenix rises from a fire.
 Epigram: Dedicated to the earl of Salisbury, this device compares the phoenix to Salisbury, who sacrifices himself for his country but in the process achieves immortal fame.
P. S., p. 110.
 Motto: "Unica semper avis."
 Icon: The phoenix rises from its ashes.
 Epigram: The phoenix is rare and unique; so, too, good things are hard to find.
P. S., p. 349.
 Motto: "Sola facta solum Deum sequor."
 Icon: The phoenix rises from a fire.
 Epigram: As the phoenix is alone in the world, so the widowed woman lives for God alone.
Van der Noodt, no. 5.
 Motto: None.
 Icon: The phoenix strikes its breast beside a dry stream and a broken tree.
 Epigram: The phoenix, disdaining this world and its impermanence, kills itself; it is a symbol of Christ.
Whitney, p. 177.

Motto: "Unica semper avis."
Icon: The phoenix rises from a fire.
Epigram: The phoenix, a traditional image of resur-
 rection, here signifies the rebirth of the
 town of Nampwiche after a fire destroyed
 the original.

See also:

PALM TREE AND PHOENIX
Hawkins, no. 14, p. 159.

PHRYXUS
Whitney, p. 214.
Motto: "In divitem, indoctum."
Icon: Phryxus rides the golden fleece through
 the sea.
Epigram: Like Phryxus, who rode the golden fleece,
 some men are enriched by goods which be-
 long to others and some fools have hand-
 some bodies.

PHYSIC
See:

CUPID, PHYSIC, SICKNESS
Van Veen, p. 121.

PHYSIC AND SICKNESS
Bunyan, no. 62.
Motto: "Of Physick."
Icon: None.
Epigram: The unconverted are like sick men; the
 Holy Word is like a physic which may cure
 the sick.

PHYSICIAN
Quarles, *Hier.*, no. 4.
Motto: "Curando Labascit."
Icon: A physician trims the wick of a taper.
Epigram: The physician often ruins rather than cures
 and thus illustrates that nature is superior
 to art.

See also:

AESCULAPIUS
Whitney, p. 212.
BLIND WOMAN AND PHYSICIAN
Whitney, p. 156.
CUPID, PHYSICIAN, SICKNESS
Van Veen, p. 169. .
PATIENT AND PHYSICIAN
Arwaker, bk. 1, no. 3.
Quarles, *Emb.*, p. 136.
ULCER
Montenay, p. 342.

PICK
See:

OX AND PICK
Montenay, p. 382.

PICKING FLOWERS
Ayres, no. 18.

Motto: "Hard to be pleased."
Icon: A woman gathers flowers while Cupid
 watches.
Epigram: Like the woman who picks flowers, casting
 many aside, the proud woman scorns her
 lover.

PIETY
Godyere, no. 12.
Motto: "Candida sal da, et immobile."
Icon: Piety holds a cup and a cross with a ser-
 pent and clings to a pillar.
Epigram: Piety is pure and constant and carries the
 cup of salvation.

PIG
See:

CHARIOT, DEVIL, WORLD
Quarles, *Emb.*, p. 44.
See also: BOAR, HOG, SOW, SWINE.

PIG AND RING
P. S., p. 106.
Motto: "Prostibuli eligantia."
Icon: A ring is in the nose of a pig.
Epigram: The honor of a shameless woman is like a
 ring in a pig's nose.

PIG AND STONE
P. S., p. 97.
Motto: "Si sciens fallo."
Icon: A hand holds a stone over a pig.
Epigram: When the Romans made peace with their
 enemies, they made a vow of faith by hit-
 ting a pig with a stone and saying, "Let
 what happens to this pig happen to me if I
 deceive you."

PIKE
See:

CUPID AND PIKE
Van Veen, p. 199.

PILGRIM
Montenay, p. 78.
Motto: "Sed Futuram inquirimus."
Icon: A pilgrim with a staff follows a path to-
 ward a gate in the heavens.
Epigram: If man desires the heavenly gate, he must
 forsake riches and become a pilgrim.

See also:

LABYRINTH AND PILGRIM
Arwaker, bk. 2, no. 2.
Quarles, *Emb.*, p. 188.

PILGRIM AND TENT OF KEDAR
Arwaker, bk. 3, no. 7.
Motto: "Wo is me, that I am constrained to dwell
 with Mesech, and to have my habitation
 among the tents of Kedar."

Icon: A pilgrim sits beside the tents of Kedar.

Epigram: Man is a wanderer on earth, in exile from God and heaven.

Quarles, *Emb.*, p. 268.

Motto: "Woe is me that I am constrained to dwell with Mesech: & to have my habitation among the tents of Cedar."

Icon: A pilgrim sits on a hill overlooking the tents of Kedar.

Epigram: The speaker laments the frailty and corruption of life in this world, and he longs to join God in heaven.

PILGRIM AND TORTOISE
Combe, no. 51.

Motto: "After youth in travell spent,
Let age be with her home content."

Icon: A pilgrim places a winged staff on the back of a tortoise.

Epigram: The aged man should stop traveling and stay at home.

PILLAR
Montenay, p. 70.

Motto: "Non confundit Nolite confidere."

Icon: A hand supports a winged pillar, while another hand breaks a winged pillar.

Epigram: The men who trust in God are blessed, but the men who trust in other men are cursed.

See also:

CROWN AND PILLAR
Astry, no. 31.

CUPID AND PILLAR
Van Veen, p. 201.

HEART AND PILLAR
Montenay, p. 62.

IVY, MOON, PILLAR
P. S., p. 87.

LAUREATE HEAD AND PILLAR
Wither, p. 2.

PIETY
Godyere, no. 12.

SAGE
Whitney, p. 130.

VIRTUE
Montenay, p. 270.

See also: COLUMN, SPIRE.

PILLAR AND SHIP
Astry, no. 30.

Motto: "Fulcitur experieniis."

Icon: Columnae Rostratae: a pillar hung with heads of ships.

Epigram: The pillar represents wisdom; the heads of ships, experience.

PILLAR AND WORLD
Montenay, p. 54.

Motto: "Et hec est victoria que vicit."

Icon: A winged pillar on the top of a hill is above the world.

Epigram: The world was wicked and oppressed with sin until Christ conquered Satan and freed man.

PILLAR, SHIELD, WEAPON
Peacham, p. 173.

Motto: "Latet abditus agro."

Icon: A shield and weapons hang on a pillar.

Epigram: After a life of valor the valiant mind desires to retire to home.

PILLARS OF HERCULES
P. S., p. 32.

Motto: "Plus oultre."

Icon: The pillars of Hercules.

Epigram: Charles V adopted the device of the pillars of Hercules, which originally marked the limits of the known world, to signify his era's discoveries in the New World and to express the idea of going farther or beyond the known.

See also:

CUPID AND PILLARS OF HERCULES
Peacham, p. 73.

SOW
Whitney, p. 53.

PILLOW
See:

ASS AND PILLOW
Combe, no. 13.

DEVIL, HEART, SLEEP
Harvey, no. 2.

See CUSHION.

PINE TREE
Peacham, p. 60.

Motto: "Ni undas ni vientos."

Icon: The wind bends a pine tree.

Epigram: Just as the lofty pine tree bends in the wind, so men in high places are easily swayed by opinion and become victims of fortune.

Whitney, p. 59.

Motto: "Nimium rebus ne fide secundis."

Icon: Pine trees crack in the wind.

Epigram: Just as the lofty pine is suddenly destroyed by the wind, so those who trust in fortune suddenly fall; therefore, put no trust in worldly things.

See also:

GOURD AND PINE TREE
Whitney, p. 34.

PIPE
See:

BACCHUS

Whitney, p. 187.
BIRDER AND PIPE
Combe, no. 54.
BUBBLE AND SMOKE
Quarles, *Emb.*, p. 76.
CANDLESTICK, LAMP, OIL, OLIVE TREE, PIPE
Willet, no. 8.

PIPKIN AND POTTER
Montenay, p. 326.
 Motto: "Quis tandem es."
 Icon: A potter surveys his pipkins and raises his stick to break one of them.
 Epigram: Like the potter who makes pipkins of all shapes and can break those that are not good, God creates all men and can destroy one if he is dissatisfied.

PIPKIN AND SUN
Montenay, p. 90.
 Motto: "Hoc sermo veritatus est reprobis."
 Icon: The sun shines on pipkins.
 Epigram: Like the pipkins which harden if they stand too long in the sun, the hearts of men harden in this world of sin.

PISMIRE
Bunyan, no. 38.
 Motto: "Upon the Pismire."
 Icon: None.
 Epigram: The pismire [ant], which provides in the summer for the coming winter, teaches man to do good works in this life in preparation for the afterlife.
See also: ANT.

PIT
See:
 HEART AND WORLD
 Montenay, p. 338.
See also: GULF.

PIT AND SPRING
Montenay, p. 334.
 Motto: "Converte oculos."
 Icon: A man digs a pit while water flows from a spring.
 Epigram: The spring flowing all day and night and available to every man represents Christ and his Gospel; the man who scorns the water and digs a pit represents the damned man who scorns God.
See also: EWER.

PITCHER
P. S., p. 113.
 Motto: "Riens ne m'est plus, Plus ne m'est riens."
 Icon: A pitcher has the letter *S* on its mouth and holes on its base.

Epigram: The pitcher with the motto "Nothing remaineth to me, nothing have I more" is an emblem of grief and mourning.

PITCHFORK, RAKE, SICKLE
Peacham, p. 150.
 Motto: "Adhuc mea messis in herba."
 Icon: A sickle, a rake, and a pitchfork are tied together.
 Epigram: Dedicated to a woman whose husband is not yet foreseen, the poem suggests that, though others reap while her hopes are still immature, "after-crops" are sometimes the best.

PLANE TREE
See:
 PLATAN TREE
 Peacham, p. 79.

PLANT
Astry, no. 66.
 Motto: "Ex fascibus fasces."
 Icon: Four plants grow beside the remains of a dead tree.
 Epigram: As the husbandman carefully preserves young plants to replace dead trees, so countries should provide for the education of youth.
Thynne, no. 59.
 Motto: "Children in youth to be framed."
 Icon: None.
 Epigram: Like a young plant, children can be shaped and bent into any form, but like a tree, they cannot be reshaped once they are grown.
See also:
 WATERING
 Wither, p. 107.

PLANT AND TAPER
Quarles, *Hier.*, no. 9.
 Motto: "Ut Luna Infantia torpet."
 Icon: A taper stands in an urn with the roman numeral X (10) at the top; on either side is a new moon and a snail; below are a budding plant, a cradle, and a rattle.
 Epigram: In the first decade of life man is like a beast, without knowledge of mortality or immortality.

PLANTING TREE
Wither, p. 35.
 Motto: "He that delights to Plant and Set, Makes After-Ages in his Debt."
 Icon: A man plants a tree.
 Epigram: Men who ravage and spoil the land care only for themselves; men who plant trees care about their posterity.

PLATAN TREE
Peacham, p. 79.
 Motto: "Umbra tantum."
 Icon: A platan [plane] tree shades a wide area.
 Epigram: Although the platan tree provides the most shade, it is barren; similarly, some wealthy and powerful men overshadow lesser men, who are better endowed.

PLATTER
See:
 GOLD ON PLATTER
 P. S., p. 124.

PLAY
Combe, no. 76.
 Motto: "We purchase nothing by our play,
 But beggary and our decay."
 Icon: A man walks away from a gambling table while another gestures to him.
 Epigram: This emblem cautions against the evils of gambling and games in which men risk and lose all their wealth.
See also:
 BOY
 Bunyan, no. 71.
 CANDLE
 Farlie, no. 11.

Pleading
See: ENTREATING.

PLINY
Whitney, p. 25.
 Motto: "Curis tabescimus omnes."
 Icon: Pliny falls into the mouth of a volcano at Vesuvius.
 Epigram: Pliny's obsession with knowing what made Vesuvius flame caused his death; he is an example of the destructive power of desire.

PLOW
Wither, p. 160.
 Motto: "The Right-hand way, is Vertues Path, Though rugged Passages it hath."
 Icon: A plow lies in front of a plowed field.
 Epigram: The new-plowed ground is likened to the difficult path of virtue.
See also:
 HEART AND PLOW
 Harvey, no. 27.
 OX AND PLOW
 P. S., p. 344.

PLOWING
Montenay, p. 182.
 Motto: "Non aptus est regno dei."
 Icon: A man plows a field.
 Epigram: No man who avoids labor comes into heaven.

Willet, no. 12.
 Motto: "Sub cruce exultandum."
 Icon: None.
 Epigram: As men plow and prepare the soil to grow better crops, so God sends affliction for our own good.
See also:
 HUSBANDMAN
 Wither, p. 106.
 R. B., no. 32.

PLOWMAN
Wither, p. 144.
 Motto: "Ere thou a fruitfull-Cropp shalt see, Thy ground must plough'd and harro'wd be."
 Icon: A plowman tills the ground.
 Epigram: As the plowman tills the field so that it will produce a crop, so God tills man's soul so that it will yield fruit.
See also:
 ASTRONOMER AND PLOWMAN
 Whitney, p. 9.

PLUM
See:
 BOY AND PLUM
 Bunyan, no. 47.

PLUME
Peacham, p. 164.
 Motto: "Ordo."
 Icon: A plume.
 Epigram: The ideal state is like this plume; each member, like each feather, keeps its rank.
See also:
 EAGLE AND SUN
 Godyere, no. 4.

PLUMMET
See:
 CUPID AND PLUMMET
 Van Veen, p. 77.
 HEART AND PLUMMET
 Harvey, no. 22.

PLUTO
See:
 PEACE
 Thynne, no. 32.

POISON
See:
 CUP AND FLOWER
 P. S., p. 119.
 EATING VIPER
 Peacham, p. 49.
 GANYMEDE
 Peacham, p. 48.

POLEAX
See:

CHAIN AND POLEAX
P. S., p. 71.

POLESTAR
Ayres, no. 37.
 Motto: "Love's my Pole starr."
 Icon: Cupid faces a woman and holds up a lodestone to the polestar.
 Epigram: The lover is like the lodestone; his beloved, like the polestar.
See also: LODESTAR, NORTH STAR.

POLIPUS
Thynne, no. 49.
 Motto: "Flatterers."
 Icon: None.
 Epigram: The fish polypus which can turn any color to deceive other fishes, represents flatterers.

POLLUX
See:

CASTOR AND POLLUX
P. S., p. 211.

Polypus
See: POLIPUS.

POOR
See:

DOOR
Whitney, p. 204.
See also: BEGGAR, POVERTY.

POOR MAN AND RICH MAN
P. S., p. 362.
 Motto: "Bis dat qui tempestivè donat."
 Icon: A rich man helps a poor man.
 Epigram: The noble man who helps the poor man in his time of need is doubly blessed.

POMEGRANATE TREE
See:

MYRTLE TREE AND POMEGRANATE TREE
Peacham, p. 41.

POND AND STONE
Astry, no. 65.
 Motto: "De un eror muchos."
 Icon: A stone lands in a pond, creating waves.
 Epigram: As a stone thrown into a pond creates a continual series of waves, so one error creates many errors, raises passions, and confounds judgment.

POOL
See:

PALM TREE
Astry, no. 96.

Pope
See: ANTI-CHRIST, PAPAL CROWN, SEVEN-HEADED BEAST, WHORE OF BABYLON.

POPPY
See:

HEAD OF STATE
Peacham, p. 22.
See also: CHESBOLE, STAFF.

PORCUPINE
P. S., p. 29 (misnumbered 17).
 Motto: "Ultus Avos Troia."
 Icon: A crown hangs above a porcupine.
 Epigram: Because men react differently to injury, the quills of a porcupine are "peace to humble men, but warre to proud" men.
See also:

HELMET AND PORCUPINE
Astry, no. 82.

PORTCULLIS
Peacham, p. 31.
 Motto: "Protegere Regium."
 Icon: A portcullis with a crown above it.
 Epigram: As the portcullis protect the walls of the city, so King James should defend his country against its enemies.
P. S., p. 39.
 Motto: "Securitas alterae."
 Icon: A crown sits on an iron portcullis.
 Epigram: The "percullice," or portcullis, is a sign of defense, security, and safety.

PORTRAIT
See:

CUPID AND PORTRAIT
Van Veen, p. 193.

PORTRAIT AND SWORD
P. S., p. 168.
 Motto: "Vel in ara."
 Icon: A sword strikes the face of a man in a portrait.
 Epigram: Before killing a certain philandering duke of Milan, a courtier practiced stabbing his portrait; the murder of this sinful man illustrates God's vengeance on the sinner.

Poseidon
See: NEPTUNE.

POST
See:

TROPHY
Astry, no. 17.

POSTBOY
Bunyan, no. 27.
 Motto: "On the Post-boy."
 Icon: None.

Epigram: The postboy who sets out in haste for a particular destination resembles those who set out for lasting bliss.

POT
Combe, no. 74.
 Motto: "With some light thing when thou needs must,
 Trie thou thy friend before thou trust."
 Icon: A man pours water into a pot.
 Epigram: Just as we test a pot's soundness by pouring water into it before we trust it with wine, so man should try a stranger with a trivial secret before confiding in him.
Willet, no. 19.
 Motto: "Excindetur & caput & cauda à posteris impiorum."
 Icon: None.
 Epigram: The pot which has only a little water in it and hangs over burning bones represents the wicked who will have nothing left when they are judged by God.
See also:
 BEARDED MAN AND POT
 Van der Noodt, no. 12.
 BRASS POT AND EARTHEN POT
 Whitney, p. 164.
 CROW AND POT
 Wither, p. 64.
 FIRE AND POT
 P. S., p. 54.
 Van Veen, p. 97.
See also: PIPKIN.

POT AND POTTER
Willet, no. 66.
 Motto: "Quo nos numen trahit, eundum."
 Icon: None.
 Epigram: As the potter forms clay into a pot, so God guides our hearts.

POTTER
See also:
 CLAY, DUST, POTTER
 Arwaker, bk. 1, no. 5.
 Quarles, *Emb.*, p. 140.
 PIPKIN AND POTTER
 Montenay, p. 326.
 POT AND POTTER
 Willet, no. 66.

POURING
Wither, p. 242.
R. B., no. 30.
 Motto: "Since overmuch, will over-fill,
 Powre out enough; but doe not spill."
 Icon: A woman pours liquid into a bowl, which overflows.

 Epigram: Pouring enough but not too much signifies temperance.
See also:
 CUPID AND SIEVE
 Combe, no. 77.
 FOUNTAIN
 Arwaker, bk. 1, no. 8.
 POT
 Combe, no. 74.

POURING AND WORLD
Montenay, p. 118.
 Motto: "Coinquinat."
 Icon: A figure with devil's ears pours water on the world and hides a firebrand behind his back.
 Epigram: The devil's messenger plants the lies of Satan where he can in this world and tries to obscure God's word.

POVERTY
See:
 FORTUNE AND POVERTY
 Peacham, p. 194.
See also: BEGGAR, POOR.

PRAYING
See:
 MOSES
 Montenay, p. 346.
See also: KNEELING, LORD'S PRAYER.

PRAYING MAN
See:
 ARROW, DEATH, PRAYING MAN
 P. S., p. 364.

PREACHER
Wither, p. 89.
R. B., no. 38.
 Motto: "The Gospel, thankefully imbrace;
 For, God, vouchsafed us, this Grace."
 Icon: A preacher delivers a sermon in a church.
 Epigram: The speaker praises God and the Gospels.
See also: MINISTER.

PRELATE
See:
 LAMP, MOUNTAIN, PRELATE
 Combe, no. 86.

PRESS
See:
 HEART AND PRESS
 Harvey, no. 15.

PRIAM
Peacham, p. 65 (misnumbered 95).
 Motto: "Deus ultimum refugium."
 Icon: King Priam kneels at a burning altar.

Epigram: As Priam turns to the altar and prays to his gods when Troy is destroyed, so every Christian should turn to God in his distress.

PRIEST
See:

WASHING HANDS
Wither, p. 41.
R. B., no. 33.
See also: CATHOLIC CLERIC.

PRIEST'S GARMENT
Willet, no. 6.
Motto: "Episcopi ornamenta."
Icon: None.
Epigram: The qualities of the priest's external garments must be internalized by the Protestant minister: this emblem gives elaborate correspondences between the outer articles of clothing and the inner states of mind.

PRINCE
See:

ASTRONOMER AND PLOWMAN
Whitney, p. 9.
See also: KING, MONARCH.

Prism
See: GLASS.

PRISON
See:

FAITH
Jenner, no. 1.

PRISONER
See:

ATTILIUS
Whitney, p. 114.
SKELETON IMPRISONS MAN
Arwaker, bk. 3, no. 8.
Quarles, *Emb.*, p. 272.
See also: CAPTIVE.

PROCRIS
Whitney, p. 211.
Motto: "Zelotypia."
Icon: Procris is pierced by an arrow shot by her husband.
Epigram: The story of Procris illustrates the dangers of jealousy; overcome by the passion of jealousy, Procris secretly followed her husband to learn his ways and was accidentally shot by him.

PROMETHEUS
Peacham, p. 189.
Motto: "Divina misericordia."
Icon: An eagle preys upon Prometheus, who is tied to a tree, while Jove watches.

Epigram: The story of Prometheus's suffering teaches us to have compassion for the unfortunate.
Whitney, p. 75.
Motto: "O vita, misero longa."
Icon: Prometheus is chained to a rock; an eagle eats his liver.
Epigram: Prometheus's suffering is an emblem of grief: this state of mind, characterized by continual sorrow, care, and the pangs of conscience, is a living death.
See also:

EAGLE AND PROMETHEUS
Thynne, no. 39.

PROPHET
See:

CANDLE, PROPHET, SEAL
Willet, no. 35.

PROTEUS
Thynne, no. 42.
Motto: "Eloquence."
Icon: None.
Epigram: As Proteus can change his body into many different shapes, so eloquence can change the minds of men.

PROWESS
Whitney, p. 30.
Motto: "In victoriam dolo partem."
Icon: The female figure of prowess sits on the tomb of Ajax and tears out her hair.
Epigram: Prowess mourns over the death of Ajax, caused by the wrongful judgment which awarded Ulysses the arms of Achilles; thus man should be aware of the consequences of faulty judgment.

PRUNED TREE
Peacham, p. 192.
Motto: "Unum alam."
Icon: A tree has its lower branches cut off.
Epigram: As the husbandman prunes the excess branches from a tree, so man should rid himself of empty wit.

PUFFBALL
See:

MUSHROOM BALL AND SMOKE
Wither, p. 85.

PULLING
See:

TAIL OF HORSE
Combe, no. 55.

PUMP
Jenner, no. 2.
Motto: "The way to get Riches."
Icon: A maiden stands at a water pump.

Epigram: The maiden who has half a pail of water and needs more wisely throws what she has into the pump so that she can draw all she needs from it; so men should give what riches they have to the poor, and they will be recompensed many times over.

PURPLE
Astry, no. 16.
Motto: "Purpura juxta purpuram."
Icon: Two bolts of purple cloth lie on a table.
Epigram: The saying "Purple is to be judged by Purple" teaches princes to compare their actions with their ancestors, not with unequals.

PURPLE FISH
See:
TONGUE OF PURPLE FISH
P. S., p. 107.

PURSE
Peacham, p. 53.
Motto: "Regia liberalitas."
Icon: A gauntlet holds a lance on which a purse hangs upside down.
Epigram: The empty purse symbolizes the virtue of liberality.
Wither, p. 167.
R. B., no. 9.
Motto: "Poore-Theeves, in Halters, we behold, And, great-Theeves, in their Chaines of gold."
Icon: A man holds two purses; in the background criminals are being executed.
Epigram: Poor thieves are hanged, but privileged men, though more guilty of theft, flourish.
See also:
AVARICE AND CUPID
Van Veen, p. 205.
CROWN, HALTER, PURSE
Peacham, p. 153.
HEART AND PURSE
Montenay, p. 138.
IDOL AND PURSE
Montenay, p. 314.
MATTOCK AND PURSE
Peacham, p. 179.
MELANCHOLY
Peacham, p. 126.
See also: MONEYBAG.

PYGMY
See also:
HERCULES
Whitney, p. 16.

PYGMY ON STILTS
Wither, p. 14.

R. B., no. 8.
Motto: "Though he endeavour all he can, An Ape, will never be a Man."
Icon: A pygmy on stilts looks at himself in a mirror.
Epigram: The man who tries to be what he is not is foolish, like the pygmy trying to be a giant.

PYRAMID
Peacham, p. 201.
Motto: "Minimus in summo."
Icon: A pyramid.
Epigram: The higher you are placed, the less you should let position affect you.
Wither, p. 218.
Motto: "True Vertue, whatsoere betides, In all extreames, unmoov'd abides."
Icon: A pyramid hangs in the sky above a stormy sea and rocks.
Epigram: Virtuous men are like the firm pyramid or the sturdy rocks in a raging sea; they are firm, unmoving, and unshaken by fortune.
See also:
GLORY
Peacham, p. 21.
IVY AND PYRAMID
Wither, p. 226.

PYRAMUS AND THISBE
Wither, p. 33.
R. B., no. 29.
Motto: "True-Lovers Lives, in one Heart lye, Both Live, or both together Dye."
Icon: Thisbe discovers the corpse of Pyramus.
Epigram: True lovers share one heart; if one dies, the other must.

PYTHON
See:
CUPID, PHOEBUS, PYTHON
Van Veen, p. 21.

Q

QUADRANT
See:
CANNON AND QUADRANT
Astry, no. 4.

QUAIL
Willet, no. 73.
Motto: "Nimium ne laetare secundis."
Icon: None.
Epigram: When God sent quail for the Israelites,

they greedily devoured them; God then sent a plague to punish their greed.

Quarrel
See: FIGHT, STRIFE.

QUEEN
See:
SPOUSE OF CHRIST
Bunyan, no. 58.
See also: MONARCH.

QUICK
See:
DEAD BOUND TO QUICK
Whitney, p. 99.

QUILL
Whitney, p. 143.
Motto: "Vindice fato."
Icon: A hand reaches for a quill.
Epigram: Emperor Valens picked up his pen to sign the warrant exiling Saint Basil, but God prevented him from writing. This story cautions man to fear God.

See also:
REWARD
Peacham, p. 121.
See also: PEN.

QUINCE
See:
MATRIMONY
Peacham, p. 132.

QUINCTILIUS [QUINTILIAN]
Whitney, p. 185.
Motto: "Scripta non temere edenda."
Icon: Quinctilius holds back a younger man from handing the youth's writing to Fame, a winged figure holding a trumpet.
Epigram: Do not rush to finish or to publish because you desire fame; true fame comes to the man who disciplines himself to revise and rework.

QUIVER
See:
CUPID AND SEA
Van Veen, p. 93.

R

RABBIT
Ayres, no. 4.
Motto: "The timerous Adventurer."
Icon: A rabbit holds onto the end of a rope which Cupid carries.

Epigram: Love rewards the bold, not the fearful.
See also:
LIGHTNING
Arwaker, bk. 2, no. 4.
See also: CONY, HARE.

RACE
Ayres, no. 39.
Motto: "Won by Subtilty."
Icon: In the middle of a race Atalanta stoops to pick up golden pippins (apples) that Hippomenes drops, thus losing to him.
Epigram: A man can win the race of love through bribery and guile.
See also: RUNNING.

RAIN
See:
CORN AND RAIN
Astry, no. 41.
SIEVE
Wither, p. 20.
R. B., no. 25.
SUN AND WIND
Van Veen, p. 125.

RAIN AND RAINBOW
Peacham, p. 77.
Motto: "Cum severitate lenitas."
Icon: A rainbow forms in the sky as rain falls.
Epigram: The rain represents God's punishment; the rainbow, His mercy.

RAIN AND SQUIRREL
Wither, p. 26.
Motto: "With Patience, I the Storme sustaine, For, Sun-shine still doth follow Raine."
Icon: A squirrel sits on a log in the rain and eats.
Epigram: As the squirrel endures the rain in its search for food, so man should have patience to endure suffering and adverse fortune.

RAINBOW
Hawkins, no. 9, p. 92.
Motto: "Pacis fero Signa futurae."
Icon: A rainbow.
Epigram: The radiance and the colors of the rainbow are likened to the Virgin Mary.
Hawkins, no. 9, p. 100.
Motto: "Apparebit arcus meus innubibus et recordabor foederis mei."
Icon: A kneeling man prays to a kneeling woman at the foot of a rainbow; Christ on the Cross is within another rainbow.
Epigram: The Virgin Mary is like a rainbow in the sky when the sinner sues for mercy; Christ appears to the Virgin as a rainbow in the

sky who pardons the sinner through his suffering.

P. S., p. 76.
 Motto: "The rainebow doth bring faire weather."
 Icon: A rainbow shines in the rain.
 Epigram: The rainbow is a sign of peace and tranquillity.

Wither, p. 240.
 Motto: "Let none in troublous times repine;
 For, after Stormes, the Sun will shine."
 Icon: A rainbow appears over storm clouds, and the sun shines above.
 Epigram: The rainbow brings promise of the sun after a storm; so man should have hope that God will relieve his sorrows.

See also:
 RAIN AND RAINBOW
 Peacham, p. 77.

RAKE
See:
 PITCHFORK, RAKE, SICKLE
 Peacham, p. 150.

RAM
P. S., p. 358 (misnumbered 458).
 Motto: "Furor fit laesa sepius patientia."
 Icon: A ram pursues a man.
 Epigram: The ram which attacks the man signifies that patience, if goaded, will turn to fury.

See also:
 TOMB OF LAIS
 Thynne, no. 54.
See also: SHEEP.

RAM AND WALL
Astry, no. 71.
 Motto: "Labor omnia vincit."
 Icon: An engine called a "ram" breaks a fortress-like wall.
 Epigram: As the continued force of the ram will break even the thickest wall, so labor and diligence can overcome any obstacle.

Rapier
See: SWORD.

RAT
See also:
 CANDLE AND RAT
 Farlie, nos. 13, 19.

RATTLE
See also:
 PLANT AND TAPER
 Quarles, *Hier.*, no. 9.

RAVEN
Willet, no. 45.

 Motto: "Deus nunquam suos deserit."
 Icon: None.
 Epigram: As a mother raven provides for her helpless young ones, so God provides for man.

Willet, no. 46.
 Motto: "Verbo Dei vivitur, non pane."
 Icon: None.
 Epigram: As ravens brought Elias food to sustain him, so God provides for those who trust in him.

See also:
 CARRION AND RAVEN
 Montenay, p. 206.
 HELMET AND RAVEN
 P. S., p. 133.
 Whitney, p. 113.
 NUT, RAVEN, STONE
 Montenay, p. 94.

RAVEN AND SNAKE
Combe, no. 56.
 Motto: "More die with surfet at their boord,
 Then in the warres with dint of sword."
 Icon: A raven devours a snake.
 Epigram: Although the raven enjoys eating the snake, it regrets its feast when the poison kills it; so gluttony seems to be pleasurable but in fact kills.

RAVEN, STONE, WATER
P. S., p. 179.
 Motto: "Ingenii largitor."
 Icon: A raven drops stones into a vessel of water.
 Epigram: When the raven needed water, it dropped stones into a vessel so that the water would rise to the top; this story shows how necessity stirs men to craft and policy.

RAVEN, TREE, WOLF
Montenay, p. 58.
 Motto: "Ex parvo satis."
 Icon: Ravens and wolves build a fire and use a bellows to kindle it; a tree quenches the fire with blood.
 Epigram: Although evil seeks to do harm, Christ's sacrifice prevents it and protects men.

RAZOR
See:
 FLINT AND RAZOR
 Combe, no. 33.
 OCCASION
 Whitney, p. 181.
 Wither, p. 4.
 R. B., no. 41.
See also: KNIFE.

REDBREAST
See:
BIRD
Whitney, p. 55.

REED AND THORN
P. S., p. 300.
Motto: "Victo seculo."
Icon: A garland of thorns surrounds a reed.
Epigram: The thorns and reed represent the passion of Christ.

REINS
See:
SHIP AND WORLD
Whitney, p. 203.

REMORA
Thynne, no. 33.
Motto: "Povertie."
Icon: None.
Epigram: As the remora fish prevents the ship from sailing into port, so poverty prevents the virtuous mind from realizing the fruit of its labors.
See also:
ARROW AND ECHENEIS
Whitney, p. 188.
See also: ECHENEIS.

REPENTANCE
Peacham, p. 46.
Motto: "Poenitentia."
Icon: The female figure of Repentance sits alone, looks at a fountain, and holds a fish in one hand and birch switches in the other.
Epigram: Repentance grieves for her sins, chastises her body, and wears green as a sign of her hope.

Reptile
See: ADDER, CROCODILE, DRAGON, FROG, HYDRA, LIZARD, PYTHON, SALAMANDER, SERPENT, SNAKE, TORTOISE, TURTLE, VIPER, WORM.

REST
See:
HEART AND REST
Harvey, no. 40.

Retribution
See: NEMESIS.

REWARD
Peacham, p. 121.
Motto: "Dii laboribus vendunt."
Icon: A hand holds jewels, a crown, a scepter, a garland, herbs, and a quill.
Epigram: Labor is rewarded by precious things of the earth including the quill of fame.

RHINOCEROS
Peacham, p. 106.
Motto: "Non invicta recedo."
Icon: A rhinoceros has an armorlike skin.
Epigram: Dedicated to Hannibal Baskerville, this emblem urges him to be like the rhinoceros who in battle is either victorious or killed, but never vanquished.

RICH
See:
DOOR
Whitney, p. 204.

RICHES
See:
BRYSUS
Peacham, p. 151.
CAMEL
Peacham, p. 125.
TRADE
Ayres, no. 40.
TREAD UPON
Ayres, no. 28.
See also: COIN, GOLD, MAMMON, MONEY, TREASURE.

RICH MAN
Montenay, p. 178.
Motto: "Propterea captivus, ductus est populus."
Icon: A rich man turns from a table laden with food and points to gold and material objects.
Epigram: Rich men are obsessed with their gold, cannot eat for grief, and dread death.
See also:
POOR MAN AND RICH MAN
P. S., p. 362.

RIDER
See:
HORSE AND RIDER
Bunyan, no. 41.
Peacham, p. 17.
Whitney, p. 38.
Willet, no. 85.

RING
Peacham, p. 87.
Motto: "Una dolo Divûm."
Icon: A banner is threaded through a ring.
Epigram: Dedicated to Lady Alicia D., the poem likens the counterfeit jewel in the ring to the lady's husband who betrayed her.
See also:
CUPID, MASK, RING
Van Veen, p. 54.
DART AND RING
P. S., p. 284.

DOLPHIN, GLOBE, RING
P. S., p. 327.

FINGER AND RING
Combe, no. 9.

FISH AND RING
P. S., p. 99.

MEASURE AND RING
Bunyan, no. 72.

MOON AND SUN
P. S., p. 332.

OLIVE TREE, RING, TURTLEDOVE
Peacham, p. 92.

PIG AND RING
P. S., p. 106.

RING AND SWINE
Combe, no. 24.
 Motto: "All things out of order runne,
 That are without decorum done."
 Icon: A ring in a swine's snout.
 Epigram: The gold ring in the swine's snout violates
 decorum.
Wither, p. 224.
 Motto: "Her favours, Fortune, oft imparts,
 To those that are of no deserts."
 Icon: A swine wears a jeweled ring in its snout.
 Epigram: Fortune often favors the undeserving, who
 resemble the swine which wears a diamond
 or a pearl in its snout.

RINGDOVE
Whitney, p. 29.
 Motto: "Amor in filios."
 Icon: A ringdove sits in a nest in a bare tree.
 Epigram: The ringdove pulls her own feathers
 to keep her brood warm and risks her
 own life to protect her young from harsh
 weather; she represents the good mother.
See also: DOVE.

RING OF MARGARITES
See:
 CROSS, CROWN, RING OF MARGARITES
 P. S., p. 323.

RISING AND SEEKING
Arwaker, bk. 2, no. 11.
 Motto: "I will rise, and go about the City in the
 streetes, and in the broad ways I will seek
 him whom my Soul loveth: I sought him,
 but I found him not."
 Icon: Rising from his bed, a human figure seeks
 Divine Love, who hides behind the bed.
 Epigram: The speaker futilely searches for God in
 bed and in the streets.
Quarles, *Emb.*, p. 224.
 Motto: "I will rise now & goe about the citie in
 the Streetes & in the broad wayes I will

seeke him whom my Soule loveth I sought
him but I found him not."
 Icon: Rising from his bed, a human figure seeks
 Divine Love, who hides behind the bed.
 Epigram: The speaker futilely searches for Christ
 and then finds him in his own troubled
 breast.

RIVER
Astry, no. 90.
 Motto: "Disjunctis viribus."
 Icon: A river divides into many branches.
 Epigram: Division is the most effective means to de-
 stroy any power.
Willet, no. 20.
 Motto: "Evangelium potentia Dei est ad salutem."
 Icon: None.
 Epigram: Just as the river flows from the altar, in-
 creases, and nourishes trees, so God's Word
 prevails.

Robber
See: THIEF.

ROBE
See:
 HYPOCRITE
 Peacham, p. 198.

ROCK
Whitney, p. 96.
 Motto: "Petre, imitare petram."
 Icon: A rock stands firm as the winds and sea
 rage around it.
 Epigram: The virtuous man will stand as firmly as
 this rock does in the storm.
See also:
 CASPIAN SEA
 Peacham, p. 27.
 HALCYON'S NEST AND ROCK
 Wither, p. 236.
 KNIFE AND ROCK
 P. S., p. 231.
 PYRAMID
 Wither, p. 218.
 SIN
 Peacham, p. 146.
 VIRTUE
 Montenay, p. 270.
See also: STONE.

ROCK AND SEA
Van Veen, p. 227.
 Motto: "Love never untroobled."
 Icon: The sea lashes a rock as a man on shore
 grieves.
 Epigram: As the sea beats against the rock, so
 thoughts trouble the lover's mind.

ROCK, SEA, SHIP
Peacham, p. 158.
 Motto: "Nec igne, nec unda."
 Icon: The sea surrounds a rock and a burning ship.
 Epigram: The sea represents the world; the ship, opinion; its flames, hot passion; the rock, manly constancy.

ROD
See:
 CHAIN AND POLEAX
 P. S., p. 71.
 FLASK, ROD, WOMAN, WORLD
 Peacham, p. 119.
 LIGHTNING AND ROD
 Arwaker, bk. 2, no. 4.
 Quarles, *Emb.*, p. 196.
See also: STAFF, WAND.

ROD AND WHEEL
Montenay, p. 154.
 Motto: "Frangor patientia."
 Icon: A hand in the clouds holds rods and breaks a wheel.
 Epigram: God sometimes sends bad fortune and suffering to try men.

ROD AND WOMAN
Wither, p. 93.
R. B., no. 14.
 Motto: "Behold, you may, the Picture, here, Of what, keepes Man, and Childe, in Feare."
 Icon: A woman holds a birch rod.
 Epigram: The rod and the woman represent man's afflictions.

ROD OF AARON
P. S., p. 142.
 Motto: "Semine ab aethereo."
 Icon: A hand holds the rod of Aaron, which buds and bears fruit.
 Epigram: The rod of Aaron alone of the rods of the Israelites budded and bore fruit.

ROE
Arwaker, bk. 3, no. 15.
 Motto: "Make haste, my Beloved, and be like the Roe or the young Hart upon the Mountains of Spices."
 Icon: A roe runs up a mountain while a human figure gestures to Divine Love.
 Epigram: When the soul parts with Divine Love, it urges him to flee and return quickly.
Quarles, *Emb.*, p. 300.
 Motto: "Make hast my Beloved, and be Thou like to a Roe, or to a yong Hart upon the Mountaines of Spices."

 Icon: A roe runs up a mountain while a human figure gestures to Divine Love.
 Epigram: When the soul parts with Divine Love, it urges him to flee and return quickly.
See also: BUCK, DEER, HART, HIND, STAG.

Roman Catholic Church
See: ANTI-CHRIST, CATHOLIC CLERIC, NUN, PAPAL CROWN, PRIEST, SEVEN-HEADED BEAST, WHORE OF BABYLON.

Rooster
See: COCK.

ROPE
See:
 ASS AND OCNUS
 Whitney, p. 48.
 CROSS AND HAND
 Wither, p. 75.
 DRAWING AND RUNNING
 Quarles, *Emb.*, p. 212.
 FORTUNE AND POVERTY
 Peacham, p. 194.
See also: CORD, HALTER.

ROPE AND SWORD
P. S., p. 293.
 Motto: "Discite justitiam moniti."
 Icon: A rope is fastened to a sword.
 Epigram: The rope fastened to a sword was used by a king to signify his judgment, which did not spare even his own son.
Wither, p. 66.
 Motto: "Marke, what Rewards, to Sinne, are due, And, learne, uprightnesse to pursue."
 Icon: A rope entwines a sword.
 Epigram: The rope and sword warn man of God's punishment of the sinner.

ROSARY
See:
 HYPOCRITE
 Peacham, p. 198.

ROSE
Ayres, no. 17.
 Motto: "The difficult Adventure."
 Icon: Cupid picks a rose.
 Epigram: As the thorn of a rose pricks the person who picks the flower, so love is dangerous and hurts the lover.
Hawkins, no. 2, p. 17.
 Motto: "Casto Perfusa rubore."
 Icon: A rose is encircled by a serpent biting its tail.
 Epigram: The rose is a symbol of the Virgin Mary.
Hawkins, no. 2, p. 25.
 Motto: "Pulchra es speciosa et macula non est inte."

Icon: Three roses stand beneath Hebrew letters,
 a dove, bleeding hands, a heart, and feet.
Epigram: The Virgin Mary was a pure-white rose;
 the Holy Ghost impregnated her, making
 her "a Damask firie-bright," and her Son
 shed his blood on the Cross, making her
 "purple red."

Peacham, p. 100.
 Motto: "Sic et Ingenium."
 Icon: A rose.
 Epigram: As a garden rose, untended, grows wild
 and common, so men with natural ability
 who are slothful grow rank and rude.

Peacham, p. 133.
 Motto: "Sed frigida pulchra."
 Icon: A hand holds a rose.
 Epigram: Lesbia is like a rose, beautiful but cold.

Whitney, p. 165.
 Motto: "Post amara dulcia."
 Icon: A man reaches for a rose growing on a
 thorny bush.
 Epigram: Though a man may prick his finger pick-
 ing a rose, he believes the beauty of the
 rose is worth the pain; so in life, pleasure
 comes after toil and pain.

See also:
 BEETLE AND ROSE
 P. S., p. 274.
 CROSS, LAUREL BOUGH, ROSE
 P. S., p. 259.
 DAMASK ROSE
 Thynne, no. 27.
 HEART AND ROSE
 H. A., p. 159.
 SCARABEE
 Whitney, p. 21.

ROSE AND THISTLE
Peacham, p. 12.
 Motto: "Quae plantavi irrigabo."
 Icon: A thistle and a rose grow in the same spot,
 as a hand from a cloud waters both.
 Epigram: Just as the thistle and the rose grow
 together, favored by heaven, so England
 thrives under its king.

ROSE AND THORN
Van Veen, p. 161.
 Motto: "No pleasure without payn."
 Icon: Cupid plucks a rose on a thorny bush.
 Epigram: In plucking a rose, man is pricked by the
 thorn; in attaining love, he experiences
 pain.

ROSE BUSH
Astry, no. 34.
 Motto: "Ferendum et sperandum."
 Icon: A potted rosebush is watered.

Epigram: The rosebush, with its ugly thorns, re-
 quires patience and care before it produces
 the beautiful rose; so, too, most things in
 government appear difficult at first, but,
 with the prince's patience and care, they
 yield much.

Bunyan, no. 34.
 Motto: "Of the Rose-bush."
 Icon: None.
 Epigram: The bush with its thorns represents Adam's
 race; the beautiful rose it produces repre-
 sents Christ.

Combe, no. 19.
 Motto: "No man reapes the pleasant graine,
 But with travell and with paine."
 Icon: A rosebush.
 Epigram: As the rose rises from the thorny stem, so
 all pleasure comes from labor and care.

Combe, no. 30.
 Motto: "There is no sweet within our powre,
 That is not sauced with some sowre."
 Icon: A man plucks a rose from a bush.
 Epigram: As the rose grows on a thorny bush, so
 pleasure is accompanied by pain.

Montenay, p. 294.
 Motto: "Ex malo bonum."
 Icon: A man picks a rose from a bush.
 Epigram: Like the rosebush, which is beautiful but
 thorny, the falsehearted man appears good
 but is harmful.

See also:
 CROWN AND BIRD
 Peacham, p. 124.

RUIN
See:
 BOOK AND RUIN
 Whitney, p. 131.
 SKULL
 Astry, p. 384.

RUIN, TAPER, TREE TRUNK
Quarles, *Hier.*, no. 15.
 Motto: "Plumbeus in terram."
 Icon: A taper stands in an urn with the roman
 numeral *70* in a small segment which has
 not yet burned; on one side a bird carries a
 fish; beside it are a bare tree trunk and a
 ruined building.
 Epigram: In the seventh and last decade of life man
 is like the ruined building and the barren
 tree trunk.

RULE AND SCALE
Wither, p. 100.
 Motto: "False Weights, with Measures false
 eschew,
 And, give to ev'ry man, their Due."

Icon: A hand holds a rule and a scale.

Epigram: Man should give every man his due.

RUMICE

P. S., p. 352.

Motto: "Virescit vulnere virtu."

Icon: A man treads the herb rumice.

Epigram: Like the herb rumice, or dock, which
 flourishes the more it is trodden, the
 virtuous man flourishes the more he is
 persecuted.

See also: DOCK.

RUN

See:

 DEER

 Arwaker, bk. 3, no. 15.

RUNNING

See:

 DRAWING AND RUNNING

 Arnaker, bk. 2, no. 8.

 Quarles, *Emb.*, p. 212.

See also: FLEEING, RACE.

RUST

See:

 CANDLE AND RUST

 Farlie, no. 12.

S

SACK

See:

 THIEF

 Whitney, p. 41.

SACRAMENT

Bunyan, no. 14.

Motto: "Upon the Sacraments."

Icon: None.

Epigram: The sacraments of Baptism and the Last
 Supper are divine mysteries, but they
 cannot ransom man or save him from the
 curse.

SACRIFICE

Willet, no. 52.

Motto: "Oblatio impii abominatio Jehovae."

Icon: None.

Epigram: As God refused the sacrifices of Nadab and
 Abihul and sent fire to destroy these men,
 so he refuses insincere prayer.

See also:

 HEART AND SACRIFICE

 Harvey, no. 19.

SAFFRON

Combe, no. 97.

Motto: "Constancie hath most renoune,
 When crosses most do beate us doune."

Icon: A man treads saffron under his feet.

Epigram: The more saffron is trodden, the more
 it flourishes; so, too, the more the vir-
 tuous mind is oppressed, the stronger it
 becomes.

See also:

 BEEHIVE, CROCODILE, SAFFRON

 Peacham, p. 154.

SAGE

Whitney, p. 130.

Motto: "Dicta septem sapientum."

Icon: The name of each of the seven sages is
 paired with an image: Cleobulus and a bal-
 ance; Chilon and a glass; Periander and an
 herb; Pittacus and a flower; Solon and a
 pillar; Bias and a man on an ass; Thales
 and a bird in a net.

Epigram: Each of these images signifies the wisdom
 of the sage.

Whitney, p. 135.

Motto: "In studiosum captum amore."

Icon: An older man sits on a throne, surrounded
 by Cupid, Venus, Pallas, and a woman.

Epigram: Love makes the sage put away his books
 and dote on a woman.

SAIL

See:

 FORTUNE

 Combe, no. 20.

 OAR AND SAIL

 Combe, no. 43.

 SHIP

 Wither, p. 13.

SAILING

Van Veen, p. 243.

Motto: "It is good sayling before the wynd."

Icon: Lovers sail in a boat piloted by Cupid and
 blown by the wind.

Epigram: Good sailing is likened to happiness in
 love.

Sailor

See: MARINER.

SALAMANDER

P. S., p. 17.

Motto: "Nutrisco, & extinguo."

Icon: A crowned salamander lies in a fire.

Epigram: The salamander, the device of Francis,
 King of France, is so cold that it can ex-
 tinguish a fire by lying in it; it represents

the desire of the king to nourish the virtuous and destroy the wicked.

See also:

FIRE AND SALAMANDER
Van Veen, p. 229.
Wither, p. 30.

SALT AND TURTLEDOVE
Peacham, p. 59.
Motto: "Nil inde insipidum."
Icon: A turtledove sits on a saltcellar.
Epigram: The turtledove represents silence; the salt reminds man that he should season his talk and not speak idly.

SANGUINE
Peacham, p. 127.
Motto: "Sanguis."
Icon: A youth with a garland of flowers plays a lute; behind him a goat eats from a grapevine.
Epigram: The sanguine loves music and merriment, is prone to women and wine, and is a friend of the learned.

SARDANAPALUS
Thynne, no. 10.
Motto: "Sotted love."
Icon: None.
Epigram: Man should resist the bewitchment of women, and avoid becoming like Sardanapalus, who gave up his kingdom for love.

SATAN
See:

BOOK
Whitney, p. 166.
BOOK AND SATAN
Montenay, p. 318.
BOWLING
Quarles, *Emb.*, p. 40.
BUCKLER AND WORLD
Montenay, p. 362.
HEART AND SATAN
Montenay, p. 146.
See also: DEVIL.

SATYR
See:

BLOWING
Whitney, p. 160.

SCAEVOLA
See:

FIRE, HAND, SWORD
Whitney, p. 111.

SCALE
Wither, p. 95.

Motto: "What ever God did fore-decree,
 Shall, without faile, fulfilled be."
Icon: A hand holds a perfectly balanced scale.
Epigram: This "Even-Skale" represents "that Fate which God weighs forth to all."

See also:

RULE AND SCALE
Wither, p. 100.
See also: BALANCE.

SCALE AND WAX
Thynne, no. 47.
Motto: "Poetrye."
Icon: None.
Epigram: As the gold scale imprints its figure in wax, so the golden poet engraves his passions in the mind of the reader.

SCALLOP SHELL
Astry, no. 23.
Motto: "Pretium virtutis."
Icon: A scallop shell hangs from the sky.
Epigram: The badge of the Order of Saint James is a scallop shell, which is "inur'd to Fatigues," having endured the buffets of the sea; within the shell is a pearl, an emblem of virtue.

Scarab
See: SCARABEE.

SCARABEE
Whitney, p. 21.
Motto: "Turpibus exitium."
Icon: A scarab on a rose.
Epigram: The scarab cannot bear the beautiful scent of the rose; instead, it lives in dung. The scarab is like those who delight in filth and baseness and cannot bear good advice.

See also: BEETLE.

SCARF
See:

FORTUNE
Wither, p. 174.

SCEPTER
Astry, no. 18.
Motto: "A deo."
Icon: A hand holds a scepter on top of which is the moon, the sun, and the world.
Epigram: The scepter represents the king's rule; the moon, the king; the sun, God, from whom the king receives his light; the world, the empire.

See also:

AESCULAPIUS
Whitney, p. 212.
BRITAIN
Peacham, p. 108.

BUBBLE AND TOY
Hall, p. 4.
CROWN AND SCEPTER
Wither, p. 78 (misnumbered p. 66).
CROWN, FOWL, SCEPTER
Wither, p. 67.
DEATH AND SCHOLAR
Wither, p. 1.
R. B., no. 3.
DEATH'S-HEAD, MATTOCK, SCEPTER
P. S., p. 373 (misnumbered p. 273).
DIANA
Hawkins, no. 10, p. 111.
DOG, HARE, SCEPTER
Combe, no. 92.
DRAGON
Peacham, p. 30.
EYE AND SCEPTER
Astry, no. 55.
GLASS, HOURGLASS, SCEPTER, SERPENT
Astry, no. 28.
KING
Wither, p. 31.
R. B., no. 35.
LEARNING
Peacham, p. 26.
LION
Peacham, p. 107.
NAKED MAN
Wither, p. 12.
R. B., no. 4.
REWARD
Peacham, p. 121.
TOMB
Astry, no. 101.
WOMAN
Wither, p. 7.
R. B., no. 16.
See also: MACE.

SCEPTER AND SUN
Peacham, p. 105.
 Motto: "Εἰς γόιξανθ ἤσω."
 Icon: The sun on top of a scepter.
 Epigram: As the sun is without peer among stars, so
 the monarch, though the vulgar plot his
 overthrow.
Wither, p. 223.
 Motto: "The King, his pow'r from God receives:
 For, hee alone the Scepter gives."
 Icon: The sun shines on a scepter in the sky.
 Epigram: The king receives his power from God.

SCEPTER, SKULL, SPADE
Wither, p. 48.
 Motto: "In Death, no Difference is made,
 Betweene the Scepter, and the Spade."

 Icon: A skull sits on a worm-infested grave on
 which lie a scepter and a spade.
 Epigram: Death makes no distinction between the
 king and the beggar.

SCHOLAR
See:
 BOOK
 Whitney, p. 171.
 DEATH AND SCHOLAR
 Wither, p. 1.
 R. B., no. 3.
 H. A., p. 122.
See also: STUDENT.

SCHOLAR AND SOLDIER
Godyere, no. 30.
 Motto: "Virtus unita fortior."
 Icon: A male figure is dressed partly in a
 scholar's robe and partly in a soldier's uni-
 form; he holds a book and a lance.
 Epigram: When virtues are joined, they are strength-
 ened.
See also: DIOMEDES AND ULYSSES, MARS AND MERCURY.

SCIENCE
Godyere, no. 19.
 Motto: "Ordine tempo numero emisura."
 Icon: A female figure of science holds a book in
 one hand, a compass in the other.
 Epigram: Science combines theory and practice.

Scissors
See: SHEARS.

SCORPION
Astry, no. 52.
 Motto: "Mas que en la tierra nocivo."
 Icon: A scorpion in the sky.
 Epigram: The scorpion does not lose its malignity
 when it is placed in the sky but extends
 its "venomous Influences"; therefore, the
 prince should be careful to raise only the
 virtuous and trustworthy.
See also:
 FISHERMAN AND SCORPION
 Combe, no. 23.

SCOURGE
See:
 ASS AND STAG
 Quarles, Emb., p. 52.
 CUPID AND ENVY
 Quarles, Emb., p. 20.
 CUPID AND SCOURGE
 Van Veen, p. 69.
 DILIGENCE AND IDLENESS
 Combe, no. 100.
 HEART AND PILLAR
 Harvey, no. 43.

HEART AND SCOURGE
Harvey, no. 44.
MILLWHEEL AND SCOURGE
Arwaker, bk. 1, no. 4.
Quarles, *Emb.*, p. 136 (note: second of two pages numbered 136).
See also: WHIP.

SCREEN AND TAPER
Quarles, *Hier.*, no. 5.
 Motto: "Te auxiliante resurgo."
 Icon: An angel holds a screen up to the flame of a taper, protecting it from the wind.
 Epigram: God protects man from the evil of earthly life.

SCROLL
See:
 FAME AND VIRTUE
 Peacham, p. 35.

SCYTHE
Jenner, no. 13.
 Motto: "Some time spent in *holy duties*, hinder not a mans perticular calling."
 Icon: A man whets a scythe.
 Epigram: The husbandman who takes time to whet his scythe will be able to perform his work more efficiently; so the Christian who spends time in holy duties will thrive.
See also:
 CHARIOT AND SCYTHE
 Astry, no. 64.
See also: SICKLE.

SEA
Hawkins, no. 20, p. 234.
 Motto: "Abamaro maria mari Maria."
 Icon: The sea.
 Epigram: The Virgin Mary is likened to "a Sea of bitternes."
Hawkins, no. 20, p. 242.
 Motto: "Spiritus Domini ferebatur super aquas."
 Icon: A dove flies over a sea in which fish swim.
 Epigram: The Virgin Mary is like the sea at Creation, when the Holy Ghost fertilized the waters.
Whitney, p. 129.
 Motto: "Constanter."
 Icon: The sea floods the earth.
 Epigram: As the sea continually threatens to overrun the land, so Satan continually threatens man's soul.
See also:
 ARROW AND SEA
 Whitney, p. 72.
 BOAT

Wither, p. 221.
CORAL
Astry, no. 3.
CUPID AND SEA
Van Veen, p. 93.
CUPID, SEA, SHELL
Van Veen, p. 203.
HALCYON'S NEST AND ROCK
Wither, p. 236.
ISTHMUS
Astry, no. 95.
PYRAMID
Wither, p. 218.
ROCK
Whitney, p. 96.
ROCK AND SEA
Van Veen, p. 227.
ROCK, SEA, SHIP
Peacham, p. 158.
WATER
Jenner, no. 3.

SEA AND SHIP
Van Veen, p. 109.
 Motto: "Where the end is good all is good."
 Icon: A ship is battered by the sea while Cupid watches from the shore.
 Epigram: If a ship fails to reach its destination, its struggle in the sea is futile; so, too, with love.

SEA AND SHIPWRECK
Arwaker, bk. 1, no. 11.
 Motto: "Let not the water-flood drown me, neither let the deep swallow me up."
 Icon: Divine Love on the shore reaches toward a shipwrecked man in the sea.
 Epigram: Man is like a ship, tossed in the sea of the world by a storm of passions; the speaker asks God to be his pilot.
Quarles, *Emb.*, p. 164.
 Motto: "Let not the water-flood overflow me, neither let the deepe swallow me up."
 Icon: Divine Love rescues a man from the sea.
 Epigram: The world is a sea; man's flesh, a leaking ship; heaven, the port. The speaker asks God for guidance on his voyage through life.

SEA AND WIND
Van Veen, p. 143.
 Motto: "After a tempest a calme."
 Icon: Cupid sits on the shore while winds rage at sea.
 Epigram: As the sea is not still until the winds stop, so the lover's mind is not calm until envy ceases.

SEA HORSE
See:

 CROWN, SEA HORSE, STORK
 Wither, p. 155.

SEAL
P. S., p. 322.
 Motto: "Huc cursus fuit."
 Icon: A seal shows a man being saved from danger.
 Epigram: The seal expresses a particular man's happiness upon being received into the service of the duke of Savoy.
See also:

 CANDLE, PROPHET, SEAL
 Willet, no. 35.
See also: SIGNET.

Search
See: SEEKING.

SEED
Ayres, no. 1.
 Motto: "The marvellous Seed of Love."
 Icon: Cupid sows a field with seeds, as heads spring from the ground.
 Epigram: The power of love transforms us, giving us new souls and improving our wits.
P. S., p. 320.
 Motto: "Spes altera vitae."
 Icon: Plants drop seeds to the ground.
 Epigram: As seeds are cast into the ground but spring to life again, so man's body is buried but will be resurrected.
See also:

 HEART AND SEED
 Harvey, no. 28.

SEEKING
Willet, no. 28.
 Motto: "Pii Deo ut pupilla oculi."
 Icon: None.
 Epigram: When the housewife loses a silver groat, she looks everywhere until she finds it; so, too, God seeks out the wicked and the good.
See also:

 RISING AND SEEKING
 Arwaker, bk. 3, no. 7.
 Quarles, *Emb.*, p. 224.

SELF-LOVE
Peacham, p. 5.
 Motto: "Philautia."
 Icon: A woman in fancy clothes has a serpent wound on her arm and holds a mirror.
 Epigram: This woman represents self-love: the gay dress indicates her merry state of mind, the poisonous serpent shows the cause of her own destruction, and the mirror indicates that she is proud and blind to her own imperfections.

SEMPERVIVUM
Peacham, p. 120.
 Motto: "Vireo tamen."
 Icon: A naked boy points to a sempervivum plant hanging from a building.
 Epigram: As the sempervivum thrives even when it hangs in the air, so many men thrive though the world gives them nothing.
See also:

 HAND AND SEMPER VIVEUM
 P. S., p. 351.

SENSE
See:

 DEVIL
 Quarles, *Emb.*, p. 60.

SEPULCHRE
See:

 BOUGH, DART, SEPULCHRE
 P. S., p. 59.
See also: TOMB.

SERPENT
Astry, no. 44.
 Motto: "Nec a ovo nec ad ovem."
 Icon: A serpent.
 Epigram: As the serpent moves first one way and then another, its intention unintelligible, so the prince's counsels and designs should be unknowable.
Montenay, p. 190.
 Motto: "Estote prudentes."
 Icon: A man touches a serpent with a long rod.
 Epigram: God commands man to be wise in his Holy Word and not to imitate the serpent.
Montenay, p. 194.
 Motto: "Derelinque."
 Icon: A serpent sheds its skin.
 Epigram: Like the serpent which sheds its skin, man should forsake evil.
P. S., p. 188.
 Motto: "Prohibere nefas."
 Icon: A serpent has a head at both ends.
 Epigram: A serpent with a head at both ends represents the double-faced traitor.
P. S., p. 276.
 Motto: "Unius compendium alterius dispendium."
 Icon: A serpent swallows another serpent.
 Epigram: Like the serpent which must swallow another serpent in order to become a dragon, the rich man must hinder others.

Whitney, p. 76.
 Motto: "Remedium tempestiuum sit."
 Icon: As a snake slides backward out of a crack in a walk, a man prepares to kill it with a stick.
 Epigram: Just as the prudent man strikes the snake before its poisoned head appears, so men should anticipate and prevent danger.

Whitney, p. 189.
 Motto: "In sinu alere serpentem."
 Icon: An army gathers at the gates of a city while a man holding a serpent watches from within.
 Epigram: The forces of an army are rendered useless by an "inwarde foe"—the hidden enemy who works from within.

Willet, no. 64.
 Motto: "Qui socius est in malo, consors erit in supplicio."
 Icon: None.
 Epigram: A serpent is punished for being the instrument which the devil used to tempt Adam and Eve.

See also:
 ARROW AND SERPENT
 P. S., p. 240.
 BOOK, SERPENT, SWORD
 Peacham, p. 2.
 BRASS SERPENT
 Willet, no. 51.
 BRAZEN SERPENT AND CROSS
 P. S., p. 7.
 CLOUD, LADY, SERPENT
 Van der Noodt, no. 6.
 CROWN AND SERPENT
 Peacham, p. 137.
 P. S., p. 246.
 CROWN, CROSS, SERPENT
 Wither, p. 47.
 CROWN, SEA HORSE, STORK
 Wither, p. 155.
 CUPID, ENVY, SHADOW
 Van Veen, p. 51.
 CUPID, ENVY, WAR
 Van Veen, p. 49.
 DEATH, FRUIT TREE, TAPER
 Quarles, *Hier.*, no. 14.
 DECEIT
 Peacham, p. 47.
 DOVE AND SERPENT
 Wither, p. 151.
 ELEPHANT AND SERPENT
 Whitney, p. 195.
 EVE, HEART, SERPENT
 Harvey, no. 1.

EVE, SERPENT, TREE
Quarles, *Emb.*, p. 4.
GLASS, HOURGLASS, SCEPTER, SERPENT
Astry, no. 28.
HEART AND SERPENT
Hall, p. 100.
HERCULES
Astry, no. 1.
KEY AND SERPENT
P. S., p. 94.
LAUREL TREE AND SERPENT
Wither, p. 142.
MOUNTAIN
Hawkins, no. 20, p. 231.
OLIVE BRANCH AND SERPENT
P. S., p. 291.
PALM TREE
Whitney, p. 118.
PARROT AND SERPENT
Astry, no. 79.
PIETY
Godyere, no. 12.
SELF-LOVE
Peacham, p. 5.
SIN
Peacham, p. 146.
TIME AND WISDOM
Godyere, no. 28.

See also: ADDER, DRAGON, HYDRA, PYTHON, SNAKE, VIPER.

SERPENT AND SHEPHERD
Peacham, p. 34.
 Motto: "Ex malis moribus bonae leges."
 Icon: A man kills a serpent.
 Epigram: Just as the shepherd can use the fat of this serpent to heal the poisonous wound given by the serpent, so the king can make out of vice laws which cure vice.

SERPENT AND STRAWBERRY
Whitney, p. 24.
 Motto: "Latet anguis in herba."
 Icon: A serpent winds itself around a strawberry plant.
 Epigram: As the serpent hides underneath the attractive strawberries, so the dissembler uses flattery.

SERPENT AND WASP
P. S., p. 104 (misnumbered 04).
 Motto: "Transfundit pasta venenum."
 Icon: Wasps surround a serpent.
 Epigram: Men who delight in calumny, stinging a man until he dies of sorrow, are like wasps who mercilessly sting the serpent.

SERPENT BITING TAIL
Combe, no. 83.
 Motto: "It is a point of great foresight,
 Into our selves to looke aright."
 Icon: On a pillar is a serpent biting its tail.
 Epigram: In Phoenicia the serpent biting its tail was
 raised on high to signify the ideal that man
 should know himself.

See also:
 CAGE AND HEART
 Hall, p. 44.
 CUPID AND SERPENT BITING TAIL
 Van Veen, p. 1.
 GARDEN
 Hawkins, no. 1, p. 5.
 LILY
 Hawkins, no. 3, p. 28.
 ROSE
 Hawkins, no. 2, p. 17.
 SHIP
 Hawkins, no. 21, p. 245.

SERPENT, SPADE, WREATH
Wither, p. 92.
 Motto: "Where, Labour, wisely, is imploy'd,
 Deserved Glory, is injoy'd."
 Icon: A spade stands on the top of a globe, a
 serpent biting its tail encircles it, and a
 wreath entwines the serpent.
 Epigram: Labor, represented by the spade, is guided
 by prudence, represented by the serpent,
 and achieves glory, represented by the
 wreath.

SEVEN-HEADED BEAST
Van der Noodt, no. 17.
 Motto: None.
 Icon: Men kneel to a seven-headed beast with
 ten horns and ten crowns; in the back-
 ground are a horned lamb and a seven-
 headed dragon breathing fire, flames, and
 divine figures.
 Epigram: The speaker describes in detail the Apostle
 John's apocalyptic vision.

See also:
 HORSEMAN, SEVEN-HEADED BEAST, SWORD
 Van der Noodt, no. 19.
 WHORE OF BABYLON
 Godyere, no. 21.
 Montenay, p. 302.
 Van der Noodt, no. 18.

SEVEN SAGES
See:
 SAGE
 Whitney, p. 130.

SHACKLE
See:
 BLINDFOLD AND SHACKLE
 Hall, p. 20.
 HEART
 Hall, p. 32.
See also: CHAIN, STOCK(S).

SHADE AND SUN
Combe, no. 89.
 Motto: "No shade of envy can obscure,
 The light of vertue shining pure."
 Icon: The sun shines above a man, creating a
 short shadow.
 Epigram: As the sun makes a very small shadow when
 it is directly above a man, so virtue chases
 away envy.

SHADOW
Arwaker, bk. 2, no. 14.
 Motto: "I sate down under his shadow (whom I
 loved) with great delight."
 Icon: A person sits in the shadow of a tree to
 which Divine Love is nailed.
 Epigram: The Tree of Life is the Holy Cross; its
 shadow, the "refreshment and defense of
 mankind."
Montenay, p. 242.
 Motto: "Socior blande."
 Icon: A man stands beside his shadow.
 Epigram: As his shadow follows a man whereever he
 goes, so people will follow the rich man.
Quarles, *Emb.*, p. 236.
 Motto: "I sat under the shadow of him whom I
 have desired."
 Icon: A person sits in the shadow of a tree to
 which Divine Love is nailed.
 Epigram: Man's soul takes refuge in the shadow of
 Christ, a shadow made by the conjunction
 of the sun of glory and the human body.
Whitney, p. 32.
 Motto: "In poenam sectatur & umbra."
 Icon: A man holds a drawn sword and attempts
 to slay his shadow.
 Epigram: The man with a guilty conscience fears
 everything, even his shadow.
Whitney, p. 218.
 Motto: "Mulier umbra viri."
 Icon: One man flees from his shadow; another
 pursues his shadow.
 Epigram: As our shadows disappear if we pursue
 them but follow at our heels if we flee them,
 so, too, our mistresses.

See also:
 CUPID, ENVY, SHADOW
 Van Veen, p. 51.

GLASS
Quarles, *Emb.*, p. 83.

SHAFT
Quarles, *Emb.*, p. 124.
 Motto: "Lord all my Desire is before Thee, & my
 groaning is not hid from Thee."
 Icon: A human figure kneels and exposes his
 breast; three arrows rise toward an eye and
 ears in heaven.
 Epigram: The groans of the soul are like shafts which
 pierce the eye and ears of God.
See also:
 CUPID AND SHAFT
 Van Veen, p. 215.
 EAGLE AND SHAFT
 Combe, no. 52.
 HEART AND SHAFT
 Harvey, no. 33.
 HEART, SHAFT, WHITE
 Van Veen, p. 153.
 SHIELD
 Whitney, p. 117.
See also: ARROW, DART, SPEAR.

SHEAF
See:
 EAR OF GRAIN AND SHEAF
 Wither, p. 50.

SHEAF AND STALKS OF GRAIN
Whitney, p. 88.
 Motto: "De parvis, grandis aceruus erit."
 Icon: A sheaf of grain is surrounded by many
 individual stalks of grain.
 Epigram: Little things in time accumulate and make
 up grand things.

SHEAF OF ARROWS
Wither, p. 177.
 Motto: "A Mischiefe, hardly can be done,
 Where many-pow'rs are knit in one."
 Icon: A bear attacks a sheaf of arrows.
 Epigram: When the arrows are tied together, the bear
 is unable to break them; the sheaf of ar-
 rows signifies the strength of unity.

SHEAF OF WHEAT
P. S., p. 257.
 Motto: "Flavescent."
 Icon: Sheaves of wheat.
 Epigram: Green sheaves of wheat signify that youth
 shall in time be turned into a ripe age.
See also:
 EAR AND SHEAF OF WHEAT
 P. S., p. 268.

SHEARS
Astry, no. 14.

 Motto: "Detrahit et decorat."
 Icon: Shears rest on a cloth.
 Epigram: As the shears perfect the cloth made by the
 loom, so the censure of others rectifies our
 manners.

SHEEP
See:
 CUDGEL
 Jenner, no. 24.
 EAGLE, SHEEP, WOLF
 Godyere, no. 6.
 GRAPEVINE
 Peacham, p. 157.
 LUTE
 Godyere, no. 20.
 SHEEP AND SHEPHERD
 Willet, no. 38.
 TENDING FIG TREE AND SHEEP
 Willet, no. 76.
See also: LAMB, RAM.

SHEEP AND SHEPHERD
Willet, no. 38.
 Motto: "Unus Pastor Unum Ovile."
 Icon: None.
 Epigram: "Christ is the sheapheard, we the sheepe."

SHELL
See:
 CUPID, SEA, SHELL
 Van Veen, p. 203.
 PEARL
 Hawkins, no. 17, p. 194.
 SCALLOP SHELL
 Astry, no. 23.
See also: COCKLESHELL, CORAL, SCALLOP.

SHEPHERD
Willet, no. 32.
 Motto: "Mercenarius fugit à grege. Ad Pastores
 otiosos & somnolentos."
 Icon: None.
 Epigram: As the shepherd protects his sheep from
 wolves, so the good pastor attends his
 people.
See also:
 HUNGER
 Hall, p. 16.
 SERPENT AND SHEPHERD
 Peacham, p. 34.

SHEPHERD AND WOLF
Montenay, p. 422.
 Motto: "Etiam usove quartam generatianem."
 Icon: A shepherd chases away wolves.
 Epigram: As the shepherd kills the wolves, so God
 will destroy tyrants.

SHIELD
Peacham, p. 24.
 Motto: "Merenti."
 Icon: A hand inscribes a shield with an ensign.
 Epigram: Trojan youths entered battle with blank shields, and the deserving ones earned an appropriate ensign; in these days, honors are no longer based on merit.
Peacham, p. 166.
 Motto: "In vos hic valet."
 Icon: A shield with a heart at the center withstands the threat of three arrows, labeled "calumniae," "cupidinis," and "mortis."
 Epigram: Innocence is likened to armor; it can protect the manly heart from slander, Cupid, and death.
Thynne, no. 21.
 Motto: "Myrtilus Sheilde."
 Icon: None.
 Epigram: As the shield of Myrtilus protected him whereever he ventured, so the speaker asks God to protect him.
Whitney, p. 117.
 Motto: "Marcus Scaeva: Audaces fortuna juvat."
 Icon: A shield is pierced by many shafts.
 Epigram: This shield expresses the valor and manhood of Marcus Scaevas, who was said to have fought so courageously in one battle that 120 shafts were found piercing his shield at the end of the battle.
Whitney, p. 141.
 Motto: "Perfidus familiaris."
 Icon: A soldier points to his shield as an arrow pierces it and wounds him.
 Epigram: Just as Brasidas put his trust in his shield and was mortally wounded when the shield failed him, so man often trusts appearances, only to be betrayed by them.

See also:
BALANCE
Astry, no. 81.
BLINDNESS AND CUPID
Van Veen, p. 61.
CHOLER
Peacham, p. 128.
CROWN, SHIELD, SWORD
P. S., p. 334.
DART AND SHIELD
P. S., p. 158.
EEL AND SHIELD
Thynne, no. 48.
HERALDIC SHIELD
Peacham, p. 102.
OLIVE BRANCH AND SHIELD
Astry, no. 98.

PILLAR, SHIELD, WEAPON
Peacham, p. 173.
See also: BUCKLER, HERALDIC SHIELD.

SHILLING
See:
 BALL, KEY, TURF, SHILLING
 P. S., p. 307.
See also: COIN, MONEY.

SHIP
Godyere, no. 22.
 Motto: "Sero Jupiter diphtheram inspexit."
 Icon: A ship is filled with Catholic clerics.
 Epigram: The Roman Catholic faith is likened to a ship tossed by the winds of error.
Hall, p. 48.
 Motto: "Lord thou hast made me for thee, and my heart is unquiet till it Rest in thee."
 Icon: A ship with Divine Love at the helm sails toward the shore, where a haloed figure sits with outstretched arms.
 Epigram: Man's thoughts are not quieted until their travels bring them home to God.
Hawkins, no. 21, p. 245.
 Motto: "De longe portans panem."
 Icon: A ship is inside a circle made by a serpent biting its tail.
 Epigram: The Virgin Mary is like a ship, bringing bread—Christ—from afar.
Hawkins, no. 21, p. 253.
 Motto: "Ego sumpanis vivus qui de coelo descendi."
 Icon: Christ as a naked child holds an armillary sphere and stands on a ship.
 Epigram: Mary is like a ship, bringing Christ, the living bread, from heaven.
Jenner, no. 30.
 Motto: "The equality of Justification by Christ."
 Icon: A man sits in a ship.
 Epigram: Christ is likened to a ship, which takes on all the elect—young and old, weak and strong; through him they reach heaven.
P. S., p. 131.
 Motto: "En altera quae vehat Argo."
 Icon: A ship.
 Epigram: The ship represents the nobility of France, which originated with the Trojans.
Whitney, p. 137.
 Motto: "Constantia comes victoriae."
 Icon: A ship at sea.
 Epigram: Just as a ship keeps its course and reaches its destination even though it is blown by the winds and tossed by the seas, so man will attain heaven if he keeps his course in this world.

Wither, p. 13.
Motto: "To him a happy Lot befalls
 That hath a Ship, and prosp'rous Gales."
Icon: A man rows a ship with an oar as the wind
 blows.
Epigram: The oar, sail, ship, and wind represent
 the outward means by which men live in
 "this worlds wide Ocean"; more impor-
 tant, however, is God, who aids the faith-
 ful.
Wither, p. 37.
R. B., no. 45.
Motto: "He, that his Course directly Steeres,
 Nor Stormes, nor Windy Censures feares."
Icon: A king rides at the helm of a ship.
Epigram: The world is compared with the sea; man,
 to a pilot of a ship, who must carefully
 direct his course.

See also:
ANCHOR
Astry, no. 63.
BEACON AND MARINER
Jenner, no. 8.
BRITAIN
Peacham, p. 108.
CROWN AND SHIP
P. S., p. 316.
DOG AND BOW OF SHIP
P. S., p. 252.
GLOBE AND SHIP
Astry, no. 68.
LANTERN AND SHIP
Farlie, no. 44.
PILLAR AND SHIP
Astry, no. 30.
REMORA
Thynne, no. 33.
ROCK, SEA, SHIP
Peacham, p. 158.
SEA AND SHIP
Van Veen, p. 109.

See also: BOAT, GALLEY.

SHIP AND STAR
Hawkins, no. 11, p. 122.
Motto: "Respices tellam, invoca Mariam."
Icon: A ship in a stormy sea follows a star.
Epigram: Sinful man is like a ship on a dark and
 stormy night; his only hope is the Virgin,
 who, like a star, guides men.

SHIP AND STORM
Astry, no. 36.
Motto: "In contraria ducet."
Icon: A ship on a sea in a storm.
Epigram: The prince, like the pilot of a ship, must

steer his state with care and diligence "in
the tempestuous Sea of his Reign."
Van der Noodt, no. 2.
Motto: None.
Icon: A tall ship at sea encounters a storm.
Epigram: Like the ship suddenly overcome and sunk
 by a storm, riches may be lost in an instant.

SHIP AND WOMAN
Combe, no. 78.
Motto: "A woman is of such a kind,
 That nothing can content her mind."
Icon: A woman stands in a ship.
Epigram: A woman is like a ship; she requires wealth,
 is never satisfied, and will trouble man all
 his life.

SHIP AND WORLD
Whitney, p. 203.
Motto: "Auxilio divino."
Icon: A ship sits on top of a globe of the world,
 and reins circumscribe the globe.
Epigram: A panegyric to Sir Francis Drake, this
 emblem celebrates his navigational tri-
 umphs.

SHIP ON SHORE
Astry, no. 37.
Motto: "Minimum Eligendum."
Icon: A ship returns to the shore.
Epigram: As the pilot of a ship caught in a storm
 heads for land to save his life and mer-
 chandise, so the prince must judge danger
 and choose the lesser evil.

SHIP, TORCH, WIND
Montenay, p. 74.
Motto: "Quem Timebo."
Icon: A man stands in a ship which the winds
 blow, and an arm holds a torch.
Epigram: Like the ship in the wind which follows
 the light of a star, man should follow the
 truth of God.

SHIPWRECK
Peacham, p. 165.
Motto: "His graviora."
Icon: A ship sinks into the sea.
Epigram: As Aeneas withstood every misfortune, so
 should the valiant mind.

See also:
ANCHOR
Quarles, *Emb.*, p. 231.
JONAH
Willet, no. 53.
SEA AND SHIPWRECK
Arwaker, bk. 1, no. 11.
Quarles, *Emb.*, p. 164.

SHIPWRECK AND SNOW
Whitney, p. 11.
 Motto: "Res humanae in summo declinant."
 Icon: A ship sinks in the sea, and snow melts in
 the sun.
 Epigram: As the ship is wrecked and the mountain's
 snow is melted, so man who climbs to
 greatness should be aware that his time is
 short, his achievement impermanent, and
 his life ruled by fortune.

SHIRT ON SPEAR
P. S., p. 61.
 Motto: "Restat ex victore Orientis."
 Icon: A shirt hangs on a spear.
 Epigram: The shirt of a dying conqueror carried on
 a spear signifies that the mighty go naked
 to their grave; the king is no different
 from the poor man in death.
Whitney, p. 86.
 Motto: "Mortui divitiae."
 Icon: A shirt hangs on a spear.
 Epigram: Saladin, the sultan of Babylon, ordered his
 subjects to put his shirt on a spear when he
 died to show that even the richest and
 greatest are stripped bare at death and take
 only a shroud to the grave.
Wither, p. 216.
 Motto: "Loe, heere is all, that hee possest,
 Which once was Victor of the East."
 Icon: A shirt hangs on a spear.
 Epigram: The shirt on a spear signifies all that the
 powerful, wealthy, and ambitious king
 takes with him to the grave: a winding
 sheet.

SHORE
See:
 SHIP
 Hall, p. 48.
 SHIP ON SHORE
 Astry, no. 37.

SICKLE
See:
 BRANCH
 Astry, no. 54.
 FORTUNE, TIME, WORLD
 Quarles, *Emb.*, p. 36.
 PITCHFORK, RAKE, SICKLE
 Peacham, p. 150.
 SORROW AND TIME
 Arwaker, bk. 1, no. 15.
 Quarles, *Emb.*, p. 180.
 TIME
 Whitney, p. 199.
 TIME AND WISDOM

 Godyere, no. 28.
 TRUTH
 Whitney, p. 4.
See also: SCYTHE.

SICKLE AND WHETSTONE
Peacham, p. 61.
 Motto: "In aliis tempestivè consulentes non sibi."
 Icon: A hand holds a whetstone and sharpens a
 sickle.
 Epigram: As a whetstone sharpens a sickle but re-
 mains blunt itself, so many give advice but
 are unable to follow it.

SICKNESS
See:
 APPLE AND FLOWER
 Arwaker, bk. 3, no. 2.
 CUPID, PHYSIC, SICKNESS
 Van Veen, p. 121.
 CUPID, PHYSICIAN, SICKNESS
 Van Veen, p. 169.
 DART
 Arwaker, bk. 3, no. 1.
 Quarles, *Emb.*, p. 244.
 DART AND WOUND
 Hall, p. 12.
 PATIENT AND PHYSICIAN
 Arwaker, bk. 1, no. 3.
 Quarles, *Emb.*, p. 136 (note: first of two pages num-
 bered 136).
 PHYSIC AND SICKNESS
 Bunyan, no. 62.

SICKNESS AND WINE
Combe, no. 50.
 Motto: "Malicious fooles worke most disgrace,
 When they are set in highest place."
 Icon: A man lies sick in bed, and a woman brings
 him wine.
 Epigram: If a man with a fever is given wine, his
 fever worsens; so a fool put into high office
 is most likely to hurt the state.

SIEVE
Quarles, *Emb.*, p. 88.
 Motto: "Hic pessima, hic optima servat."
 Icon: Divine Love and Cupid each hold a sieve
 and sort through objects in an ark; Divine
 Love discards toys while Cupid discards a
 balance and a book.
 Epigram: The world is filled with good and bad
 things; the wise man keeps the good and
 discards the bad, but the foolish man does
 the opposite.
P. S., p. 184.
 Motto: "Ecquis discernit utrumque?"

Icon: A sieve separates the grain from the chaff.
Epigram: The sieve represents the good man who can, with judgment, distinguish the good from the bad.

Whitney, p. 68.
 Motto: "Sic discerne."
 Icon: A sieve separates the grain from the chaff.
 Epigram: Just as a sieve can separate grain from chaff, so the sound judgment of a prudent man should discern good from bad.

Wither, p. 20.
R. B., no. 25.
 Motto: "A Sive, of shelter maketh show;
 But ev'ry Storme will through it goe."
 Icon: A man holds a sieve over his head as rain pours through it.
 Epigram: Like the sieve which seems to protect a man from the rain but does not, so the hypocrite seems other than he is.

See also:
 BREAST AND FOOL
 Quarles, *Emb.*, p. 48.
 CLOCK
 Combe, no. 71.
 CUPID AND SIEVE
 Combe, no. 77.

SIGN
Jenner, no. 28.
 Motto: "The foolishnes of Transubstantiation."
 Icon: A man tries to drink the image of a grapevine painted on a tavern sign.
 Epigram: In their belief in transubstantiation, papists mistake the Communion bread, which is a sign of Christ's body, for the actual body; they are as foolish as the man who tries to drink the image of the grape on the tavern sign.

Signet
See: SEAL.

SIGNET AND SWORD
P. S., p. 302.
 Motto: "Terriculum noxae."
 Icon: A signet on a sword.
 Epigram: To prevent his soldiers from oppressing the people, Pompey marked their swords with his own signet.

SILENCE
Whitney, p. 60.
 Motto: "Silentium."
 Icon: A man in his study sits at a desk, reads a book, and makes the gesture of silence, his forefinger over his mouth.
 Epigram: The gesture of holding a finger to the mouth, which was devised by Harpocrates,

signifies the value of silence, long an ideal of philosophers.

Willet, no. 31.
 Motto: "Silentii commendatio."
 Icon: None.
 Epigram: A student who sits alone with his finger to his mouth in the gesture of silence represents the wise man who spares his words.

See also:
 CUPID, GOOSE, PEACH, SILENCE
 Van Veen, p. 71.
 FLEEING, HEARING, SILENCE
 Whitney, p. 191.
 WIFE
 Combe, no. 18.
 Whitney, p. 93.
See also: BAND OVER MOUTH, FINGER OVER MOUTH.

SILKWORM
Peacham, p. 89.
 Motto: "Sic vos non vobis."
 Icon: Silkworms weave silk beneath a tree.
 Epigram: Silkworms, which spend their lives weaving silk for others, are likened to artists, who serve others for little reward.

SILVER GROAT
See:
 SEEKING
 Willet, no. 28.
See also: COIN, MONEY.

Simpleton
See: FOOL.

SIN
Bunyan, no. 2.
 Motto: "The awakened Childs Lamentation."
 Icon: None.
 Epigram: The speaker laments his sinfulness and looks to God for mercy.

Peacham, p. 146.
 Motto: "Icon Peccati."
 Icon: A naked, blind man stands on a rocky, thorny path as serpents entwine his body and eat his heart.
 Epigram: This figure personifies Sin: his nakedness expresses the absence of grace; his blindness, lack of wisdom; his youth, folly; his thorny path, danger; the serpent around his waist, hell's power; the serpent eating his heart, a bad conscience.

SINGING
See:
 HEART AND SINGING
 H. A., p. 171.
 SWALLOW
 Bunyan, no. 8.

SINNER
See:
FAITH
Jenner, no. 1.

SIREN
Whitney, p. 10.
Motto: "Sirenes."
Icon: Tied to the mast of his ship, Ulysses resists the Sirens, who tempt him with music.
Epigram: As Ulysses resisted the alluring song of the Sirens, so men should flee ensnaring beauty.
See also:
MUSE AND SIREN
Thynne, no. 57.

SISTER
See:
INFANT AND SISTER
Arwaker, bk. 2, no. 9.

SISYPHUS
Whitney, p. 215.
Motto: "Interminabilis humanae vitae labor."
Icon: Sisyphus rolls a stone up a hill.
Epigram: Sisyphus represents the race of Adam, which must ceaselessly toil and work.
Wither, p. 11.
R. B., no. 5.
Motto: "A Foole, in Folly taketh Paine, Although he labour still in vaine."
Icon: Sisyphus rolls a millstone up a hill; in a second scene he stands at the top of the hill and watches the stone roll back down.
Epigram: Sisyphus's punishment is likened to the vanity of labor which is undertaken for the sake of ambition.

SITTING
Whitney, p. 85.
Motto: "Desidiam abjiciendam."
Icon: Two people sit idly on the ground.
Epigram: Avoid idleness and engage in work.
Whitney, p. 103.
Motto: "Interdum requiescendum."
Icon: Minerva sits under a tree in a relaxed position on the left and stands alert on the right.
Epigram: Continual work dulls the mind; students should rest from their labor.
See also:
AESCULAPIUS
Whitney, p. 212.

Skeleton
See: BONE, DEATH, DEATH'S-HEAD, SKULL.

SKELETON IMPRISONS MAN
Arwaker, bk. 3, no. 8.

Motto: "O wretched man that I am! who shall deliver me from the body of this death."
Icon: A human figure is trapped inside the rib-cage of a skeleton.
Epigram: Man longs to escape the body, which is a prison, and be free of the flesh, which is death to the soul.
Quarles, *Emb.*, p. 272.
Motto: "O wretched Man that I am; who shall deliver me from the body of this Death."
Icon: A human figure is trapped inside the rib cage of a skeleton.
Epigram: Man longs to escape the body, which is a prison, and be free of the flesh, which is death to the soul.

Sketching
See: DRAWING.

SKIN
See:
SERPENT
Montenay, p. 194.

SKULL
Astry, p. 384.
Motto: "Lubibria mortis."
Icon: A skull lies among ruins and a crown.
Epigram: Death makes no distinction between a prince and a slave.
Peacham, p. 8.
Motto: "Nec metuas nec optes."
Icon: A hand holds a skull.
Epigram: Man should remember that he is mortal and think on his end.
Whitney, p. 46.
Motto: "Varii hominum sensus."
Icon: A woman carrying skulls to a chapel drops some which another woman picks up.
Epigram: As a woman gathers skulls to put them in a sacred place, some of the skulls drop and scatter; in life, as in death, men's minds differ.
Whitney, p. 229.
Motto: "Ex maximo minimum."
Icon: A skull and a bone.
Epigram: What was once the lively image of God and seat of reason, the head, is now a rotten skull.
See also:
AGED MAN
Wither, p. 87.
R. B., no. 23.
CANDLE, HOURGLASS, SKULL
Wither, p. 184.
CHILD, SKULL, SNAKE BITING TAIL
Wither, p. 45.
R. B., no. 1.

CROWN AND SKULL
P. S., p. 319.
EAGLE AND HART
P. S., p. 107.
HOURGLASS
Hall, p. 104.
HOURGLASS AND SKULL
Wither, p. 152.
R. B., no. 24.
Wither, p. 235.
OWL AND SKULL
Wither, p. 168.
SCEPTER, SKULL, SPADE
Wither, p. 48.
See also: DEATH'S-HEAD.

SKULL AND WHEAT
Wither, p. 21.
 Motto: "Death is no Losse, but rather, Gaine;
 For wee by Dying, Life attaine."
 Icon: Wheat grows from a skull on an hourglass;
 on top of the skull is a burning candle.
 Epigram: As wheat is renewed after lying in the
 earth, so man is reborn after death.

SLANDER
See:
 TRUTH
 Whitney, p. 4.

SLEDGE
See:
 ANVIL, DIAMOND, SLEDGE
 Wither, p. 171.

Sledgehammer
See: SLEDGE.

SLEEP
Quarles, *Emb.*, p. 28.
 Motto: "Latet hostis, et otia ducis?"
 Icon: Cupid sleeps on top of a sphere containing
 hellish torments while Divine Love tries
 to awaken him and Death shoots an arrow.
 Cupid holds a cock.
 Epigram: Sloth causes man to sin, fall, and be
 damned; man must instead be vigilant and
 actively fight the devil.
See also:
 ARGUS AND CUPID
 Van Veen, p. 239.
 CUPID AND SLEEP
 Van Veen, p. 149.
 DEVIL, HEART, SLEEP
 Harvey, no. 2.
 EYE, HEART, SLEEP
 Harvey, no. 32.
 FORTUNE
 Combe, no. 29.

 HEART, SLEEP, WIND
 H. A., p. 199.
 PHLEGM
 Peacham, p. 129.
 SWALLOW
 Whitney, p. 50.

SLEEP AND WINDMILL
Whitney, p. 26.
 Motto: "Otium sortem exspectat."
 Icon: A man sleeps beside a windmill.
 Epigram: The man who inherits a windmill but
 trusts in the wind to work the mill is an
 example of idle fools who hope fortune
 will favor them.

SLING
See:
 DEATH AND YOKE
 Montenay, p. 46.

SLING AND STONE
P. S., p. 146.
 Motto: "Vindice fato."
 Icon: A stone in a sling.
 Epigram: David refused armor and killed Goliath
 with a simple sling and stone; likewise,
 man may overcome the devil with faith.

Sloth
See: IDLENESS.

SLOTHFUL MAN
Willet, no. 65.
 Motto: "De ignavo."
 Icon: None.
 Epigram: The slothful ("sluggish") man neglects his
 garden and prefers to keep his hands warm
 by folding them.

Slug
See: SNAIL.

SMALL CREATURE
See:
 FEAR OF SMALL CREATURES
 Bunyan, no. 64.

SMOKE
Farlie, no. 35.
 Motto: "Flamma sumo proxima est."
 Icon: Smoke rises from a candle.
 Epigram: As smoke often precedes a fire, so words
 often precede lust.
See also:
 BOOK, HEART, SMOKE, WING
 Wither, p. 91.
 BUBBLE AND SMOKE
 Quarles, *Emb.*, p. 76.
 CANDLE
 Farlie, no. 58.

CANDLE AND SMOKE
Farlie, no. 36.
HEART AND SMOKE
Wither, p. 39.
MUSHROOM BALL AND SMOKE
Wither, p. 85.

SNAIL
Bunyan, no. 57.
Motto: "Upon the Snail."
Icon: None.
Epigram: Like the snail which goes slowly and
 quietly but achieves its goal, the man of
 faith, however humble and unobtrusive,
 will attain the kingdom of God.
Whitney, p. 91.
Motto: "Tecum habita."
Icon: A snail crawls to the base of a throne where
 Jove sits surrounded by many animals.
Epigram: When the snail arrived late at a solemn
 feast, Jove criticized it for its tardiness; the
 snail excused itself, saying he was slow
 because he bore his house with him. The
 snail teaches that no place compares to
 home.
Wither, p. 19.
Motto: "When thou a Dangerous-Way dost goe,
 Walke surely, though thy pace be slowe."
Icon: A snail crawls on a stick.
Epigram: The snail represents perseverance, cau-
 tiousness, and slow-moving but inevitable
 vengeance.
See also:
ASS AND STAG
Quarles, *Emb.*, p. 52.
LANTERN
Quarles, *Hier.*, no. 8.
PLANT AND TAPER
Quarles, *Hier.*, no. 9.

SNAKE
See:
ALTAR, BALL, EAGLE, SNAKE
Wither, p. 101.
ARROW AND SNAKE
Wither, p. 220.
BALL, LAUREL, SNAKE, SWORD
Wither, p. 109.
CENTAUR
Wither, p. 103.
R. B., no. 42.
CROWN, SNAKE, STAR
P. S., p. 329.
ENVY
Whitney, p. 94.
LORD, MONSTER, AND SNAKE
Hall, p. 1.

RAVEN AND SNAKE
Combe, no. 56.

SNAKE AND STRAWBERRY
P. S., p. 83.
Motto: "Latet anguis in herba."
Icon: A snake hides in a strawberry plant.
Epigram: When picking strawberries, man must be-
 ware of the snake lurking in the grass;
 likewise, when reading books which please
 the eye, man must beware of absurdi-
 ties, wrong judgments, and false opinions
 which may endanger his soul.

SNAKE BITING TAIL
Wither, p. 102.
Motto: "Time, is a Fading-flowre, that's found
 Within Eternities wide round."
Icon: A snake bites its tail.
Epigram: The "Circled-snake" is a symbol of eter-
 nity.
Wither, p. 157.
Motto: "Through many spaces, Time doth run,
 And, endeth, where it first begun."
Icon: A snake bites its tail.
Epigram: A snake biting its tail signifies eternity.
See also:
CHILD, SKULL, SNAKE BITING TAIL
Wither, p. 45.
R. B., no. 1.

SNAKE BITING TAIL AND STAR
Wither, p. 74.
Motto: "Let none despaire of their Estate,
 For, Prudence, greater is, than Fate."
Icon: A star is enclosed by a snake biting its tail.
Epigram: Prudence in man is stronger than destiny.

SNAKE, SPADE, WREATH
Wither, p. 5.
Motto: "By Labour, Vertue may be gain'd;
 By Vertue, Glorie is attain'd."
Icon: A snake entwines a spade and holds a
 wreath in its mouth.
Epigram: The spade signifies labor; the snake, the
 virtue which is attained by labor; the
 wreath, the glory which is attained by
 virtue.

SNARE
Hall, p. 68.
Motto: "Mine enemy hath laid many nets for
 my feet, and fill'd all the way with am-
 bushments."
Icon: A woman sits under a tree as Cupid and
 Divine Love run between a snare.
Epigram: The world is filled with snares and cannot
 be trusted; man should put his faith in
 God.

P. S., p. 195.
 Motto: "Spe illectat inani."
 Icon: A snare to lure birds.
 Epigram: Like the fowler's snares which entrap birds, worldly things seem appealing from a distance but are nothing more than vanity and deceit on close examination.

See also:
 CUPID AND SNARE
 Van Veen, p. 87.
 HELL AND SNARE
 Arwaker, bk. 1, no. 9.
 Quarles, *Emb.*, p. 156.
See also: NET.

SNOW
See:
 GLASS AND SNOW
 Thynne, no. 17.
 SHIPWRECK AND SNOW
 Whitney, p. 11.

SNUFFER
See:
 CANDLE AND SUN
 Farlie, no. 9.
 DEATH AND TIME
 Quarles, *Hier.*, no. 6.

SODOM
See:
 WINGED BOOK
 Peacham, p. 140.

SOLDIER
See:
 ANTEBATS
 Combe, no. 26.
 FIGHTING
 Astry, no. 75.
 LEVITES AND ARK
 Willet, no. 60.
 SCHOLAR AND SOLDIER
 Godyere, no. 30.

SOLDIERS SCALE WALL
Astry, no. 89.
 Motto: "Concordiae cedunt."
 Icon: Many soldiers, joined together, scale the walls of a fortress.
 Epigram: Working together, the soldiers can scale formidable battlements; likewise, concord makes a kingdom strong.

SOLOMON'S THRONE
Willet, no. 49.
 Motto: "Majestas principis."
 Icon: None.

 Epigram: Solomon's ivory chair, engraved with lions, shows what is proper for a prince.

SOLON
See:
 TONGUE
 Peacham, p. 156.

SONG
See:
 BIRD AND CHILD
 Bunyan, no. 31.

SONGBOOK
See:
 LUTE
 Arwaker, bk. 2, no. 115.
 Quarles, *Emb.*, p. 240.

SORROW
Peacham, p. 114.
 Motto: "Par nulla figura dolori."
 Icon: A shield has the motto "par nulla figura dolori" inscribed on it.
 Epigram: There is no image for sorrow, which is like chaos or the dark night.
See also: GRIEVING, WEEPING.

SORROW AND TIME
Arwaker, bk. 1, no. 15.
 Motto: "My life is waxen old with heaviness, and my years with mourning."
 Icon: A human figure lies groaning in sorrow while Time—with an hourglass, sickle, beard, and wings—moves over the sky, from moon to sun.
 Epigram: Man's life is sorrowful; it begins, continues, and ends in groans.
Quarles, *Emb.*, p. 180.
 Motto: "My life is spent with grief, & my yeeres with sighing."
 Icon: A human figure lies groaning in sorrow while Time—with an hourglass, sickle, beard, and wings—moves over the sky, from moon to sun.
 Epigram: Man's life is sorrowful; it begins, continues, and concludes in groans.

SOUL
See:
 HOURGLASS AND SKULL
 Wither, p. 152.
 R. B., no. 24.

SOW
Whitney, p. 53.
 Motto: "In dies meliora."
 Icon: A man points to a sow rooting in the ground and to the pillars of Hercules.

Epigram: Just as the sow never looks back as it searches for food, so man should not turn back.

SOWING
See:
ADAM SOWS EARTH
Quarles, *Emb.*, p. 8.

SPADE
Wither, p. 141.
Motto: "If thou thy Duties truely doe,
Of thy Reward, be hopefull too."
Icon: A woman digs with a spade.
Epigram: An analysis of the relationship between good deeds and salvation concludes that one's work reflects one's faith.
See also:
ALTAR, BALL, SPADE
Wither, p. 239.
ANCHOR AND SPADE
Wither, p. 150.
R. B., no. 22.
SCEPTER, SKULL, SPADE
Wither, p. 48.
SERPENT, SPADE, WREATH
Wither, p. 92.
SNAKE, SPADE, WREATH
Wither, p. 5.

SPANIEL
See:
FAVOR
Peacham, p. 206.
See also: DOG.

SPEAR
Astry, no. 87.
Motto: "Auspice deo."
Icon: A spear has leaves sprouting from it.
Epigram: Divine Providence favors daring actions and supports princes in just causes.
See also:
GARLAND ON SPEAR
Whitney, p. 115.
HELMET AND SPEAR
P. S., p. 77.
IVY AND SPEAR
P. S., p. 270.
SHIRT ON SPEAR
P. S., p. 61.
Whitney, p. 86.
Wither, p. 216.
See also: DART, SHAFT.

SPECTACLES
Bunyan, no. 63.
Motto: "Upon a Pair of Spectacles."
Icon: None.
Epigram: God's ordinances are like spectacles, which help men see their dark natures.
See also:
OWL
Wither, p. 253.

Sphere
See: ARMILLARY SPHERE, BALL, GLOBE, WORLD.

SPHERE OF HEAVEN
See:
KING
Wither, p. 31.
R. B., no. 35.

SPHERE OF UNIVERSE
Ayres, no. 33.
Motto: "Love keepes all things in order."
Icon: Cupid shoots arrows at the sphere of the universe.
Epigram: Love orders nature and controls the motion of the spheres.

SPIDER
Bunyan, no. 17.
Motto: "The Sinner and the Spider."
Icon: None.
Epigram: In a dialogue between a sinner and a spider the spider likens its nature, venom, and color to a sinner and its web making and behavior to the devil, which catches sinners.
See also:
ANT, CONY, GRASSHOPPER, SPIDER
Willet, no. 97.
FLOWER
Whitney, p. 51.

SPIDER AND WEB
Combe, no. 49.
Motto: "The rich men sinne and serve no lawes,
When poore are punisht for light cause."
Icon: A spider catches flies in a web.
Epigram: As the spider catches flies but dares not catch the wasp, so the law too often punishes the poor and ignores the rich.

Spike
See: PIKE.

SPIRE
See:
IVY AND SPIRE
Whitney, p. 1.
See also: COLUMN, PILLAR.

SPIRE AND TEMPEST
Van der Noodt, no. 8.

Motto: None.
Icon: An ornate spire, with four golden lions on its base and a golden pot at its top, is destroyed by a tempest.
Epigram: The monuments of great emperors are mere vanity, easily destroyed.

SPIRIT
See:
GLASS
Quarles, *Emb.*, p. 176.

SPITTING
See:
GLASS AND SPITTING
Montenay, p. 330.

SPLINTER
See:
BOARD AND SPLINTER
Montenay, p. 102.

SPLITTING WOOD
See:
WILLOW
Peacham, p. 117.

SPONGE
See:
KING AND SPONGE
Combe, no. 40.
Whitney, p. 151.

SPOUSE OF CHRIST
Bunyan, no. 58.
Motto: "Of the Spouse of Christ."
Icon: None.
Epigram: The spouse of Christ was a naked and forlorn beggar; Christ made her queen, and heir of heaven.

SPREAD EAGLE
P. S., p. 222.
Motto: "Praepete penna."
Icon: A spread eagle on a standard.
Epigram: The image of the spread eagle originated when the Roman Empire became divided into East and West.

SPRING
Montenay, p. 42.
Motto: "De Plenitudine Eius."
Icon: Men gather at a spring (fountain) and drink its waters.
Epigram: Although this spring cures the blind, sick, and lame, men will leave this good to do evil and indulge their senses.
See also:
FAUN, NYMPH, SPRING
Van der Noodt, no. 15.

FOUNTAIN
Hawkins, no. 19, p. 219.
MUSE AND SPRING
Van der Noodt, no. 4.
PIT AND SPRING
Montenay, p. 334.
See also: FOUNTAIN.

SPROUT AND TREE
Wither, p. 46.
Motto: "Though very small, at first, it be,
 A Sprout, at length, becomes a Tree."
Icon: A small sprout grows beside a mature tree.
Epigram: As the small sprout grows into a lofty tree, so men's endeavors may in time be brought to perfection.

SPUR
Montenay, p. 98.
Motto: "Durum est tibi."
Icon: A man kicks spurs hanging on a tree.
Epigram: Like the man who kicks the spurs until he hurts himself and then runs from them, man is likely to be stubborn and bold against God, until God punishes him.
See also:
LEVITY
Peacham, p. 149.

SQUARE
Wither, p. 164.
Motto: "Faire-shewes, we should not so much heed,
 As the Uprightnesse of the Deed."
Icon: A square.
Epigram: An instrument like a square is valued for its usefulness, not its appearance; so, too, man is valued for his actions and inner character, not his appearance.
See also:
CITY OF GOD
Van der Noodt, no. 20.
FAME
Wither, p. 146.
R. B., no. 37.
FORTUNE AND MERCURY
Thynne, no. 5.
GOLDEN MEAN
Wither, p. 169.
R. B., no. 11.

SQUARED STONE
See:
FAITH
Wither, p. 81.

SQUIRREL
Wither, p. 136.
Motto: "A little Wit, may stand in stead,

When Strength doth faile, in time of need."

Icon: A squirrel gathers food by a stream.

Epigram: Like the squirrel which uses strategy to cross the stream, man may achieve by wit what seems to be impossible.

See also:

RAIN AND SQUIRREL
Wither, p. 26.

STAFF
P. S., p. 156.

Motto: "Tutus ab igne sacer."

Icon: A crooked staff.

Epigram: A crooked staff used by the Roman soothsayers did not perish in a fire of Rome and thus represents the invulnerability of what is holy.

See also:

AESCULAPIUS
Whitney, p. 212.

CHESBOLE AND STAFF
P. S., p. 182.

DISGUISE AND STAFF
P. S., p. 341.

ENVY
Whitney, p. 94.

FIRE AND WATER
P. S., p. 57.

HAND AND STAFF
P. S., p. 235.

HYPOCRITE
Peacham, p. 198.

PILGRIM AND TORTOISE
Combe, no. 51.

See also: ROD, WAND.

STAFF AND WATER
Peacham, p. 67.

Motto: "—Nec te quaesiveris extra."

Icon: A staff is put in clear water and appears crooked; a banner reads "mihi conscia recti."

Epigram: As the straight staff appears to be crooked when put into water, so the honest mind is falsely judged by the vulgar.

STAFF, STONE, STORK
Wither, p. 149.

Motto: "A Shepherd carefull of the Sheepe,
At all times, faithfull Watch doth keepe."

Icon: A hand holds a staff on top of which a stork stands with a stone in one foot.

Epigram: The staff on which a stork holds a stone signifies the watchfulness of the clergy.

STAG
Thynne, no. 55.

Motto: "Earthlie mindes."

Icon: None.

Epigram: When the stag feeds on the ground, it cannot hear the hunter or the dogs pursuing it; likewise, when man concerns himself with worldly things, he cannot hear the voice of the heavens.

Whitney, p. 153.

Motto: "Pro bono, malum."

Icon: A stag, pursued by hunters and hounds, hides in the trees.

Epigram: A stag successfully hid from hunters in the trees until it bit the boughs of the tree and gave itself away; this shows that man should not harm what helps him.

See also:

ASS AND STAG
Quarles, *Emb.*, p. 52.

FEAR
Whitney, p. 52.

HUNT
Ayres, no. 26.

See also: BUCK, DEER, HART, HIND, ROE.

STALK OF GRAIN
See:

SHEAF AND STALK OF GRAIN
Whitney, p. 88.

STANDARD
P. S., p. 237.

Motto: "Consultori pessimum."

Icon: A standard.

Epigram: As the standard-bearer is the first to be attacked if he makes a mistake, so the man who gives evil counsel is punished for it.

See also:

HAND ON STANDARD
P. S., p. 92.

See also: ENSIGN.

Standard-bearer
See: ENSIGN.

STAR
Hawkins, no. 11, p. 114.

Motto: "In itinere Pharus."

Icon: A star is encircled by a cloud.

Epigram: A star is a lamp of heaven and a guide to men; it is a symbol of the Virgin Mary.

P. S., p. 19.

Motto: "Monstrant Regibus astra viam."

Icon: A crown sits on top of a star.

Epigram: The star signifies that heaven will guide men.

Wither, p. 251.

Motto: "God, by their Names, the Stars doth call;
And, hee is Ruler of them all."

Icon: An astronomer studies stars in the sky.
Epigram: The stars do not control our fate; rather,
 God controls the stars.
See also:
 ARROW AND STAR
 P. S., p. 108.
 CANDLE
 Farlie, no. 7.
 CANDLE AND MORNING STAR
 Farlie, no. 17.
 COMPASS
 Peacham, p. 72.
 CROWN AND STAR
 Peacham, p. 160.
 CROWN OF STARS AND WHEAT
 P. S., p. 199.
 CROWN, SNAKE, STAR
 P. S., p. 329.
 ETERNITY
 Peacham, p. 141.
 HAND, STAR, SUN
 Godyere, no. 11.
 LODESTAR
 Peacham, p. 145.
 LODESTONE
 Whitney, p. 43.
 SHIP AND STAR
 Hawkins, no. 11, p. 122.
 SNAKE BITING TAIL AND STAR
 Wither, p. 74.
 URANIA
 Peacham, p. 177.
See also: COMET, LODESTAR, NORTH STAR, POLESTAR,
 MORNING STAR.

STATUE
Astry, no. 53.
 Motto: "Custodiunt non carpiunt."
 Icon: Statues without arms stand at the entrance
 to a garden.
 Epigram: The statues without arms represent the
 integrity of ministers who guard the
 commonwealth without stealing from it.
See also:
 STATUE OF ISIS
 Whitney, p. 8.
See also: FIXED-HEAD STATUE, LAUREATE-HEAD STATUE.

STEEL
See:
 CANDLE AND MATCH
 Farlie, no. 43.
 FLINT AND STEEL
 Wither, p. 175.
 FLINT, STEEL, TINDERBOX
 Peacham, p. 103.

STILL
See:
 CUPID AND STILL
 Combe, no. 79.

STILTS
See:
 PYGMY ON STILTS
 Wither, p. 14.
 R. B., no. 8.

STINKING
See:
 BREATH
 Bunyan, no. 55.

STIRRING FIRE
Combe, no. 7.
 Motto: "He that doth love to live at ease,
 An angry man must not displease."
 Icon: A man stirs a fire with a sword.
 Epigram: As the man who stirs the fire risks having
 sparks fly in his face, so the man who stirs
 the angry man risks his own disgrace.
P. S., p. 342 (misnumbered p. 242).
 Motto: "Ignis gladio non fordiendus."
 Icon: A man stirs a fire with a sword.
 Epigram: The man who stirs a fire with his sword
 signifies the quarrelsome man.

STITH
See:
 HAMMER AND STITH
 Combe, no. 66.
See also: ANVIL.

Stithy
See: STITH.

STOCKS
Whitney, p. 202.
 Motto: "Aureae compedes."
 Icon: A well-dressed gentleman sits in the stocks.
 Epigram: It is better to be poor than to be bound
 with fetters of gold; riches can be a prison
 of the mind.
See also:
 FAVOR
 Peacham, p. 206.
 MATRIMONY
 Peacham, p. 132.

STONE
P. S., p. 206.
 Motto: "Terit & teritur."
 Icon: A sharpening stone.
 Epigram: A stone which sharpens iron, if continually
 rubbed against the iron, will be consumed;

so, too, the wicked man will destroy himself to bring others to destruction.

See also:

ARROW AND STONE
P. S., p. 203.
BALL, GRIFFIN, STONE
Wither, p. 139.
CORNUCOPIA, STONE, WHEEL
P. S., p. 205.
CRANE AND STONE
Thynne, no. 50.
CUSHION, HAMMER, STONE
Jenner, no. 4.
DOG AND STONE
Thynne, no. 31.
Whitney, p. 56.
FAITH
Wither, p. 81.
NUT, RAVEN, STONE
Montenay, p. 94.
PALM TREE AND STONE
Wither, p. 172.
PIG AND STONE
P. S., p. 97.
POND AND STONE
Astry, no. 65.
RAVEN, STONE, WATER
P. S., p. 179.
SLING AND STONE
P. S., p. 146.
STAFF, STONE, STORK
Wither, p. 149.

See also: BOUNDER STONE, CHALKSTONE, LODESTONE, MAGNET, MARBLE, MILLSTONE, ROCK, TERMINUS, TOUCHSTONE, WHETSTONE.

STONE AND TREE
Wither, p. 28.
 Motto: "No Inward Griefe, nor outward Smart, Can overcome a Patient-Heart."
 Icon: A large stone weighs down a tree.
 Epigram: When some trees are oppressed with weighty stones, they are more fruitful; likewise, the oppression of the Israelites made the faithful among them strong.

STONE AND WING
Whitney, p. 152.
 Motto: "Paupertatem summis ingeniis obesse ne provehantur."
 Icon: A man raises a winged hand and holds a stone in the other, lowered, hand.
 Epigram: Desire lifts man towards immortal fame, but poverty pulls him down.
Wither, p. 176.
R. B., no. 12.

 Motto: "My Wit got Wings, and, high had flowne; But, Povertie did keepe mee downe."
 Icon: A man raises a winged hand and holds a weighty stone in the other, lowered, hand.
 Epigram: Wit raises a man, but poverty keeps him down.

STONE TABLET
Willet, no. 72.
 Motto: "De legis tabulis lapdeis."
 Icon: None.
 Epigram: The Mosaic laws were written in stone; the stone represents the hardness and the eternal nature of the laws.

STOOL
See:

CODRUS, DIOGENES, KING
Whitney, p. 198.

STORK
Whitney, p. 73.
 Motto: "Gratiam referendam."
 Icon: A stork feeds its young.
 Epigram: The stork teaches the ideal relationship between parent and child, for the parent stork provides and cares for its young, and the young storks revere their parents and care for them in their old age.

See also:

CHURCH AND STORK
Astry, no. 25.
CROWN, SEA HORSE, STORK
Wither, p. 155.
STAFF, STONE, STORK
Wither, p. 149.

STORK AND TORCH
Peacham, p. 111.
 Motto: "Conjugii Symbolum."
 Icon: A white stork holds a torch in each claw.
 Epigram: The white stork with the torches is a symbol of chaste wedlock.

STORM
See also:

ANCHOR
Quarles, *Emb.*, p. 232.
RAINBOW
Wither, p. 240.
SEA AND SHIPWRECK
Arwaker, bk. 1, no. 11.
Quarles, *Emb.*, p. 164.
SHIP AND STORM
Astry, no. 36.
Van der Noodt, no. 2.

See also: TEMPEST.

STORM AND TRAVELER
Jenner, no. 21.
 Motto: "The third false putting on of Christ."
 Icon: A traveler on a horse in a storm.
 Epigram: Travelers who put on coats and hoods for a storm but toss them off as soon as it is warm are like men who embrace Christ only when they need protection.

STRAIT, TREE, WIND
Wither, p. 243.
 Motto: "They passe through many stormes, and streights,
 Who rise to any glorious heights."
 Icon: Winds blow on a tree grown through a strait at the trunk.
 Epigram: Like the tree which grows tall and healthy despite constricting straits and harsh winds, man may prosper despite hardship.

STRAW
See:
 FIRE AND STRAW
 Van Veen, p. 219.
 TORTOISE
 Peacham, p. 178.

STRAWBERRY
See:
 SERPENT AND STRAWBERRY
 Whitney, p. 24.
 SNAKE AND STRAWBERRY
 P. S., p. 83.

STREAM
See:
 CITY OF GOD
 Van der Noodt, no. 20.
 PHOENIX
 Van der Noodt, no. 5.
 ZEAL
 Peacham, p. 170.

STRIFE
See:
 TRUTH
 Whitney, p. 4.
See also: FIGHT, FIGHTING.

String
See: CORD, ROPE, THREAD.

STROKE
See:
 CHOPPING OAK
 Wither, p. 29.
 R. B., no. 40.

STROKING
See:

COLT
Astry, no. 38.

STUDENT
Willet, no. 67.
 Motto: "Puerorum educatio."
 Icon: None.
 Epigram: The ideal education of a student is described.
See also:
 SILENCE
 Willet, no. 31.
See also: SCHOLAR.

STUDY
Godyere, no. 7.
 Motto: "Qui curat, vigilans dormit."
 Icon: A man alone in his study holds a key and writes in a book.
 Epigram: The statesman who holds the key to the king's treasury must be just, trustworthy, and hardworking.
See also:
 SILENCE
 Whitney, p. 60.

SUICIDE
Montenay, p. 38.
 Motto: "Surge."
 Icon: A man pierces himself with a sword and falls dead.
 Epigram: A man can easily kill himself, but only God can resurrect a man.

SUN
Astry, no. 86.
 Motto: "Rebus adest."
 Icon: The sun orbits the earth.
 Epigram: As the sun moves about the world, lighting and heating all parts of it, so the prince should continually move about the state, inspiring the affection of his subjects.
Jenner, no. 22.
 Motto: "The benefit of keeping the Sabboth."
 Icon: The sun shines as men work in the fields.
 Epigram: The sun reminds us to keep the Sabbath holy.
Montenay, p. 250.
 Motto: "Lumine carens."
 Icon: A man holds the sun.
 Epigram: A man must know himself before he can show himself to others.
Peacham, p. 42.
 Motto: "I fledd unshamed: Tanto clarior."
 Icon: The sun rises on the right, sets on the left.
 Epigram: Dedicated to Edmund Ashfeild, this emblem likens the setting sun to Ashfeild's

disgrace, the rising sun to his reappearance
and new splendor.

Van Veen, p. 223.
 Motto: "First pleasant and afterward painfull."
 Icon: Cupid watches the sun rise.
 Epigram: Like the sun which brings joy when it rises
 but scorches at noon, love brings pleasure
 at the beginning, then pain.

Whitney, p. 20.
 Motto: "Minuit praesentia famam."
 Icon: The sun shines on a hill where goats and a
 goatherd climb.
 Epigram: When a rumor spreads that snow has
 covered the hills, the cowards are afraid
 to go out, but the braver seek the truth
 themselves.

Willet, no. 71.
 Motto: "Justo geminantur anni."
 Icon: None.
 Epigram: As the sun is sometimes hidden even at
 noon, so the wicked often do not live long.

See also:

BELLOWS, SUN, TORCH
Quarles, *Emb.*, p. 64.
BOOK AND SATAN
Montenay, p. 318.
BOOK, CANDLE, SUN
Montenay, p. 174.
BROTHER
Montenay, p. 310.
CANDLE
Farlie, no. 7.
CANDLE AND SUN
Farlie, no. 3.
Farlie, no. 9.
Farlie, no. 34.
Montenay, p. 402.
CLOUD AND SUN
Bunyan, no. 11.
COALS AND SUN
Peacham, p. 29.
CUPID DEFORMED
Quarles, *Emb.*, p. 96.
EAGLE
Van der Noodt, no. 11.
EAGLE AND SUN
Godyere, no. 4.
ECLIPSE
Astry, no. 77.
EMBRACE
Whitney, p. 216.
EYE, HEART, SUN
Wither, p. 43.
FLAME AND TIME
Farlie, no. 57.

FLOWER AND SUN
Wither, pp. 140, 159.
FRUIT TREE AND SUN
Combe, no. 72.
GARDEN AND SUN
Jenner, no. 12.
GLASS
Astry, no. 76.
Peacham, p. 56.
Quarles, *Emb.*, p. 176.
GOSHAWK
P. S., p. 220.
GROUND AND SUN
Wither, p. 104.
HAND, STAR, SUN
Godyere, no. 11.
HEART OF ICE AND SUN
Harvey, no. 16.
HELIOTROPE
Hawkins, no. 5, p. 56.
Van Veen, p. 75.
HELIOTROPE AND LODESTONE
Arwaker, bk. 3, p. 3.
JANUS
Combe, no. 1.
LANTERN
Farlie, no. 5.
LEARNING
Peacham, p. 26.
LILY
Hawkins, no. 3, p. 35.
LORD, MONSTER, AND SNAKE
Hall, p. 1.
MARIGOLD AND SUN
P. S., p. 46.
Wither, p. 209.
MOON AND SUN
Thynne, no. 61.
MOUNTAIN
Peacham, p. 163.
NIGHT AND SUN
Astry, no. 12.
OWL
Wither, p. 253.
PALM TREE AND PHOENIX
Hawkins, no. 14, p. 159.
PEARL
Hawkins, no. 17, p. 194.
PIPKIN AND SUN
Montenay, p. 90.
RAINBOW
Wither, p. 240.
SCEPTER
Astry, no. 18.
SCEPTER AND SUN

Peacham, p. 105.
Wither, p. 223.

SHADE AND SUN
Combe, no. 89.

SHIP
Hawkins, no. 21, p. 253.

SNARE
Hall, p. 68.

TOMB
Astry, no. 121.

TRUTH
Peacham, p. 134.

WORLD IN ARMS
Quarles, *Emb.*, p. 68.

ZODIAC
Peacham, p. 122.

SUN AND TAPER
Quarles, *Hier.*, no. 7.

Motto:	"Nec sine, nec Tecum."
Icon:	The sun shines on an extinguished taper, and an owl sits in a dark cave.
Epigram:	This emblem acknowledges the inferiority of man in the presence of God and pleads for divine grace.

SUN AND TEMPEST
Wither, p. 70.

Motto:	"When wee have greatest Griefes and Feares, Then, Consolation sweet'st appeares."
Icon:	A storm cloud pours rain on flowers in the left half of the picture as the sun shines on flowers in the right half.
Epigram:	Without tempests calm would not seem as sweet or comforting.

SUN AND TORCH
Peacham, p. 109.

Motto:	"Eo magis caligat."
Icon:	The sun shines above two crossed torches.
Epigram:	As the sun outshines earthly fire, so God's essence is beyond man's comprehension.

SUN AND TREE
Godyere, no. 13.

Motto:	"Pace fermezza, e frutto all'alme apporto."
Icon:	The sun shines on a tree.
Epigram:	As the sun shines on a tree, making it fruitful, so the prince's love bestowed on good men makes their virtue flourish.

SUN AND WIND
Van Veen, p. 125.

Motto:	"Loves miserie."
Icon:	A lover, with an arrow in his breast, lies in misery in the sun, wind, and rain and stretches his arm toward Cupid.

Epigram: Love lives in misery, enduring both heat and cold.

Sunflower
See: HELIOTROPE.

SUNDIAL
Arwaker, bk. 1, no. 13.

Motto:	"Are not my days few? Cease then, and let me alone, that I may bewail my self a little."
Icon:	Divine Love comforts a man who points to a sundial.
Epigram:	Although man mourns the shortness of his life, he should not fear death.

Quarles, *Emb.*, p. 172.

Motto:	"Are not my dayes few? Cease then, and let me alone that I may bewayle me a little."
Icon:	Divine Love comforts a man who points to a sundial.
Epigram:	Man should not fear death but should live with the knowledge of his mortality and repent his sins.

See also:
DEATH AND TIME
Quarles, *Hier.*, no. 6.
HEART, LIGHT, SUNDIAL
Harvey, no. 25.

SUNRISE
Bunyan, no. 25.

Motto:	"On the rising of the Sun."
Icon:	None.
Epigram:	When the sun rises, we know that day has arrived; so, too, when Christ shows his face, we are assured of his love and grace.

See: DAWN.

SUNSET
Bunyan, no. 35.

Motto:	"Of the going down of the Sun."
Icon:	None.
Epigram:	The setting sun, which seems angry and frowns on man, represents the Gospel which man has ignored; if it vanishes, night will possess the world.

Willet, no. 70.

Motto:	"Senis descriptio."
Icon:	None.
Epigram:	The setting sun is likened to the state of an old man.

See also:
AGED MAN
Wither, p. 87.
R. B., no. 23.
OAK AND SUN SETTING
Whitney, p. 230.

SUNSHINE
See:

BIRD AND CHILD
Bunyan, no. 31.

Surgeon
See: PHYSICIAN.

SURGEON AND WOUND
Van Veen, p. 177.
 Motto: "Shewing causeth curing."
 Icon: One cupid points to a wound, while the other, as a surgeon, holds up a vial.
 Epigram: As the injured man shows his wound to a surgeon that it may be cured, so the wounded lover should show his sorrow to his beloved that it may be relieved.

SWALLOW
Bunyan, no. 8.
 Motto: "Upon the Swallow."
 Icon: None.
 Epigram: The swallow represents the believing Christian; her wings, faith; her song, peace.
Whitney, p. 5.
 Motto: "Diffidia inter aequalis, pessima."
 Icon: A swallow flies to a nest with a grasshopper in its bill.
 Epigram: The unsuspecting grasshopper falls prey to its former friend the swallow, which betrays it because of envy.
Whitney, p. 50.
 Motto: "Garrulitas."
 Icon: A sleeping man is awakened by a swallow.
 Epigram: The swallow is like those people who chatter incessantly and impede rest.
See also:
 BIRD
 Whitney, p. 54.
 MEDEA
 Whitney, p. 33.

SWAN
Hawkins, p. 267.
 Motto: "Ad vada concinens elisii."
 Icon: A swan.
 Epigram: Like the swan, singing at its death, the Virgin Mary felt joy at the approach of death.
Hawkins, p. 271.
 Motto: "Hoc cygno vincès."
 Icon: A wind blows on the reeds beside a swan and her young.
 Epigram: When the wind blows, the swan sings; so the Holy Spirit breathes on the Virgin Mary when death approaches and she aspires to sing.
Whitney, p. 126.
 Motto: "Insignia poetarum."
 Icon: A shield with the image of the swan hangs on a tree.

 Epigram: The swan is the proper device of the poet because of the sweetness of its song and its white color, signifying sincerity and purity.
See also:
 PEGASUS
 Godyere, no. 24.

SWIMMING
See:
 FARDEL
 Combe, no. 70.
 Whitney, p. 179.

SWINE
Combe, no. 17.
 Motto: "They that want knowledge, do despise The virtues honoured of the wise."
 Icon: A swine lies in a barnyard, and a man pours liquid from a bottle.
 Epigram: As the swine prefers mire to sweet balms, so some men prefer vice to virtue.
Wither, p. 38.
 Motto: "A sudden Death, with Shame, is due To him, that, sweares What is untrue."
 Icon: A hand holds a stone in front of a swine.
 Epigram: The pagan sacrifice of a swine represents the sudden death which the falsifier of oaths deserves.
See also:
 BAY TREE, LYRE, TAPER
 Quarles, *Hier.*, no. 72.
 CORD AND SWINE
 Jenner, no. 7.
 GRAPEVINE
 Peacham, p. 157.
 RING AND SWINE
 Combe, no. 24.
 Wither, p. 224.
See also: BOAR, HOG, PIG, SOW.

SWORD
Astry, no. 91.
 Motto: "No se svelda."
 Icon: A sword lies broken on the ground.
 Epigram: Just as a sword once broken can never be soldered again, so a friendship once violated cannot be reconciled.
P. S., p. 29.
 Motto: "Non sine causa."
 Icon: A hand holds a lance on top of which is a hand holding a sword.
 Epigram: Because the administration of justice is necessary to kingdoms, rulers and magistrates may use the sword for the sake of justice.
P. S., p. 111.
 Motto: "Without all falshood or deceipt."
 Icon: An armed hand holds a sword.

Epigram: The French arming sword in the hands of
an armed man signifies faith.

P. S., p. 171.
 Motto: "Caelitus impendet."
 Icon: A sword hangs from the sky.
 Epigram: The sword of God's justice hangs over the
 wicked and the ungodly by a thin thread.

Whitney, p. 102.
 Motto: "In sortis suae contemptores."
 Icon: A naked sword hangs from a thread.
 Epigram: The sword hanging precariously by a
 thread represents the cares, dangers, and
 constant threats of monarchs.

Whitney, p. 226.
 Motto: "Amico ficto nulla fit injuria."
 Icon: A gentleman taps another with a sword.
 Epigram: Beware of the hypocrite who is all outer
 show and treat him as an enemy.

See also:

AGE AND YOUTH
Combe, no. 12.
AJAX AND HECTOR
Whitney, p. 37.
ALTAR AND LION
Peacham, p. 20.
ALTAR AND SWORD
Godyere, no. 8 (misnumbered 12).
ANVIL AND SWORD
Whitney, p. 192.
ARMED HAND AND SWORD
P. S., p. 333.
BALANCE
Astry, no. 81.
BALL, LAUREL, SNAKE, SWORD
Wither, p. 109.
BAY WREATH, OLIVE BRANCH, SWORD
Wither, p. 241.
BEAST AND SWORD
P. S., p. 280.
BEE AND SWORD
Combe, no. 21.
BOOK AND SWORD
Wither, p. 32.
BOOK, LION, SWORD
Godyere, no. 25.
BOOK, SERPENT, SWORD
Peacham, p. 2.
BOOK, SWORD, WORLD
P. S., p. 336.
BROTHER
Montenay, p. 310.
CHOLER
Peacham, p. 128.
COMET AND SWORD
P. S., p. 143.

CONQUEROR AND KNEELING FOE
Arwaker, bk. 1, no. 6.
Quarles, *Emb.*, p. 144.
CORONET AND SWORD
Wither, p. 245.
CROWN, FIRE, SWORD
Montenay, p. 298.
CROWN, LILY, SWORD
P. S., p. 277.
CROWN, PALM TREE, SWORD
P. S., p. 255.
CROWN, SHIELD, SWORD
P. S., p. 334.
DEATH AND KING
Montenay, p. 106.
EAGLE AND SUN
Godyere, no. 4.
EMBRACE
Whitney, p. 216.
FIRE
Wither, p. 98.
R. B., no. 50.
FIRE, HAND, SWORD
Whitney, p. 111.
FLAME AND SWORD
P. S., p. 63.
FLAMING SWORD, GARDEN, HEART
Harvey, no. 31.
FLASK AND SWORD
Peacham, p. 83.
FRUIT TREE, SWORD, TAPER
Quarles, *Hier.*, no. 13.
GAUNTLET, PEDESTAL, SWORD
Peacham, p. 162.
GLASS
Arwaker, bk. 2, no. 14.
Quarles, *Emb.*, p. 176.
GLOBE, GOLDEN BOUGH, SWORD
Astry, no. 69.
GORDIAN KNOT AND SWORD
P. S., p. 272.
HARE AND SWORD
P. S., p. 265.
HORSEMAN, SEVEN-HEADED BEAST, SWORD
Van der Noodt, no. 19.
JUDGE AND JUSTICE
Arwaker, bk. 1, no. 10.
Quarles, *Emb.*, p. 160.
LAW AND SWORD
Wither, p. 3.
LAWBOOK AND SWORD
Wither, p. 163.
R. B., no. 31.
LION
Godyere, no. 2.

Peacham, p. 107.

Peacham, p. 123.

LION AND SWORD

P. S., p. 105.

LION HOLDING SWORD

Whitney, p. 116.

LODESTONE AND SWORD

Astry, no. 88.

MACE AND SWORD

Wither, p. 137.

MARTYR

Whitney, p. 224.

MYRRH TREE

E. M., no. 3.

OLIVE BRANCH AND SWORD

Wither, p. 238.

PEN AND SWORD

P. S., p. 230.

PORTRAIT AND SWORD

P. S., p. 168.

ROPE AND SWORD

P. S., p. 293.

Wither, p. 66.

SIGNET AND SWORD

P. S., p. 302.

STIRRING FIRE

Combe, no. 7.

P. S., p. 342 (misnumbered 242).

SUICIDE

Montenay, p. 38.

SWORD AND TROWEL

P. S., p. 145.

Motto: "In utrumque paratus."

Icon: The right hand holds a sword, and the left hand holds a trowel.

Epigram: The sword and the trowel represent the ministers of the Church who fight sin with God's word and bring the ignorant and erring into the faith.

Whitney, p. 66.

Motto: "In utrumque paratus."

Icon: The right hand holds a sword, and the left hand holds a trowel.

Epigram: When Jerusalem was under siege, the Jews saved their city by fighting the enemy with the sword and working to repair the damaged walls with the trowel.

SWORD AND WINE

Montenay, p. 322.

Motto: "Prunas enim congregabis."

Icon: A man offers a cup of wine to his enemy, who stands with a drawn sword.

Epigram: Love your enemy, offer him bread and wine, and you will win his heart.

T

TABLE

See:

CANDLE AND TABLE

Wither, p. 181.

SALT AND TURTLEDOVE

Peacham, p. 59.

TABLET

Peacham, p. 14.

Motto: "Fatum subscribat Eliza."

Icon: An empty tablet is ornately framed.

Epigram: Since the author's muse is given life and sustenance by the Princess Elizabeth, he asks her to write his muse's fate on the empty tablet.

Whitney, p. 100.

Motto: "Frontis nulla fides."

Icon: A man in the foreground writes on a tablet; in the background a man, a dog, and a bull pass by.

Epigram: Whereas animals openly show when they are hostile and untrustworthy, men can hide their true feelings. Therefore, before you decide to trust someone, take a tablet, record his words and deeds, and judge them.

TAIL

See:

APE AND FOX

Thynne, no. 62.

TAIL OF HORSE

Combe, no. 55.

Motto: "Wit can do with little paine,
 That strength alone cannot attaine."

Icon: One man pulls the tail of a horse; another makes a thread from hair.

Epigram: Although a man cannot pull off a horse's tail by strength, he can pull out the hair one by one and make a thread with it; similarly, strength and hastiness fail where wit and patience succeed.

TANTALUS

Whitney, p. 74.

Motto: "Avaritia."

Icon: Tantalus in a river up to his neck looks up at a fruit tree.

Epigram: Tantalus with his unsatisfied hunger and thirst is like the greedy man who hoards his wealth and never enjoys it.

TAPER

Quarles, *Hier.*, no. 1.

Motto: "Sine Lumine inane."
Icon: A taper burns; in the background two buckets are on a pulley.
Epigram: Nature gives a false light; man needs the spiritual light of God.
Quarles, *Hier.*, no. 2.
Motto: "Nescius unde."
Icon: A hand, holding flames, reaches from a cloud and lights a taper.
Epigram: Man is like the flame of this taper; his creation and life are a mystery to him.
Quarles, *Hier.*, no. 3.
Motto: "Quo me cunq rapit."
Icon: A wind blows the flame of a taper.
Epigram: As the wind blows the taper, so sorrows and danger afflict us during life.
See also:
 ARROW, BOW, TAPER
 Quarles, *Hier.*, no. 11.
 BAY TREE, LYRE, TAPER
 Quarles, *Hier.*, no. 12.
 CANDLE AND TAPER
 Farlie, no. 39.
 DEATH, FRUIT TREE, TAPER
 Quarles, *Hier.*, no. 14.
 FRUIT TREE, SWORD, TAPER
 Quarles, *Hier.*, no. 13.
 HORSE AND TAPER
 Quarles, *Hier.*, no. 10.
 PHYSICIAN
 Quarles, *Hier.*, no. 4.
 PLANT AND TAPER
 Quarles, *Hier.*, no. 9.
 RUIN, TAPER, TREE TRUNK
 Quarles, *Hier.*, no. 15.
 SCREEN AND TAPER
 Quarles, *Hier.*, no. 5.
 SUN AND TAPER
 Quarles, *Hier.*, no. 7.
See also: CANDLE.

TARGET
See:
FLY ON TARGET
P. S., p. 102.

TAU
P. S., p. 1.
Motto: "Nullis praesentior aether."
Icon: A hand holds a banner with the Greek letter tau.
Epigram: The letter tau is the proper badge of men who do war in the church of Christ.
See also:
 CROWN, CROSS, SERPENT
 Wither, p. 47.

TAVERN
See:
 SIGN
 Jenner, no. 28.

TEAR
Peacham, p. 142.
Motto: "Hei mihi quod vidi."
Icon: Tears fall from an eye.
Epigram: Though tears express sorrow, the lady remains cold and pitiless.
See also:
 CUPID, FURNACE, TEAR
 Van Veen, p. 189.
 HEART AND TEAR
 Harvey, no. 41.
 MYRRH TREE
 E. M., no. 3.

TEARING DECREE
P. S., p. 127.
Motto: "Pressa est insignis gloria facti."
Icon: Hands tear an official decree.
Epigram: Saint John tore up the decree forbidding Christians the use of schools; this action teaches that nothing should constrain man's conscience.

TELEMACHUS
See:
 DOLPHIN AND TELEMACHUS
 Thynne, no. 64.

TELESCOPE
Astry, no. 7.
Motto: "Auget et minvit."
Icon: A telescope sits on a hill.
Epigram: Affections are like telescopes—magnified at one end but diminished at the other.
See also:
 GLASS
 Quarles, *Emb.*, p. 176.

TEMPERANCE
Peacham, p. 93.
Motto: "Temperantia."
Icon: The female figure of Temperance holds a bridle and a golden cup.
Epigram: Temperance holds a bridle to curb affection and a golden cup to show that she is a foe of excess.
See also: GOLDEN MEAN.

TEMPEST
See:
 SPIRE AND TEMPEST
 Van der Noodt, no. 8.
 SUN AND TEMPEST

Wither, p. 70.
See also: STORM.

TEMPLE
Montenay, p. 34.
 Motto: "Sapiens mulier aedieicat domii."
 Icon: A queen builds a temple.
 Epigram: With good intent the prudent queen builds a temple in which the rich and poor may worship God.
See also:
 EARTHQUAKE AND TEMPLE
 Van der Noodt, no. 7.
See also: CHURCH.

TEN COMMANDMENTS
Bunyan, no. 1.
 Motto: "Upon the Ten Commandments."
 Icon: None.
 Epigram: The Ten Commandments are described in verse.

TENDING FIG TREE AND SHEEP
Willet, no. 76.
 Motto: "Qui laborat, manducat."
 Icon: None.
 Epigram: He who tends the tree shall enjoy the fig, and he who tends the sheep shall enjoy the wool. Labor is thus rewarded.

TENNIS
Combe, no. 5 (misnumbered 55).
 Motto: "One bird in hand is better farre, Than three which in the hedges are."
 Icon: A man with a tennis racket chases a ball on a tennis court.
 Epigram: As the bad tennis player wrongly anticipates the ball's uncertain bounce and thus misses the certain, so the man who neglects truth, in vain hopes for glory.

TENNIS BALL
Combe, no. 41.
 Motto: "From one t'another taunts do go, As doth a ball tost too and fro."
 Icon: Men hit at a ball with tennis rackets.
 Epigram: Like the tennis ball hit back and forth, words and blows are exchanged between men.
Peacham, p. 113.
 Motto: "Sic nos Dii."
 Icon: A hand bounces a tennis ball.
 Epigram: As the tennis ball rebounds with greater force when it is bounced, so a man should show courage when he is struck low by fortune.

TENT
Peacham, p. 196.

 Motto: "Super terram peregrinans."
 Icon: A tent.
 Epigram: Man has no home on earth but is like an itinerant pilgrim or a Tartar with only a tent for shelter.

TENT OF KEDAR
See:
 PILGRIM AND TENT OF KEDAR
 Arwaker, bk. 3, no. 7.
 Quarles, *Emb.*, p. 268.

TERMINUS
Peacham, p. 193.
 Motto: "Terminus."
 Icon: Jove, with his thunderbolt and eagle, looks at the statue of Terminus which is half woman, half marble pillar.
 Epigram: The statue called Terminus refused to obey Jove, explaining that it was "the bound of things" fixed by God.
P. S., p. 129.
 Motto: "Cedo nulli."
 Icon: The statue of Terminus with a human head on a stone pillar.
 Epigram: Terminus, which refused to yield to Jupiter himself, is an emblem of Erasmus, who would yield to no one on any point of learning.
Thynne, no. 36.
 Motto: "Our terme or limit of life not removeable."
 Icon: None.
 Epigram: When Jove ordered Terminus, which was half human, half pillar, to depart, Terminus stood fixed and could not be moved; men likewise have fixed terms in life which cannot be changed.
Wither, p. 161.
 Motto: "I was erected for a Bound, And I resolve to stand my ground."
 Icon: Terminus, with a human head and a stone base, stands in a landscape.
 Epigram: Christ is compared to a bounder stone, marking borders and limits; he confines all but is confined by none.
See also:
 CUPID AND TERMINUS
 Van Veen, p. 19.

THETIS
See:
 TOMB OF ACHILLES
 Whitney, p. 193.

THIEF
Bunyan, no. 30.
 Motto: "Upon the Thief."

Icon: None.
Epigram: The thief thinks that he gains when he
 steals, yet he really sustains the greatest
 loss—eternal life.
Farlie, no. 48.
 Motto: "Qui male facit odit lucem."
 Icon: Two thieves flee from a castle.
 Epigram: A light in a window frightens thieves away;
 so, too, Christ puts Satan to flight.
Whitney, p. 41.
 Motto: "Poena sequens."
 Icon: A thief is choked to death by a sack filled
 with the goods he has stolen.
 Epigram: As this thief's death illustrates, criminals
 will be punished by God.
See also:
 LIGHT AND THIEF
 Jenner, no. 17.
 MOTHER AND THIEF
 Whitney, p. 155.

THISBE
See:
 PYRAMUS AND THISBE
 Wither, p. 33.
 R. B., no. 29.

THISTLE
Wither, p. 232.
R. B., no. 26.
 Motto: "Hee that enjoyes a patient Minde,
 Can Pleasures in Afflictions finde."
 Icon: A man walks through thistles.
 Epigram: Patience can find pleasure in affliction.
See also:
 ASS
 Whitney, p. 18.
 ROSE AND THISTLE
 Peacham, p. 12.

THORN
Montenay, p. 430 (misnumbered 422).
 Motto: "Patientia vincit omnia."
 Icon: Thorns lie on a bed.
 Epigram: The man who endures suffering with pa-
 tience shall be rewarded.
See also:
 BIRD AND CHILD
 Bunyan, no. 31.
 CROWN AND THORN
 Astry, no. 25.
 CROWN OF THORNS AND HEART
 Harvey, no. 45.
 REED AND THORN
 P. S., p. 300.
 ROSE AND THORN
 Van Veen, p. 161.

SIN
Peacham, p. 146.

THREAD
See:
 GLOBE, KNIFE, THREAD
 Wither, p. 213.
 LABYRINTH AND PILGRIM
 Arwaker, bk. 2, no. 2.
 Quarles, *Emb.*, p. 188.
 LION AND THREAD
 Combe, no. 58.
 TAIL OF HORSE
 Combe, no. 55.
See also: CORD, ROPE.

THRONE
See:
 FELICITY
 Peacham, p. 25.
 HEAVEN
 Arwaker, bk. 3, no. 14.
 Quarles, p. 296.

THRUSH
Thynne, no. 11.
 Motto: "Pride."
 Icon: None.
 Epigram: A king asked each of three sons to choose a
 bird and then gave his crown to the son
 who chose not the mighty eagle or hawk
 but the simple thrush, a sign of humility.

THUNDERBOLT
Godyere, no. 16.
 Motto: "Quis contra nos."
 Icon: A gauntlet holds a thunderbolt.
 Epigram: Dedicated to the earl of Essex, this em-
 blem symbolizes the valor of the earl's
 ancestors.
See also:
 BIRTH OF PALLAS
 Peacham, p. 188.
 CAVE AND THUNDERBOLT
 Arwaker, bk. 1, no. 12.
 Quarles, *Emb.*, p. 168.
 EAGLE
 Astry, no. 22.
 MOUNTAIN AND THUNDERBOLT
 Astry, no. 50.
 TERMINUS
 Peacham, p. 193.
See also: LIGHTNING.

Tiara
See: PAPAL CROWN.

TIMBER
P. S., p. 303.

Motto: "Hic terminus haeret."
Icon: A piece of timber.
Epigram: To remind himself of his and all other men's mortality, a man had a piece of timber inscribed with the motto "Here is the furtherest bound or limit" cast to the ground.

See also: LOG, WOOD.

TIME
Whitney, p. 199.
Motto: "Quae sequimur fugimus."
Icon: Time—bearded, winged, and with a sickle—pursues two men.
Epigram: Since time will inevitably cut man off, he should learn to be content with what he has.

See also:
CUPID AND TIME
Van Veen, p. 237.
DEATH AND TIME
Quarles, *Hier.*, no. 6.
FLAME AND TIME
Farlie, no. 57.
FORTUNE, TIME, WORLD
Quarles, *Emb.*, p. 36.
SORROW AND TIME
Arwaker, bk. 1, no. 15.
Quarles, *Emb.*, p. 180.
TRUTH
Whitney, p. 4.

TIME AND WISDOM
Godyere, no. 28.
Motto: "Tempus coronat industriam."
Icon: Time—an old man with an hourglass and a sickle—presents a crown to Wisdom—a man with a book and a serpent coiled on his arm.
Epigram: Man attains wisdom only after long and arduous toil; time crowns him for his achievement.

TINDERBOX
See:
CANDLE AND MATCH
Farlie, no. 43.
CUPID AND TINDERBOX
Van Veen, p. 159.
FLINT, STEEL, TINDERBOX
Peacham, p. 103.
HEART
Ayres, no. 7.

TOBACCO
Jenner, no. 31.
Motto: "Tobacco."
Icon: None.

Epigram: Tobacco is an image of vanity: its leaves wither, the pipe disintegrates, the smoke disappears, and the pipe grows foul.

TOMB
Astry, no. 101.
Motto: "Futueum inincat."
Icon: Above a tomb are a crown, a scepter, and a sun rising over the world.
Epigram: The good prince sets an example for his successor.

See also:
FLAME AND TIME
Farlie, no. 57.
MARBLE
Whitney, p. 136.
See also: SEPULCHRE.

TOMB OF ACHILLES
Whitney, p. 193.
Motto: "Strenuorum immortale nomen."
Icon: Thetis stands beside the tomb of Achilles, which is decorated with flowers. A palm tree grows nearby.
Epigram: As Achilles was not forgotten after his death but was mourned and honored by Thetis, so great men are remembered for their noble deeds.

TOMB OF AJAX
See:
PROWESS
Whitney, p. 30.

TOMB OF LAIS
Thynne, no. 54.
Motto: "Monument of a harlott."
Icon: None.
Epigram: On the tomb of Lais a lioness holds a ram with bloody claws; this tomb illustrates how Lais held and kept her foolish lovers.

TOMB OF NERO
Peacham, p. 144.
Motto: "Et minimi vindictam."
Icon: Bees and flies land on the tomb of Nero.
Epigram: Bees and flies take revenge on the tyrant Nero who, when alive, terrorized men but, in the end, was laid low.

TONGS
See:
FIRE AND TONGS
Van Veen, p. 139.

TONGUE
Peacham, p. 156.
Motto: "Silentii dignitas."
Icon: Solon cuts out his tongue.

Epigram: By cutting out his tongue, Solon embraced the ideal of silence.

P. S., p. 137.
Motto: "Quo tendis."
Icon: A winged tongue.
Epigram: The tongue is dangerous and should be controlled by reason.

Willet, no. 34.
Motto: "Linguae malum."
Icon: None.
Epigram: The tongue, though small, rules the body.

See also:
FIERY TONGUE
P. S., p. 13.
FOX AND LION
Whitney, p. 156.
HEART AND TONGUE
Combe, no. 73.
HEART, NUN, TONGUE
Montenay, p. 130.

TONGUE AND WING
Wither, p. 42.
Motto: "No Heart can thinke, to what strange ends,
The Tongues unruely motion tends."
Icon: A winged tongue.
Epigram: Man should be slow to speak and control his tongue so that it does not tell secrets, utter curses, or spread slander.

TONGUE OF LION
P. S., p. 189.
Motto: "Tu decus omne tuis."
Icon: A hand holds the tongue of a lion.
Epigram: When Lysimachus was thrown to the lion, he killed it by pulling out its tongue; he is an example of valor.

TONGUE OF PURPLE FISH
P. S., p. 207.
Motto: "Sic praedae patet esca sui."
Icon: A purple fish has a protruding tongue.
Epigram: The tongue of a purple fish is beneficial because it gathers food, but harmful because it is preyed upon by other fish; so, too, man's tongue is a jewel when wisely governed but poison when given to slander.

Tool
See: ANVIL, AWL, AX, BAR, BLADE, CLUB, HAMMER, HARROW, KNIFE, LEVEL, MATTOCK, MEASURE, PESTLE, PICK, PITCHFORK, PLOW, PLUMMET, RAKE, RAZOR, SCYTHE, SICKLE, SLEDGE, SPADE, SQUARE, TONGS, TOOL OF WORKMAN, TROWEL, WEDGE.

TOOL OF WORKMAN
See also:

APE
Whitney, p. 145.

TOP AND WHIP
Bunyan, no. 37.
Motto: "Upon the whipping of a Top."
Icon: None.
Epigram: As the top will not spin until it is whipped, the legalist will not do his duty unless Moses whips him.

TORCH
Astry, no. 19.
Motto: "Vicissim traditur."
Icon: A hand passes a burning torch to another hand.
Epigram: As the burning torch in Greek games was passed from one hand to another, so the scepter passes by succession from one ruler to the next.

Ayres, no. 2.
Motto: "Mutual Love."
Icon: Two cupids hold flaming torches together.
Epigram: Love requires love; the lovers' hearts burn with equal fire.

Farlie, no. 8.
Motto: "Sola Lux mihi laus."
Icon: A torch burns.
Epigram: As the light is the life of the torch, so man's mind—divine reason—is essential to man.

Farlie, no. 15.
Motto: "Nec minor est mea lux."
Icon: An arm lights a torch by the flame of another torch.
Epigram: As the torch can give light without diminishing itself, so divine wisdom.

Farlie, no. 27.
Motto: "Non suffulta pereo."
Icon: A man stands by a leaning torch.
Epigram: Like the torch which falls and is in danger of going out, man is vulnerable to falls and needs help.

Farlie, no. 32.
Motto: "Extinguar quin ascendam."
Icon: A torch is held upside down.
Epigram: When the torch is held upside down, its flame reaches upward; so, too, man's soul rises heavenward at death.

Peacham, p. 52.
Motto: "Undique, flamma."
Icon: A lighted torch stands in the ground, and small, unlighted torches surround its flame.
Epigram: The prince is like the torch, a bright example giving light to thousands.

P. S., p. 357.
Motto: "Qui me alit, me extinguit."

Icon: A burning torch.
Epigram: When a torch is held upside down, the wax which feeds the flame extinguishes it; so, too, the beauty of a woman may both please and endanger men.

See also:
BED
Arwaker, bk. 2, no. 11.
BELLOWS, SUN, TORCH
Quarles, *Emb.*, p. 64.
CANDLE AND TORCH
Farlie, no. 50.
CUPID AND TORCH
Van Veen, p. 191.
DRAWING AND RUNNING
Arwaker, bk. 2, no. 8.
Quarles, *Emb.*, p. 212.
HEART AND TORCH
Wither, p. 178.
LION
Peacham, p. 123.
OWL
Wither, p. 253.
SHIP, TORCH, WIND
Montenay, p. 74.
STORK AND TORCH
Peacham, p. 111.
SUN AND TORCH
Peacham, p. 109.

TORTOISE
Peacham, p. 178.
Motto: "Movere levissima sensum."
Icon: A hand touches a tortoise with a straw.
Epigram: As the tortoise withdraws into its shell at the mere touch of a straw, so many men will fight over the most trivial thing.
Wither, p. 86.
Motto: "I beare, about mee, all my store; And, yet, a King enjoyes not more."
Icon: A tortoise crawls on the ground.
Epigram: The tortoise represents the man "who in himselfe, hath full contents," needing nothing external because of his virtuous mind.
Wither, p. 222.
Motto: "The best, and fairest House, to mee, Is that, where best I love to bee."
Icon: A tortoise.
Epigram: Like the tortoise's house, the ideal house is not pretentious but is, rather, a place where man is safe and content.

See also:
BEE AND TORTOISE
Combe, no. 28.
CUPID AND TORTOISE

Van Veen, p. 91.
HARE AND TORTOISE
Van Veen, p. 99.
PARROT AND TORTOISE
Thynne, no. 46.
PHLEGM
Peacham, p. 129.
PILGRIM AND TORTOISE
Combe, no. 51.
WIFE
Combe, no. 18.
Whitney, p. 93.
See also: TURTLE.

TORTURE
Hall, p. 8.
Motto: "Thou art with me in secret O Lord, whipping me oft with the rods of fear and shame."
Icon: Divine Love holds the hand of a human figure and points to a man who is tortured by being pierced through the chest with a lance.
Epigram: Sin is its own punishment; the sinful man is tortured by his own guilt, fear, and shame.

See also:
CUPID AND TORTURE
Van Veen, p. 185.

TOUCHSTONE
Whitney, p. 139.
Motto: "Sic spectanda fides."
Icon: A gold seal is held to a touchstone.
Epigram: Just as the touchstone distinguishes gold from the superficial appearance of gold, so we should distinguish men by their works, not their looks or outward behavior.

See also:
COIN AND TOUCHSTONE
Wither, p. 233.
GOLD AND TOUCHSTONE
P. S., p. 213.

TOWEL
See:
MARBLE
Whitney, p. 136.

TOWER
Hall, p. 81.
Motto: "I am come a light into the world, and whosoever believeth in me shall not abide in darkness."
Icon: A path leads to a stone tower.
Epigram: Both sense and reason may err, but faith sets man right and is the best perspective.
Willet, no. 9.

Motto: "Regnum coelorum vim patitur."
Icon: None.
Epigram: Many people are going toward a tower that represents the Church.

Tower of Babel
See: TOWER OF BABYLON.

TOWER OF BABYLON
Montenay, p. 122.
Motto: "Quid superest."
Icon: Wind and fire destroy the tower of Babylon.
Epigram: Because the wicked men of Babylon would not trust in God but only in their own building, God destroyed their tower.

Willet, no. 43.
Motto: "Sumptuosae aedes."
Icon: None.
Epigram: God punished the men who built the Tower of Babylon for their own fame.

TOY
See:
BUBBLE AND TOY
APE AND TOY
Peacham, p. 168.
BUBBLE AND TOY
Hall, p. 4.
CHILD AND FOOL
Whitney, p. 81.
CUPID, TOY, VENUS
Quarles, *Emb.*, p. 92.
FOOL
Arwaker, bk. 1, no. 2.
SIEVE
Quarles, *Emb.*, p. 88.
See also: BAUBLE, TOP.

TRADE
Ayres, no. 40.
Motto: "Love bought & sold."
Icon: Cupid examines the merchandise which a man offers for sale.
Epigram: Love has become a "Smithfield Trade," where man bargains for and buys a wife.

Trample
See: TREAD UPON.

Transgression
See: SIN.

Transgressor
See: SINNER.

Trap
See: NET, SNARE.

TRAVELER
Wither, p. 153.

R. B., no. 6.
Motto: "His Pace, must wary be, and slow, That hath a Slippery-way to goe."
Icon: A traveler with a walking stick passes along a street.
Epigram: Man is a traveler through life who must move on dangerous paths.

See also:
STORM AND TRAVELER
Jenner, no. 21.
See also: WANDERER.

TREAD UPON
Ayres, no. 28.
Motto: "Loves Triumph over Riches."
Icon: Cupid treads on royal ensigns, as other riches lie around him.
Epigram: Love is more powerful than pomp and riches.

See also:
DOCK
Whitney, p. 98.
ONE
Ayres, no. 34.
RUMICE
P. S., p. 352.
TRUTH
Peacham, p. 134.

TREASURE
See:
BELLOWS, HEART, TREASURE
Harvey, no. 5.
CIRCUMCISION AND HEART
Harvey, no. 13.
COIN
Quarles, *Emb.*, p. 80.
CUPID AND TREASURE
Van Veen, p. 129.
DEATH AND SCHOLAR
Wither, p. 1.
R. B., no. 3.
FOOL AND HEART
Harvey, no. 4.
HEART AND TREASURE
Harvey, no. 7.

TREE
Astry, no. 67.
Motto: "Poda a no corta."
Icon: A barren tree.
Epigram: The prince should not overburden his subjects with taxes.

Astry, no. 70.
Motto: "Dum scinditur frangor."
Icon: Hands pull apart two branches of the same tree, each branch with a crown on it.

Epigram: The tree signifies a kingdom; when it is divided, it is ruined.

Godyere, no. 17.

Motto: "D'odore il mondo e d'acutezza il cielo."

Icon: A tree stands with its lower branches spreading toward earth and its top pointing to heaven.

Epigram: Man should resemble the tree, bestowing his wealth on the earth and his thoughts on heaven.

Whitney, p. 77.

Motto: "Dum vivo, prosum."

Icon: A man collects boughs from an aged tree.

Epigram: Just as the tree is useful to men as long as it is alive but rots and is useless after it dies, so man may do good while he lives but not after he is dead.

Willet, no. 1.

Motto: "Boni Principis encomium."

Icon: None.

Epigram: The tree which shades the beasts and houses the bird resembles the good king.

See also:

ARROW AND TREE
Peacham, p. 16.

AX, CUPID, TREE
Van Veen, p. 211.

ELEPHANT
Wither, p. 183.
R. B., no. 48.

EVE, SERPENT, TREE
Quarles, *Emb.*, p. 4.

FIRE AND TREE
Montenay, p. 278.

FOOL IN TREE
Peacham, p. 112.

GRAFTED TREE
P. S., p. 191.

IVY AND TREE
P. S., p. 265.

LEAF, TREE, WIND
Hall, p. 64.

OAK AND WIND
Montenay, p. 262.

PHOENIX
Van der Noodt, no. 5.

PLANTING TREE
Wither, p. 35.

PRUNED TREE
Peacham, p. 192.

RAVEN, TREE, WOLF
Montenay, p. 58.

SHADOW
Arwaker, bk. 2, no. 14.

SPROUT AND TREE
Wither, p. 46.

STAG
Whitney, p. 153.

STONE AND TREE
Wither, p. 28.

STRAIT, TREE, WIND
Wither, p. 243.

SUN AND TREE
Godyere, no. 13.

See also: BOUGH, BRANCH, FLOWER, FRUIT TREE, GRAFTED TREE, LEAF, NUT, TREE TRUNK, WOOD, WOODS; ALMOND, APPLE, BANANA, BAY, BEECH, CEDAR, CLOVE, CORNEL, CYPRESS, DODANIAN, ELDER, ELM, FIG, HAWTHORN, LAUREL, MYRRH, MYRTLE, OAK, OLIVE, PALLAS, PALM, PEAR, PINE, PLATAN, POMEGRANATE, PRUNED, WILLOW.

TREE OF KNOWLEDGE

See:

EVE, HEART, SERPENT
Harvey, no. 1.

TREE TRUNK

See:

ARROW, BOW, TAPER
Quarles, *Hier.*, no. 11.

RUIN, TAPER, TREE TRUNK
Quarles, *Hier.*, no. 15.

TRIMMING WICK

See:

TAPER
Quarles, *Hier.*, no. 4.

TRINITY

P. S., p. 162.

Motto: "Ulterius tentare veto."

Icon: Three heads are on one base.

Epigram: The threefold image of the Sabines figure the trinity and unity of the Godhead.

TRIUMPHAL ARCH

Van der Noodt, no. 9.

Motto: None.

Icon: An elaborate triumphal arch breaks into pieces.

Epigram: Even the richest man-made monuments collapse in time.

TROJAN HORSE

Astry, no. 27.

Motto: "Specie religionis."

Icon: The Trojan horse enters the gates of Troy.

Epigram: Fraud under the guise of religion succeeded where force failed in the Trojan War; "Of such Influence is Religion."

TROPHY

Astry, no. 17.

Motto: "Alienis spoliis."

Icon: Military trophies hang on a post.

Epigram: The glorious exploits of one's ancestors are no more than trophies on a tree, unless the inheritor imitates the actions, as well as the glory, of the ancestors.

TROWEL

See:

SWORD AND TROWEL

P. S., p. 145.

Whitney, p. 66.

TROY

See:

AENEAS AND ANCHISES

Whitney, p. 163.

TRUMPET

Astry, no. 35.

Motto: "Interclusa respirat."

Icon: A hand holds a trumpet.

Epigram: As the trumpet makes greater harmony the closer the breath is pressed into it, so virtue is more harmonious when it is suppressed by malice.

Hall, p. 108.

Motto: "The Lord cometh with ten thousand of his Saints to execute judgement upon all."

Icon: An angel stands on a ball and blows a trumpet.

Epigram: The trumpet shall announce Doomsday, when the good and the wicked shall be judged.

See also:

ALMSGIVING AND TRUMPET

Montenay, p. 390.

Whitney, p. 224.

ANGEL, TRUMPET, WIND

Montenay, p. 426.

BEAST AND TRUMPET

Montenay, p. 110.

COCK AND TRUMPET

P. S., p. 267.

DEATH AND KING

Montenay, p. 106.

FAME

Whitney, p. 196.

Wither, p. 146.

R. B., no. 37.

FLAME AND TIME

Farlie, no. 57.

TRUMPET AND WING

Montenay, p. 162.

Motto: "Deo Recipiam."

Icon: A hand in a cloud holds a winged trumpet on a string.

Epigram: The good man should not be proud or call attention to his goodness but think his treasure is in God's hands.

TRUMPETER

Whitney, p. 54.

Motto: "Agentes, & consentientes, pari poena puniendi."

Icon: Two soldiers capture an enemy trumpeter.

Epigram: When the trumpeter was captured by his enemy, he begged for mercy, saying that he had killed no one; the captains denied his plea, saying that he provoked the others.

TRUTH

Peacham, p. 134.

Motto: "Veritas."

Icon: The female figure of Truth is naked, holds a book and a palm, stands on the world, and holds the sun.

Epigram: This figure personifies truth: her nakedness symbolizes simplicity; the sun, her association with light; the book, the strength history affords her; the palm, her triumph; the world she treads on, her transcendence of earthly things.

Whitney, p. 4.

Motto: "Veritas temporis filia."

Icon: Winged Time, with a sickle, helps Truth from a cave where she has been imprisoned by Strife (who makes fire with a firebrand and bellows), Envy (who eats her heart), and Slander (with a firebrand and an innocent victim).

Epigram: In time truth shall be discovered despite the attempts to suppress it.

TUN

Whitney, p. 12.

Motto: "Frustra."

Icon: A tun full of holes leaks water.

Epigram: This tun, or barrel, represents three sorts of men: The "blab" who can keep no secrets; the "ingrate" who does not know how to use his friends' goodwill; and the "covetous man" who is not satisfied with what he has.

See also: BARREL.

TURF

See:

BALL, KEY, TURF, SHILLING

P. S., p. 307.

See also: EARTH, GROUND.

TURTLE

See:

LANTERN

Quarles, *Hier.*, no. 8.

See also: TORTOISE.

TURTLEDOVE
Peacham, p. 110.
 Motto: "Piorum vita luctuosa."
 Icon: A turtledove sits on a branch while other birds fly around a tree.
 Epigram: As the turtledove prefers shade and solitude, so the godly person rejects worldly pleasure for the contemplative life.

See also:
 OLIVE TREE, RING, TURTLEDOVE
 Peacham, p. 92.
 SALT AND TURTLEDOVE
 Peacham, p. 59.

TYING HEART
Harvey, no. 39.
 Motto: "Cordis Unio."
 Icon: Divine Love and a human figure tie their hearts together with a rope.
 Epigram: Love unites hearts, tying them together.

TYPHAEUS'S SISTER
Van der Noodt, no. 16.
 Motto: None.
 Icon: Typhaeus's sister, in armor, holds a trophy and stands with vanquished knights at her feet.
 Epigram: Typhaeus's sister represents the conqueror of the world, but she, too, falls.

TYRANT
See:
 BOY AND TYRANT
 Montenay, p. 134.

U

ULCER
Montenay, p. 342.
 Motto: "Difficilis exitus."
 Icon: A physician treats a sick man's ulcer, draining it.
 Epigram: Like the sick man who calls for a physician to expell the infection from his ulcer, sinful man should call on Christ to purge him of his corrupting sin.

ULYSSES
See:
 DIOMEDES AND ULYSSES
 Whitney, p. 47.
 PALLAS AND ULYSSES
 Peacham, p. 69.
 SIREN
 Whitney, p. 10.

UNICORN
Astry, no. 8.
 Motto: "Prae oculis ira."
 Icon: A unicorn.
 Epigram: As the unicorn has a horn, the weapon of anger, exactly between the eyes, so men should have both eyes on anger, which so tyrannizes them.

UNIVERSE
See:
 MAN AND UNIVERSE
 Peacham, p. 190.
See also: COSMOS, WORLD.

UPRIGHT
See:
 HEART AND LEVEL
 Harvey, no. 23.

URANIA
Peacham, p. 177.
 Motto: "Hinc super haec, Musa."
 Icon: Urania, dressed in a gown filled with stars, holds a sphere of the universe and points to the stars.
 Epigram: The speaker desires Urania's inspiration and seeks to sing of the divine creation.

URN
See:
 ARROW, BOW, TAPER
 Quarles, *Hier.*, no. 11.
 BAY TREE, LYRE, TAPER
 Quarles, *Hier.*, no. 12.
 DEATH, FRUIT TREE, TAPER
 Quarles, *Hier.*, no. 14.
 FRUIT TREE, SWORD, TAPER
 Quarles, *Hier.*, no. 13.
 HORSE AND TAPER
 Quarles, *Hier.*, no. 10.
 PLANT AND TAPER
 Quarles, *Hier.*, no. 9.
 RUIN, TAPER, TREE TRUNK
 Quarles, *Hier.*, no. 15.
 TAPER
 Quarles, *Hier.*, no. 1.

USURER
Thynne, no. 20.
 Motto: "Usurie."
 Icon: None.
 Epigram: Although the gods may enrich men, they also punish the greedy and insatiate, as Pluto did the usurer who hoarded gold in a cave.
See also:
 APE AND USURER
 P. S., p. 367.

V

VALENTINUS
See:
> PEN
> P. S., p. 197.

VALERIUS
See:
> HELMET AND RAVEN
> Whitney, p. 113.

VALLEY
Willet, no. 86.
> Motto: "Qui pulchra affectat ardua perferat."
> Icon: None.
> Epigram: The valley where the Israelites struggled, thirsty, on their way to Zion represents affliction which men must bear with patience.

See also:
> CROWN AND VALLEY
> P. S., p. 315.
> MOUNTAIN AND VALLEY
> Peacham, p. 55.

VANITY
Arwaker, bk. 2, p. 5.
> Motto: "O turn away mine eyes, lest they behold vanity."
> Icon: Divine Love covers a man's eyes so that he cannot see Vanity, a woman finely appareled, with a fan of feathers and bubbles.
> Epigram: Man must guard against the temptation of vanity.

Quarles, *Emb.*, p. 200.
> Motto: "Turne a way myne eyes least thay behold vanite."
> Icon: Divine Love covers a man's eyes so that he cannot see Vanity, a woman finely appareled, with a fan of feathers and bubbles.
> Epigram: Man is given to vanity and should look to God to shield his eyes from it.

Vegetation (general)
See: BERRY, BOUGH, BRANCH, BRIAR, BUSH, FLOWER, FRUIT, GRAIN, GRASS, HAY, HERB, LEAF, NUT, PLANT, REED, SEED, SPROUT, STALK, TREE, TREE TRUNK, THORN, VINE, WEED, WOOD, WOODS.

Vegetation (specific, excluding trees)
See: BRAMBLE, CHESBOLE, CORN, DAMASK ROSE, DICTAMAN, DICTANUS, DOCK, GOURD, HELIOTROPE, HYOSCYAMUS, HYSSOP, IVY, LILY, MUSHROOM BALL, MUSTARD SEED, POPPY, PUFFBALL, ROSE, RUMICE, SAFFRON, SEMPERVIVUM, THISTLE, VIOLET, WHEAT, WOODBINE, WORMWOOD.

VEIL
Arwaker, bk. 3, no. 12.
> Motto: "When shall I come and appear before the presence of God?"
> Icon: A human figure stands in front of a veil behind which stands Divine Love.
> Epigram: The speaker longs to see God and to behold him unveiled.

Vengeance
See: NEMESIS.

VENUS
See:
> BEE AND CUPID
> Whitney, p. 148.
> CUPID AND OATH
> Van Veen, p. 141.
> CUPID AND VENUS
> Peacham, p. 174.
> Thynne, no. 3.
> CUPID, TOY, VENUS
> Quarles, *Emb.*, p. 92.
> JUDGMENT OF PARIS
> Whitney, p. 83.
> MOMUS AND VENUS
> Thynne, no. 2.
> NET
> Combe, no. 2.
> PARIS
> Thynne, no. 29.
> SAGE
> Whitney, p. 135.
See also: MORNING STAR.

Vessel
See: BARREL, BOWL, CUP, EWER, FLAGON, FLASK, GOBLET, PIPKIN, PITCHER, POT, TUN.

VESUVIUS
Astry, no. 93.
> Motto: "Impia faedera."
> Icon: Mount Vesuvius erupts.
> Epigram: As Mount Vesuvius is always a threat to its neighborhood, so princes of different religions are dangerous, and alliances with them are potentially destructive.

See also:
> PLINY
> Whitney, p. 25.

VICE
See:
> HERCULES
> Whitney, p. 40.

VICE AND VIRTUE
Wither, p. 22.
R. B., no. 2.
> Motto: "When Vice and Vertue Youth shall wooe, To hard to say, which way 'twill goe."

Icon: A youth labeled Hercules chooses between Vice—a naked woman with horns, a mask, and claws—and Virtue—a man with an open book and caduceus.

Epigram: Youth must choose between vice and virtue.

VICTORY
Wither, p. 254.
Motto: "None Knowes, untill the Fight be past, Who shall bee Victor, at the last."
Icon: Victory, a winged figure in the sky, holds a wreath and a palm above a man in combat with another.
Epigram: Because victory is always doubtful and cannot be predicted, men should not rashly enter fights.

See also:
MARS AND MERCURY
Godyere, no. 14 (misnumbered 13).

VIOLET
Hawkins, no. 4, p. 38.
Motto: "Humi serpens extollor honore."
Icon: A violet is encircled by a wreath.
Epigram: The violet is an image of humility, solicitude, and virtue, and thus it is a symbol of the Virgin Mary.
Hawkins, no. 4, p. 45.
Motto: "Effudit odorem divinum excelso Principi; oculus Dei respexicissam."
Icon: A violet grows in a garden, and an eye in a cloud observes it.
Epigram: The Virgin Mary is likened to the violet, which is humble, submissive, and hidden.

VINE
E. M., no. 8.
Motto: "Sterilis nisi falce putetux."
Icon: A grapevine.
Epigram: The vine, which is strengthened when it is pruned, represents those who are persecuted for righteousness' sake.
Willet, no. 81.
Motto: "In desciscentes."
Icon: None.
Epigram: The fruitful vine is very useful, but the barren vine is useless; so, too, with righteous and evil men.

See also:
ELM AND VINE
Van Veen, p. 245.
Whitney, p. 62.
GRAPEVINE
Combe, no. 87.
LANCE AND VINE
Astry, no. 74.
See also: WOODBINE.

VINE FINCH
See:
BIRD
Whitney, p. 54.

VINE TREE
Bunyan, no. 45.
Motto: "Upon the Vine-tree."
Icon: None.
Epigram: The vine tree is no different from any other tree if it is fruitless; likewise, professors of the faith are no different from other men if they do not mortify their sin: the excellence of both vine tree and professor lies in the fruit.

VIOLA
See:
ARION
Wither, p. 10.
R. B., no. 39.

Violin
See: FIDDLE.

VIPER
Peacham, p. 152.
Motto: "Libidinis effecta."
Icon: A viper bites off another viper's head; below, a viper gives birth.
Epigram: The copulation of vipers, which ends with the female biting off the male's head, symbolizes the destructive power of lust.
P. S., p. 374.
Motto: "Ingratis servire nefas."
Icon: A viper.
Epigram: The viper, which kills her mate during copulation and is later killed by her offspring, is a symbol of ingratitude.
Willet, no. 94.
Motto: "Hypocritae progenies viper arum."
Icon: None.
Epigram: The hypocrite is like the viper, which makes a "goodly show" but is inwardly evil.
Wither, p. 247.
Motto: "How ever thou the Viper take, A dang'rous hazzard thou dost make."
Icon: A hand holds a viper.
Epigram: Meddling in dangerous affairs is like handling a stinging viper.

See also:
EATING SERPENT
Peacham, p. 49.
ENVY
Whitney, p. 94.
PAUL AND VIPER
P. S., p. 242.

Whitney, p. 166.

See also: ADDER, DRAGON, SERPENT, SNAKE.

VIRGIN MARY
See:
 DOVE AND VIRGIN MARY
 Hawkins, no. 18, p. 207.
 RAINBOW
 Hawkins, no. 9, p. 100.

VIRTUE
Montenay, p. 270.
 Motto: "In via, no virtuti Nulla est via."
 Icon: The female figure of Virtue stands on a rock and holds a pillar and a banner; below, a man in a boat moves toward her.
 Epigram: The man that will find virtue must labor long and hard; so, too, the man who seeks paradise.

See also:
 FAME AND VIRTUE
 Peacham, p. 35.
 HERCULES
 Whitney, p. 40.
 VICE AND VIRTUE
 Wither, p. 22.
 R. B., no. 2.
 WIFE
 Combe, no. 93.

VIZARD
See:
 CUPID AND VIZARD
 Van Veen, p. 221.
See also: DISGUISE, MASK.

VULCAN
See:
 BIRTH OF PALLAS
 Thynne, no. 38.

VULTURE
Whitney, p. 119.
 Motto: "Ex damno alterius, alterius utilitas."
 Icon: A lion and a boar fight as a vulture watches from a tree above.
 Epigram: Just as the vulture watches the noble lion and boar fight in hopes of gaining from the slaughter, so some men hope to gain from battles between great men.

W

WAGONER
See:
 HORSE
 Whitney, p. 6.

WALKER
See:
 CHILD AND WALKER
 Arwaker, bk. 2, no. 3.
 Quarles, *Emb.*, p. 192.
 INFANT AND HANDMAID
 Quarles, *Emb.*, p. 216.
 INFANT AND SISTER
 Arwaker, bk. 2, no. 9.

WALKING
See:
 COUNTRY
 Quarles, *Emb.*, p. 208.

WALL
See:
 CROWN AND WALL
 P. S., p. 314.
 ELDER TREE
 Peacham, p. 6.
 RAM AND WALL
 Astry, no. 71.
 SERPENT
 Whitney, p. 76.
 SOLDIERS SCALE WALL
 Astry, no. 89.

WAND
See:
 GANYMEDE
 Peacham, p. 48.
 HEAD OF STATE
 Peacham, p. 22.
See also: ROD, STAFF.

WANDERER
See:
 APODES AND WANDERER
 Whitney, p. 89.
 HEART AND WANDERER
 Harvey, no. 11.
See also: TRAVELER.

WAR
See:
 CUPID, ENVY, WAR
 Van Veen, p. 49.

Warden
See: KEEPER.

WASHING
Willet, no. 74.
 Motto: "Ad Deum ne accedas imparatum."
 Icon: None.
 Epigram: As Moses taught the Israelites to wash in preparation to see God, so man should be "cleane within" when he prays.

See also:

HEART AND WASHING
Montenay, p. 354.

WASHING HAND
Wither, p. 41.
R. B., no. 33.
 Motto: "Let him, that at Gods Altar stands,
 In Innocencie, wash his Hands."
 Icon: A priest washes his hands.
 Epigram: As the priest washes his hands before ap-
 proaching God's altar, so men should be
 purified, repentant, and innocent when
 they pray to God.
Wither, p. 162.
 Motto: "Where Lovers fitly matched be,
 In mutuall-duties, they agree."
 Icon: Cupid pours water over the joined hands
 of a man and a woman.
 Epigram: Like hands which wash each other, true
 lovers share mutual duties and live in sym-
 pathy and amity.

WASHING THE AETHIOPEAN
Whitney, p. 57.
 Motto: "Aethiopem lavare."
 Icon: Two men wash a black man.
 Epigram: Because the Aethiopean is black by nature,
 he cannot be washed white; we must accept
 the power of nature and not attempt the
 impossible.

WASP
See:

BEE
Peacham, p. 41.
SERPENT AND WASP
P. S., p. 104.
SPIDER AND WEB
Combe, no. 49.

WASP AND WORLD
Quarles, *Emb.*, p. 12.
 Motto: "Ut potiar, patior, Patieris, non potieris."
 Icon: Cupid puts his hand into the world in
 which wasps have made a hive as Divine
 Love holds a tablet and points to heaven.
 Epigram: The world is a hive which gives stings but
 no honey.

WATCH
P. S., p. 226.
 Motto: "Vivit ad extremum."
 Icon: A round watch.
 Epigram: The watch is round so that the more the
 winds blow the surer it keeps the fire burn-
 ing; so, too, a man's love for his prince
 ought to be constant and unextinguishable.

See also:

BOY, WATCH, WATCHMAKER
Bunyan, no. 46.
CHILD AT WATCH
Wither, p. 94.

WATER
Jenner, no. 3.
 Motto: "A Remedy against Dispaire."
 Icon: A man pours a pail of water on the floor;
 an inset scene shows a pail of water being
 poured into the ocean.
 Epigram: When a pail of dirty water is poured on
 the floor, it seems abundant, but when it is
 poured into the ocean, it disappears; so,
 too, with man's sin: man alone cannot dis-
 charge it, but Christ can abolish it.

See also:

ADAM SOWS EARTH
Quarles, *Emb.*, p. 8.
BEARDED MAN AND POT
Van der Noodt, no. 12.
CASTLE AND WATER
Astry, no. 83.
FIRE AND WATER
P. S., p. 57.
Van Veen, p. 171.
FISH AND WATER
Bunyan, no. 7.
FLINT AND WATER
Bunyan, no. 6.
FOUNTAIN AND WATER
Arwaker, bk. 1, no. 8.
Quarles, *Emb.*, p. 152.
GRASS AND WATER
P. S., p. 217.
HEART AND WATER
Harvey, no. 12.
HOPS AND WATER
Thynne, no. 20.
JAWBONE OF ASS AND WATER
P. S., p. 234.
LAUREL
Peacham, p. 200.
MEAL AND WATER
P. S., p. 174.
RAVEN, STONE, WATER
P. S., p. 179.
STAFF AND WATER
Peacham, p. 68.

WATERING
Wither, p. 107.
 Motto: "Things, to their best perfection come,
 Not all at once; but, some and some."
 Icon: A hand waters a plant and wind blows.
 Epigram: Young plants thrive when watered little by

little but are drowned by too much water; so, too, actions are brought to perfection by degrees but are ruined by haste.

See also:

CUPID WATERING GARDEN
Van Veen, p. 79.

ROSE
Astry, no. 34.

ROSE AND THISTLE
Peacham, p. 12.

WATERING HEART
Harvey, no. 29.

Motto: "Cordis Irrigatio."

Icon: Divine Love waters a heart held by a human figure.

Epigram: The speaker asks God to water his heart with grace.

WAX
See:

FLAME AND WAX
Whitney, p. 183.

SCALE AND WAX
Thynne, no. 47.

Way
See: PATH.

WAY TO HEAVEN
Montenay, p. 406.

Motto: "Facile difficile."

Icon: One man walks on the way to heaven, while another man falters.

Epigram: The godly easily walk the way to heaven, but the wicked fail.

Wealth
See: GOLD, MAMMON, MONEY, TREASURE.

WEAPON
See:

PILLAR, SHIELD, WEAPON
Peacham, p. 173.

See also: ARROW, BAR, CANNON, CLUB, CUDGEL, DART, LANCE, PIKE, POLEAX, ROD, SHAFT, SLING, SPEAR, STICK, SWORD.

WEATHERCOCK
Bunyan, no. 69.

Motto: "Upon the Weather-cock."

Icon: None.

Epigram: Like the weathercock, which sets its nose against the wind, the Christian sets himself against Antichrist.

Weathervane
See: WEATHERCOCK.

WEB
See:

BUTTERFLY AND SPIDER
Wither, p. 18.

HELL AND SNARE
Arwaker, bk. 1, no. 9.
Quarles, *Emb.*, p. 156.

SPIDER AND WEB
Combe, no. 49.

WEDGE
See:

WILLOW
Peacham, p. 117.

WEED
Thynne, no. 23.

Motto: "Losse of hurtfull thinges is gayne."

Icon: None.

Epigram: As the earth is enriched when weeds are destroyed, so man is bettered when hurtful and needless things are taken from him.

WEEPING
See:

CHRIST ON CROSS
E. M., frontispiece.

DEMOCRITUS AND HERACLITUS
Whitney, p. 14.

FOUNTAIN AND WATER
Arwaker, bk. 1, no. 8.
Quarles, *Emb.*, p. 152.

WANDERER
Arwaker, bk. 3, no. 7.

See also: GRIEVING, SORROW.

Weight
See: PLUMMET.

WELL
See:

ASTRONOMER AND WELL
Whitney, p. 157.

BUCKET AND WELL
Jenner, no. 23.

PEGASUS
Godyere, no. 24.

WHALE
Willet, no. 90.

Motto: "De cetu vel Balaena."

Icon: None.

Epigram: When one considers the greatness of the whale, he should worship God, who created it.

See also:

JONAH
Willet, no. 53.

WHEAT
Whitney, p. 23.

Motto: "Mihi pondera, luxus."

Icon: A sheaf of wheat.

Epigram: As the weight of the ripened grain breaks the stalk, causing the grain to spoil, so worldly wealth spoils our senses and wits; avoid excess and strive for the mean.

See also:

CROWN OF STARS AND WHEAT
P. S., p. 199.
EAR AND SHEAF OF WHEAT
P. S., p. 268.
FLAIL AND WHEAT
Wither, p. 108.
HARVEST
Wither, p. 44.
LILY AND WHEAT
Astry, no. 6.
PARTRIDGE AND WHEAT
Peacham, p. 131.
SHEAF OF WHEAT
P. S., p. 257.
SKULL AND WHEAT
Wither, p. 21.

WHEEL
See:

CORNUCOPIA AND WHEEL
Wither, p. 248.
CORNUCOPIA, STONE, WHEEL
P. S., p. 205.
CROWN AND WHEEL
Peacham, p. 76.
FORTUNE
Combe, no. 20.
Thynne, no. 44.
FORTUNE AND POVERTY
Peacham, p. 194.
HORSE AND WHEEL
Willet, no. 23.
IXION
Wither, p. 69.
OCCASION
Whitney, p. 181.
Wither, p. 4.
R. B., no. 41.
ROD AND WHEEL
Montenay, p. 154.

WHEEL, WIND, WORLD
Quarles, *Emb.*, p. 108.
Motto: "In cruce stat securus amor."
Icon: Divine Love stands on a wheel on top of the world, which is blown by four winds; he points heavenward with an arrow.
Epigram: The world is mutable, its treasures vain; man can overcome it through trust in the Cross.

WHELP
Thynne, no. 60.
Motto: "Of the same."
Icon: None.
Epigram: As the whelp is trained to be obedient with a yoke, so children should be taught obedience with "the staffe of feare."

See also: DOG.

WHETSTONE
See:

SCYTHE
Jenner, no. 13.
SICKLE AND WHETSTONE
Peacham, p. 61.

WHIP
See:

COLT
Astry, no. 38.
CUPID
Whitney, p. 63.
HORSE AND WHIP
Jenner, no. 16.
TOP AND WHIP
Bunyan, no. 37.
See also: SCOURGE.

WHITE
See:

HEART, SHAFT, WHITE
Van Veen, p. 153.

WHITE HORSE
See:

HORSEMAN, SEVEN-HEADED BEAST, SWORD
Van der Noodt, no. 19.

Whore
See: HARLOT.

WHORE OF BABYLON
Godyere, no. 21.
Motto: None.
Icon: The papal crown tops a shield on which the Whore of Babylon holds a cup, wears the papal crown, and rides the seven-headed beast.
Epigram: This emblem attacks the Roman Catholic church (whore), papal authority (crown), and the Roman mass (cup).
Montenay, p. 302.
Motto: "Abundabit iniquitas."
Icon: The Whore of Babylon sits on the seven-headed beast and holds a cup from which water pours onto a fire.
Epigram: The Whore of Babylon seeks to extinguish the fire which Christ keeps burning.
Van der Noodt, no. 18.

Motto: None.
Icon: The Whore of Babylon holds a cup and
 rides the seven-headed beast. Men kneel
 and worship her.
Epigram: Describing the apostle John's apocalyptic
 vision, the speaker foresees the fall of
 Babylon and its forces of evil.
See also:
DRAGON WITH TEN HORNS
Willet, no. 22.

WIFE
Combe, no. 18.
Motto: "Within this picture are displaid,
 The beauties of a woman staid."
Icon: A woman stands on a tortoise, puts her fin-
 ger to her lips, and holds a key.
Epigram: The ideal wife stays at home, is silent, and
 keeps her husband's goods.
Combe, no. 93.
Motto: "He that would leade a happie life
 For vertue let him chuse his wife."
Icon: Virtue links a blindfolded man to a woman
 with a chain.
Epigram: A wise man will choose a wife for her vir-
 tue, not her beauty.
Whitney, p. 93.
Motto: "Uxoriae virtutes."
Icon: A woman stands on a tortoise, puts her fin-
 ger to her lips, and holds a ring of keys.
Epigram: The virtuous wife stays at home, maintains
 silence, cares for her husband's goods, and
 is honest.
Willet, no. 39.
Motto: "Materfamilias."
Icon: None.
Epigram: The ideal wife is described.
See also:
ANELLUS'S WIFE AND MILLER
Whitney, p. 80.
COLASMUS
Whitney, p. 158.
See also: LADY, MATRON, MOTHER, OLD WOMAN.

WIFE OF MOSES
See:
MOSES AND WIFE
Bunyan, no. 32.

WILLOW
Peacham, p. 84.
Motto: "In prodigos."
Icon: A willow drops its fruit, and the fruit
 blows away.
Epigram: As the willow quickly loses its lovely fruit,
 so the prodigal heir loses his patrimony
 and the prodigal artist wastes his earnings.

Peacham, p. 117.
Motto: "Soboles damnosa parenti."
Icon: A man uses the branches of a willow as
 wedges to split the trunk of the tree.
Epigram: The willow which was split by means of its
 own branches is like the parent of un-
 grateful children.

WIND
P. S., p. 214.
Motto: "Sic violenta."
Icon: The wind rattles a gate.
Epigram: Idle chatter is like the blustering noise of
 the wind.
See also:
ANGEL, TRUMPET, WIND
Montenay, p. 426.
BEE
Hawkins, no. 7, p. 78.
CANDLE AND WIND
Farlie, no. 24.
CHAFF
Willet, no. 95.
EAR AND HEART
Montenay, p. 414.
EARTH, FIRE, WIND
Willet, no. 36.
FIRE AND WIND
Ayres, no. 42.
Van Veen, p. 147.
FIRE, MOUNTAIN, WIND
Wither, p. 97.
FLAME AND WIND
Wither, p. 68.
FRUIT AND OLIVE TREE
Wither, p. 147.
R. B., no. 18.
FRUIT TREE, SWORD, TAPER
Quarles, *Hier.*, no. 13.
GARDEN
Hawkins, no. 1, p. 13.
HEART, SLEEP, WIND
H. A., p. 199.
LANTERN AND WIND
Farlie, no. 51.
LEAF, TREE, WIND
Hall, p. 64.
NET AND WIND
Combe, no. 36.
OAK
Ayres, no. 21.
Whitney, p. 220.
OAK AND WIND
Montenay, p. 262.
Van Veen, p. 117.
OAR AND SAIL

CLOCK, WING, YOUTH
Combe, no. 68.
FLAME AND HEART
Hall, p. 72.
FLAME AND TIME
Farlie, no. 57.
FORTUNE
Combe, no. 29.
Wither, p. 174.
FOUNTAIN
Hall, p. 88.
HAND AND OLIVE BRANCH
Montenay, p. 158.
HAND AND WING
Van Veen, p. 111.
HEART
Hall, p. 32.
HEART AND PILLAR
Montenay, p. 62.
HEART AND WING
Harvey, no. 38.
HOURGLASS
Hall, p. 104.
HOURGLASS AND SKULL
Wither, p. 235.
HOURGLASS AND WING
Wither, p. 49.
KEY AND WING
Peacham, p. 38.
LIGHTNING AND WING
P. S., p. 166.
OCCASION
Combe, no. 63.
Whitney, p. 181.
PILGRIM AND TORTOISE
Combe, no. 51.
PILLAR
Montenay, p. 70.
PILLAR AND WORLD
Montenay, p. 54.
STONE AND WING
Whitney, p. 152.
Wither, p. 176.
R. B., no. 12.
SWALLOW
Bunyan, no. 8.
TONGUE
P. S., p. 137.
TONGUE AND WING
Wither, p. 42.
TRUMPET AND WING
Montenay, p. 162.
VICTORY
Wither, p. 254.
ZEAL
Peacham, p. 170.

WING CLIPPED
See:
 DEVIL
 Quarles, *Emb.*, p. 60.

WINGED WOMAN
See:
 EPHA
 Willet, no. 21.

WISDOM
See:
 TIME AND WISDOM
 Godyere, no. 28.

Wise man
See: SAGE.

WOLF
See:
 BEARDED MAN AND POT
 Van der Noodt, no. 12.
 CHILD, MOTHER, WOLF
 Whitney, p. 162.
 EAGLE, SHEEP, WOLF
 Godyere, no. 6.
 GOAT AND WOLF
 Whitney, p. 49.
 LAMB, LION, WOLF
 Montenay, p. 222.
 LION AND WOLF
 Godyere, no. 10.
 RAVEN, TREE, WOLF
 Montenay, p. 58.
 SHEPHERD AND WOLF
 Montenay, p. 422.

WOMAN
Whitney, p. 182.
 Motto: "Pulchritudo vincit."
 Icon: Nature fashions a beautiful woman as ani-
 mals look on.
 Epigram: When Nature fashioned woman, she had
 already used the attributes of defense
 (teeth, horns, hooves, wings) on other
 creatures, so she gave women beauty, en-
 abling them to conquer the bold and the
 fierce.
Wither, p. 7.
R. B., no. 16.
 Motto: "A fickle Woman wanton growne,
 Preferres a Crowd, before a Crowne."
 Icon: A woman on a ball grasps a fiddle and a
 fiddlestick, which are held by a musician,
 and a scepter, which is held by a king.
 Epigram: A fickle woman prefers a fiddle (youth and
 music) to a scepter (power and wealth).
See also:
 DUEL

Wither, p. 27.

R. B., no. 46.

EEL AND HANDSHAKE

Combe, no. 88.

FLASK, ROD, WOMAN, WORLD

Peacham, p. 119.

GLASS

Combe, no. 37.

GLASS AND WOMAN

Wither, p. 249.

HEADLESS WOMAN

Combe, no. 16.

ROD AND WOMAN

Wither, p. 93.

R. B., no. 14.

SHIP AND WOMAN

Combe, no. 78.

See also: DAUGHTER, HARLOT, LADY, MATRON, MOTHER, OLD WOMAN, WIFE.

WOOD

See:

FIRE AND WOOD

Van Veen, p. 135.

See also: LOG, TIMBER.

WOODBINE

E. M., no. 7.

Motto: "Pacis conjunctio firma."

Icon: A woodbine entwines two trees.

Epigram: The woodbine, which entwines two warring trees, represents the peacemaker.

See also: VINE.

WOODS

Peacham, p. 182.

Motto: "Nulli penetrabilis."

Icon: A thick woods.

Epigram: The shady woods warn men to be close and impenetrable.

See also:

MELANCHOLY

Peacham, p. 126.

WOODSMAN

See:

AX AND WOODSMAN

Whitney, p. 228.

WORD AND WORLD

Montenay, p. 254.

Motto: "Nemo duobus."

Icon: A man holds the world on his shoulder while God's word, on a tablet, is attached to his foot with a rope.

Epigram: Man bears great pain to gain worldly riches but ignores God's word.

Work

See: LABOR.

WORKMAN

See:

Whitney, p. 145.

WORLD

Quarles, *Emb.*, p. 24.

Motto: "In cruce tuta quies."

Icon: Cupid reaches toward the world on a table.

Epigram: All wealth and worldly power is vanity and care; instead, the Cross of Christ brings rest and salvation.

Quarles, *Emb.*, p. 100.

Motto: "Tinnit: Inane est."

Icon: Cupid puts an ear up to the world, while a wind blows on him and Divine Love watches.

Epigram: The world is empty and vain; the man who trusts in it is a fool.

Thynne, no. 16.

Motto: "Mann."

Icon: None.

Epigram: Man is a little world, a microcosm of the universe.

See also:

ASS AND STAG

Quarles, *Emb.*, p. 52.

BELLOWS, SUN, TORCH

Quarles, *Emb.*, p. 64.

BOOK, FIRE, WORLD

Montenay, p. 238.

BOOK, SWORD, WORLD

P. S., p. 336.

BUCKLER AND WORLD

Montenay, p. 362.

CANDLE AND WORLD

Montenay, p. 226.

CHARIOT, DEVIL, WORLD

Quarles, *Emb.*, p. 44.

CRAB AND WORLD

Wither, p. 219.

CUPID AND ENVY

Quarles, *Emb.*, p. 20.

CUPID AND WORLD

Montenay, p. 210.

CUPID DEFORMED

Quarles, *Emb.*, p. 96.

DART AND DEVIL

Quarles, *Emb.*, p. 112.

DEATH AND KING

Montenay, p. 106.

DEATH AND WORLD

Montenay, p. 386.

DEVIL

Quarles, *Emb.*, p. 60.

DIVINE LAW AND WORLD

Whitney, p. 223.

EAGLE AND WORLD

Peacham, p. 28.
FLASK, ROD, WOMAN, WORLD
Peacham, p. 119.
FORTUNE, TIME, WORLD
Quarles, *Emb.*, p. 36.
GLASS
Quarles, *Emb.*, p. 84.
HAND AND WORLD
Wither, p. 210.
HEART
Quarles, *Emb.*, p. 120.
HEART AND NET
H. A., p. 30.
HEART AND WORLD
Harvey, no. 10.
Montenay, p. 282.
Whitney, p. 225.
LEOPARD
Peacham, p. 97.
NIGHT AND SUN
Astry, no. 12.
O AND WORLD
P. S., p. 347.
PAPAL CROWN
Astry, no. 94.
PILLAR AND WORLD
Montenay, p. 54.
POURING AND WORLD
Montenay, p. 118.
SCEPTER
Astry, no. 18.
SHIP AND WORLD
Whitney, p. 203.
TOMB
Astry, no. 101.
TRUTH
Peacham, p. 134.
WASP AND WORLD
Quarles, *Emb.*, p. 12.
WHEEL, WIND, WORLD
Quarles, *Emb.*, p. 108.
WORD AND WORLD
Montenay, p. 254.
See also: ARMILLARY SPHERE, COSMOS, EARTH, GLOBE,
 SPHERE, UNIVERSE.

WORLD IN ARMS
Quarles, *Emb.*, p. 68.
 Motto: "Donce totum expleat orbem."
 Icon: Cupid holds the world in his arms; on his
 head are two half-moons lit by the sun;
 Divine Love watches.
 Epigram: Like the moon which greedily draws light
 from the sun, insatiate minds vainly at-
 tempt to possess the world, but can never
 be satisfied.

WORM
See:
 SCEPTER, SKULL, SPADE
 Wither, p. 48.
WORMWOOD
Willet, no. 78.
 Motto: "De Absynthio: Amarus vitiorum fruc-
 tus."
 Icon: None.
 Epigram: As the wormwood is lovely to look at but
 salty to taste, so evil appears fair but is
 poisonous.

WORTH
See:
 BOUNTY
 Godyere, no. 31.

WOUND
See:
 CHRIST ON CROSS
 E. M., frontispiece.
 DART AND WOUND
 Hall, p. 12.
 SURGEON AND WOUND
 Van Veen, p. 177.

WOUNDED MAN
Jenner, no. 6.
 Motto: "The tryall of a true broken heart."
 Icon: The good Samaritan aids a victim; in the
 background a man lies dead.
 Epigram: Two men are victims of thieves; one de-
 spairs, does not seek remedy, and dies,
 while the other seeks help and is restored
 to health. The despairing man is like
 the wicked, who, wounded by Satan, fears
 God's wrath, despairs and dies; the man
 who seeks help is like the good man who
 seeks pardon for his sin and is saved by
 God.

WREATH
Wither, p. 135.
 Motto: "If well thou dost, and well intend,
 Thou shalt be crowned, in the end."
 Icon: A wreath on a pedestal.
 Epigram: God rewards the righteous.
See also:
 ALTAR AND LION
 Peacham, p. 20.
 BEE
 Hawkins, no. 7, p. 70.
 BOOK AND SATAN
 Montenay, p. 318.
 BOUNTY
 Godyere, no. 31.

CUPID AND NUMBER ONE
Van Veen, p. 3.
FAME
Wither, p. 146.
R. B., no. 37.
HEART AND JEHOVAH
Montenay, p. 286.
HELIOTROPE
Hawkins, no. 5, p. 48.
IRON HAND AND WREATH
P. S., p. 278.
LEOPARD
Peacham, p. 97.
LILY AND WREATH
Arwaker, bk. 3, no. 3.
Quarles, *Emb.*, p. 252.
OLIVE TREE
Peacham, p. 13.
SERPENT, SPADE, WREATH
Wither, p. 92.
SNAKE, SPADE, WREATH
Wither, p. 5.
VICTORY
Wither, p. 254.
VIOLET
Hawkins, no. 4, p. 38.
See also: CROWN, GARLAND, LAUREL.

WRESTLE
See:
FALL
Quarles, *Emb.*, p. 116.

WRITING
See:
HEART AND LAW
Harvey, no. 26.
MARBLE
P. S., p. 338.
Whitney, p. 183.

Y

YOKE
Ayres, no. 6.
Motto: "Fair and softly."
Icon: Cupid puts a yoke on an ox.
Epigram: As the ox learns to wear the yoke, so resistant lovers eventually submit to love.
See also:
CAP OF LIBERTY, CUPID, YOKE
Van Veen, p. 73.

DEATH AND YOKE
Montenay, p. 46.
MATRIMONY
Peacham, p. 132.
MILLWHEEL
Arwaker, bk. 1, no. 4.
OIL AND YOKE
P. S., p. 139.
OX AND YOKE
Van Veen, p. 27.
WHELP
Thynne, no. 60.

YOUTH
See:
AGED MAN AND YOUTH
Combe, no. 12.
Whitney, p. 50.
CLOCK, WING, YOUTH
Combe, no. 68.
SIN
Peacham, p. 146.
See also: BOY, CHILD.

Z

ZEAL
Peacham, p. 170.
Motto: "Zelus in Deum."
Icon: A winged figure looks heavenward, puts his hand over a heart, which is in flames, and stands in front of a hart drinking from a stream.
Epigram: Zeal, with a heart full of desire, ascends to God through faith; the soul, like the hart drinking from a stream, is purified and desires God.

Zeus
See: JOVE, JUPITER.

ZION
See:
VALLEY
Willet, no. 86.

ZODIAC
Peacham, p. 122.
Motto: "Gloriae latavia."
Icon: The sun shines above the zodiac.
Epigram: Man's life is compared with the journey of the sun.

Illustrations

H. A. [Henry Hawkins]. *The Devout Hart, or Royal Throne of the Pacified Salomon*. Rouen, 1634.

Number and Type: Eighteen copperplate emblems and two emblems without plates.

Form: Each emblem includes a picture with a Latin verse beneath it, an English title, a hymn, an incentive, a preamble, a meditation with a prayer, and a colloquy.

Content: Each emblem features an image of a heart, for example, "Jesus pierces a heart with arrows." The subject matter of every emblem is religious.

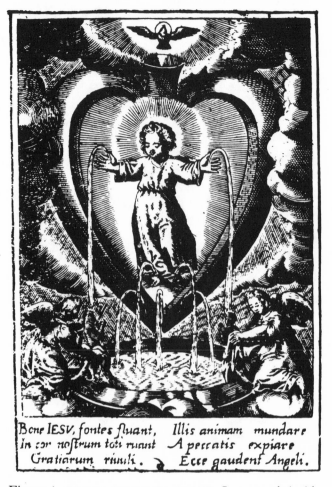

Figure 1. BLOOD, FOUNTAIN, HEART. Jesus stands inside a heart; blood from his wounds flows into a fountain. H. A., p. 83.

H. A. [Henry Hawkins]. *Parthenia Sacra, or, the Mysterious and delicious Garden of the Sacred Parthenes.* [Paris], 1633.

Number and type: Title page engraved by P. van Langeren, a full-page copperplate of the garden, and forty-six devices and emblems.

Form: Twenty-three "symbols" (the final two unnumbered), each containing a device (a picture with a Latin motto within it), a title, a character, morals, an essay, a discourse, an emblem (another picture and Latin motto within it), a poesie, theories, and an apostrophe. I have indexed both pictures of every symbol. All the explanations are in prose.

Content: Each symbol features a traditional Roman Catholic image of the Virgin Mary; for example, the rose.

Figure 2. GARDEN AND NIGHTINGALE. A nightingale sings in a tree inside an enclosed garden; an eye and ears are in a cloud above the garden. Hawkins, no. 13, p. 148.

Edmund Arwaker the Younger. *Pia Desideria; or Divine addresses*. London, 1686.

Number and type: Engraved frontispiece and forty-five copperplates imitated from Hugo.

Form: Each emblem includes a picture, a verse from the Bible, a poem, and concluding quotations from the Bible and the church fathers. The work is divided into three books of fifteen emblems each.

Content: A book of divine emblems, *Pia Desideria* features Divine Love in almost every illustration. Typically Divine Love interacts with a human figure. Arwaker omits from his source stories of the saints and "several fictitious stories" he identifies as Roman Catholic. He substitutes for these omitted emblems images based on Scripture.

Figure 3. LABYRINTH AND PILGRIM. A human figure with a pilgrim's staff and hat stands in the middle of a labyrinth and holds a thread stretching to a tower outside the labyrinth where Divine Love sits and guides him. Arwaker, bk. 2, no. 2. Reproduced by permission of the Joseph Regenstein Library, the University of Chicago, Chicago, Illinois.

Figure 4. GLASS, HOURGLASS, SCEPTER, SERPENT. A serpent entwines a scepter which is on top of an hourglass and between two looking glasses. Astry, no. 28. Reproduced by permission of the Joseph Regenstein Library, the University of Chicago, Chicago, Illinois.

Sir James Astry. *The Royal Politician*. London, 1700.

Number and type: A portrait at the beginning of each of two volumes, a preliminary and a final device, and 101 copperplate devices in the body of the text.

Form: Each emblem includes a picture framed by an ornate oval border, a Latin motto within, and a long prose explanation.

Content: A book of political emblems, *The Royal Politician* features emblems on the education and the behavior of a prince. The images are predominately symbolic objects such as swords, scepters, crowns, globes, and mirrors.

Philip Ayres. *Emblemata Amatoria; or, Cupids Address to the Ladies.* London, 1683.

Number and type: A title page engraved by Francis Parlow and forty-four plates derived from Otto van Veen and Daniel Heinsius.

Form: Each emblem includes a picture on one page and an English motto and a four-line English verse, as well as mottoes and verses in three other languages on the opposite page.

Content: Each emblem focuses on love and usually features Cupid. Images are typically traditional personifications, mythological figures, and symbolic objects.

Figure 5. BEE AND CUPID. Cupid, crying beside Venus, points to a scene of himself with bees and beehives. Ayres, no. 16.

XI.

Upon a low'ring Morning.

WEll, with the day, I ſee, the Clouds appear,
And mix the light with darkneſs every where :
This threatning is to Travellers, that go
Long Journeys, ſlabby Rain, they'l have or Snow,
Elſe while I gaze, the Sun doth with his beams
Belace the Clouds, as 'twere with bloody Streams :
This done, they ſuddenly do watry grow,
And weep, and pour their tears out where they go.

Compariſon.

Thus 'tis when Goſpel-light doth uſher in
To us, both ſenſe of Grace, and ſenſe of Sin ;
Yea when it makes ſin red with Chriſt's blood,
Then we can weep, till weeping does us good.

Figure 6. CLOUDS AND SUN. The sun in the clouds creates red streams; then the clouds pour forth rain; likewise, the Gospel light creates in us a sense of both grace and sin. Bunyan, no. 11.

J. B. [John Bunyan]. *A Book for Boys and Girls, or, Country Rhymes for Children.* London, 1686.

Number and Type: No plates in the original 1686 edition. Fifty copperplate engravings were added in the second edition of 1701.

Form: Mottoes are simple, straightforward titles.

Content: Some emblems are based on personal observations of nature. Others use conventional images like the candle. A few are not emblematic, but rather quotations of such biblical passages as the Apostles' Creed and the Ten Commandments. Governing this work are the assumptions that the Christian believer is a child and the things of the world are created by God for man's instruction.

R. B. [Robert or Richard Burton, pseudonym for Nathaniel Crouch]. *Delights for the Ingenious: Emblems, Divine and Moral, Ancient Modern.* London, 1684.

Number and Type: Engraved frontispiece, full page portrait, lottery, and fifty emblems. Imitated from George Wither.

Form: Each picture includes a Latin motto beneath it and, on the opposing page, an English motto and verse copied directly from Wither. At the end of the main verse R. B. has added a four-line "lot" or epigram.

Content: A collection of miscellaneous images, this book includes personifications, mythological figures, and symbolic objects. A number of the emblems concern political issues and many others feature images like the skull and the hourglass which encourage the reader to meditate on death.

Emblem XV.

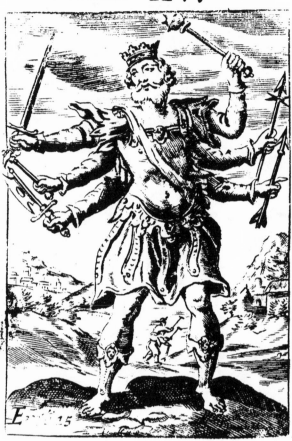

Figure 7. KING WITH SIX ARMS. A king with six arms, each holding a weapon, instrument, or scepter. R. B., no. 15. Reproduced by permission of the Joseph Regenstein Library, the University of Chicago, Chicago, Illinois.

He that doth loue to liue at eafe,
An angry man muft not difpleafe.

Figure 8. STIRRING FIRE. A man stirs a fire with a sword. Combe, no. 7.

Thomas Combe. *The Theater of Fine Devices.* London, 1614.

Number and Type: One hundred woodcut emblems, each with an engraved border.

Form: Each emblem begins with a motto in English, followed by a picture within a decorative border and a poem.

Content: A collection of miscellaneous emblems, this book features mythological images, fables, images from the natural world, actions, and parts of the human body.

Robert Farlie. *Lychnocausia*. London, 1638.

Number and Type: An engraved frontispiece, a woodcut scene at the end, two devices of Oxford and Cambridge, and fifty-seven woodcut emblems and one engraved emblem.

Form: Each emblem includes both Latin and English mottoes and verses. The verses frequently refer to the image in the first person.

Content: Each emblem features an image of light (e.g., a candle, a taper, a lantern, a sun). Combined with the particular image of light are images drawn from nature and myth.

Figure 9. CANDLE. A candle shines on the earth; the sun, moon, and stars shine in the heavens. Farlie, no. 7. Reproduced by permission of the Huntington Library, San Marino, California.

H. G. [Sir Henry Godyere]. *The Mirror of Majesty; or, The Badges of Honour.* London, 1618.

 Number and Type: Thirty-two emblems and thirty heraldic devices. The coats of arms are not indexed.

 Form: Each emblem includes a Latin motto which is inscribed in an oval border around the picture and a poem.

 Content: A collection of miscellaneous emblems, this book features personifications, symbolic objects, heraldic images, and a few religious images of an anti-Catholic nature.

Figure 10. LION. A lion sits on a three-headed mountain and holds a balance, a sword, and a cornucopia while a hand holds a caduceus above him. Godyere, no. 2

Figure 11. DARKNESS AND HAND. Divine Love takes a human figure by the hand and pulls him out of darkness. Hall, p. 36.

J. H. [John Hall]. *Emblems with Elegant Figures*. London, 1658.

Number and Type: A frontispiece and twenty-eight emblems.

Form: Each emblem includes a picture, an English motto, a multiverse poem, and a four-line epigram. The work is divided into two volumes, the first of which gives twenty emblems, the second eight. The motto is a quotation, typically from Saint Augustine.

Content: A collection of divine emblems, this book features images of Divine Love, the heart, and such symbolic objects as the hourglass, the globe, and the skull. The connections between the images and the accompanying verses are frequently implicit, rather than explicit.

Christopher Harvey. *Schola cordis or the heart of it selfe*. London, 1647.

Number and Type: A frontispiece and forty-seven emblems engraved by William Marshall and Michael van Lochem.

Form: Each emblem includes a picture with a Latin motto beneath it, Latin quotations from the Bible, and a Latin epigram, followed by English translations of the quotations and epigram and an extended poem called an ode. Number thirty-seven is a shaped poem.

Content: Each emblem features an image of the heart; many also include images of Divine Love and a human figure; quite a few feature an image of the Devil. The entire collection is devoted to divine emblems.

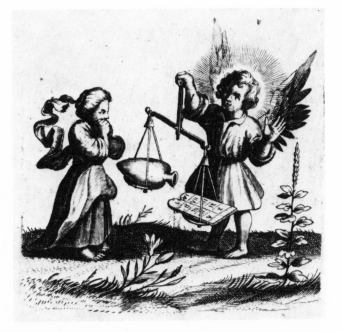

Figure 12. BALANCE, HEART, LAW. Divine Love holds a balance on which law outweighs a heart. Harvey, no. 20. Reproduced by permission of the New York Public Library, Rare Books and Manuscripts Division, Astor, Lenox, and Tilden Foundations, New York, New York.

Thomas Jenner. *The Soules Solace, or thirtie and one spiri-tuall emblems.* London, 1626.

Number and Type: Thirty pictures.

Form: Each emblem includes a motto or title, an extended poem, and a picture often printed in the middle of the poem. Sometimes images in the picture are labeled, identifying the concepts they represent.

Content: The images in this book tend to be highly original rather than imitative of Continental sources. Jenner considers Protestant theological issues and controversies in this book and attacks Roman Catholic beliefs and doctrine.

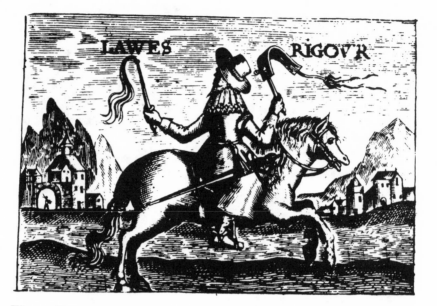

Figure 13. HORSE AND WHIP. A man rides a horse and holds a whip in each hand. Jenner, no. 16.

Figure 14. WOODBINE. A woodbine entwines two trees.
E. M., no. 7.

E. M. [Edward Manning]. *Ashrea: or, The Grove of Beatitudes.* (London, 1665).

Number and Type: Eight copperplate emblems and an engraved frontispiece.

Form: Each emblem includes a quotation of one of the eight beatitudes, a title identifying the image, a picture with a Latin motto beneath it, and an explanation of the image.

Content: Each image features a tree or plant which is compared to one of the beatitudes, making the "Grove of Beatitudes."

Figure 15. GLASS AND SPITTING. A man spits on a glass. Montenay, p. 330. Reproduced by permission of the Joseph Regenstein Library, the University of Chicago, Chicago, Illinois.

Georgette de Montenay. *A Book of armes, or remembrances*. Frankfort, 1619.

Number and Type: An engraved title page by Peter Rollos and one hundred emblems.

Form: A polyglot edition, this work includes pictures with mottoes inscribed within and short English poems.

Content: A collection of miscellaneous emblems, this work features personifications, images from the natural world, symbolic objects, and human actions. It makes repeated use of the image of the globe. A Protestant work, it emphasizes theological issues, biblical stories, and ethical behavior.

Henry Peacham. *Minerva Britanna, or a garden of heroical Devises*. London, 1612.

Number and Type: Two hundred and four woodcut emblems believed to be by Peacham himself.

Form: Each emblem includes a Latin motto, a picture, and an explanatory poem.

Content: A collection of miscellaneous emblems, this work features personifications (often drawn from Cesare Ripa's *Iconologia*), mythological figures, images from the natural world, and symbolic objects often combined in an original way. There are some personal applications of common images and dedications to specific individuals and quite a few emblems on political matters.

Doctrina.

Figure 16. LEARNING. An old woman sits with her arms outstretched as dew falls from the heavens onto her; an open book lies in her lap, and she holds in her right hand a scepter topped by a sun. Peacham, p. 26.

Francis Quarles. *Emblemes*. London, 1635.

Number and Type: Seventy-eight copperplates by William Marshall, William Simpson, Vaughan, and John Payne and an engraved title.

Form: Five books with fifteen emblems each. Each emblem includes a picture, a Latin or English motto, a biblical quotation, an explanatory verse, quotations from the church fathers, and a short epigram.

Content: A collection of divine emblems, this work features Divine Love, often interacting with a human figure or opposing the devil or Earthly Love. It repeatedly uses images of symbolic objects like the globe, and it bases some of its images on biblical passages.

Figure 17. SLEEP. Cupid sleeps on top of a sphere containing hellish torments while Divine Love tries to awaken him and Death shoots an arrow. Cupid holds a cock. Quarles, *Emb.*, p. 28. Reproduced by permission of the Main Library, University of Iowa, Iowa City, Iowa.

Tempus erit

342

Figure 18. DEATH AND TIME. Death with an arrow holds a candlesnuffer above a burning taper while Time, with wings and an hourglass, stays Death's arms; on a post is a sundial. Quarles, *Hier.*, no. 6.

Francis Quarles. *Hieroglyphikes of the Life of Man*. London, 1638.

Number and Type: Fifteen engraved emblems by William Marshall.

Form: Each emblem includes a picture with a Latin motto beneath it and a multiverse poem.

Content: Each emblem features an image of light, most commonly a taper or candle. The first nine emblems deal with general issues of time, death, and earthly and spiritual existence. The last five present the ages of man and feature a candle divided into segments representing the different stages in a person's life. Combined with these images of light are miscellaneous hieroglyphs.

P. S. *The Heroicall Devises of M. Claudius Paradin*. London, 1591.

Number and Type: About 190 devices.

Form: Each emblem includes a Latin and an English motto, a picture, and a long prose explanation or, occasionally, a verse.

Content: A collection of miscellaneous devices, this work features heraldic images, beast lore, historical legends, symbolic images, and images from the natural world. There are also quite a few religious emblems dealing with such topics as ministers, preaching, and Old Testament stories. Many of the images are personal devices, applied to the life of a particular individual. Often these images are put in their historical or cultural context.

Reſtat ex victore Orientis.

That onely reſteth of all his victoi ies
in the Eaſt.

Figure 19. SHIRT ON SPEAR. A shirt hangs on a spear. P. S., p. 61.

(5) Art, the antidote against fortune.

On rolling ball doth fickle fortune stande ;
on firme and setled square sitts *Mercurie,*
The god of Arts, with wisdomes rodd in hande :
which covertlie to vs doth signifie, 4
that fortunes power, vnconstant and still frayle,
against wisdome and art cannot prevaile. 6

ffor as the Sphere doth move continuallie, 7
and showes the course of fickle fortunes change,
soe doth the perfect square stand stedfastlie,
and never stirrs, though fortune liste to range. 10
[leaf 6, back] wherefore, Learne Artes, which allwaies stedfast prove ;
therbye, hard happes of fortune to remove. 12

Figure 20. FORTUNE AND MERCURY. Mercury, sitting on a square, opposes Fortune, standing on a ball; art and wisdom are steadfast and prevail against inconstant fortune. Thynne, no. 5.

Francis Thynne. "Emblems and Epigrames." Presented to Sir Thomas Egerton, 1600.

Number and Type: No plates.

Form: Each emblem includes a motto and a poem which typically describes an imaginary picture in some detail.

Content: A collection of miscellaneous emblems, this work features figures from mythology and classical literature and personifications. It includes a number of pairs of images, often in opposition to each other.

Jan Van der Noodt. *A Theatre wherein be represented the miseries that follow the voluptuous worldlings*. London, 1569.

Number and Type: Twenty plates, attributed to Marcus Gheeraerts, the Elder and Lucas de Heere.

Form: Pictures without mottoes followed by explanatory verses. At the end of the book Van der Noodt adds an extended prose commentary entitled "Briefe Declaration" which provides further explanation of the plates.

Content: The first part of this book depicts visions of the ruins of time; its theme is the vanity and transience of earthly existence. The second part of the book depicts John's visions of the Apocalypse; it opposes the corruption of the Roman Catholic church to the spiritual City of God to be established at the end of time.

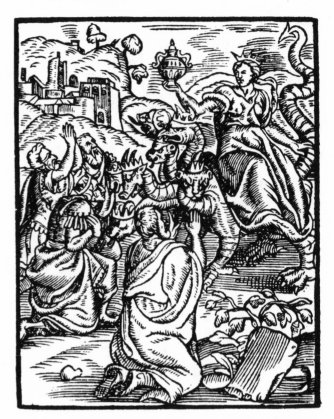

Figure 21. WHORE OF BABYLON. The Whore of Babylon holds a cup and rides the seven-headed beast. Men kneel and worship her. Van der Noodt, no. 18.

Otto Van Veen. *Amorum Emblemata*. Antwerp, 1608.

Number and Type: One hundred and twenty-four emblems engraved by Cornelius Boel.

Form: A polyglot edition, this work includes short verses and mottoes in Latin, English, and Italian accompanied by pictures in an oval frame.

Content: Each emblem addresses some aspect of human love. Typically, it combines the figure of Cupid with personifications, mythological figures, and symbolic actions. The entire work is based on quotations from Ovid.

Figure 22. CUPID, GOOSE, PEACH, SILENCE. Cupid, holding a peach branch, stands beside a goose and makes a gesture of silence. Van Veen, p. 71.

Geoffrey Whitney. *A Choice of Emblemes*. Leyden, 1586.

Number and Type: Two hundred and forty-eight woodcuts and a coat of arms. Of these, two hundred and two had previously been printed in continental emblem books.

Form: Each emblem has a Latin motto, a picture, and an accompanying verse.

Content: A collection of miscellaneous emblems, this work features mythological stories, beast lore, fables, personifications, historical narratives and legends, and symbolic objects. Whitney made some changes in his sources, applying certain traditional images to individuals, secularizing certain religious images, and adapting continental images to English concerns.

In auaros.

Figure 23. ASS. An ass, loaded with food and goods, eats a thistle. Whitney, p. 18.

Figure 24. JACOB'S LADDER. Jacob's dream of the ladder shows us that God will guide us. Willet, no. 14. Reproduced by permission of the Huntington Library, San Marino, California.

Andrew Willet. *Sacrorum emblematum centuria una.* Cambridge, n.d.

Number and Type: No figures. One hundred emblems.

Form: Each emblem includes a motto in Latin and a verse in both Latin and English.

Content: A collection of sacred emblems, this book presents Protestant doctrine and is explicitly anti-Catholic. A number of emblems are based on biblical passages and Old Testament figures. Some emblems are dedicated to a specific individual and applied to that person's life.

George Wither. *A collection of emblemes, ancient and modern*. London, 1635.

Number and Type: Two hundred emblems by Crispyn de Passe (printed previously in Gabriel Rollenhagen's *Nucleus* . . .). Frontispiece engraved by William Marshall. A portrait of Wither by John Payne. At the end of this volume is a lottery table with movable pointers.

Form: Each emblem includes an English motto, a picture with a Latin motto inscribed in the circular border, and a poem. The English motto is not always a translation of the Latin and sometimes differs entirely from the point of the Latin motto.

Content: A collection of miscellaneous emblems, this work features mythological figures, personifications, and symbolic objects like the book, candle, or skull. Frequently a picture is framed by a serpent biting its tail, the hieroglyph for eternity. Sometimes the picture includes a background scene depicting the human world which connects thematically to the foreground image. Wither often alters the meaning of the original picture from Rollenhagen; he also ignores details in some of the pictures and even fails at times to connect his poem to the image from the borrowed picture.

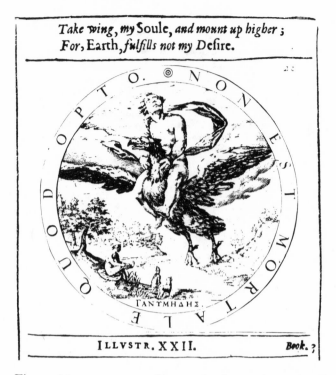

Figure 25. GANYMEDE. Ganymede sits on the eagle of Jupiter. Wither, p. 156.

Bibliography of Sixteenth- and Seventeenth-Century English Emblem Books

Arwaker, Edmund, the younger. *Pia Desideria; or Divine addresses.* 3 books in 1 vol. London, 1686. Wing: *STC* H3350, Reel 603. See also *STC* H3349, H3351. From Herman Hugo, *Pia Desideria Emblematis* (Antwerp, 1624). Modern edition (selections): *A Selection of Emblemes* (Los Angeles: University of California Press, 1972).

Astry, Sir James. *The Royal Politician.* London, 1700. Wing: *STC* S211, Reel 616. From Don Diego Saavedra Fajardo, *Idea de un Principe politico Christiano* (Milan, 1642).

Ayres, Philip. *Emblemata Amatoria; or, Cupids Address to the Ladies.* London, 1683. Wing: *STC* A4307, Reel 9. See also *STC* A4308, A4309, A4310, A4311. Polyglot: English, Latin, French, Spanish. Modern edition: Philip Ayres, *Emblemata amatoria. 1683* (Menston: Scolar Press, 1969).

B[unyan], J[ohn]. *A Book for Boys and Girls, or, Country Rhymes for Children.* London, 1686. Wing: *STC* B5489, no reel listed. Variants: Revised in 1701 edition and in succeeding editions. No plates in 1686 edition. Modern Edition: John Bunyan, *A Book for Boys and Girls* (London: Elliot Stock, 1890).

B[urton] R[obert or Richard, pseud. Nathaniel Crouch]. *Delights for the Ingenious: Emblems, Divine and Moral, Ancient and Modern.* London, 1684. Wing: *STC* C7312, Reel 687. Exact reproduction, without acknowledgment, of selected emblems from George Wither, *A Collection of Emblemes* (London, 1635).

Combe, Thomas. *The Theater of Fine Devices.* London, 1614. Pollard: *STC* 15230, Reel 549. From Guillaume de la Perrière, *Le Theatre des bons engins* (Paris, 1539). Modern Edition: Thomas Combe, *The Theater of Fine Devices* (San Marno: Huntington Library, 1983).

Farlie, Robert, *Lychnocausia.* London, 1638. Pollard: *STC* 10694, Reel 790. Variant: Alternative spelling, Farley.

H. A., [Henry Hawkins]. *The Devout Hart, or Royal Throne of the Pacified Salomon.* Rouen, 1634. Pollard: *STC* 17001, Reel 848. From Etienne (or Stephanus) Luzvic, *Le coeur devot, trone royal de Jesus Pacifique Salomon* (Paris, 1626). Modern edition: Stephanus Luzvic, *The devout hart*, trans. H. A. (Ilkley: Scolar Press, 1975).

H. A., [Henry Hawkins]. *Parthenia Sacra, or, the Mysterious and delicious Garden of the Sacred Parthenes.* [Paris], 1633. Pollard: *STC* 12958, Reel 926. Variants: Authorship sometimes attributed to Henry Aston rather than Henry Hawkins. Place of publication sometimes cited as Rouen. Modern editions: Henry Hawkins, *Parthenia sacra*, intro. Iain Fletcher (Aldington: Hand and Flower Press, 1950); Henry Hawkins, *Parthenia sacra. 1633* (Menston: Scolar Press, 1971).

G[odyere, Sir H[enry]. *The Mirror of Majesty; or, The Badges of Honour.* London, 1618. Pollard: *STC* 11496, Reel 1098. Modern edition: H[enry] G[odyere], *The Mirrour of Majestie*, ed. Henry Green and James Croston (London, 1870).

H[all], J[ohn]. *Emblems with Elegant Figures.* London, 1658. Wing: *STC* H344, Reel 32. See also H344a. Variant: Place of publication sometimes cited as Cambridge. Modern edition: John Hall, *Emblems with elegant figures. 1658* (Menston: Scolar Press, 1970).

[Harvey, Christopher]. *Schola cordis or the heart of it selfe.* London, 1647. Wing: *STC* H183, Reel 457. See also H184, H185. From Benedict von Haefton, *Schola Cordis* (Antwerp, 1629). Published anonymously.

Jenner, Thomas. *The Soules Solace, or thirtie and one spirituall emblems.* London, 1626. Pollard: *STC* 14494, Reel 742. See also 14495, 14496. Modern edition: *The Emblem Books of Thomas Jenner* (Delmar, N.Y.: Scholars' Facsimiles & Reprints, 1983).

M[anning], E[dward]. *Ashrea: or, The Grove of Beatitudes.* London, 1665. Wing: *STC* M482, no reel listed. Modern edition: E[dward] M[anning]. *Ashrea. 1665* (Menston: Scolar Press, 1970).

Montenay, Georgette de. *A Book of armes, or remembrances.* Frankfort, 1619. Pollard: *STC* 18046, Reel 1075. See also 18047. Polyglot edition: Latin, Spanish, Italian, High Dutch, English, Low Dutch. From Georgette de Montenay, *Emblemes, ou Devises Chrestiennes* (Lyons, 1571). Another Renaissance edition: *Monumenta emblematum Christianorum virtutum* (Frankfort, 1619).

Peacham, Henry. *Minerva Britanna, or a garden of heroical Devises.* London, 1612. Pollard: *STC* 19511, Reel 898. Modern editions: Henry Peacham, *Minerva Britanna. 1612* (Leeds: Scolar Press,

1969); Henry Peacham, *Minerva Britanna* (Amsterdam: Theatrum Orbis Terrarum, 1971; New York: Da Capo Press, 1971).

Quarles, Francis. *Emblemes*. London, 1635. Pollard: *STC* 20540, Reel 904. See also, 20541, 20542. From Hermann Hugo, *Pia Desideria Emblematis* (Antwerp, 1624); and the anonymous *Typus mundi* (Antwerp, 1627). Modern edition: Selections in *A Selection of emblemes* (Los Angeles: University of California Press, 1972).

————. *Hieroglyphikes of the Life of Man*. London, 1638. Pollard: *STC* 20549, Reel 934. Modern edition: Francis Quarles, *Hieroglyphikes. 1638* (Menston: Scolar Press, 1969).

P. S., *The Heroicall Devises of M. Claudius Paradin*. London, 1591. Pollard: *STC* 19183, Reel 968. From Claude Paradin, *Devises Heroiques* (Lyons, 1551); and Gabriele Simeoni, *Le Imprese heroiche et morali* (Lyons, 1559). Modern edition: *The Heroicall Devises of M. Claudius Paradin* (Delmar, N.Y.: Scholars' Facsimiles & Reprints, 1984).

Thynne, Francis. "Emblemes and Epigrames." Presented to Sir Thomas Egerton, 1600. Unpublished manuscript. Modern edition: Francis Thynne, *Emblemes and Epigrams*, ed. F. J. Furnivall, Early English Text Society, vol. 64 (London, 1876).

Van der Noodt, Jan. *A Theatre wherein be represented the miseries that follow the voluptuous worldlings*. London, 1569. Pollard: *STC* 18602, Reel 347. Variant: Alternative spelling, van der Noot. Modern edition: Jan van der Noot, *A Theatre for Voluptuous Worldlings* intro. Louis S. Friedland (Delmar, N.Y.: Scholars' Facsimiles and Reprints, 1977).

Van Veen, Otto. *Amorum Emblemata*. Antwerp, 1608. Not listed in Pollard. Polyglot edition: Latin, English, and Italian. Variant: Author also known as Otho Vaenius. Modern edition: Otto van Veen, *Amorum Emblemata* (New York: Garland Publishing Co., 1979).

Whitney, Geoffrey. *A Choice of Emblemes*. Leyden, 1586. Pollard: *STC* 25438, Reel 401. Modern editions Geoffry Whitney, *A Choice of Emblemes*, ed. Henry Green (New York: Benjamin Blom, 1967; reissue of London, 1866 ed.); Geoffrey Whitney, *A choice of emblemes and other devises* (Amsterdam: Theatrum Orbis Terrarum, 1969; New York: Da Capo Press, 1969); Geoffrey Whitney, *A choice of emblemes. 1586*, ed. John Horden (Menston: Scolar Press, 1969); Geoffrey Whitney, *A choice of emblemes*, ed. Henry Green (New York: G. Olms, 1971; reissue of London, 1866 ed.).

Willet, Andrew. *Sacrorum emblematum centuria una*. Cambridge, n.d. Pollard: *STC* 25695, Reel 553. Variant: Publication date cited as 1591–98.

Wither, George. *A collection of emblemes, ancient and modern*. London, 1635. Pollard: *STC* 25900. Reel 1564. See also, 25900a, b, c, d, Reel 1564. Plates from Gabriel Rollenhagen, *Nucleus Emblematum Selectissimorum* (N.p., 1613). Modern editions: George Wither, *A collection of emblemes. 1635* (Menston: Scolar Press, 1968); George Wither, *A collection of emblemes, ancient and moderne* (Zurich: Inter Documentation Co., 1969 or 1971); George Wither, *A collection of emblemes, ancient and moderne (1635)*, intro. Rosemary Freeman (Columbia, S.C., University of South Carolina Press, 1975).

Index

WITHDRAWAL